Aesthetic Spaces

Aesthetic Spaces

The Place of Art in Film

✦

Brigitte Peucker

NORTHWESTERN UNIVERSITY PRESS
EVANSTON, ILLINOIS

Northwestern University Press
www.nupress.northwestern.edu

Printed in the United States of America

10 9 8 7 6 5 4 3 2 1

Library of Congress Cataloging-in-Publication Data

Names: Peucker, Brigitte, author.
Title: Aesthetic spaces : the place of art in film / Brigitte Peucker.
Description: Evanston : Northwestern University Press, 2019. | Includes
 bibliographical references and index.
Identifiers: LCCN 2018040725 | ISBN 9780810139077 (cloth : alk. paper) |
 ISBN 9780810139060 (pbk. : alk. paper) | ISBN 9780810139084 (ebook)
Subjects: LCSH: Painting and motion pictures. | Space in motion pictures. |
 Motion pictures—Aesthetics.
Classification: LCC PN1995.25 .P462 2019 | DDC 791.4301—dc23
LC record available at https://lccn.loc.gov/2018040725

To Ciné Club and its theatrical scenarios

CONTENTS

ACKNOWLEDGMENTS

My work on this project began some time ago, was interrupted by health issues, then resumed with greater intensity and conviction. The support of colleagues and friends sustained me throughout: among them I am fortunate to count Jeffrey and Morel Alexander, Johannes Anderegg, Dudley and Stephanie Andrew, Penny Bellamy, Eugenie Brinkema, Susan Bryson, Richard and Cindy Brodhead, Francesco Casetti and Ornella Rossi, Janice Carlisle, Angela Dalle Vacche, Maria DiBattista, Susan Felleman, Victor Fan, Roy Grundmann, Moira Fradinger, Laurie Fendrich and Peter Plagens, Thomas and Martha Hyde, Konrad Kenkel and Jocelyne Kolb, Edith Kunz, Carol Jacobs, Steven Jacobs, Leo Lensing, Joe McElhaney, John Mackay, Penny Marcus, Charles Musser, Laurence Nadel, John David Rhodes, Andreas Schmidt-Rögnitz, Joseph Roach, Mark Simon, Noa Steimatsky, Henry Sussman, and Manuela Zappe. At Yale, students in graduate seminars on the topics of theatricality and intermediality raised incisive questions that helped to shape my thinking. Swagato Chakravorty, Kirsty Dootson, Regina Karl, Jason Kavett, Ido Lewit, Max Fulton, Herbert Gilman, Anna Shechtman, and Tessa Smith are among them.

And then there are those who lent cheerful assistance in ways that made both work and life more pleasant: Marie Kessler in Yale's German Department, Katherine Germano Kowalczyck of the Film Studies Program, and Michael Kerbel, head of the Film Study Center, who has for years offered his kind support. Erica Sayers was instrumental—and patient—in the formatting of the manuscript, and I am indebted to Jason Douglass for technical help with the images. Trevor Perri, acquisitions editor for Northwestern University Press, was exemplary in providing guidance and moving things along. My grateful thanks go to all of them.

Special thanks go to Paul H. Fry, as always, who urged me to keep my nose to the grindstone and supported me while I did so. Our son Spencer kept things real.

A final thanks goes to Wiley-Blackwell Publishers for permission to republish the following, which occur in this book with some emendations: "Unframing the Image: Theatricality and the Art World of *Bitter Tears*," in *Companion to R. W. Fassbinder*, ed. Brigitte Peucker (London: Wiley-Blackwell, 2012), 352–71; and "Fritz Lang: Object and Thing in the German Films," in *Companion to Fritz Lang*, ed. Joe McElhaney (London: Wiley-Blackwell, 2014), 279–99.

Aesthetic Spaces

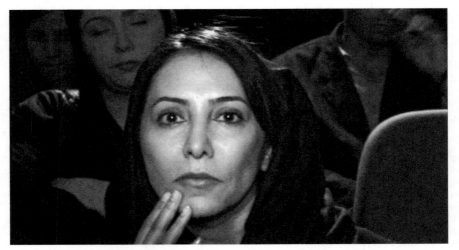

The female spectator. *Shirin* (Abbas Kiarostami, 2008), frame enlargement.

Kiarostami's *Shirin* and the Continuing Life of Cinema

The following chapters contribute to the discussion around intermedial issues in cinema and—by implication—to the ongoing questions surrounding medium specificity. Cinematic space and mise-en-scène are at issue in my analyses, which privilege close reading and formal concerns in the context of film and art theory and offer a reconsideration of film form by these means. The book's theoretical underpinnings are a mix of the canonical and the contemporary. I return repeatedly to the insights of André Bazin—one of the original media archaeologists—concerning the ontology of film and its mixed modes. Bazin's thinking was from the start outside the box, provocative and inspiring. But I rely as well on Gilles Deleuze's cinema books, and my ideas have been shaped by reading Slavoj Žižek, Jacques Rancière, Alain Badiou, Jean-Luc Nancy, Pascal Bonitzer, Fredric Jameson, Laura Mulvey, Linda Williams, and Erika Fischer-Lichte, to name a few. And then there are the art historians and art theorists on whom the book draws, who are also a mix of the canonical and the contemporary: Aby Warburg, Heinrich Wölfflin, Alois Riegl, Clement Greenberg, T. J. Clark, Norman Bryson, and Svetlana Alpers, among others. This is not to mention the film and media scholars and theorists whose work has brought specific films into focus for me.

Questions of film form matter to those interested in film aesthetics and to those for whom the arrival of new media and the issue of "expanded cinema"—very much in the center of current debates—are a matter of concern. They matter also, I hope, to those who resist the dire prophecies surrounding the "end of cinema." This book makes no overarching historical claims, but its arguments are carefully grounded in art and film historical specificities and practices. "Dissonance" is a central term in this study, a term that signals an indebtedness to modernism in its Brechtian form, which underpins all of my chapters. To make this claim is in itself to make a political statement: the term suggests the concern with the Frankfurt School aesthetics—and ethics—that we value in the work of Walter Benjamin and Theodor Adorno, among others. My readings privilege how more than why some films emphasize their dissonant textualities, but the project of expanding and interrogating the medium of film is always at their center.

There Is No Movie; There Is No Movie Theater

This situation describes Abbas Kiarostami's *Shirin* (2008), a film that stages cinematic spectatorship as chronicled by the documentary of its making, *Taste of Shirin* (2008). The films of the Iranian director are not primarily concerned with "paradoxes of representation," writes Jean-Luc Nancy in *The Evidence of Film*, even if these are present in his work. For Nancy, Kiarostami's cinema is not an art of the imaginary, but an art of looking or regarding.[1] But how does Nancy's metaphysical understanding of Kiarostami's films intersect with the experimental aspect of his cinema?—with *Close-Up* (1990), a film that interrogates the temporal and ontological ambiguities of reenactment; with *Ten* (2002), a series of conversations shot entirely in a moving taxi; with *Five Dedicated to Ozu* (2003), comprised of five lyrical single-take sequences the director calls documentary; with *Certified Copy* (2010), which addresses the ontological status of original and copy—and with *Shirin* (2008), perhaps the most experimental of his films and the one we address here? The visuals of the latter are almost exclusively facial close-ups, primarily of female Iranian actors, along with two close-ups of Juliette Binoche, soon to star in *Certified Copy*. In what initially seems an inversion, these actors play an audience of moviegoers. The film they are figured as watching is never shown to us: we do not glimpse so much as one image for Nizami Ganjavi's (1141–1209) famous Persian romance *Khosrow and Shirin*, from which *Shirin*'s soundtrack is drawn. And neither do the actors—because there is no film for the actor-spectators to watch, and the soundtrack we hear was chosen, recorded, and added later.

As Hamideh Razavi's documentary about the production of *Shirin*, *Taste of Shirin* (2008), makes clear, the only thing the actors are "watching" is a piece of cardboard with stick figures and directional arrows. Kiarostami's film was shot in his living room, with a few theater seats on which small groups of women and a few men were seated for five minutes at a time and shot in rotation. The film is a montage of these shots. For Jonathan Rosenbaum, it is the illusionism of *Shirin* that is of note, along with the film's recourse to a romance that is well known throughout the Persian world—a tradi-tional and popular text, that is—which is somewhat "perversely" subjected to experimental techniques.[2] Arguably, Kiarostami's experiment would not have worked without a well-known source behind it, one that provides the Iranian spectator, at least, with a familiar narrative.

Can we demand of film audiences that they study a film's production his-tory before they view it? Without Razavi's documentary, we are privy to only half the story. *Taste of Shirin* shows Kiarostami directing the facial expres-sions of the female actors, instructing them to "move your eyes only, not your neck"; "your eyes should smile, not your face"; "if you have an inner feeling you can communicate through the eyes, good . . . I don't mean *acting*." The director is primarily concerned with the eyes, but also with facial expressions

of fear, happiness, and sorrow, along with the flutter of hands touching the lips, perhaps, or adjusting headscarves. Kiarostami exhorts his actors to "play a personal movie of your own," to delve into their memories of films in which they *have* acted to find their emotion. If they are not to act in this film—"and I don't mean *acting*," he asserts—but to call on memories of films in which they have done so, what is at issue? In part, of course, Kiarostami's directions are meant to elicit the lower-key, less theatrical style of expressivity appropriate to cinema. But to suggest that the actors call on memories of films is also an oblique strategy for promoting the film's self-reflexivity. This motive only emerges from the documentary of the film's production.

The human face has been called *the* cinematic subject par excellence. When, in *The Face on Film*, Noa Steimatsky asks how "the human face evolved as such a privileged locus, as a measure—as the essence—of the cinema," she is interrogating a line of thinking pursued by film historians and theorists as diverse as Béla Balázs, Gilles Deleuze, and Jacques Aumont.[3] And it is clear that Kiarostami is aware of the freighted subject he is taking on: there can be little doubt that Dreyer's *The Passion of Joan of Arc* (1928) is an important intertext for *Shirin*. With respect to the Dreyer film André Bazin's comments are noteworthy: "Let there be no mistake," Bazin writes, "that prodigious fresco of heads is the very opposite of the actor's film. It is a documentary of faces."[4] The pockmarked skin, the wrinkles, the tears that so frequently course down Joan's face—for Bazin and for Dreyer himself, it is these details that make the film "real," despite the artifice of the film's set. And this is how Kiarostami understands *Shirin*. But there is no fresco of faces in his film: the camera approaches each face frontally, avoiding the high- and low-angle shots and eccentric framing of Dreyer and producing features less sculptural than his. In contradistinction to the mobile camera of *The Passion of Joan of Arc*, Kiarostami's camera is static for the duration of each shot, as if to refute the earlier director's approach. These are portraits, even though the faces move.

Here we make a detour or two, for other films resonate in *Shirin* as well. The first detour is to Jean-Luc Godard's *Vivre sa vie* (1962), where tableau 3 contains the famous scene in which Godard's Nana (Anna Karina) visits the cinema to watch Dreyer's *The Passion of Joan of Arc*. In this sequence Nana's face is illuminated by the light of the screen—as are the faces in Kiarostami's *Shirin*. Nana is shot frontally, like the actors in *Shirin*, and her face stands out in relief—like a cameo—since her hair merges with the dark space of the theater. When *Vivre sa vie* alternates Nana's face with Joan's, intercutting shots of Nana and of Joan's reaction as she learns she will be executed, tears are flowing down the cheeks of both women. For Aumont this sequence is "a paradigmatic example of how the face signifies in film,"[5] and Steimatsky calls the sequence "an extraordinary situation of shot-reverse-shot, joining archaic and modern,"[6] bridging two disparate moments of cinema history. The scene is generally understood as an example of spectatorial identification: Joan's impending death at the stake, her martyrdom, so the argument

goes, is felt by Nana as resonating with her own life. But is it a scene of rec-
ognition, or is Nana simply moved to tears by the fate of Joan of Arc—or
giving vent to other inchoate emotions?[7] Is this an example of what Gilles
Deleuze calls "strange cinematographic nuptials in which the actress provides
her face . . . whilst the director invents the affect or the form of the expressible
which borrows and puts them to work"?[8] Steimatsky argues that in the early
1960s Godard believed in the movie theater as a "space of intersubjective
potentiality,"[9] but for Susan Sontag, Godard's evocation of Nana renders her
"stripped down,"[10] evacuated of interiority, while for Kaja Silverman and
Harun Farocki the "double eradication" of her outside and her inside "implies
death as inexorably as being burned at the stake."[11] Interiority is at stake, if
I may say so. Silverman and Farocki's comment refers to the anecdote that
Nana's estranged husband relates concerning a child's essay about a bird that
is similarly stripped down—but whose soul is revealed in the process. In an
interview Godard says that interiority is what he had hoped to render when he
approached Nana from the outside: "How can one render the inside? Perhaps
by staying prudently on the outside."[12] This is also Kiarostami's approach.

Maureen Turim's fine essay on Godard's film, from which I have profited,
argues on behalf of Nana's interiority, which surfaces for Turim primarily in
Nana's assertion of agency—the repetition of "I am responsible"—and in
tableau 12, where Nana makes the decision to leave her pimp Raul in order
to pursue life with her young lover, leading directly to Raul's "selling" of Nana
and her death in a shoot-out. Much as we might like to see Nana's behavior
as revealing interiority or "soul" (as is claimed of the bird), there are details
that problematize this reading. Nana asserts her agency over simple physical
actions only and appears naive in suggesting that this kind of agency is mean-
ingful. She is also impervious to the import of her lover's reading from Edgar
Allan Poe's *The Oval Portrait* (spoken by Godard himself; see chapter 4),
interrupting the reading to ask where the young man got the book. And while
Nana initiates the conversation with philosopher Brice Parain, it is doubtful
that she takes in what he is saying about the nature of language. Parain's
message is intended for Godard's spectator.

What Turim's essay clarifies beautifully is the way in which Godard's film is
both a structural film and a modernist film: "This modernism extends beyond
the striving for new forms consonant with his ideas; it sees structures as
already an idea, already an argument, and as a support for a multiplicity of
complex and paradoxical references and meanings."[13] In interviews, Godard
mentions that the twelve tableaux of *Vivre sa vie* emphasize the theatrical,
Brechtian aspect of his film.[14] In *Vivre sa vie* narrative episodes exist quite
independently of one another. It is not simply the film's division into twelve
"pictures" that is Brechtian, however, but also the way its intertitles suggest
the action to come. And, as Turim puts it, the film emphasizes the series and
variations that characterize modernism at the level of both image and narra-
tive. Composed of a series of dialogues, *Vivre sa vie* is a "demonstration"[15]

which from the first dissociates word from image. So argues Susan Sontag. In a variety of ways, then, Godard resorts to acts of fragmentation elaborated in Brecht's theory of epic theater. (See chapter 7.) During the period of the film's making, Godard is engaged with Brecht, but as Godard puts it, he is also "thinking as a painter, of confronting my character head-on, as in the paintings of Matisse and Braque, so the camera is always upright."[16] A similar approach is taken by Kiarostami, who by way of *Shirin* is deliberately inserting himself into the history of European art cinema—Dreyer, Godard, Kiarostami. Like Godard, Kiarostami also sees structures and new forms as "already an idea, already an argument," as Turim writes of the French director.

Second detour, this one to Francesco Casetti's chapter "Performance" in his recent book, *The Lumière Galaxy.* Here Casetti analyzes the events of a three-and-a-half-minute film by Atom Egoyan, *Artaud Double Bill*, part of the anthology film *To Each His Own Cinema* commissioned by the Cannes Film Festival in celebration of its sixtieth anniversary in 2007. Egoyan's short film portrays two types of film spectatorship. One is spectatorship as identification or immersion, anchored to the sequence in *Vivre sa vie* in which Nana is cut with Joan of Arc—the shot-reverse-shot, as Steimatsky put is, that bridges two moments of film history.[17] In *Artaud Double Bill* this passage from *Vivre sa vie* is watched by a woman named Anna, while her friend Nicole watches another film at another movie theater, a film called *The Adjuster* (1991), also by Egoyan. Of interest to Casetti is that Anna does not respond to Jeanne and Nana with tears, but rather texts a clip from Godard's film to her friend Nicole. This type of spectatorship is decidedly not immersive, writes Casetti; rather, it makes the space of the movie theater continuous with life, since Anna is communicating about a movie she is watching to her friend Nicole. Casetti points out that the attention of these two twenty-first-century women is multiple: they watch and text, they multitask. For Anna and Nicole, writes Casetti, "film is a discourse that hosts other discourses, that collaborates with other discourses, and that generates other discourses."[18] (Hasn't that always been the case? Consider the intermediality of Godard's cinema, even in the early *Vivre sa vie.*) But Casetti goes on to qualify: the discourses to which he is referring constitute a network of social discourses. Ultimately he will argue that it is the spectator who becomes the performer, creating the experience of watching moving images by way of image-capturing devices. The new spectator as bricoleur is someone who constructs the visual experience she wants.

This is no doubt why Egoyan constructed his three-and-a-half-minute film—which cites several others—in the way he did. Casetti's project being to analyze changes in the experience of viewing moving image technologies in our century, it is no surprise that he does not pursue other points of connection between the two films *Artaud Double Bill* references. Yes, the women's names—Anna, Nana—are anagrams and Anna takes her name from Anna Karina, who plays Nana.[19] And Arsinée Kahnjian, who plays Nicole, also acts one of the central characters in *The Adjuster.* But the tapestry woven by the

connections among these characters and the women who act them is dense, so there may be additional reasons that Egoyan cites these particular texts. We might add: like Anna Karina, who in 1962 is still Godard's wife, Kahnjian is Egoyan's wife, so that the excerpt from *The Oval Portrait* read by Godard in *Vivre sa vie*, which recounts the story of an artist who vampiristically sucks his wife's lifeblood dry for the sake of his art, might conceivably resonate for Egoyan as well, even if that is not in the clip that Anna texts.[20] (See chapter 4.)

Interestingly, *The Adjuster* features Kahnjian playing Hera, a film censor who watches pornographic films in order to rate them—and while doing so records them surreptitiously in order to bring them home for her sister to watch. Not only is her practice another example of recording and repurposing but, as in the case of *Shirin*, while we hear the soundtrack of the films Hera screens, we never see their images. As Linda Williams tells her readers in a number of different books, pornographic films set up another kind of spectatorship altogether. Even if they do not prompt psychological identification, body genres produce a physical experience in their spectators, and Kahnjian's Hera is not immune to their seductions. This is a form of immersive spectatorship—and it is not new. Egoyan's films habitually resort to soft-core pornography for their impact, so it is not surprising that *Artaud Double Bill* also suggests this type of spectatorship. Interestingly, Egoyan titles his short film *Artaud Double Bill* because Anna, who texts the clip from *Vivre sa vie*, has responded to the looks of Antonin Artaud as Jean Massieu in Dreyer's film, as Casetti also notes. But we should add that in that case the experience of cinema for Anna is physiological—perhaps tangentially psychological—not wholly distanced. Anna texts the images that provoke her physical attraction to Artaud to her friend Nicole with the thought that Nicole may respond similarly. Should we read Egoyan's short film as distancing itself from psychologically immersive forms of spectatorship, but not from the bodily address set up by pornography—or as continuing to insist on our seduction by images? And let's recall that even if Nana is immersed in *The Passion of Joan of Arc*, the spectator of Godard's film is not. She is distanced from its pictures of Nana's life, made to feel sympathy, no doubt, but also invited to reflect on the social contradictions the film presents—as Godard, with Brecht, demands. Is distanciation in play for the external spectator of Egoyan's short film—or does she experience the acts of internal spectatorship she views as representational, as part of a story? *Artaud Double Bill* is a film, not a text message.

Let's return now to Kiarostami. What about *Shirin*'s place in this chain of textualities? It was released in 2008, one year after *Artaud Double Bill*. Did Egoyan's film provoke Kiarostami to structure *Shirin* in the way that he did? A preliminary sketch for *Shirin* called *Where Is My Romeo?* was shown at Cannes as part of the same anthology film in which *Artaud Double Bill* appeared,[21] so Kiarostami would certainly have seen Egoyan's contribution. And no doubt *Artaud Double Bill* prompted Kiarostami to take another look at Dreyer's and Godard's films. Kiarostami's own three-minute film,

Where Is My Romeo?, contains footage of actor-spectators similar to those in *Shirin*, but uses the romantic soundtrack of Franco Zeffirelli's *Romeo and Juliet* (1968).[22] Could *Artaud Double Bill* have moved Kiarostami in another direction—to return to Persian culture for his text? If so, why?

In one way only—its representation of social media—is Egoyan's film more avant-garde than *Shirin*, a film that—like *The Adjuster*—withholds from its spectator the images its characters are purportedly watching. There are no figures of identification on offer here. *Shirin* divorces its characters' acts of spectatorship from images on a screen, thus making "an idea function," like Godard, in modernist fashion. Radical, too, is that none of its actors speaks and there is no plot save on the soundtrack, which was chosen later. The faces, shoulders, and hands of its actors and the bare outlines of theater seats are the only visuals afforded by the film. There is very little action and no interaction among the female spectators we watch—certainly not in the form of an exchanged glance, since each woman looks only in the direction of a purported "screen." Once only do we observe an actor performing an action—passing candy—that connects her to someone offscreen. A few men are among *Shirin*'s movie audience as well, but the camera never focuses on them. In *Shirin*—as in the other films under discussion—only female faces are on display. Their moved and moving expressions stand in place of the unseen images of the Persian romance. The camera focuses on one face at a time, and each face is differentially lit, with moments of brightness and shadow simulating what would be the reflected light from the changing images on an actual movie screen. Light scrupulously fades at the end of each shot. Portrait shots and spoken text relate to one another only in the *illusion* of a watched film. As we learn from Razavi's documentary, image and sound in *Shirin* were recorded in entirely different spatial and temporal contexts. This is common in film production, of course, but it is the splitting of "performance," such as it is, from any narrative context—indeed, any context whatsoever except the memories of each actor—that sets the film apart. Kiarostami is interrogating the cinematic *dispositif*: the dissonance of the film lies partly in its premise.

For Godard the proper way to present Nana's interiority was by staying on the "outside." Kiarostami likewise stays on the "outside" of the women whose faces he records: their expressivity is based in emotions they experienced as they acted in other films. While *Shirin* simulates as well the space of a movie theater, in this it does not differ from *Vivre sa vie*—except insofar as the movie screen and its images are never on view. In *Shirin* the screen has migrated to the faces of its spectating characters, its images replaced by their affect-rich—if ersatz—expressivity. Only in conjunction with the documentary about its production does *Shirin* fully reveal its discontinuities. (Here is another contemporary mode of viewing, one based on the availability of DVD supplements.) While the spectator-actors are urged to re-present previously acted emotion, for the spectators of Kiarostami's film, who hear a soundtrack that cites the romance of *Khosrow and Shirin*, the affect reflected in facial

expressions appears motivated, perhaps provoking affect in us. Immersive spectatorship may not be possible, but a degree of identification with the spectacle of emotion is.

Like Dreyer, Kiarostami emphasizes the documentary quality of his film: for Kiarostami, too, it is the portrait shots of faces that anchor the film in the real. The film images the core of Kiarostami's filmmaking for Nancy: the act of seeing or regarding "made possible and required by a world that refers only to itself and what is real."[23] As Nancy points out, representation has been supplanted by presentation, and Kiarostami's cinema is a central example of this shift.[24] For Nancy, it is only when cinema was released from its status as an art of the imaginary—and thus released from semiology—that it was able to distinguish itself from painting, photography, theater, and circus.[25] Nancy's assertive reading of Kiarostami's films—which predates the release of *Shirin*—approaches Bazin's stance toward Dreyer's film in its emphasis on the "real." As *Taste of Shirin* shows us, Kiarostami tells his actors that their *images* are real: "We don't always have a chance to watch such private moments of a person," he says, "picture by picture." Picture by picture: Sergei Eisenstein's critique of Dreyer's film is that it is a series of stunning photographs—that it is photographic, not cinematic.[26] Kiarostami views *Shirin* the same way.

Is it the face or the indexicality of the photograph that Kiarostami wishes to honor in *Shirin*? With photography in mind, I suggest that another important medium is present in *Shirin*, one that would have held significance for Kiarostami, a much-touted poet and photographer as well as a filmmaker. It is photography, more specifically Jeff Wall's *Movie Audience* (1979), three lightboxes with groups of larger-than-life-size heads all looking in the same direction in simulation of gazing at a screen. Wall's works are cinematographic at this stage in his career, preoccupied with cinema and understood by Wall to be intermedial. Of *Movie Audience*, Wall writes: "Technically, it approaches replication of the experience. Therefore, the work undergoes an eclipse as art in the process of its display."[27] Perhaps this is what "presentation" is. Hung higher than eye level, the three photographic works display images of spectatorship to their beholders. Because the works are in lightboxes, Wall's transparencies can throw actual light on the museumgoers' faces as they gaze up at them—a strategy of which Kiarostami makes heavy use in *Shirin*, where the play of light and shadow on the actors' faces simulates the way that light cast by cinematic images emanates from the screen. This technique draws attention to the abstract nature of Kiarostami's film, for the pattern of light and shadow in *Shirin* suggests that it is a trace of images—but in reality the images themselves are hypothetical, the lighting carefully orchestrated.

So the face becomes a screen of sorts. As we recall from Steimatsky, the face is the essence of cinema, hence Kiarostami's choice to feature it almost to the exclusion of other images is an assertion of cinema's power as well as its history. His film creates a bridge to Dreyer and Godard (Kiarostami's ardent

supporter), "joining archaic and modern" to more modern still (his own film), a bridge that may question *Artaud Double Bill*'s presentation of film's appeal to the body and its fragmentation—or repurposing—at the hands of its audience. Can we say that by way of *Shirin* Kiarostami reasserts the integrity of cinema?

That is not to say that *Shirin* is a unified text or that its disparate parts come together. The film's piecemeal presentation of the *Khosrow and Shirin* story—the film is heavily cut, modernist in its approach to narrative, like *Vivre sa vie*—and its separation of image and text problematize immersion. *Shirin*'s cinematic predecessors, *The Passion of Joan of Arc* and *Vivre sa vie*— perhaps *Artaud Double Bill* as well—together with its source in Wall's photographic transparencies—are juxtaposed with the film's literary source that is its soundtrack, a Persian text that enjoys the status of *Romeo and Juliet* in Western culture. It is not surprising that Kiarostami, who is himself a poet and often cites Persian poetry in his films, might let the soundtrack of the romance speak for itself, that he would choose to keep soundtrack and image track apart as he does. Literary text as sound, images of spectatorship that recall photographic portraits—these disparate media function in modernist fashion. Like *Vivre sa vie*, *Shirin* is predicated on the dissociation of word and image. Rather than signaling the death of cinema—which I am not sure that *Artaud Double Bill* actually does, either—*Shirin* suggests how film's dissonant hybridity can be made to preserve its medium, even in the act of expanding it. It is by means of its formal ruptures, by bringing other media into play, that the film calls attention to its exploration of the cinematic medium. Recall further that Kiarostami's film puts the essence of cinema—the situation of looking, regarding, seeing—on view. Kiarostami's movie addresses the experience of watching a film, an experience that carries an aesthetic and a political charge.

For there is more. Social meaning is not absent from our experience of *Shirin*, which discreetly addresses a number of ideologically charged issues. This is precisely how Kiarostami sets himself apart from a history of European art cinema that he also expands by bringing Iran into the picture. As one critic puts it, "The act of looking touches on highly sensitive nerves in the Iranian regime, which has put in place a 'rule of modesty' law and 'commandments for looking' for the cinema."[28] What *is* permitted is an "exhibition of inward space" that is shown by the act of looking.[29] Rendering interiority by showing the exterior is a lesson Kiarostami did not learn exclusively from Godard. Three years after *Shirin* was released, in 2011, the Iranian government censors refused to allow the more than eight-hundred-year-old romance *Khosrow and Shirin* to be republished, arguing that it is too sexually explicit. Kiarostami's film critiques censorship and the Muslim prohibition on images—recall that the actors "watch" only stick figures on a piece of cardboard—substituting for that unimaged romance the potentially problematic because unveiled female face. In *Shirin* the female face is not exploited. It is a vehicle for protest.

The Persistence of Film

In his review of Casetti's book, Dudley Andrew tackles the debate about the death of cinema, asking whether "interpreting and historicizing film" has been "replaced by media sociology."[30] I do not explicitly enter this debate except through my discussion of *Shirin*, which is simultaneously engaged with the life and death of cinema and with cinema's engagement with film history and other media in order to think about and expand its own. The acts of fragmentation in *Artaud Double Bill* are more radical than those in Kiarostami's modernist film. But only use value and personal whim dictate the acts of bricolage that Egoyan's spectator as performer undertakes. Egoyan's short film is at most a sociological record, charting the practices of contemporary viewers, while *Shirin*'s openness to other media—literary and photographic—both expands its medium and opens it up to reflection, aesthetic and political. Likewise, the fiction films addressed in the chapters to follow—whether analog or digital, whether viewed on a small or a large screen, communally or alone—are valuable spaces for aesthetic and mediatic experimentation and analysis. In most of them, film's dissonant hybridity is a means of "baring the device," thus opening up the smooth surface of representation, or story, for the sake of presentation. This may be how film refuses to die.

Where There Are Two Arts, There Is Usually a Third

In 2000, Jay Bolter and Richard Grusin announced that remediation was the logic of the new media.[31] But it has always been the logic of cinema, as I have argued in earlier work—in *Incorporating Images: Film and the Rival Arts* (1995), which reads the art of film in relation to the other visual arts but also to literature and other media such as the landscape garden, and in *The Material Image: Art and the Real in Film* (2007), which concerns forms of illusionism and immediacy and in which the real is read with respect to spectatorial experience and embodiment.[32] Using Bolter and Grusin's terminology with *Shirin* in mind, we would say that Kiarostami *remediates* the poetic romance *Khosrow and Shirin* by cutting it and using it as the soundtrack for his film; that photography as a medium marks Kiarostami's recording of the spectatorial face, rendering it *intermedial*; that *Shirin*'s evocation of other films in this process is an example of *refashioning*; and, more generally, that *Shirin* is an example of *hypermediacy*, of one medium's *remediation* of others in a way that allows them to "show." All of these terms highlight transformation. The suggestion of process implied by transformation is the advantage of Bolter and Grusin's somewhat rigid system of classification for textual appropriations by new media. For Yvonne Spielmann and most European theorists, transformation is central to the concept of intermediality,[33] while American scholars of intermediality and interarts issues tend to use the term

more expansively. This book does *not* make use of Bolter and Grusin's catego-
ries, preferring a terminology more locally specific to address the instances of
mediatic boundary crossings and interarts problems it examines. It insists on
the close reading of individual films, whether analog or digital, and draws on
terminology appropriate to each film. This terminology comes primarily from
the fields of cinema studies and art history.

Two postulates underpin this study. The first is the by now generally
acknowledged hybridity of film. It is commonly understood that even—or
perhaps particularly—as a burgeoning medium in the early twentieth century,
film borrowed from the popular theater, from painting, and from literature
to elaborate its own discursive regime. My premise is that film investigates
the aesthetic problems and strategies of other media in order to interrogate
and expand its own. In this line of thinking, I follow Jacques Rancière, who
stresses the "relation of one art to itself via the mediation of another"—an
insight he may well have derived from André Bazin.[34] For Bazin, film theorist
and media archaeologist, cinema is by its very nature ontologically "impure."[35]
More recently, Alain Badiou, borrowing Bazin's term, has stressed that film's
"impurity" can be resolved through a "synthetic fusion" of its elements: for
Badiou cinema invents new syntheses.[36] And Ágnes Pethő is intrigued by the
way moving pictures "can initiate fusions and 'dialogues' between the distinct
arts,"[37] suggesting both fusion and rupture as possibilities in the relation of
the media to one another. But in this study the question of rupture or syn-
thesis, fusion or gap, is most often resolved in favor of rupture and gap: it is
the dissonance of a film's disparate elements that is most revealing. We may
find ourselves in a postmedium condition, as Rosalind Krauss puts it,[38] yet we
continue to reflect on the nature of the media, if only to bend them into other
shapes, until they are nearly—but not wholly—unrecognizable.

My second premise derives from my experience as a reader of film: where
two media—or arts—are in evidence, there is also at least a third. In these
chapters, films that engage with one medium always invoke others. Perhaps
that is because, having opened themselves to exploration—or improvisation,
as Krauss puts it—they simultaneously take chances "in the face of a medium
now cut free from the guarantees of artistic tradition"[39] to explore the tradi-
tions of other media.

Scenes of Encounter

Why take up canonical art cinema and its relation to traditions in Western
art and theater? The films that I read are primarily films that address art-
works and theatrical forms that belong to the Western tradition, even when
they borrowed from Asian traditions, as Artaud and Brecht did. Kiarostami's
Shirin fits my rubric because it deliberately positions itself with respect to
European art cinema (Dreyer, Godard) and North American photography

(Jeff Wall) and film (Atom Egoyan). Of course I have profited from Rosalind Galt and Karl Schoonover's anthology *Global Art Cinema: New Theories and Histories*, which aims to fill the lacunas in our understanding of global art cinema.[40] Given my reliance on art theory and close reading, it seems inappropriate to look at films from mainland China or Taiwan, for instance, without an understanding of the rather different aesthetics and philosophies that govern visual representation in China. While I teach some Chinese and Taiwanese films, my understanding of Chinese painting and cinema is not thorough enough to enable an analysis that is not derivative. Nor can I read the requisite languages. I admire Victor Fan's *Cinema Approaching Reality: Locating Chinese Film Theory*, which mediates between Chinese and Western theories of film, and have found Stephen Teo's *The Asian Cinematic Experience: Styles, Spaces, Theory* very informative.[41] I have profited from Jean Ma's work on Hou Hsiao-hsien's *The Puppetmaster* in Richard Suchenski's thought-provoking anthology concerning the Taiwanese director.[42] Hao Dazheng's "Chinese Visual Representation: Painting and Cinema" and several other essays in Linda C. Ehrlich and David Desser's pathbreaking anthology, *Cinematic Landscapes: Observations on the Visual Arts and Cinema of China and Japan*, are very helpful as well in providing a bridge to other conceptions of art.[43] But it will be some time before the lack of familiarity most non-Asian writers on cinema have with Asian aesthetic traditions is fully repaired

In the chapters that follow, I group my readings around aspects of cinematic form and structure. The seven categories I have chosen are by no means exhaustive; rather, they serve to organize my thinking about particular groups of films and how they intersect with the other arts, primarily but not exclusively painting. These chapters do not offer general discussions of these formal categories, nor do they provide the interpreter or theorist of film with rigid paradigms for analysis. Instead, they are readings that demonstrate how one can approach the intermedial questions they set up. All of these chapters invoke issues of space and mise-en-scène from different, but interconnected perspectives.

The first chapter, on space, "Pictureness and Anti-perspectivalism in Modernist Cinema," is specifically focused on aspects of what Rudolf Arnheim calls *Bildlichkeit*, translated here as pictureness (rather than the less precise term, pictorialism) in a range of films. It considers perspective and its undermining or denial by *The Cabinet of Dr. Caligari*, a number of films by Alfred Hitchcock, and Antonioni's *Red Desert*, ending with a quick glance at Godard's *Passion*. All are read in conjunction with the rejection of the perspectival system by modernism, taking Noël Burch's discussion of "the cohabitation of two modes" for its point of departure and emphasizing the competing spaces produced in these films. The second chapter, on the spectator, is titled "The Spectator and the Text: The Space of Art in Greenaway" and in several ways follows from the first. It, too, asks about the spatiality of film in relation to painting, but also to theatrical space, focusing primarily on two films by

Peter Greenaway, *The Cook, the Thief, His Wife and Her Lover* and *Nightwatching*. It reads the complex, oscillating spaces of Greenaway's multimedial palimpsests with respect to Alois Riegl on *The Dutch Group Portrait* and its positioning of the spectator—the mediating function of theater between painting and film, installation space—and ends with a reading of *Rembrandt's J'Accuse* as ekphrasis.

The third chapter, "Unframing the Image: Theatricality and the Art World of *Bitter Tears*," concerns frames and framing from several points of view, once again tackling the issue of space. It considers a famously intermedial film by Rainer Werner Fassbinder, *The Bitter Tears of Petra von Kant*, which uses an enlarged reproduction of Nicolas Poussin's *Midas Giving Thanks to Bacchus* as its backdrop. Here the issue of space takes into account Poussin's methods of working, Fassbinder's attachment to the theatrical stage, the frame of painting, and the film frame. The ideologically motivated disruption of all acts of framing in the film is linked to masochistic theatricality and a metastatic aesthetic. The fourth chapter, on color, titled "Effacement: Color, Modernism, and the Female Body," examines the use of color—especially the color red—in modernist films by Ingmar Bergman, Jacques Rivette, and Alfred Hitchcock, where the body of the woman is pressed into service for formal or artistic ends. Gilles Deleuze's comments on the face and color, Edgar Allan Poe's *The Oval Portrait*, and Honoré de Balzac's *The Hidden Masterpiece* have a role to play, as does the long-standing art historical debate between line and color, in which color is devalued and notoriously linked to the feminine. Effects of figure and ground play a role in each of the films considered. This chapter also features a coda—an antidote of sorts to the effacement of the woman featured above. It asks how the female filmmaker recovers the woman's face and body co-opted for his use by the male director, who uses that face as the very support of his art, perhaps to be covered over by painterly technique? Reading two of Varda's intermedial films as portraits and self-portrait, it suggests how the arts might function in a feminist project.

Props are the topic of chapter 5, "Object and Thing in Lang's German Films," which is structured around the presence and use of objects—and uncanny Things—in a number of films by Fritz Lang. Lang's collector's drive and obsessive attention to mise-en-scène have a role to play, as do changing views on the nature of the object in German culture. The presence of the hand in Lang's work—each of his films contains an image of his hand—is a topic as well, leading directly to the hieroglyphs it sometimes produces. Neither image nor letter, their hybridity renders them uncanny, a Thing in the Žižekian sense: Lang makes writing itself an object. This chapter leads naturally into the one on décor: chapter 6, "Collection and Display in Fassbinder's *Lola*," which begins with a consideration of Josef von Sternberg's art world—his obsession with the image—and his stylistic appropriation by Fassbinder. It focuses on painterly spaces in *Lola* produced by the theatrical and painterly superimposition of light and color in the Sirkian manner, and on the unmen-

tioned mute—though speaking—objects with which the film is strewn. These citational "collection objects" speak to identity and issues of gender.

Chapter 7, concerns the actor, theatrical and cinematic: that is, the issue of presence or its lack and other matters of performance. Beginning with the conjunction of Brechtian epic theater and film melodrama in Lars von Trier's *Dogville*, it moves on to consider actor and puppet in Spike Jonze's *Being John Malkovich*, where the question of spectatorial identification is parodied. Taking up the dissonance produced by human bodies in artificial mise-en-scènes, it next looks at Eric Rohmer's *Perceval* and *The Lady and the Duke*, and, finally, Lech Majewski's *The Mill and the Cross*, in which human actors move across a digitized backdrop of Pieter Bruegel's *The Road to Calvary*. The mixed form of tableau vivant—the nodal point of theater, painting, and sculpture—plays a role in most of these films. And Majewski's film returns us to the beginning of this introduction, since it poses questions about expanded cinema and the ontology of painterly, digital, and cinematic spaces.

Paintings by Poussin and Bruegel, Rembrandt and Hals; medieval illustrations and modernist abstractions—the films I examine draw on them as materials, testing and expanding cinematic space, drawing on older arts still to critique and to renew cinema at different moments of its history. Spectator and actor, elements of mise-en-scène—color, lighting, and objects—and the ideological frameworks that determine them come together in this book, creating ruptures from which new modes of looking arise.

Chapter 1

Space

Pictureness and Anti-perspectivalism in Modernist Film

"Perspective was the original sin of Western painting."[1] This blanket pronouncement concerning the pseudo-realism enabled by perspectival practices dates from 1945, when André Bazin argued that such practices promote a "deception aimed at fooling the eye."[2] Painting cannot properly depict reality, writes Bazin, but that should not matter to painting, since realism is the proper purview of the cinema: film's photographic basis allows it to register the world appropriately, without deception. Painting is thus liberated from realism, Bazin argues, and Paul Cézanne's interest in "mere form" is right and proper, since for painting "there is no longer any question of the illusions of the geometry of perspective."[3] This line of argumentation allows Bazin to embrace modernist practices in painting such as Cubism and abstraction, clearing the way for film to take over the function of registration—but woe to those films that do not see the act of registration as their mandate, or that play havoc with the rules of perspective and space.[4] According to Bazin, in undermining the cinema's ideological imperative to register the world, such films offend against the ontological basis of their medium. In this chapter we examine a number of films that do just that—that render space pictorial, that flatten it, or that otherwise include formal features enlisted in the struggle against perspectival practices. In constructing a relation to space that does not conform to realism, these films ally themselves with another moment in another medium—with the art of painting in its modernist phase, which turned away from perspective.[5] Our examination of these films is intermedial and concerns the space of painting in its relation to cinema.

By the 1970s and '80s, well after Bazin's pronouncement, perspective had become a bad object for film theorists as well as for art historians. Apparatus theorists critiqued central perspective's production of a spectator whose point of view was centered and fixed, a subject in a position of mastery. Since the film camera was modeled on the camera obscura, it was argued, the ideology reflected in perspective carries over to the cinematic image.[6] So writes Noël Burch in his seminal essay of 1990, "Building a Haptic Space," referring to the art historian Pierre Francastel's work on painting and to Jean-Louis Baudry's reading of the cinematic apparatus.[7] In his short essay Burch slices through an intricate web of textual references and interconnections, a debate

The film camera meets figures from Francisco Goya's *Naked Maja* and *The Parasol*. *Passion* (Jean-Luc Godard, 1982), frame enlargement.

in the arts that by 1990 is already decades old, to suggest that the "good object" in the binarism set up by theorists—in other words, modernism in cinema and its rejection of perspective—could just as easily be viewed as a return to the primitive system. Like modernist painting, in Burch's view the cinematic avant-garde is invigorated by a return to "primitive" systems of representation. By way of formal analysis set firmly within early film history, Burch points out that Quattrocento perspective in cinema—the classical system—is not "natural" at all but was generated over twenty years of formal experimentation with camera, light, and color. In making this claim Burch refutes Baudry's assertion that film's photographic basis necessarily creates perspectival space, demonstrating instead that perspectival space is not a given in cinema—that it can be camouflaged—or emphasized—by formal means. Classical space, Burch asserts, was the result of labor.

In his references to the avant-garde, Burch positions himself with respect to Stephen Heath's canonical essay of 1980, "Narrative Space,"[8] insofar as Heath calls to our attention traditions of experiment within the framework of narrative cinema.[9] Indeed, Heath acknowledges that cinema can use projections that deviate from Quattrocento perspective in one and the same film, "projections that approximate more or less, but differently, to the perspective model."[10] Further, Heath ingeniously displaces attention from the fixed relation of spectator to image in a suturing central position—the perspectival view that creates a "central master-spectator"[11]—by focusing on film's movement. "Film is not a static and isolated object but a series of relations with the spectator it imagines, plays and sets as subject in its movement," Heath rightly points out.[12] Movement is central to narrative cinema's ability to tell stories, with the rapid replacement of one film frame by another creating narrative space, the space in which a story evolves. Inspiration for Heath's argument may have been Rosalind Krauss's contention—relegated to an endnote by Heath—that perspectival space *in and of itself* "carried with it the meaning of a narrative: a succession of events leading up to and away from this moment; and that within that temporal succession—given as spatial analogue—was secreted the 'meaning' of both that space and those events."[13] Temporal succession as spatial analogue: Krauss's formulation points forward to cinema. In the body of his essay Heath cites Rudolf Arnheim's observation in *Film as Art* to the effect that the "film gives simultaneously the effect of an actual happening and of a picture."[14] It is because film's illusion of reality is only partial, writes Arnheim, precisely because film images do *not* give a strong impression of space, that montage is possible, enabling the spectator to relate diverse images—close-ups; long shots—to one another as though they were pictures in a book.

In this chapter I focus on some moments in narrative film in which their "pictureness" is foregrounded, moments that undermine vanishing point perspective and ally themselves with modernist painting. I choose the somewhat awkward term "pictureness" because it more closely approximates Arnheim's

Bildlichkeit than the term "pictorialism," with its slightly pejorative and more limited implications. My aim is not only to reflect on perspective in its relation to the film image, but rather to examine some renderings of cinematic space that undermine what Phil Rosen terms "spatial likeness" in the representation of reality.[15] In no way does this chapter constitute an exhaustive treatment of this complex issue. Rather, the films under discussion are case studies of sorts, formal experiments with the adoption of painterly approaches to space. For most of these films, pictureness is an intermedial issue rather than an ideological one. Beginning with Burch on the "surface effects" of a deliberately modernist and avant-garde film, *The Cabinet of Dr. Caligari* (1920), I subsequently return to "narrative space," more specifically to Heath's observations on Hitchcock's *Suspicion*. With these as my starting point, I argue that the largely classical narrative films of Hitchcock's American period repeatedly contain moments when the pictureness of the image is foregrounded, moments in Hitchcock that in a variety of ways hinge on a modernist undercutting of perspective and symmetry. The next section of the chapter engages with pictureness and the collapse of perspective in a quintessentially modernist film, Michelangelo Antonioni's *Red Desert* (1964). There follows a brief meditation on the undermining of perspective by Godard's *Passion* (1982), where formal experimentation is also a matter of ideology. While my approach is chronological and reads the pictorial interests of different films within their film historical moment, it does not stress an evolution in the approach that these films take toward perspective, but treats each film's appropriation of painterly strategies as significant in its own right.

The "Unexpected Cohabitation of Two Modes"

The Cabinet of Dr. Caligari (1920) has the dubious honor of being Germany's first Expressionist film. Film historians have repeatedly linked art director Hermann Warm and set designers Walter Reimann and Walter Röhrig to the group of Expressionists that called themselves Der Sturm, but there is no evidence to support this claim.[16] It was Reimann who suggested that the film be made in the Expressionist manner—not a surprising choice since he had worked as a set designer in German theater during its Expressionist period, and his paintings of 1916–20 still exhibited features of this style.[17] Expressionism comes to film belatedly, years after the heyday of the movement, but *Caligari*'s appropriation of this painterly style was embraced enthusiastically as an avant-garde practice by writers and critics such as Kurt Tucholsky and Herbert Ihering. In 1922 Sergei Eisenstein criticized *Caligari* for its "assortment of painted canvases," but later on, in 1940, he saw it as an important alternative to the dominance of naturalist-illusionist tendencies in the cinema of the West, much as his own experiments in theater and film had been.[18]

More recently, in 1990, the film historian Kristin Thompson refers to its style as "radical."[19] But in what, we ask, does the film's radical style consist?

Burch's essay on early film space grows out of an interest in the development of filmmaking practices, concentrating on the way one technology enabled different articulations of space to emerge. The central tenets of apparatus studies have no particular role to play here, nor does Burch focus on the claims of such noted theorists of perspective as Erwin Panofsky—whom he mentions—even if Francastel's sociohistorical reading of perspective is clearly indebted to Panofsky's groundbreaking *Perspective as Symbolic Form*, which connects changing experiences of space to the worldview of a given epoch.[20] But as art historian Christopher Wood points out, Panofsky undermines "the claims to legitimacy or naturalness of linear perspective,"[21] and in this view Burch clearly concurs. The flatness of Georges Méliès's film images—referred to by Burch as "the perceptual flatness of the picture on the screen"—was both an essential cinematic truth for Méliès *and* a matter of choice, Burch contends, perhaps drawing—as Heath does—on Arnheim.[22] In the Lumière brothers' *Arrival of a Train at a Train Station*, on the other hand, Burch finds a perfect appropriation of perspectival space, an affirmation of spatial depth in a documentary approach. As Burch points out, the attention to surface in Méliès's tableau-based cinema and the in-depth approach coexist in France during the early period. Slightly later, Burch goes on to say, the films of Louis Feuillade provide formal evidence of the perspective box suppressed by Méliès, the means by which art historians traditionally connect perspective to the art of scenography and to the proscenium stage.[23] While Burch's account of perspective practices is indebted to Heath's take on scenographic and narrative space, it resorts to early film history to lend flexibility to Heath's more rigid ideas.

With the claims of art historians to back him up, Burch reminds us that the tension between surface and depth was in fact institutionalized by modernism,[24] suggesting that the modern eye derives pleasure from "the unexpected cohabitation in a transition period between two modes of representation."[25] A perceptive observation—although we might add that visual artists have engaged in games with the rules of perspective from at least the sixteenth century, when "wit" and a "sense of play" were considered de rigueur in artistic renderings of perspective.[26] For Burch, *The Cabinet of Dr. Caligari* exemplifies such wit in a modernist vein, given that the film's graphic, highly artificial style is a matter of choice, not attributable to a lack of technical proficiency. Ambiguity is the order of the day, according to Burch, and I quote his description of *Caligari*'s style in full: "The film's notorious visual style presents each tableau as a flat, stylized rendering of deep space, achieved by a design of dramatically oblique strokes so plainly graphic, producing effects of relief so artificial that they immediately recall the tactile surface of the engraver's page."[27] Engravings and, earlier in the essay, nineteenth-century

woodcuts are mentioned as prototypes for the film's style. Burch points to the tactile qualities of the image—his essay concerns haptic space, after all—but the hapticity of which he writes is not that of Alois Riegl.[28] Rather, it refers to the volumetric space conjured up by painterly perspective: it is not *perspectiva naturalis* but painterly perspective that is at issue. In *Caligari* the tension between flatness and depth resides in the contrast between the film's sets—whose suggestion of three-dimensional space is the product of perspective lines—and the human figures that populate these painterly spaces. These figures have the bulk and heft of real bodies, even if the actors' costumes are designed to conform to the décor, such as Caligari's white gloves with their noticeable black perspective lines. The actors' three-dimensional bodies within the artificial, two-dimensional spaces of the set are the nodal point of the tension between two forms of spatiality that interest Burch.

Among the factors that contribute to the flatness of the image in early cinema are the camera's lack of motion and its frontal approach to what it records, both characteristic of the camerawork of *Caligari*. But its actors are *not* spread out in a linear tableau arrangement and *are* capable of axial movement. And while critics often comment on the rays of light painted on the set (real light is used in the film as well), it hasn't been noticed that the oblique lines that seem merely decorative are broken versions of perspectival orthogonals, a stylistic device that at once imitates perspectivalism and undermines it. While these space-creating obliques point to an illusion of depth, their obvious ontology as mere lines—broken ones at that—is one aspect of the film's modernist self-reflexivity. The human figures that emerge from deep space in *Caligari*'s tableaux emerge from a vanishing point, but also from a *space behind* that suggests the offstage space beyond the theater flat. The space created by these means is more hybrid even than Burch suggests, since along with etchings and woodcuts (mediums favored by Expressionist artists), it also brings theater into play.

Games with surface and depth—the cohabitation of two approaches to space—are multiply apparent: the first three tableaux (not including the narrative frame, which is shot in another style) are marked by irises, the graphic signals of cinematic grammar over what is obviously a painted set. The first tableau presents a painterly rendition of a mountain village in a style that recalls a stylized version of a Lyonel Feininger or Paul Cézanne. It is merely a painting, static and flat. The second shot of the village goes beyond the two-dimensional painting to include a portion of a floor—or stage—in its foreground. Finally, the third tableau introduces movement into the frame as Caligari (Werner Krauss) emerges from a space below, walking up a stairway defined by lines that in the second tableau had appeared to belong to the painted backdrop. As Caligari approaches the camera, he looms increasingly larger until the shot ends with an iris-in on his face. These three shots are distinguished by an ever greater complexity of space, the second tableau only in retrospect shown to have more depth than the first, when what appeared

to be a painted object—the stair railing—stands revealed as an actual prop. Finally, the figure of Caligari creates a theatrical space as he walks across a stage. The film's narrative continues in a series of frames in which the human figure is contained in a half-painterly, half-theatrical space. The rigid rules of perspective are discarded for an avant-garde approach.

While attention is paid to the recession that characterizes perspectival space even in *The Cabinet of Dr. Caligari*, there are also many moments when the line itself is stressed. Various strategies allow the film to suggest staging in depth—as when the opening of what appears to be a painted door in Caligari's tent reveals the space in which his "creature's" cabinet is kept, recalling sixteenth-century German intarsia whose subversions of perspective boxes demonstrate a "lack of interest in logical or consistent 'fictive space.'"[29] And the flat, Munch-like poster of Cesare (Conrad Veidt) outside Caligari's tent "comes to life" when the cabinet opens and he slowly and deliberately opens his eyes. Here the actor's control over movement stresses a transition between picture and story. But later, Cesare's balletic movements as he approaches the sleeping Jane and then absconds with her across a rooftop includes a balancing act along a diagonal that is only suggestive of space and in which Cesare's body itself approaches reduction to line. It is at this point in the film that the famous diagonal line of Expressionism—touted by its first theorist, Wilhelm Worringer, and meditated upon by Gilles Deleuze in *Cinema 1*—is most clearly in evidence. According to Worringer, the diagonal line is central to the dynamism characteristic of Expressionism, to the intensity of its emotion. This diagonal is the Gothic decorative line, as Deleuze puts it, or "a broken line which forms no contour by which form and background might be distinguished, but passes in a zigzag between things."[30] As read by Deleuze, this line constitutes an aspect of "a violent perspectivist geometry" in which "diagonals and cross-diagonals tend to replace the horizontal and the vertical . . . acute angles and sharp triangles replace curved or rectangular lines."[31] What Deleuze is describing is a wrenching of the perspective system, a twisting of its coordinates, a deliberate distortion of the space it is traditionally intended to suggest. Lines such as these are not conducive to realist renderings—rather, they evoke modernist ideas of form, creating a tension within the image, a tension between "pictureness" and story.

Years later, Alfred Hitchcock, famously influenced by Expressionist cinema during his years in Germany (1922–24), will call on the dynamism—or is it violence?—of such angles to disrupt the perspectival and symmetrical arrangements of his film frames, and actor movement will be a favored means of doing so. In *North by Northwest* (1959), for instance, Hitchcock recalls the moment of Cesare's steep ascent on a diagonal, Jane in his arms, when Cary Grant as Roger Thornhill climbs an astonishingly oblique buttress of a modernist Frank Lloyd Wright–style house in order to rescue Eve from her captors. This is not the only sequence in which Hitchcock enlists Arnheim's tension between "pictureness" and story in the service of his narrative cinema.

Oscillating Spaces: Realism and Modernism

Films, Stephen Heath famously reminds us, "take place"—they establish scenographic space, and their spectator "*completes* the image as its subject."[32] Situated at the center of the perspectival system that underpins narrative film, the spectator is set into relation with its images. With Hitchcock's *Suspicion* (1941) as his example, Heath notes that the portrait that anchors the film's narrative—the portrait of General McLaidlaw (a speaking name if ever there was one)—establishes the scenographic space of Hitchcock's film as perspectival, the Quattrocento view. But at the fringes of this film's discourse, Heath suggests, there is another kind of space, one intimated when a look cast by a character offers a glimpse of a different visual organization. As it happens, this character is Benson (Vernon Downing), a detective, and the object of his look is astonishing—perhaps even shocking—to him: it is a reproduction of a Picasso still life in the Cubist manner, *Pitcher and Bowl of Fruit* (1931), and its notion of space is in marked contradistinction to that of the McLaidlaw portrait. If the still life's transgression against the portrait's perspectival system is a joke in this film, writes Heath, then it is a telling one.[33] While the detective's glance at the painting is irrelevant to the film's narrative, Heath argues, it nevertheless serves "to demonstrate the rectitude of the portrait, the true painting at the centre of the scene, utterly in frame in the film's action."[34]

But the scene in question takes place in the home of Lina McLaidlaw (Joan Fontaine) and her husband Johnny Aysgarth (Cary Grant), and the general's portrait is in not at its center, even figuratively. It does not grace the mantle, as it had in the McLaidlaw residence: indeed, it is on the floor—propped up against a wall, askew, dethroned. A modern landscape painting hangs over the Aysgarth fireplace in its stead, while the still life graces a wall in another room. True, the landscape doesn't flaunt the rules of perspective with its central observer, but neither is McLaidlaw's paternal gaze centrally positioned in this space. It is allowed neither to confront the film's characters directly nor to look out at the spectator. After the detectives leave, Lina returns to address her father's portrait, denying that anything untoward has happened. But at this moment, two dark Expressionist lines of shadow—very obviously at a diagonal—are visible across the portrait, undermining its spatial unity, its coherence.

My question, therefore, is this: what if the joke that Benson's encounter with Picasso suggests were of another kind—one whose point were not to confirm the "proper" rendering and placement of the McLaidlaw portrait, but rather to *affirm* the tear the Picasso still life promotes in the scenographic space of classical cinema? What if the multiple points of view that coexist in Cubist space—the painting's rupture of the film's aesthetic illusion, in other words—were its object instead? Or what if the painting's spectator's—here Benson's—puzzlement at a painting that forecloses continuity between his diegetic world and the work of art were the issue? Hitchcock's interest in diag-

onals may or may not derive from the German Expressionist films he revered. But they are clearly the formal means, I argue, by which Hitchcock addresses the problem of perspective, a nodal point between realism and modernism, with respect to which his films position themselves.[35]

As Hubert Damisch convincingly argues, symmetry is "a remarkable tool for rendering the work of perspective visible."[36] Death in Hitchcock's films often occurs onstage, but it takes place in museum spaces, too, especially in the neoclassical museums in which perspective and symmetry reign. Central perspective imposes constraints that, in the Hitchcock film, may very well lead to death. *Blackmail*'s (1929) villain, Tracy (Donald Calthrop), eventually falls through the glass cupola of the British Museum, but his passage to this space holds interest as well. Presenting in another register the imbrication of art and death that forms the earlier portion of the film's narrative, the introduction of this space is not arbitrary. One shot after another stresses the symmetry of the museum's architectural spaces: a shot of the building's neoclassical façade—at a slight angle, however—is followed by one of the blackmailer ascending the stairs of this imposing structure. A cut to the space of the colonnade has no function other than to stress its columns' cold, imposing symmetry. With the police in hot pursuit, the blackmailer enters a hall whose space is centered on a large curtained portal in the background. The spectator's attention is drawn to the centrally positioned door with curtain, that is, to the point that should function as the vanishing point in deep space, here cut off by the curtain. Two human figures gesticulate wildly while the blackmailer makes his way to the center of the hall but—fortunately for him—he does so at an angle. He has entered the Egyptian galleries, where a shot reveals receding doors—the perspectival corridor—leading from one display space to another.

Evading the police in hot pursuit, the blackmailer ducks behind a glass case, and a medium close-up reveals him in a complex, three-layered composition: he stands in front of the case which reflects his shadow over the objects on display there, while—through the glass—we see men running. Already identified with the display, in some sense already a relic, the blackmailer is figuratively contained in the space of art. His only escape is the passage through the perspectival corridor—which is no escape at all, a visual trap. There follows the shot that features the most memorable image of the film: the blackmailer shimmying down a rope at the left-hand side of the film frame, alongside an Egyptian colossus. Cut to the reading room of the British Museum, shot from above—the blackmailer's point of view—to reveal the space as a pattern of concentric circles of tables from which other tables radiate like vectors from a center. The blackmailer wisely chooses not to enter its geometrical layout. With our focus on the spatial arrangement of the museum sequence, we notice an alternation between spaces shot frontally, stressing central perspective (the space of pursuit) and those in which the pursued traverses a space obliquely, at an angle, temporarily evading the symmetrical arrangement of the space. But the blackmailer meets his death when he falls through the glass dome and

into the rotunda that houses the reading room. In other words, he arrives at the center of the British Museum after all: he is contained by its symmetries in a theatrical moment—the moment of death—not presented to our view.

Unlike the blackmailer, the protagonist of *Torn Curtain* (1966)—Paul Newman as Michael Armstrong—escapes pursuit by an East German spy when he makes a detour through Berlin's Old National Gallery, which we first see as a photograph in a tourist brochure. A shot of the photo is followed immediately by a shot of the same image as a full-size building "in the real." But this is not a photographic image. It is painted, as Steven Jacobs tells us; only the doorway and the pillar are constructions.[37] To his satisfaction, the impossibility of shooting in East Germany during the Cold War gave Hitchcock free rein to shoot the film in the controlled atmosphere of the studio. The film is the height of artifice. Perhaps it was Hein Heckroth, the film's production designer, but more probably it was Hitchcock himself who deliberately altered the shape of the real museum to emphasize its symmetry, for Armstrong walks through the center of a portico-enclosed courtyard along a walkway to a door at the center of the neoclassical building. In other words, he enters the museum via a path that leads directly to the vanishing point of the perspectival corridor. Bilateral symmetry, with some infractions, is linked to central projection. Of interest here is that the walkway did not exist in the courtyard of the real building, but was deliberately added. *Blackmail*'s concern with the constraints imposed by central perspective surfaces in this choice.

As Frieda Grafe points out, the film's museum sequence consists in matte shots alternating with shots of Armstrong walking on a painted studio floor.[38] In other words, the paintings we see on the museum walls are paintings of paintings—not the real thing at all. The claustrophobia promoted by the setting is intense. Hurrying through its deserted galleries, Armstrong is contained in the space of representation. In an overhead shot he stands on an octagonal mosaic floor pattern, halted at the center of several concentric circles from which vectors emanate—a centric pattern, Arnheim would call it,[39] such as the one in which the blackmailer dies, a pattern that recalls the asylum floor in *The Cabinet of Dr. Caligari*. In *Torn Curtain* as in *Blackmail* our awareness of central perspective is intensified by neoclassical architecture. Armstrong repeatedly passes through the perspectival corridor, then traverses other spaces at an angle.

It is clear that the oppressiveness of central perspective in this sequence emblematizes the rigidity—not the rectitude—of the state, whose unilateral vision extends to the control of all aspects of life and of art. But it is also the ideological implication of central perspective itself—as control over the visual field—that is at issue. While no Cubist paintings with multiple points of view offer escape, as in *Suspicion*, Armstrong and the film camera often traverse these spaces obliquely, at an angle. When Armstrong finally leaves by a simple back door (of a museum, we wonder?), he is released from its symmetrical arrangements, and we heave a sigh of relief. In some sense it is the museum

itself as façade or curtain that must be torn to reveal the theatrical space of East Germany. But the film's title also refers to the "tear" in scenographic space that occurs when *Torn Curtain* figures the passage from one ontological register to another.[40] If the illusionistic space of the museum opens out into the space of a simulated, theatrical East Germany, it is no wonder that Armstrong escapes by way of a theatrical stage, through the simulated hellfire of a ballet performance.

When *North by Northwest* uses a photographic image of a modernist New York skyscraper for its credit sequence, a building shot at an angle so acute that its glass façade of windows creates a grid of oblique lines on which the credits are printed—also at an angle—is it telling us something about the film's subsumption of modernist formal elements into realistic spaces? It would seem so, since the modernist grid becomes first a mirror that reflects passersby and then the movie screen on which the narrative plays out. And then there is the view from the UN Building, which, despite the presence of the tiny human figure within it—is surprisingly flat, exposing a space that is the height of artifice and abstraction, a modernist painting. Deflating the feigned three-dimensionality of film, it emphasizes the film frame, its support.

In *North by Northwest* spaces that evoke "pictureness" are often natural spaces. Mount Rushmore features the most obvious convergence of nature and art, with the presidential heads carved into its surface. Like the portrait of McLaidlaw, they are symbolic of a patriarchal order to be undermined by art and play. Release from the perspectival system in this film occurs in the aestheticized spaces of nature. In his analysis of this film's scenotopes—or spaces organized as a language—Fredric Jameson suggests that those most clearly imbued with "a sense of the 'aesthetic' as such" are the cornfield and the pine woods.[41] For Jameson, the latter evokes a "distinctive Cézanne landscape,"[42] and, as I've argued elsewhere,[43] in both the pinewoods setting and in Cézanne, we find an oscillation between a Cubist three-dimensionality suggested by depth of field and the flattening of space produced by an emphasis on line. And the famous cornfield sequence contains frames that have a nearly abstract feel, despite the presence of Roger Thornhill incongruously in their midst. Here space is flattened by the lack of horizon line and the drab colors of the desiccated fields. This is the space of death not only because nature is dried up, a maze of dried stalks and leaves, but also because Thornhill is caught in a geometric, perspectival space created by the intersecting lines of two highways. When a truck emerges out of this vanishing point to run over Thornhill, it breaks the fourth wall, threatening to enter our space.

In Hitchcock films the look can be implicated in the disruption of illusionistic, perspectival space. The blinds that are opened at the beginning of *Rear Window* (1954) reveal a series of picture windows that position James Stewart's Jefferies as the spectator with an aestheticized experience of reality. Eyes trained on the narratives that unfold before him, he is separate from the spaces in which they occur, divided from them by a courtyard that functions

as a moat. Throughout the film, Jefferies is most often found in the position of the Albertian spectator, the spectator from whose place the perspectival system is drawn. His eye is in a position of control over space, sees through the pane of glass—Alberti's "window on the world" that the perspectival system produces—and gazes at the scene laid out for his viewing eye. But when a figure in that scene, the murderer, leaves it to appear from what for Jeffries (who so often has his back to us) is the space behind him, Jefferies must turn around to face the intruder. Read with respect to central perspective, this scene in *Rear Window* emblematizes the multiple perspectives that define the Picasso-like still life in *Suspicion*. By suggesting spaces of great ontological complexity, Hitchcock's film simulates Cubist spatial simultaneity and disrupts the unitary point of view of the perspectival system. For the film's spectator, there is a sudden recognition of the film's mix of spatialities. In bringing the heterogeneity of its spaces in and out of focus, *Rear Window* points toward that "other" space that detective Benson of *Suspicion* regards with puzzled fascination in the Picasso. When Doyle, the detective character in *Rear Window*, looks with similar puzzlement at a painting in this film, this too is a modernist still life with fruit.

Looking is the central metaphor of *Vertigo* (1958) as well, and here too looking and "pictureness" are disruptive of spatial unity. In the sequence of tableaux in which Madeleine (Kim Novak) participates, the museum space of the Palace of the Legion of Honor in San Francisco is of particular significance. Here Scottie (James Stewart), who has been pursuing "Madeleine," discovers her seated before a portrait of the "mad Carlotta," her purported "ancestress." In a series of point-of-view shots, the camera traces the path of Scottie's vision as it makes connections choreographed in advance by Judy as actress and her "director," Elster (Tom Helmore), husband of the real Madeleine, who is the victim of the plot. Scottie's gaze moves back and forth between objects in the portrait and their copy in the supposed reality of the diegesis, which is actually a simulated one, for the museum is the scene of dissimulation and role-play. During these transactions between art and reality, "Madeleine" is seated across from the portrait in the position of the central spectator, her eyes raised to encounter its eyes in a posed meeting of gazes. Scottie, on the other hand, views this scene from an oblique angle: his position is *not* the centered position of the Albertian spectator. Here Scottie's angle suggests that the "off-center" nature of his look, a look that collapses reality and fantasy, is that of madness, recalling the stylized world of *Caligari*. What is acted by Madeline is *en*acted in the diegetic real by Scottie.

Small wonder, then, that when Midge (Barbara Bel Geddes) shows Scottie her painted copy of the museum portrait with her own face replacing Carlotta's, Scottie flees in horror. This sequence takes place in Midge's studio apartment, a space of art whose walls are covered with modernist works and where a model of a brassiere on a pedestal functions as a sculpture. The shock

at the unnaturalness of Midge's portrait is experienced not only by Scottie but also by the film's spectator, for whom the incongruous conjunction of Midge's head with the body of Carlotta is uncanny. Such dissonant, anti-illusionist effects are modernist effects. Importantly, we see Scottie's dismayed reaction before we see the actual portrait. Then Scottie's reaction shot is followed by a shot from his point of view that contains both Midge's portrait and the seated diegetic Midge looking up at him. Within the film frame her painting is interestingly situated: its edge creates a diagonal that disrupts narrative space. Its two-dimensional flatness emphasizes its "pictureness" within three-dimensional diegetic space.[44]

What the spectator sees from Scottie's point of view is a split-screen effect—except that the line formed by the canvas bisects the film frame at a diagonal. In this second scene of looking at a woman and a portrait, now placed side by side, Scottie's look is again at a diagonal, askew. In a sense, this is how his look has been represented from the start: before Scottie's first glance at Madeleine at Ernie's Restaurant, it's the camera that reveals her sculptural neck and back. Scottie does not see her this way: craning his neck, he sees her at an angle. It is not just the vertigo effect (the simultaneous zooming in and pulling back of the camera signaling acrophobia) that distorts Scottie's vision. While the vertigo shot as visual paradigm stands in for the duplicity around which *Vertigo*'s plot is constructed, it is Scottie's diagonal, angled vision—deviating from central perspective—that sets him apart. How? As a modernist of sorts, yes, but also as someone who displays a "bordering subjectivity,"[45] someone who transgresses the boundary between fantasy and reality, art and life—someone out of Expressionist cinema. But like the detective peering at the Cubist still life in *Suspicion*, Scottie is also the means to another angle of vision, another kind of space.

A final example brings the issues around vanishing point perspective into even sharper relief. *Marnie* (1964) begins with a close-up on an overtly sex-ualized yellow purse held by a woman in a suit, shot from behind, which expands to contain her entire body as she walks along the platform of a rail-road station. It is a tracking shot: the camera is a stalker pursuing the woman closely, then halting its motion as she continues to move. The sequence takes place in an unreal space: the station is empty; there are two halted trains, but there are no other people. There's no motion in the frame save the motion of the woman. The space is perspectival, complete with receding orthogonals and a vanishing point; though representational, it has a nearly abstract feel.[46] The two trains are at diagonals that would meet at the vanishing point if they could be extended far enough, and the woman's head is located just under the place where the platform's roof, shot at an angle, meets the vanishing point as well. We should note that the vanishing point is the place where lines perpendicular to the picture plane appear to come together and that the classic example of this is the illusion of converging train tracks, such as we find in

Marnie and *Strangers on a Train* (1951). Here Hitchcock's early training in drawing, in which problems of perspective would have been featured, is in evidence.

Interestingly, the woman walks along a red line that leads directly to this point in the film frame; only in the final second of the shot does she swerve a bit to frame left and then put down her suitcase. Her long black hair stands in contrast to her yellow purse; the grays and browns of the station are accentuated by the red stripe that marks her path into the depths of the frame. In other words, the film presents us with a stunningly abstract rendering of the perspectival system, with a woman moving toward the vanishing point and then swerving from it. What earthly purpose does it serve in Hitchcock's film? It finds its visual correlative in the artifice of the film's harbor scene at its conclusion, I suggest, a scene for which *Marnie* has repeatedly been criticized. With its obviously painted backdrop and its overt use of a set, it is unnatural in the extreme. But it is precisely this constructed, aestheticized space, like so many in Hitchcock, that is utterly in keeping with this film's meditation on the relation of illusion and reality. The moment when we see the space of the harbor most clearly is the one in which Mark (Sean Connery) and Marnie (Tippi Hedren) drive to her mother's house at the end of the film. Shot from above—a sign of authorial intervention in Hitchcock—the rowhouses on either side of the street echo the diagonal lines formed by the trains in the film's opening. The road functions as the red line—red thread or red herring?—between them, leading to the huge ship that more than one critic describes as "looming." The ship is located where the central vanishing point of the frame would be, but its painted quality renders it an image on a theater flat, a flat that obscures nondiegetic space, a barrier between representation and some suggested other, "real" space, the space behind the stage.[47]

But it is also the Žižekian blot par excellence, and its presence at the vanishing point is telling. As James Elkins, a theorist of perspective, puts it, "The uncontrolled vanishing point in perspective signifies eternity, infinity, and death."[48] While the exaggerated size of the ship points to an irruption of the real, its presence is also recuperated by the film's setting, bringing to mind the strategies that Renaissance artists resorted to control the vanishing point.[49] In this sequence of *Marnie* the moving car substitutes for the moving woman at the film's beginning; it too swerves at the last minute, this time to the right—creating a symmetrical arrangement of movements that to some extent reinstates the symmetries of the classical system. In *Marnie*, then, as in the other films under discussion, deviation from the perspectival system is represented—in this case not only once, but twice—precisely within aestheticized spaces, spaces notable for their artifice. These are the spaces in which the tension between representation and abstraction in Hitchcock is at its most intense. By way of these strategies, Hitchcock vies with the modernist tendency of European art cinema as exemplified by the films of Michelangelo Antonioni. In the 1960s Antonioni became a source of great anxiety for

Hitchcock, who feared that the Italian director, as Joe McElhaney puts it, "was surpassing him in formal audacity."[50]

In Hitchcock's films we repeatedly find moments when film collapses into painting, or realistic spaces provide modernist views. This oscillation between illusion and abstraction is also a determining one for painting in the 1950s, of course, as Clement Greenberg asserts in "Abstract, Representational, and so forth" (1954): "The painter's first task had been to hollow out an illusion of three-dimensional space" through which one looked "as through a pro-scenium on a stage"[51]—by means of perspective, in other words. But with the coming of modernism, Greenberg continues, this stage became shallower and shallower, "until now its backdrop has become the same as its curtain."[52] While the painter may still inscribe recognizable images on this "curtain," the illusionistic space surrounding those images has disappeared. In the open-ing shots of *Marnie*, Hitchcock parodies perspectival space and only at the last minute prevents the female character from walking into the vanishing point that signifies death. In the film's closing shots, Marnie and her husband nearly drive into the backdrop that flaunts its identity as a painted set—it is a painting, a backdrop that is also a curtain. A tear in that curtain might have revealed the void.

"An Intensity in the Formal Idea": Pictureness in *Red Desert*

Agreed: *Red Desert*, Antonioni's first color film, uses color magisterially, in painterly fashion, to enhance the pictorial quality of its frames. In *Red Desert* color is a principal means of confounding perspectival space in modernist fashion, more often by flattening it, but also by projecting it outward. But it is space, not color in and of itself that is the focus here. In *Red Desert* there is a tension between two spatialities reminiscent of *Caligari* and some moments in Hitchcock, when human figures generate a three-dimensional space that cohabits with effects of flatness derived from modernist painting. We also take up the relation of anti-perspectival space to narrative space from another direction, connecting *Red Desert* formally and thematically to another famous example of film's concern with painting—F. W. Murnau's *Nosferatu* (1922). Here our emphasis will be the determination of space by the presence of the human figure and its look.

There has been a great deal of discussion around the tendency toward the pictorial and abstraction in Antonioni's film, not least by Antonioni himself, who famously professed his desire to privilege the formal arrangements of line and color over his film's characters. Antonioni's remark in an interview with Jean-Luc Godard to the effect that the "abstract white line that enters the pic-ture at the beginning of the sequence of the little gray street interests me much more than the car that arrives"[53] has understandably raised the anxiety levels of critics eager to exonerate Antonioni from the charge of formalism.[54] Yet the

tendency to pictureness in *Red Desert* has been repeatedly flagged, first and foremost by Pier Paolo Pasolini, who notes in "The Cinema of Poetry" (1965) that Antonioni's film is a series of pictures, with the passage of its characters through its frames "leaving the picture once again to its pure, absolute significance as picture."[55] Critics have variously noted formal similarities between the film's images and the work of several modern painters. The most convincing are those that link Antonioni's film to paintings by Mark Rothko, Giorgio Morandi, and Giorgio de Chirico,[56] although their points of connection with *Red Desert* have not been much explored. Arguing against the significance of the human figure and in favor of abstraction in *Red Desert*, Pascal Bonitzer suggests that "the object of Antonioni's cinema is to reach the non-figurative through an adventure whose end is the eclipse of the face, the obliteration of characters." Commenting on the film's predilection for abstraction, for Gilles Deleuze—who cites this passage from Bonitzer—in Antonioni color "elevates space to the power of the void."[57]

Space is indeed inflected by color in this quintessentially modernist film, but it is equally produced by the placement and actions of the human figure. The impression of Rothko-like color fields is most obvious in the sequence in Giuliana's (Monica Vitti) shop, where colors are applied to the walls and around corners in such a way as to collapse space, leading us to wonder where the corners of the room are, whether there are indeed any corners, how surfaces relate to one another, and whether surfaces are flat or protrude. But in front of and within the confusing sense of space color produces, Giuliana poses or walks, often in medium shot, creating a troubling conjunction of three-dimensional figure with flat space that suggests the tension between spatial systems in *Caligari*. A central debate around the earlier film is whether its style reflects—and naturalizes—the point of view of a character that is mad, an issue which surfaces in commentary on *Red Desert* as well. Giuliana's state of mind would seem to be reflected in the confused spatiality described above, for instance, when she relates the story of "a girl" who felt "like there was no ground behind her." But while Antonioni's film often posits a relation between character and visual style, it does not do so consistently.

On another wall of Giuliana's shop there are squares of color arranged on top of one another, Rothko fashion, but here too she interacts with the blocks of color, touching the paint to see whether it is dry, simultaneously stressing and undermining the impression of the wall as canvas. Minutes later, when Giuliana and Corrado leave the shop, their point-of-view shot focuses on the falling page of a newspaper, black and white against the gray and beige backdrop of the shop's peeling exterior. Even the minimal movement of the newspaper as it glides to the street reminds us that we are watching a film, not regarding a painting, yet the moment is so contrived as to promote the painterliness of the wall nevertheless. When Giuliana steps on the newspaper page, she gives the image narrative significance, but the following shot features only the newspaper again, now free and blowing along the street. By

these means the street sequence features a mix of conflicting approaches to space. Pasolini notices that whenever the human figure leaves the frame, its pictorial nature—its pictureness—is once again in evidence, but as we have noted, often painterly and narrative tendencies coexist in the frame.

The camera next moves with character as Giuliana walks to screen left to reveal a handcart with fruit and a somewhat menacing vendor, equally motionless. She sits down and poses with them for a moment, immobile, a participant in a figural painting with a monochrome palette. Like Giuliana's coat and the wall, the fruits on the cart are a light gray, seemingly inedible, perhaps the products of an ecological disaster, recalling still lifes by Morandi, in particular the grayish-white *Natura Morta* (many were painted in 1956)— whose title speaks to *Red Desert*'s ecological concern with dying nature.[58] Here the film's painterly style is tied to its ideological project via an image that cites a painting. But shortly thereafter there is another shot of the empty, gray street from Giuliana's point of view: now the curvilinear street lined with houses whose walls and windows seem painted façades, insubstantial, creates a mood of foreboding that recalls de Chirico's oddly angled buildings. In the following shot, Giuliana walks up this street, her body hugging the curved walls of the buildings that line it, in the fashion of *Caligari*'s Cesare. Once again the situation of Giuliana's figure in space is incongruous—even though it is anchored by the presence of Corrado (Richard Harris) in the foreground, watching Giuliana as she walks away. The film abounds in shots that feature character look. Character point of view—and by extension look—is a form of perspective within the perspectival system, Heath claims, "orientating space."[59] Such shots have the function of naturalizing pictorial space for narrative, of smoothing over the tension between pictureness and story.

A similar tension between narrative space and painterly abstraction occurs in the following sequence as well. After a cut to the workers' housing complex, the film image features the yellow and green walls of a building in the background, calling attention to color and to the flatness of the wall—in front of which Corrado and Giuliana are seen to be walking. Central to the production of flattened, abstract space is the film's frequent recourse to the telephoto lens, as Antonioni notes in his interview with Godard.[60] Moments after we see Giuliana and Corrado walking into the housing complex, Pasolini's famous out-of-focus pink flowers are visible in the foreground of the frame.[61] For Pasolini it is the out-of-focus image of the flowers contrasted with these same flowers in focus slightly later that is one of the film's most obvious poetic, aestheticized moments, and I suggest that it is the blurring of color, the fact of the pink color exceeding the containment of line, to which the film calls attention (actually, we see the flowers once in focus before we see them as a blur, then again in focus). Deliberate changes in focus produce shallow, abstract spaces in the context of more naturalistic shots, one aspect of the film's juxtaposition of flat and deep. For Seymour Chatman, a hallmark of Antonioni's style is precisely a *rhythm* of "alternating flat and deeply recessed shots," but he con-

cedes that this rhythm is highly irregular.⁶² In the scenes outside the workers' apartments, Antonioni's motivation for flattening space has little to do with Giuliana's state of mind. Rather, it reflects deliberate experimentation with the conflicting spatialities of painting and film: the final view of the flowers in focus, now in a space vacated by Corrado and Giuliana, shows them in a vase tightly framed by buildings and passageways whose lines transform this floral display, perhaps ironically, into the subject of a picture. Here Pasolini's insight into the film's tendency toward pictureness holds.

Once Antonioni's characters have entered a worker's apartment, there is another evocation of de Chirico: the scene outside the window is obviously a painting, not even a painted architectural set. The colors, the grayed-out mauve and rose, are Morandi colors and not so much from de Chirico's palette, but the angles of the buildings seen through the window recall de Chirico and give the scene an unnatural, uninhabited look. As Arnheim points out, de Chirico often evokes a sense of the uncanny in his architectural landscapes by deviating from the rules of perspective.⁶³ What we see through the window is designed to appear two-dimensional: lest we miss this effect, the worker's wife draws the window's curtain and with it our attention to this other kind of space. Like Hitchcock, Antonioni allows his dissonant spatiality to "show" on the two fleeting occasions when the camera reveals the window. A similar moment occurs later in the film with reference to a window of Corrado's hotel room, from which Giuliana gazes at a nocturnal street scene with solitary human figure and stylized shadows. While clearly filmic—the image is photographic and there is movement in the frame—this view, too, could have been lifted from de Chirico. Antonioni's "windows on the world" are not strictly that: time and again views through windows depict aestheticized spaces, not "real" ones.

Other pictorial strategies that deny perspective and promote flatness are in evidence as well. More than once, a close-up unanchored by an establishing shot reveals what, briefly, might be a painting. A notable example occurs when the film frame contains no shapes, only black color with patches of white, gray, and rust that could well be a close-up of a Jackson Pollock—until Giuliana enters the frame and is shown walking past the peeling hull of a ship. And then there is the flattening effect of an in-focus stripe across the film frame, behind which there is a blurred, out-of-focus background: this is the famous red bar produced by a close-up of the bedframe in Corrado's hotel room. Here the geometric effect of color contained by line flattens the blurred shapes behind it and cancels out space. Further, in *Red Desert* mirrors are shot so that they don't contribute depth to film space, as they usually do, but seem rather to negate it, most notably the mirror in the fishing shack when it reflects the entwined limbs of Giuliana's reclining friends. The same holds for the mirrors in the worker's apartment, where a long, horizontal mirror over a sideboard has a similar flattening—or even recessive—effect.

But then there is the audacious sequence in the fishing shack when Corrado and several others begin to pull down the flimsy white walls that separate the living space of the shack from its bedroom, whose walls are painted a vibrant red. Here the camera in the living space shoots the doorway to the red bedroom that frames the rectangle of red created by the walls seen through the doorway. As the somewhat frenzied group begins to remove more and more of the planks that form the white wall, this red rectangle grows ever larger. Here the effect of the bright red color is projective, appearing to move outward toward spectatorial space. At this moment, the film establishes that color has the effect of positioning us with respect to the image in a new way. *Red Desert*, then, resorts to several different strategies to negate perspectival space, strategies that at times promote a wholly two-dimensional film frame and, at others, a two-dimensional space within a scenographic space inhabited by characters. In many of the film's flattened spaces, color compensates for the lack of perspective, taking on perspective's function of orienting the spectator with respect to the image.[64]

Of course, interior framing also orients us within the image: in *Red Desert* railings, painted lines, door frames, and windows have this function of concentrating vision as they articulate spaces. A great deal of attention is paid to windows, especially when it is Giuliana who looks through them, most often at ships. As Stephen Heath and countless art historians of perspective remind us, Alberti's *Della Pittura*, his manual on perspective drawing, features the picture plane as a transparent glass through which the painter must look and within whose frame he should present what he sees. Heath writes: "What is fundamental is the idea of the spectator at a window, an *aperta finestra* that gives a view on the world—framed, centred, harmonious."[65] Small wonder that the figure at the window becomes a central motif of painting—and of film, for that matter, as *Rear Window* makes abundantly clear. The figure at the window is often female. We think of Vermeer women looking out but presented sideways, not from a fully frontal view, perhaps mocking Alberti's centered spectator in paintings that derive their geometrical sense of space from a rigid perspective created by its instrument par excellence, the camera obscura. The figure at the open window is again in fashion during the Romantic period, witness Caspar David Friedrich's *Woman at a Window* (1822), one of his signature *Rückenfiguren*, spectator figures viewed from behind in which the beholder of Friedrich's paintings finds a conduit to a viewed natural scene. In a number of paintings Friedrich depicts spectator figures in a central position, among them *Wanderer above a Sea of Fog* (1818), *Woman before the Rising Sun* (1818–20), and *Woman at a Window*. In such renderings the figure's point of view is ours: we participate in a rigid relay of gazes.

Friedrich's *Woman at a Window* does not represent just any window: it is the window of his studio in Dresden, and the woman figured here is his wife. The space of the painting is such that we imagine ourselves to occupy

the artist's place as we stand before the picture. In line with the artist as well as his subject, we assume a central position within a rigidly conceived space, a space that is nearly symmetrical, full of interior frames. The painting is as much about the power of central perspective as it is about spectatorial—or female—experience. Even if the woman's body is at a slight angle, her head tilted and breaking the strict geometry of the scene, pictorial space in this painting is meant to seem constraining.[66] Quattrocento perspective is based on point of view, and *Woman at a Window* emphasizes the pressures it exerts. The painting's spectator sees only a portion of the scene that the woman regards as she looks out the window: in evidence is the mast of a ship, also slightly tilted, as if to indicate movement, and a stand of trees on the other side of what we know to be a river. In keeping with the project of Romanticism, the painting suggests that what she sees—more importantly, what she imagines beyond the visible—releases her from of the narrowness of her confines.

What relevance does the work of a nineteenth-century German Romantic painter have for Antonioni's *Red Desert*? Surprisingly, Friedrich's work holds some explanatory significance for the film, functioning as a possible source for several of *Red Desert*'s most enigmatic images. Seemingly out of the blue, at one point in his reading of *Red Desert* Peter Brunette mentions Friedrich in a discussion of the placement of Antonioni's camera behind a character (Corrado) gazing out at the landscape, "a motif and composition reminiscent of the work of the nineteenth-century German painter Caspar David Friedrich, whose characters always seem to be questioning the epistemological relation of the self to the external world."[67] Brunette does not elaborate. Yes, from a compositional point of view the contemplative looks of Friedrich's human figures do relate to those of the existentially troubled characters in Antonioni's film. But more is involved. If Friedrich's spectator figures haunt *Red Desert*, it is probably through the mediation of F. W. Murnau's *Nosferatu* (1922), which famously cites painting, particularly the work of Friedrich. Eric Rohmer argues that Murnau's penchant for painting dominates his films to such a degree that the composition and balance of each frame remains undisturbed despite being replaced by another frame—despite, that is, being subjected to motion[68]—thus nearly echoing Pasolini's remarks on pictorial space in *Red Desert*. For Murnau as for Antonioni read by Pasolini, there seems to be "a deep, mysterious, and—at times—*great intensity in the formal idea* that excites the fantasy" (my emphasis).[69]

But it is not only the presence of the gazing spectator figures productive of "character look" that bring the use of Friedrich's work in Murnau's film—and Antonioni's—to mind. While *Wanderer above a Sea of Fog* is the obvious source for a shot of Jonathan contemplating the mountains and sky on his way to the vampire's castle, the vampire ship that enters the city in Murnau's film is based on Friedrich's nautical paintings of sailing ships. Other citations abound, but these particular examples relate to *Red Desert*. In *Nosferatu* the ship enters the harbor with a slow movement that invades a static frame.

While narrative space is created by the ship's movement, contrasting with and undermining the static pictureness of Murnau's frames, it is the noticeable conjunction of spaces—of painting and narrative—that intrigues. In Antonioni's film we also find instances of a ship's movement through an otherwise static frame: once when a ship is seen incongruously moving as though through a wooded landscape, with no water visible in the film frame (the ship is only seen by Giuliana), and once when a ship that seems much too close to the fishing shack is viewed through a window—spatially, in this shot there is a problem of scale. There is a third such sighting when a ship is literally framed by a long, horizontal window, looking exactly like a picture frame that paradoxically contains motion—or an oddly shaped movie screen. Each of these instances deliberately transgresses against a naturalistic rendering of the world, introducing pictureness and spatial dissonance into the frame.

From a formal point of view, the inappropriateness of these ships' spatial positioning underlines the relation of stillness and motion, of framed pictorial to filmic narrative space. There is a sense that *Nosferatu*'s film frame itself is invaded when the vampire's ship moves in a succession of shots from right to left and then phallically invades the harbor. Interestingly, Antonioni's ships relate thematically to Murnau's film as well: in *Nosferatu* the ship is carrying not only a vampire but also the plague. For John David Rhodes writing on *Red Desert*, "The ship is a charged object, one that connects to the problem of mental and physical illness" and to global capitalism.[70] Yet the notion that a ship is bringing a contagious disease, perhaps smallpox, into Giuliana's city (Ravenna) is surprising and seemingly unmotivated in Antonioni's film, even if we recuperate its strangeness as expressing fears produced by globalization. But this is how the plague enters the city in *Nosferatu*. More surprisingly still, *Nosferatu*'s ghost ship *Demeter* could serve as a model for the sailing ship in Giuliana's fantasy tale, which she calls a "real sailing ship" (visually it resembles those in Friedrich's paintings), a ship "with a mysterious air," with no one on deck, that glides in the direction of the girl and pauses, then turns and glides mysteriously away again. And with no one at its helm, the *Demeter* too moves mysteriously; Angelo Restivo calls Antonioni's a "ship of the dead,"[71] which is also precisely what the vampire ship is. In *Red Desert*, the fantasy ship "discloses itself as a stain on the vast blueness of the sea," Restivo writes in his Lacanian reading of the film. The ship collapses meaning in the visual field[72] very much like the gigantic ship in *Marnie*. And in fact, the incongruity of their spatial positioning makes a stain of all three of the other ships in *Red Desert* mentioned above—of the ship that seems to move through a wood, of the ship that is much too close to a window, and of the ship that glides across a window whose frame fails to contain it.

In preparation for his most pictorial film, perhaps Antonioni watched Murnau's for its engagement of painterly with narrative space. The progression of *Nosferatu*'s narrative, the necessary replacement of each frame and shot by the next, undermines the film's pictureness in favor of motion and narrative

progress. In *Red Desert* the presence of the human body is in tension with the film's pictureness, and the anti-perspectival flatness of the frame is only partially recuperated by the presence of moving, three-dimensional bodies. Character look and point-of-view shots call attention to the film's dissonant spaces and only partially suture them into a story, a story perhaps recoverable as an admonitory story of late capitalism.[73] There is a notable exception, however: when Corrado gives his recruitment speech to the workers, it is as though his interest in commerce suddenly falters. His gaze goes fuzzy, and his eye—along with the camera tracking horizontally and then upward—begins to follow an abstract blue line that extends to the ceiling of the room and continues around the corner, confounding spatiality in much the way that color did in the shop sequence. In this sequence Corrado is exiting the naturalistic scene for a space of reverie: the line is blue, the color of vision. In this moment, for Corrado at least, the lure of color and form—of abstraction—wins out over capital.

Engaging with the means of its medium in typical modernist fashion, Antonioni's film draws on painting, the flat art, in order to fashion an alternative conception of film space as inherently dissonant. But perhaps it is possible to link the question of capitalism to the film's formal procedures, after all: as a "bad object," central perspective's connection to the rise of capitalism is suggested by Samuel Edgerton when he notes that the new double-entry system of bookkeeping may have made Florentine businessmen more receptive to "a visual order that would accord with the tidy principles of mathematical order that they applied to their bank ledgers,"[74] while John Berger suggests—somewhat tongue in cheek—that Alberti's "window on the world" might be replaced by another metaphor: "a safe let into the wall . . . in which the visible has been deposited."[75] In those moments when Antonioni undermines naturalistic space in favor of pictureness, it may not only be the formal idea that motivates.

Dismantling the Picture

For Fredric Jameson, Jean-Luc Godard's *Passion* (1981), a film about the making of films, looks back with nostalgia to a story, to closure. *Passion* has not liberated itself from modernist concerns so fully as to be called postmodern, Jameson suggests, but it is characterized by a new kind of incoherence.[76] *Passion* is modernist still, despite the film's juxtapositions of media (film, painting, video, music), of political points of view (the workers' collective, the auteur's control, its sexual politics), of spaces (factory, motel, film set—and tableau vivant)—and its lack of a unifying narrative. (Consider James Joyce's *Ulysses*.) Ostensibly looking to famous paintings for stories, the film flaunts its diegetic and formal flexibility at one and the same time. Its theatrical stagings of great masterworks as tableaux vivants are notable for the way they dismantle pictorial space and undo that bad object, central perspective.

At times the surprising angles from which the camera approaches the human figure produce political readings, as when we find ourselves face to face with the executioners in Goya's *The Third of May*. Here the film's ideological concerns are laid bare by its formal strategies—in Goya's painting, we do not see their faces.

In this discussion of *Passion*, I will not comment much on the intermediality of the tableau vivant form itself, about which I've written elsewhere,[77] nor will I examine the staging of *Passion*'s tableaux in detail.[78] What is central to our concerns here is that in *Passion*, as Murray Pomerance notes, "painting steps completely away from Renaissance perspective, the painter [is] no longer trapped within the limits of what light can reflect to him when he stands at a chosen point."[79] While in perspectival painting the painter—and by extension the spectator—is fixed in place, film makes it possible to free them both from their constraints. It is often Raul Coutard's camera that produces another sense of space in Godard's film, as for example when the restless, roving camera insinuates itself between the actors who act the figures of the paintings to be transposed into tableaux vivants. As Laura Mulvey puts it, "The appropriate metaphor here is 'penetration,' not behind, but into the surface" of the painting represented as tableau, as if to suggest by negation the sex act that Jerzy and Isabelle will perform "from behind."[80] By means of the camera's probing, the structural coherence of the masterworks is undermined. Up close, the camera exposes the small inadvertent movements of the actors (anathema to the tableau vivant genre, which demands stasis), and reveals the beads of sweat produced by the heat of klieg lights. It moves up, down, and around the actors' bodies with ease, and it moves in in close-up, undoing perspective and dismantling the position of painter and spectator in front of the canvas. The sense of liberation this strategy produces finds its way into the framing of narrative shots, which is often unconventional, uncentered, askew—decidedly not from the position of a centered subject.

By these means, canonical masterpieces—among them Rembrandt's *The Night Watch* (1642; for a discussion of Greenaway's *Nightwatching*, see chapter 2), Goya's *The Third of May* (1814), Delacroix's *The Entry of the Crusaders into Constantinople* (1840), Ingres's *The Turkish Bath* (1863), and El Greco's *Immaculate Conception* (1607–14)—nothing modernist, of course—are both fragmented and reshaped by the camera. Instrumental as well in producing another sense of space is the paintings' embodiment by three-dimensional human bodies in performances straddling painting, theater, and film that Jerzy, the director of the film-within-a-film, hopes will provide a transition to a story. These strategies ensure that there remains only a residual trace of the spatiality implied in pictureness in these tableau vivant sequences, despite their deliberate evocation of paintings.

Light is a central concern for film and painting alike and consequently it too is under discussion in *Passion*, especially with regard to the gaps in painterly space exposed in the tableaux. Jerzy never finds the right light—with the

irony that light alone does not serve to unify the spaces[81]—just as he never finds the story he is looking for, perhaps because he is unconvinced of narrative's efficacy. The stories in Godard's film cannot hold *Passion* together, either. All is in flux: love affairs are consummated and terminated; the film-within-the-film is never made. At the thematic and political level, however, *Passion* strains to establish commonalities and connections: it wants to demonstrate that labor in the factory and on the film set share a great deal and that the same holds for work and lovemaking. As the shooting style of the tableaux vivants makes clear, however, the film's formal system privileges fragmentation. The strategy of structuration by fragmentation is a Brechtian, modernist strategy. Brechtian structuration by fragmentation is in conflict with Jameson's claim that *Passion* exemplifies the "modernist ideal of formalist totality by way of the impossibility of achieving it."[82] For Jameson, Godard's film is at the tipping point between the modern and the postmodern.

What captures my attention in the critical discourse surrounding the film, however, is the sense of wonder at the visual impact of the film's tableaux vivants. For Jameson, "To gaze at the folds of the no longer painted togas and draperies is to recover an extraordinary experience of visuality which has probably been lost since the completion of the experimental exploration of perspective in the late Renaissance."[83] For Alain Badiou, the tableaux images are "absolutely enigmatic . . . It is a matter neither of the simple display of paintings nor of something that is their exact equivalent. Rather, it is the filming of live bodies recreating something that already existed as an image within the painting."[84] Is it the use of the human body as living material, bringing painting to life, that astonishes? Is it the dissonance of diverse art forms that is so compelling? Or is it that the synthesis between theater, painting, and sculpture that characterizes tableau vivant never quite comes together? And then there are the film's interstitial spaces, spaces where more than one ontological register cohabits with another, that elicit both puzzlement and wonder. This spatial disjunction is evident when a few costumed figures wander out of not-yet-staged or already-staged painterly compositions and walk about freely within the film set, their costumes—or their nudity—setting them apart from the "real" world. The angel from Delacroix's *Jacob Wrestling with the Angel* (1861) interacts briefly with Jerzy. We catch a glimpse of figures out of Manet's *Déjeuner sur l'herbe* (1862–63), and a naked Maja reclining on a couch. What distinguishes such moments from those we might see on the set of any other film-within-a-film is our awareness that the costumed actors belong in well-known static compositions—in paintings. What is operative in these frames is their complex ontology. At the conclusion of *Passion*, a landlocked galleon and human figures out of Watteau's *Embarkation to Cythera* (1717)[85] walk about aimlessly in the Swiss countryside in which Godard's film was shot, perhaps in homage to Luigi Pirandello's *Six Characters in Search of an Author* (1921).

Or consider the gap in the painted set for the Delacroix *Crusaders*—a sign of fragmentation, a *rupture* (to borrow Badiou's term)—in the world of the fabricated set, with the "real world" visible through its opening. In the film's staging of this same painting, actors as crusaders on horseback charge through a set comprised of miniatures, intensifying the visible tension between the "real" and the manufactured by way of scale. This is not simply rupture: it is dissonance. Once again the "real"—the horses, the riders—coexists with artifice in the form of the models and miniatures. In Godard, Burch's cohabitation of two spaces is intensified to that of two *registers* at odds with one another, a formal strategy that is a form of aesthetic play already practiced, if differently, in eras prior to our own.[86]

Painting is present in *Passion*'s frames and theater is, as well, but the perspectival system that once structured them both is deconstructed by the camera and undermined by video's intimacy. In his essay "Film as Philosophical Experimentation," Badiou contends that "cinema invents new syntheses" precisely "where there is a rupture, where there is in fact a disjunction" between arts.[87] But is there actually a synthesis in *Passion*? Jameson doesn't think so, and neither do I. Godard asks us to accept his film's competing registers, it mediatic juxtapositions, its structuration as fragmentation as productive—perhaps of an expanded form. Collage, the art form with which Godard's films are most often compared, uses disparate materials for the sake of their resonant interplay, even if these materials remain in productive tension with one another. Godard, writes Raymond Bellour, is "at home between-the-images like no one else."[88] Twenty years after *Red Desert*, whose pictureness incompletely participates in its ideological concerns, *Passion*'s productive dissonance spawns aesthetic and ideological inquiry in tandem.

Actors onstage in front of Rembrandt's *The Nightwatch*. *Nightwatching* (Peter Greenaway, 2007), frame enlargement.

Chapter 2

Spectator

The Spectator and the Text: The Space of Art in Greenaway

Peter Greenaway is a curator of exhibitions, an installation artist, and a filmmaker whose films exhibit paintings, feature writers as well as painters, juxtapose time-based arts with spatial arts, and analog with digital images. Trained as a painter, he still occasionally exhibits his work. His films create intermedial palimpsests that layer painting, literature, photography, architecture, landscape architecture, and dance. Greenaway has also made considerable forays into theater and opera and has created web-based multimedia projects designed to work in concert with books, DVDs, CD-ROMs, and a TV series, which never materialized. His *Stairs* project was installed in locations throughout Geneva and commemorated in a book; he has created exhibitions and installations for the Louvre, the Palazzo Fortuny in Venice, and the Rijksmuseum in Amsterdam, among others. Recent installations from the projected *Classic Paintings Revisited* series have been based on Rembrandt's *Night Watch* (his film *Nightwatching* grew out of this), da Vinci's *Last Supper*, and the Veronese *Marriage at Cana*.

His first feature film, *The Draughtsman's Contract* (1982), established Greenaway as an edgy filmmaker with a theoretical bent, and *The Cook, the Thief, His Wife, and Her Lover* (1990) consolidated this reputation. Not surprisingly, *The Cook, the Thief* is complexly intermedial, especially with respect to its spaces: in its first frames it represents itself as theater with the opening of curtains onto a stage, and in its last frames these curtains close. But that theater space is also a movie soundstage complete with steel rafters: the film plays on genre expectations set up by both media. The film is rife with references to painting: in the parking lot of the restaurant in which the narrative takes place, two trucks stand open to reveal Dutch-style "still lifes" of rotting meat and fish, and still-life compositions abound as well in the space of the kitchen. In the dining room an enlarged reproduction of Frans Hals's *Banquet of the St. George Shooting League* (it is the earliest of these, painted in 1616) dominates the space. The film's central character, Spica the gangster, is attired in seventeenth-century Dutch costume, and the tableau vivant moments of Spica's carousing gang are visual echoes of Dutch genre painting.

Greenaway's films are organized around visual arrangements, classifica-tions, or other structures that organize contingency. As he claims in one inter-view:

> In *The Cook, the Thief* the organizing principle is color. That owes
> something to my beginnings as a painter. Painting in the twentieth
> century has succeeded in divorcing colors from their objects. Because
> of that, both colors and objects become freely useable and open to
> choice. That's why I attempt to make color into a constitutive part of
> the structure rather than using it as a decorative afterthought. When
> the characters in the film change color, it relates to the fact that, in
> some sense, we are all chameleons.[1]

In other words, he suggests that abstract painting, in which color is not attached to a referent, liberates color to be used arbitrarily. Here we have one explanation for the changing colors of the characters' costumes. But since the director, who loves binaries, often counters one assertion with its oppo-site, Greenaway also acknowledges that the film's spaces are color-coded and exploit color symbolism: green is the vegetal, life-bringing color that pre-dominates in the space of the kitchen, while a bright red tends to dominate the dining room space where much of the film's high drama takes place, and so forth. The toilets are a dazzling white—to suggest the lovers' heaven, the director claims—and since the actors' costumes change color to match each space, when Georgina, the Helen Mirren character, leaves the dining room to enter the toilet, her red Gaultier-designed dress turns white. Color clearly has a function with respect to space, but perhaps the association of a dazzling white with heaven is not what is centrally at issue. "When the white comes on-screen," claims Greenaway, "the audience is lit up—the light reflects back into the theater."[2] The bright white light also functions, in other words, to effect a continuity between diegetic space and spectatorial space, a relationship of central concern to Greenaway.

Repeatedly the director has exhorted his spectators to "apply the aesthet-ics of painting"[3] to his films and to read them from the perspective of art history—not a surprising strategy for a skilled painter and amateur art histo-rian with an abiding interest in the "visual literacies" of painting as they relate to cinema.[4] In this chapter I do just that, analyzing space in several films by Greenaway that take up Dutch painting of the seventeenth century against notions of space familiar to art historians from Alois Riegl's *The Dutch Group Portrait* (1902) and Heinrich Wölfflin's magisterial *Principles of Art History* (1922), with a quick glance at Norman Bryson's book on still life, *Looking at the Overlooked* (1990), and Svetlana Alpers's *Rembrandt's Enterprise* (1988). While Lev Manovich locates Greenaway's intermedial cinema at the intersec-tion of narrative and database,[5] this is not the focus of our concern: narrative and electronic media will take a back seat to painting—and to theater, since

theater is often the mediating third term when the relation of film to painting is under discussion.

Several discursive systems visibly battle for space in Greenaway's cinema: we are dealing with what Grusin and Bolter call "hypermedia"—with texts that choose to efface the representational markers of different systems, preferring instead to let them "show."[6] When Greenaway's films juxtapose different notions of space within a given text, this strategy raises questions about the nature of the cinematic space that ensues from their juxtaposition. While Stephen Heath's canonical essay, "Narrative Space,"[7] famously aligns the space of film narrative with the Albertian perspectival system—with a disembodied viewer who remains decidedly *outside* the space of representation—something else is at stake in Greenaway, whose work complicates our notions of scenographic space in its relation to the spectator.

As Panofsky famously noted in the 1930s, in film there is a "dynamization of space":[8] it is a commonplace that space in the cinema derives from camera movement, from the mobilization of point of view—the famous mobile frame—as well as from mise-en-scène and editing strategies. But what would it mean to include concepts of space familiar from painting within cinema's arsenal of space-creating devices? The first part of this chapter examines camera movement in *The Cook, the Thief* with respect to received ideas about painterly space, asking what mode of spectatorship they set up. The next section addresses the intermedial space of *Nightwatching* with attention to lighting and sound in their relation to spatiality. Theatricality and games with illusion—favorite topics of Greenaway's—are a meeting ground for both concerns. The last section of the chapter reads *Rembrandt's J'Accuse* (2008), a digitized coda to *Nightwatching*, as a political ekphrasis that calls for yet another form of spectatorship.

The Cohabitation of Several Spaces

For André Bazin painting was one of the framed arts, while cinema was "limitless realism," revealed by a camera for which there is always more space to travel across, with the movie screen a mere mask imposed on reality. But this is not the notion of cinema on which Greenaway's artificial worlds are posited. *The Cook, the Thief*, bracketed by a proscenium arch and curtains with which it opens and closes, it has more in common with Bazin's evocation of theater than of film. The space of theater, writes Bazin, is "an area materially enclosed, limited, circumscribed . . . It exists by virtue of its reverse side and of anything beyond, as the painting exists by virtue of its frame . . . The stage and the décor where the action unfolds constitute an aesthetic microcosm inserted perforce into the universe but essentially distinct from the Nature which surrounds it."[9] The microcosm of *The Cook, the Thief*, a mix of the painterly and theatrical, is minimal indeed: its most significant spaces—the parking lot, kitchen, toilets,

and dining room of a restaurant—are primarily arranged in linear fashion and color coded. If theater is "bounded" (like framed art, as Bazin suggests), one of its "reverse sides" will be formed by its audience, the others by what lies beyond the set that cuts it off from the real world. In Greenaway's film the back wall of the restaurant's dining room features an enlarged reproduction of Hals's *Banquet of the St. George Shooting Guild*, which constitutes part of the boundary that separates the space of the set from one of its "reverse sides." The reproduction is framed by curtains that echo the painted curtains of Hals, a kind of double bracketing of painting by theater, framed spaces both.

Complex, dissonant spaces are characteristic of Greenaway's intermedial cinema. In *The Cook, the Thief* the camera's pronounced movement back and forth against its linearly arranged spaces—the lateral tracking movement that is one recurrent aspect of the camerawork in Greenaway's filmmaking—sets up what can only be read as a planar relation to the image. In Greenaway's first full-length feature film, *The Draughtsman's Contract*, lateral, back-and-forth movement is in fact the only camera movement—and it occurs exclusively in the film's two table scenes, where its motion emphasizes the horizontality of these arrangements, referencing the genre of the table painting. In *The Cook, the Thief* the camera's planar movement re-creates the screen as the picture plane. Interestingly, the space produced by the camera's tracking movement is interrupted at the moments when one room—or space—meets another. What initially appear to be pillars separating these spaces is actually no image at all; rather, it is black footage, or unexposed film stock. The film's use of this footage is complex insofar as it functions not only as an elision of the "walls"—that is, the lack of image stands in the place of the walls that would ordinarily separate the rectangular rooms of the film's setting—but also as a marker of the divisions between these spaces. If we read these black spaces in the context of the cinematic medium, they recall the edge that separates one film frame from another on the material surface of the filmstrip. (See chapter 1. From another point of view, they point to early film's relation to the cartoon strip, its "visual flatness" as theorized by Noël Burch.)[10] Adding to the complexity of these spaces is the scaffolding that supports the stage on which the film's action takes place: this is at once a soundstage, a theatrical stage, and—since we see the bottom boundary of the stage that way—a narrow horizontal line. The linearity thus introduced into the mise-en-scène reinforces the linearity of camera movement and the planar quality of the image. In some sequences, actors move across these spaces in ritualized processions, which likewise underscore the planar organization of such scenes. Linear composition is further heightened by the repeated grouping of the film's characters around a table, a composition that also evokes the arrangement of figures in Hals's painting.

Heinrich Wölfflin's famous distinction between Renaissance and Baroque notions of space, between Leonardo and Rembrandt, between planar and spatial, is of use here, and it is significant that the table painting the art historian

most often references with respect to the classic planar style is Leonardo's *Last Supper*, which served as the centerpiece of one of Greenaway's recent installations. For Wölfflin, Leonardo is the central proponent of the "decided line theme" of the Cinquecento, which "subjected the visible world to line" and thus emphasized the plane.[11] In *The Last Supper*, Wölfflin argues, "the alignment of the figures and their relation to the picture space here for the first time achieves the wall-like compactness which forces the plane upon us."[12] I am not suggesting that the characters of the film form a group as compact as Leonardo's—they are not static, for one thing—but rather that the lateral motion of the tracking film camera reinforces the line that marks a boundary of the stage and seems in the process to "paint" the images of the figures on the screen as though it were a canvas. With the camera's emphasis on the picture plane, the film screen on which the image appears is brought into focus as its material support.

Importantly, however, this is not the only kind of space the camera traces: it also tracks into deep space, setting up the process that Noël Burch with respect to primitive cinema (1905–15) calls the "cohabitation" of two notions of space, where effects of surface coexist with effects of depth.[13] (See chapter 1.) This is the central tension that informs spatiality in films by Greenaway, but while they may harken back to primitive cinema, alternation between these models of space has a primarily art historical provenance, one that contrasts Riegl's and Wölfflin's planar relation to space, represented by Leonardo, with what Riegl calls the "spatial" and Wölfflin calls the "painterly" style, the style they connect with Rembrandt. The action of the film takes place in the performance space between the planar movements of the camera and— in the dining room—its space-creating movements toward the back wall against which Frans Hals's militia painting as scenery is situated.

Repeatedly in films by Greenaway, the camera tracks into deep space and into a vanishing point that is marked by perspective lines in the form of carpets, for example, or that ends in symmetrically arranged arches or doorways. This strategy occurs most markedly in *A Zed and Two Noughts* (1986) and *The Belly of an Architect* (1987), where the exaggerated symmetrical arrangements of the mise-en-scène ironize by overemphasis the visual constraints imposed by central perspective. In *The Cook, the Thief* this technique is most apparent in the parking lot space, where white traffic lines on the pavement provide the depth-producing lines in question. By this means—the juxtaposition of horizontal, planar camera movements with space-creating, recessive camera movements and props that gesture toward deep space—Greenaway sets up a tension between spatial systems. While on the one hand the film seems to favor the linear, planar dimension that keeps the spectator *outside* the space of the film—the tracing of the picture plane that calls a modernist attention to its surface as support, or, as Diderot might put it, creates a *toile* or fourth wall—the presence of Hals's painting emphasizes a Dutch permeability between spectatorial and represented space, the melding of the real

with the represented that Greenaway favors.[14] Its concern for figuratively including the spectator in the space of representation is the formal interest that Dutch seventeenth-century art holds for Greenaway. As Riegl argues, the Dutch artistic volition is internal and external coordination, meaning that it features strategies that set up an external unity with the beholding subject.[15] The figuration of spectatorial space as continuous with the space of representation, an aspect of illusionism, is a strategy present in Greenaway's fiction films from *The Draughtsman's Contract* to *Nightwatching* (2007), films that embrace this popular tendency in the visual arts of the seventeenth and eighteenth centuries.[16]

Riegl's analysis of Dutch group portraits reads them in terms of their internal and external unity, then—internal unity being the manner in which the depicted members of a group relate to one another, while external unity is judged by the way *represented* figures relate to spectator figures *not* represented in the painting, figures imagined to be outside its space, but nevertheless implied by the formal arrangement of the painted group. For Riegl the spectator of this kind of painting is part of a theatrical scene whose space extends into the space of the spectator.[17] Characteristically for the frontally arranged Dutch group portrait, several members of Hals's St. George militia look out of the painting. But their looks do not all have the same object. Just to the left of the painting's center one of the militiamen turns as though to face an undepicted new arrival to the scene. Hals chooses an unimportant moment for his portrayal of the militia, one that depicts the gossiping of the men. By this means, Riegl suggests, the painting establishes an inner unity among the figures as the baldheaded man tells the man next to him about the arrival of a figure outside the painting—with whom he then establishes an external unity in time and space. Typically Dutch about this scene is its depiction of psychological attention, which Hals heightens by fusing it with pleasure or *Lust*.[18]

When figures such as these look out of the painting, its fourth wall is transgressed and both its implied spectators and the film's spectators are figuratively integrated into one space. In deploying an enlarged reproduction of Hals's painting against the back wall of its dining room set, Greenaway's film renders the narrative space in which the film's characters reside permeable to the space of the reproduced painting, an effect enhanced by the color coordination of these spaces and by the similarity of costuming in both. By this means Greenaway turns Hals's painted figures at table into spectators of the film's characters, likewise at table, since the sight lines of the central figure of Hals's painting point to the film's characters. Depending on the position of the camera, the figures in the Hals reproduction also look *beyond* the diegetic characters to its other implied spectators—that is, to the *film's* spectators. With the film's spectators, they set up a relay of looks that encloses the diegetic characters in the space between.

Theater plays a significant role in this exchange: as mentioned above, the floor of the dining room is a stage with occasionally visible supports and

the painting itself is encased in curtains that underscore its theatrical nature. Sometimes the camera boldly asserts its mobile framing within the space of the dining room. Often, however, as mentioned above, the camera's pronounced lateral tracking accentuates the horizontality suggested both by the visible edge of the stage along the bottom of the film frame and by the edge of the table in Greenaway's recurrent table arrangements. In such moments the plane of the screen is evoked, the depth of field created by the strategy of spectator emplacement is relativized, and the film spectator's entry is metaphorically blocked. Now the spectator remains decidedly outside the text. At other times, however, the arrangement of figures at table enables a frontality such as we see in Dutch militia paintings—a frontality that suggests that the space of the painting is continuous with spectatorial space. The two spatial systems are in tension with one another.

While there is no tracking into the vanishing point in this film's dining room space, the last sequence of the film is complex in its spatial arrangements. It alternates images of the cook and his entourage in a frontal arrangement moving out of a recessive space marked by an arched doorway—they are coming out of the kitchen, toward the spectator of the film—repeatedly cut with shots at a 90-degree angle that reveal the planar disposition of the moving procession. In this sequence the thief, Spica, is seated behind the corpse in aspic whose horizontal shape the camera traces in a linear movement from right to left. Instead of being shot in front of the painting, which has consistently formed the backdrop for these characters at table—though obliquely, at an angle—Spica is now shot in front of a glass-paned French door between two other windows, to which our attention has not been called up to this point. Then the camera, in a departure from its usual movements, circles around and repositions itself behind Spica, whose point of view with respect to the corpse the spectator now also occupies. After Georgina shoots Spica, a curtain is drawn over the scene that Spica, the camera, and the film's spectator have been viewing and the film ends.[19] When the curtain falls, the spectator sees it from a position that is not only behind Spica, but also in front of the curtained central window, with the spectator's back to the Albertian pane of glass, as it were. We spectators do not face the "window on the world": we are figuratively situated between two curtains, one of which covers the staged spectacle. The camera's—and spectator's—complex positioning is between two aspects of the mise-en-scène, the window and the curtain. When the curtain is fully drawn, the spectator is definitively immersed in the space of art: we are now figuratively located in the same space as the militia in Hals's painting, and the film affirms the artistic volition of Dutch art to include the beholder in its space, the *Kunstwollen* described by Riegl. But as so often in Greenaway, there is an oscillation between systems: the curtain is at one and the same time the theatrical curtain that frames the space of theater, locating the spectator on its reverse side, suggesting a space outside the space of spectacle. Here we might look to another film by Greenaway, *The Baby of Mâcon*

(1993), whose ending is illuminating in this regard. At the film's conclusion, the camera keeps tracking backward out of the frame and toward the film's spectator to reveal layer upon layer of spectators of spectators, thus generating multiple theatrical frames. In this way the camera seems to emerge out of a mise-en-abyme of multiple productions, finally opening out as if also to encompass us, the spectators of the film.

Mixed Modes: Painting, Theater, Film

In foregrounding the *figured* place of the spectator within the text, Greenaway's films relate to one condition of spectatorship in his installations, for example to the commissioned work surrounding Rembrandt's *Night Watch* (2006), the first of his projects in the *Classic Paintings Revisited* series. An avowed pedagogical intention lies behind the projects in Greenaway's series, an intention that centers on the reading of painting and the role of theatricality and illusion within it. Greenaway's installation of the *Night Watch* used digital images and overlays and imposed a soundtrack over a digitized reproduction of the painting. For the installation, the room housing Rembrandt's painting in Amsterdam's Rijksmuseum was transformed into a hybrid space of movie theater and traditional theater, a space with thirty-four seats—one seat for each figure in Rembrandt's painting. The conceit suggested by this seating is that the painted figures themselves might at any time enter the space of the audience and sit down. Such seating arrangements also suggested that the visitor to the museum—the spectator of the installation—could sit down and "watch" the *Night Watch*, a famously theatrical painting, as though it were a play.[20]

Greenaway speaks of himself as having interacted "almost physically"[21] with Rembrandt's painting in his films on the *Night Watch*, a "physical" interaction that spawned a proliferation of texts, including a published screenplay. Out of the installation of 2006 grew both the fiction film *Nightwatching* (2007) and the art documentary *Rembrandt's J'Accuse* (2008), which draws on footage from the fiction film. In *Nightwatching* theater is even more obviously the mediating term between painting and film than it is in *The Cook, the Thief*. Greenaway contends that Rembrandt's *Night Watch* is a moment of "frozen theater" that tells the story of a murder, and his films on Rembrandt's painting are organized around the decoding of this "mystery in paint." Arguing that *The Night Watch* accuses the Amsterdam Musketeer Militia of murder, Greenaway analyzes the imagery of their portrait from this perspective, a narrative strategy he had already featured in *The Draughtsman's Contract*.

Nightwatching the film frequently resorts to frontality and direct address as a means of suggesting continuity between its spaces and that of its audience, emulating the genre of Dutch militia painting before the formal innovations

of Rembrandt's *Night Watch*. One of the film's characters, Jacob de Roy, complains that Rembrandt's painting, in undermining the frontal style that seeks to establish external unity with the spectator such as we see in Hals, is actually a "work of the theater," since only actors are trained to pretend that they are not being watched. All the Amsterdam militia wanted, de Roy claims, was to "stand still and be looked at," to be present in a painting that says "I am watching you and you are watching me." This is an understanding of group portraiture that Riegl reads as characteristically Dutch: "The Northern beholder sensed when looking at the figures that they did not present themselves in this way naturally . . . but were thus arranged for the sake of the beholder."[22] In actuality, Rembrandt's painting is mixed in this regard, containing two figures whose looks do break the fourth wall, one of them a self-portrait of Rembrandt that embodies the self-consciousness of the older style. Rembrandt's self-portrait with its look out of the frame constitutes one aspect of de Roy's denunciation of the painting: "You look at us within the old tradition of these sorts of painting with an admirable self-consciousness. You're giving yourself an old-fashioned position and responsibility in a new-fashioned painting which tries to deny that position and responsibility." Here we find the collision of two understandings of portraiture. "By its very nature," de Roy proclaims, Rembrandt's painting "denies being a painting. It is a work of the *theatre*."

What is new about Rembrandt's *Night Watch*, writes Riegl, is the way in which the artist embraced a Latin or Roman style of presentation learned from Rubens, a dramatic style in which the *sub*ordination of the figures is emphasized, not their *co*ordination as represented in the militia portrait genre heretofore.[23] Riegl suggests that on a first viewing "all external connection between the visible figure in the picture and the unseen beholder seem to be severed."[24] Yet here the significance of gesture, of the extended hand of the central figure comes into play: his raised hand—even if at an angle—leaves no doubt that the group will "converge upon the beholder in the next moment."[25] For the history of painting the significance of this oblique extension of the hand is that it "tears the movement away from the picture plane"—and out toward us—for the first time in northern painting, thus undermining what Riegl calls "a thousand year old constraint."[26] At the same time, however, the painting also features a pronounced horizontal axis, a row of figures, across the bottom of the picture. As Riegl suggests, in his *Night Watch* Rembrandt mixes the spatial and the planar styles, emphasizing the former. Whereas there is an implication of space-creating frontal movement out toward the spectator, in other words, the figures are arranged in three planes in order to balance the impression of space that implied movement conveys. This mixed mode of presenting space is similar to the one we have analyzed in *The Cook, the Thief* and may be one reason Rembrandt's painting holds such appeal for Greenaway, although in the case of Rembrandt the mixed mode is not bur-

dened with the sort of antagonism against central perspective we tend to find
in Greenaway.

Like *The Cook, the Thief*, Greenaway's *Nightwatching* employs a mixed
mode of articulating space and its opening emphasizes its multimedial inter-
ests in its references to painting, screen, and theater curtain. The image of a
painted eye in close-up that initiates the credit sequence—it is Rembrandt's
depiction of his own eye in *The Night Watch*—is followed by other details
from the painting. Short takes of torches are cut with their moving shadow
images on a curtain, suggesting an amalgam of theater and cinema. The space
from which the figure emerges is a stage upon a stage—a curtained bed on
pulleys, the space of intimate performance. A figure tumbles out of the bed:
it is Rembrandt, having fallen out of bed during a nightmare in which he is
blinded.[27] In his dream Rembrandt has been "nightwatching," as he puts it,
"seeing the night," "seeing miles and miles of painted darkness." His mono-
logue continues over a black screen: the film's unexposed footage suggests that
this painted blackness has a cinematic equivalent, that "painted blackness"
is also the space beyond the frame, that it is precisely the lack of image in
the unexposed footage—that extends blackness into the "world," as Bazin
might put it. Toward the end of the film a black-and-white *grisaille* scene of
uncertain ontological status—is it real, is it imagined, is it a dream?—recalls
Rembrandt's earlier nightmare, a scene in which two men on horseback come
to put out his eyes with a torch, a mininarrative Greenaway lifts from his
Draughtsman's Contract.

The ill-defined black-and-white scene of torture in this second dream
or vision—from which Rembrandt emerges with a diegetically *real* bloody
eye—is cut with a sequence in color that features a tableau vivant of *The
Night Watch* stationed in front of the curtained painting—until, that is, its
participants break out of their static pose and—now again characters in the
film—move forward in the film frame to sit down at a heavily laden banquet
table. The film concludes as Jacob de Roy, one of the militiamen, now also a
spokesman for Greenaway's conspiratorial narrative—emerges out of a central
archway in a symmetrically arranged space, out of the vanishing point of the
film frame. This set design suggests the power attached to the single point of
view, to the symmetry and central perspective that define the space and hence
express the triumph of the burghers, but de Roy walks toward the spectator
of the film, looks straight out of the frame and raises his glass to us, repeating
with a difference the gesture of the hand in Rembrandt's painting, now with
an unmistakable theatricality.[28] Clearly these final frames of the film, in which
de Roy predicts the burghers' retaliation against Rembrandt and raises his
hand to toast the film's spectator, accord with the representational strategy of
Dutch seventeenth-century art, in which an internal figure establishes contact
with the external—here the film's—spectator. *Nightwatching* suggests that
the burghers have triumphed over Rembrandt in their preference for a more
established, traditional form of visual representation—the direct look out in

the earlier militia paintings—one repudiated by Rembrandt's *Night Watch*. But this strategy accords with Greenaway's project.

Between the two dreams that bracket the film's narrative, the body of the film includes numerous shots of symmetrically composed interiors of public, official spaces, shots in which strict attention is paid to perspective using visual cues such a carpets. One such space is the church, where the lateral movement of Saskia's funeral procession is relativized by the tracking camera that emphasizes the planar disposition of this shot even as it reveals the architectural symmetries of the space. There is little doubt that ideology is at issue in symmetrically composed spaces such as these. In this film as in *The Cook, the Thief*, the lateral, planar tracking of the camera is opposed to a tracking into and out of recessive space. But something new is introduced into Greenaway's arsenal of space-creating strategies here, insofar as the planar and the spatial modes so often traced by the camera are contrasted with new modes of spatial organization within Rembrandt's studio. In *Nightwatching* the film camera is often set free to rove among the spaces of the studio, whose boundaries are indistinct in the nighttime scenes (there are daytime scenes in which its boundaries are perfectly apparent) in imitation of Rembrandt's use of chiaroscuro and black space to obscure spatial boundaries. While the diegetic world of Rembrandt's dream is "painted blackness," total artifice, in moments when Greenaway's film has recourse to spatial blackness, the space of painting, the theatrical performance space, and the space of the film are figuratively unframed.[29]

The film's use of the curtained bed as a movable intimate stage—it is on wheels—allows the rest of the studio, when in shadow, to function variously with regard to the film's diegetic world. At times the space beyond the bed includes groups of figures in a place that is somehow *outside* Rembrandt's studio—including scenes that might very well exist in different temporalities. Here the deathbed sequence assumes special importance: it begins with a slow and deliberate tracking shot, the camera encircling two groups of characters (lawyers drawing up Saskia's will, it would appear) seated a different tables, theatrically lit, at quite a distance from the bed-stage on which the conversation between Saskia and Rembrandt is taking place. While the camera traverses some distance toward that stage until it centers it, the quality of the sound and its volume do not vary. Nor do they change when an abrupt cut brings Rembrandt and Saskia into medium close-up. Here, then, is a subtle example of the cohabitation of dissonant spaces Greenaway favors, with sound suggesting one space and the camera another. At other times, the studio becomes an installation space, as when kitchen objects and muskets are arranged in rows covering the floor, objects now part of a formal pattern, deprived of their diegetic function. And finally, the indistinctness of the chiaroscuro lighting makes it difficult to situate the space in which the table compositions are located.

Indeed, the objects displayed as still lifes on table compositions address space differently. Like the line of the stage in *The Cook, the Thief*, they empha-

size linearity—the table edge or tablecloth is represented as a white horizontal line in the darkness, no doubt with reference to the line in Leonardo's *Last Supper*. But stressing the table edge as line is also a formal characteristic of the still life genre per se. Despite their arrangement within a space that seems unframed, another dimension of painterly space is brought into play in these compositions. Once again spatial systems cohabit but collide, never to arrive at a synthesis. That the table is depicted as a line undermines its materiality, Norman Bryson argues, noting that the still life genre as a whole "is disinclined to portray the world beyond the edge of the table":[30] it tends not to suggest a space beyond the indistinct wall that contains it. In still lifes, one rarely finds perspective lines that track into depth; there is no vanishing point. Here Bazin's notion of theater's "aesthetic microcosm," with its reference to a self-contained world of art, comes into play. In Caravaggio's *Basket of Fruit* especially Bryson reads a hyper-real space that reverses the Albertian gaze and deceives the eye, a trompe l'oeil: "Its space is not that of reality but artifice, theatre, a space where art can display itself."[31] Caravaggio's still life exists in "a purely aesthetic space."[32] When spatial darkness surrounds objects in Greenaway's film, they are simultaneously unframed *and* suspended in a space of art. But in *Nightwatching* the "purely aesthetic space" Bryson locates in Caravaggio is in tension with another aspect of still-life arrangements: the goblets, bread, fruit, and the like are displayed on tables at which the film's characters are seated, characters for whose use the objects are placed there. In *Nightwatching*, then, the thematics of the meal would seem to situate still life arrangements within a domestic space of consumption—except that the films' characters seemingly seated at table and the objects in front of them exist in different planes of the image.

As we have noted, the concerns of *Nightwatching* contribute to the interest in effacing the boundary between reality and illusion omnipresent in Greenaway's filmmaking—which is in any case a spatial problem, as Bryson's reading of Caravaggio's still life suggests. In this context one might cite the scene in the film in which Rembrandt's finished painting—huge in scale, yet here displayed on a giant easel and framed—is mirrored by actors facing it, costumed as militiamen who enact the painting in a loose (not wholly immobile) tableau vivant, a "making real" of the painted images that is their unframing. Yet tableau vivant, as an embodiment of painting that is itself a nodal point among the arts of painting, theater, and sculpture, also bears the pressure of multiple artistic systems. At this point in the film Greenaway is eager to underscore the painting's innate theatricality, its manner of suggesting sound, in particular that of the musket shot that kills Hasselburgh, and when his Rembrandt orders a shot to be fired into the men, their sculptural group dissolves into random movements. Equally instructive with respect to an oscillation between reality and illusion is the character Bloemfeldt, an actor in the diegesis. The film's narrative suggests that the actor has been hired by the militia to take the place of a member of their group, Egremont, who flees

after he is accused of Hasselburgh's murder. Wishing to sketch Egremont in preparation for *The Night Watch*, Rembrandt goes to Egremont's flower shop, where he encounters a man who claims to be the flower merchant—who wears his clothes, arranges his flowers—but Rembrandt quickly realizes that this man, Bloemfeldt, is a "man of the theater" whom he has recently seen onstage. Although Bloemfeldt readily admits that he is playing a role, he counters with the accusation that Rembrandt's paintings are also "full of actors posing and stalking about," and that, indeed, Rembrandt himself is an actor "always peering in a mirror" to see how he looks.

Svetlana Alpers's study of Rembrandt, *Rembrandt's Enterprise: The Studio and the Market* (1988), is no doubt one source for this insight into the historical Rembrandt's connection with theatricality. "Always peering in a mirror to see how he looks"—the accusation that Bloemfeldt levels against Rembrandt—this characterization of Rembrandt derives from Alpers's claim that, in the production of his self-portraits, Rembrandt was always "presenting himself as a model in the theatrical mode."[33] For Alpers, Rembrandt's self-portraiture is a dramatic spectacle in which the artist is both model and maker, displaying himself and his artistry at one and the same time: "He is a painter who delights in displaying his delight in the laying on of paint. In his self-portraiture his performance of the artist as model is matched by the performance of his brush."[34] Indeed, Alpers's Rembrandt "offers the act of painting itself as the performance we view."[35] Needless to say, the topic of Rembrandt's theatricality is not new with Alpers: she freely acknowledges her sources for these insights in the work of the many scholars who have analyzed *The Night Watch* in the context of theatrical performance.[36]

Alpers maintains that it is not surprising that Rembrandt's paintings of this period should have a theatrical cast, since it was common practice for artist's models to be clad in costumes and arranged in dramatic scenes. Samuel von Hoogstraten, for example, a student of Rembrandt's and an artist who later had his own studio complete with apprentices, used the attic of his house as a theater where his students performed plays designed to teach the intricacies of pose and gesture.[37] (When in Greenaway's film the militia makes the accusation against Rembrandt that their costumes are out of date and have come out of his cabinet of curios, they are dead on target: the historical Rembrandt was known for his collection of opulent costumes and props.) Further, this attitude of theatricality could be internalized: as Alpers reports, in his writings Hoogstraten first compares the mind of an artist to a stage and then suggests that that the artist pull back the curtain to see what is performed there.[38] But the theatrical model that Alpers sees in Rembrandt's work is equally derived from observations about his drawings and paintings in which similar subjects and compositions are seen from different perspectives, in which scenes are restructured from other points of view.[39] This is a cinematic technique. Especially when it is based on a theatrical model, painting has a good deal to say to the cinema.

How, then, *does* theater function as a mediating third term when the relationship of cinema to painting comes under discussion? The ways it does this are multiple and various, of course. Most pertinent to our discussion is Riegl's meditation on the relation of the internal to the external spectator in Dutch militia painting, a relation posited on attention, on a psychological connection between the figures represented in a painting and a spectator outside it. In imagining these points of connection, Riegl constructs an explanatory narrative that connects what is depicted to what is implied—the understanding is that the poses and gestures of the represented spectators imply a certain kind of external spectator whose place we inhabit. Thus, understanding the painting takes the form of imagining the theatrical scene of which both its figures and its spectators are a part. Writing, for example, about a later group portrait by Rembrandt, *The Staalmeesters* (1661–62), Riegl makes clear that it is the task of the painting's beholder to complete this scene: the beholder "is immediately able to recognize a self-contained dramatic scene behind the juxtaposition of five or six portrait heads . . . Théophile Thoré-Bürger was the first to sketch out this dramatic content. He correctly assumed that one had to presume an unseen party in the place of the beholder, with whom the *Staalmeesters* are negotiating."[40] This strategy is not far removed from Denis Diderot's approach to landscape painting in his *Salons*, in particular to landscapes by Vernet, which Diderot describes by narrating walks that he takes through picturesque spaces with his friend the Abbé. Only at the end of each description are they revealed to be fictional scenes: they are actually descriptions of the spaces in a painting into which he has introduced himself as a figure and character. In both instances ekphrasis—the verbal evocation of a visual work of art—takes the form of dramatic scenes.

Of interest to me in these examples is that both Riegl's and Diderot's mini-dramas figuratively break the fourth wall of the paintings they describe—Riegl's by extending the space of the painting into spectatorial space, and Diderot's by figuratively introducing the real world—that is, himself, Diderot—into the space of the painting. Could there possibly be a more radical strategy for unframing the framed world of painting? When in Greenaway's films the spectator is figuratively introduced into the space of the film—as in *The Cook, the Thief,* when we are "placed" between window and curtain—or the space of the film is extended into spectatorial space—as in *The Cook, the Thief* when we complete Hals's painting—it is the interaction of the film's real spectator with its imaged figures that is at issue. What is suggested is the filmic spectator's placement within the scenographic space of the film, if not the spectator's participation in its dramatic action. De Roy's toast to the spectator with which *Nightwatching* concludes is only the most obvious example of this strategy. In his films around Dutch art, Greenaway uses painterly means to figuratively unframe the framed media of painting and theater by way of strategies that conflate the represented with the real. By such means, despite the "aesthetic microcosm," the self-contained world that

Greenaway's cinema of artifice also creates, cinematic space is paradoxically reestablished, as Bazin puts it, as part of the "picturable world that lies beyond [the cinema]—on all sides."[41]

Spectatorship and Installation

As suggested earlier, in foregrounding the *figured* place of the spectator within the text Greenaway's films figure a condition of spectatorship in installations, especially those that exhibit painting. Greenaway embraces this form with the commissioned installation surrounding Rembrandt's *Night Watch* (2006), the first of his projects in the *Classic Paintings Revisited* series, of which the more recent *Leonardo's Last Supper* (2008) is the second. In the latter installation especially the spectatorial body is contained—literally—within a space of representation, and its position, its movement through space, and its views are both guided and free; now focused, now distracted. But how is perceptual and aesthetic experience shaped for the spectator? And what kind of spectatorial pleasure do such practices produce?

Before pursuing these questions, I return briefly to two earlier models of spectatorship—to one practice that sets up a figurative merger of spectator with text and to another that promotes a more literal merger and prefigures the place of the spectator in the installation. Borrowed from the archives of other media, these artistic practices include Dutch painting of the seventeenth century and English garden art of 1650 through 1750.

Greenaway has repeatedly harangued his audiences concerning cinema's need to renew itself by returning to the visual arts, but how are we to read his embrace of earlier artistic practices, what are their commonalities, and what light do they shed on his recent installations? There are more continuities than breaks between Greenaway's understanding of seventeenth- and eighteenth-century artistic practices and his own theoretically inflected work—films, exhibitions, and installations alike. While the incorporation of earlier visual practices first into film and then into installation art reflects repeated instances of remediation, what exactly has changed about the situation of the spectator? Despite the centrality of digital technologies to Greenaway's installation of Leonardo's *Last Supper*, a sense of "back to the future" shapes this visual artist's composite texts.

Dutch art of the seventeenth century famously thrives on the intertwining of realism with illusionism and on trompe l'oeil effects derived from Italian models—a tendency also present in seventeenth- and eighteenth-century garden art, which is similarly fascinated with the borderland between reality and illusion. Aesthetic practices that embrace these ambiguities often generated a frisson in their spectator, whether they involved the programmed walk through a garden or a visit to a candlelit sculpture gallery whose flickering light animated the statues on display.[42] Games with illusion, then, took

center stage during this period, and an important aspect of the spectator/ participant's aesthetic pleasure was an oscillating awareness of reality and illusion. Yet what is at issue in the example of the aestheticized landscape garden is not only the liminal space shared by art and reality: it is that the spectator is now literally—no longer simply figuratively—placed within an aestheticized space. Pertinent to the topic of the twentieth-century installation, moreover, is the movement of the spectator within this space. Indeed, the introduction of motion into the experience of landscape was stressed as the garden's primary advantage over painting by eighteenth-century theorists. I have suggested elsewhere that the experience of the walk through the garden is protocinematic,[43] but the multiple perspectives available to the spectator simply by a chance turn of the head enabled spectatorial participation that is more on a par with the installation than with cinema. Since the scenes of the landscape gardener's art were arranged to be perceived sequentially, the strolling spectator experienced a gradual unfolding of scenes and frequent changes of perspective. Temporality entered the scene in a number of ways: by the pace of the individual walk—governed by the objects that caught and held spectatorial attention—and by the time of day and season. Some garden rooms were actually designed for specific seasons and times of day, so that if one entered a morning garden in the afternoon—which one was free to do— one was running counter to programmed experience. Time also shaped the experience of the walk by way of ruins, ornaments, and statuary that evoked a mythological, historical, or personal past—one might, for instance, come upon a bench erected in memory of the dead, complete with an inscription. In this way, citations from poetry brought written texts into the mix. And who knew how long the perambulating spectator would linger over lines from Milton?

For early eighteenth-century England, the doctrine of associationism held that perceptions and their accompanying emotions were at least partially structured in advance. Before 1750 especially, the English landscape garden is an aesthetically heightened space through which the eye is guided by the emblematic presence of statuary, grottoes, obelisks, and inscriptions, each of which was meant to be *read*, to evoke a specific set of spectator affects. Designed to promote a field of varied perceptions, the garden enabled a convergence of the senses: sound (the sound of a melodic brook, for example), touch (the rough texture of a turnstile or gate), and smell (the fragrance of flowers) are deliberately programmed into the walk. But how the precise sequence and duration of a landscape garden's combination of effects spoke to the individual spectator—and how these effects invoked affect and personal experience—these were among the factors that introduced arbitrariness into aesthetic experience. And then there was the weather: a sudden cloudburst might easily dampen enthusiasm, while a chance thunderclap enhanced sublime experience.

Thus the landscape garden was already a multimedia space, a space in which actual paintings were sometimes strategically placed, framed by rock outcroppings and other natural formations. Sometimes empty frames were present to remind spectators that they were seeing the landscape in pictures; the frames also brought to mind the favored visual toys of the period—the viewfinder and Claude glasses—that shaped viewing experience by means of lenses and their tints. Greenaway took up the conceit of the frame set up in the garden in the Geneva *Stairs* installation of 1994, in which one hundred viewfinders mounted on vantage points were scattered about the city. As in the *Stairs* installation, the empty frame in the landscape garden played on the presentation of real objects as images, juxtaposing three-dimensional with two-dimensional effects, an interest that both the garden and the *Stairs* project share. (Greenaway has repeatedly spoken of his desire to present even cinema "as a three-dimensional exhibition.")[44] But aestheticized garden spaces also played on the opposite effect: mirrors were used to multiply the scenes they reflected, thus fooling the eye into perceiving two-dimensional images as three-dimensional *things*.

Theater also entered the landscape garden, most obviously by way of the spectator who was incorporated into it as a figure—as an actor—in the landscape.[45] Earlier, from 1650 on and shaped by Italian garden art, English gardens provided ample opportunity for the blurring of art and reality. Pleasure gardens featured theatrical spaces for performances by actual actors in addition to providing spaces in which the spectator's experience was staged.[46] While spaces such as these were not immersive spaces as defined by Bolter and Grusin—spectator/actors would not have lost an awareness of their bodies— they *were* spaces in which identities were fluid.[47] With reference to the trope of *theatrum mundi*, one theorist writes that in such gardens "we are placed as admiring spectators in the theater of the world, but soon this slips into our being also actors."[48] A similar slippage is common to Greenaway's film work: in *Baby of Mâcon*, for instance, diegetic spectators are similarly taken up into a performance—with the added twist that they are actors after all. And in *The Draughtsman's Contract* garden views and the drawings based on them are staged to suggest a perfidious—Jacobean—drama to be read.

The perambulating spectator's experience of the pre-1750 landscape garden points forward to the contemporary spectator's role in Greenaway's *Last Supper* installation, where the spectatorial body was likewise contained within representation, its perceptions divided and reassembled differently—if not wholly randomly—from moment to moment. I experienced Greenaway's vision of *Leonardo's Last Supper* in New York's Park Avenue Armory in January 2011, but it was originally exhibited in Milan. In New York the installation consisted of two very large screens as well as a number of smaller screens on each side of a central space, scrims layered over one another, all suspended from the ceiling. A three-dimensional version of a refectory

table—set with goblets, plates, knives, and loaves of bread—was located in the middle of the space (Leonardo's painting was made especially for the refectory of the monastery Santa Maria delle Grazie). The two large screens at either end held vastly enlarged and identical digitally scanned replicas of Leonardo's painting, onto which Greenaway projected a light show that fused his cinematic and museum exhibition practices. Blending cinematic, painterly, and museal space, the installation constructed an experience in which each spectator was a perceptual center. To say that the spectator entered the space of a painting—or a film—would not tell the whole story. In this installation, the spectators inhabited an aestheticized space between multiple versions of the same performance. But it was also a space in which other screens, other projected images, and a three-dimensional sculpture coexisted, and in which sound played an important part.

At times the smaller screens held the same image, underscoring their digitally reproduced nature. Here, for instance, there were variations on images of Leonardo's *Vitruvian Man*, a pen-and-ink study of proportion from Vitruvius's *De Architectura*—just to add another art or two to the mix. At times each screen contained only details of the *Last Supper*, details so enlarged as to be abstract, products of an extreme act of deconstruction. These and other digitized images were of photographs as well as of paintings and drawings, and banners suspended from the ceiling served to reinforce the three-dimensionality of the space and of aesthetic experience at the same time. Whether mobile or standing still, attentive to stereophonic music or to the primarily disembodied voice of Greenaway as "audio-guide," the spectator was contained within a space of projections, objects, and sounds that promoted multisensory perception. The sculptural refectory table holding semi-abstracted plates and goblets added tactility to spectatorship, even as its diffuse and changing lighting effects reinforced the experience of time in the "show" that Greenaway called his "vision." In this installation, then, there was the palimpsest-like layering of representational systems characteristic of Greenaway's work: the three-dimensional table was sculptural with interior kinetic light effects, yet its bleached color and still-life composition called to mind the still-life paintings of Giorgio Morandi, particularly his *Natura Morta* (1956), which had just recently been on view at the Metropolitan Museum of Art. (Is this the auratic work of art, satirized? If so, this inclusion entailed a measure of self-mockery as well.) Painting and sculpture, movement and stasis, multiple screens and moving images, a voice-over narrative—all of these affected spectators who moved freely and arbitrarily between the sometimes contemplative, sometimes distracted looking of the typical museumgoer. A disembodied gaze would not have been possible.

While the spectator had the choice of looking at one image or another, at objects as well as images, for a long or a short period of time, the temporality of Greenaway's *son et lumière* was circumscribed, of course, although it included repetitions that impinged on the temporality of perceived experience

and gave the show the semblance of a loop. Lighting effects projected on the large-screen versions of *The Last Supper* introduced a constant motion onto—seemingly almost into—these exact reproductions. Light was made to "shine through" the three windows in the background of the painting; light isolated different groups of the Apostles; its beams sometimes played over the whole, but it also lit the Apostles' and Christ's hands and feet (with the interesting *addition* of Christ's feet, in actuality cut from the painting in 1654 when a new door was installed in the refectory, and borrowed by Greenaway from a contemporary copy of the painting now in Antwerp). At times light streamed auratically from the body of Christ; and a cross of light was occasionally superimposed on the reproduction's surface. Typically for Greenaway, numbers and writing also inscribed the *Last Supper* and, at times, groups of Apostles were set off by red outlining, producing a paint-by-numbers effect.

And then there were the moments in Greenaway's vision of *Leonardo's Last Supper* when the grid depicted on the painting's ceiling—the grid that anchors the *Last Supper* within a perspectival system—was "set free" from that place, was tilted and rotated, and allowed to play over the surface of the reproductions in an arc now originating from their right side, now from their left side. Interestingly, these grids appeared as shadows on the reproduction, shadows that served to reinforce the grids' space-producing function. Projected onto the reproduction, no doubt the grids liberated from their fixed position in the actual painting served to suggest that the Albertian model of spectatorship had been "dissolved," as Norman Bryson puts it, "into computative space,"[49] but they by no means promoted immersion in the spectator. They remained images on a screen, images that figured three-dimensionality, but could no more literally take us up into their space than a painting can. They remained mere allusions to another kind of space, constituents of the hypermediatic landscape represented here. The spectator of Greenaway's installation was contained within an aesthetic space by virtue of the installation as a whole—not by means of the screens alone.

The spectatorial effects promoted by the *Last Supper* installation bore a striking similarity to those of the aestheticized garden such as we find in Greenaway's *Draughtman's Contract*—acts of framing, games with two and three dimensions, and the like. And in fact, within the space of Greenaway's installation there was another projection, one that derived from the landscape garden and used the floor as a screen: images of a brook rippling over stones flowed across the Armory floor, and it was amusing to see several people move into the stream of images, as though to take a quick dip. Here the performative aspect of spectatorship came into play. Not a pleasure to be enjoyed very long by an adult, perhaps, but among the spectators that day there was a child, a little boy of perhaps three or four, who promptly sat down in the projected images of water, moved around in them, and didn't get up from the floor until the images had stopped at the end of the show. It was here that immersion was played out—metaphorically, not literally—in a space even the

child recognized as a liminal space between image and reality. But that was no doubt the fun of it, not just for the ambulatory spectators of the landscape garden before 1750, but also for the twenty-first-century spectator: it is specifically one's presence within illusion that is the attraction of such effects. Theorists of spectatorship have tended to ignore the spectatorial pleasure that participation in theatrical spectacles such as installations enables. Prominent among them, I suggest, is the pleasure we take in aesthetic play. Not only do we apprehend such effects intellectually, but we experience enjoyment, pleasure—like the child's—in the juxtaposition of real bodies and real objects with represented ones.[50] To come full circle, we, the installation's spectators, were filmed throughout Greenaway's "show" by camera people clearly hired for the purpose, producing images to be used in a film that will likely grow out of this installation, a film that will surely—as so often in Greenaway—contain images of spectators.

Enter Ekphrasis: Spectator and World

Convinced that Rembrandt's famous painting *The Night Watch* is a "forensic enquiry in paint; a Crime Scene Investigation," Greenaway made his fiction film *Nightwatching* (2007) with the avowed intention of "bringing murder to light."[51] As Greenaway argues in this film, Rembrandt acted as "investigator, detective, prosecutor" in painting *The Night Watch*, creating a history painting meant to serve as an indictment of the Amsterdam militia for the murder of one of their company, Peirs Hasselburgh. With close formal attention to the painting, its genre, its significance in the history of Dutch art, and an expertise gleaned from the work of many art historians, as suggested earlier, in *Nightwatching* Greenaway creates a multimedia fiction film in which the meeting of painting and film is mediated by theater. But Rembrandt's painting as an indictment of murder: did Greenaway decide that he had not made this message concerning *The Night Watch* sufficiently clear in his fiction film, and did he for this reason decide to make its companion piece, *Rembrandt's J'Accuse* (2008), a film that draws loosely on the art documentary genre to make its points? It is entirely possible that this remake in another genre was just a matter of clarifying Greenaway's art historical point, but his choice of title for the film gives us pause, since it brings Zola's *J'Accuse,* his open letter to the French president concerning the Dreyfus case, into the picture.[52] How does Zola's text relate to Rembrandt's painting and to Greenaway's film? We'll return to this issue later.

Unlike *Nightwatching*, with its stress on high art and its attention to the place of the spectator drawn from Alois Riegl's work on *The Dutch Group Portrait*, *Rembrandt's J'Accuse* is concerned to utilize contemporary digital media to create its spaces. The film is at bottom an illustrated lecture which resorts to new media strategies such as windowing: Greenaway himself is prominently featured as a talking head. It makes use of looping, graphics, and text bars

that move laterally, sometimes in and sometimes out of sync with the traveling camera. Perhaps because strategies such as these split spectatorial attention, address the film's textuality, and prevent the illusionism that promotes spectatorial incorporation into the text, Greenaway chooses to include images of museumgoers visiting Rembrandt's painting in the Rijksmuseum—an act of literal incorporation. In keeping with Greenaway's multimedial approach, they no doubt allude to Thomas Struth's *Museum Photographs*, wall photographs that imply sound, movement, and spatial continuity between museumgoers and the figures in the paintings they are viewing. Here Greenaway's ironic literalization of the "spectator in the text" that Riegl reads as the artistic volition (*Kunstwollen*) of Dutch painting substitutes spectatorial self-consciousness for strategies that promote spectator entry. And, in homage to the planar composition in the mode of Leonardo that is also a recurrent formal characteristic of Greenaway's filmmaking, in this film he includes collaged bands or layers of images in his frames, perhaps harkening back to the layering of space that Riegl reads as a remnant of an earlier spatial composition in Rembrandt's work. The imagistic layering that results ties the superimpositions and inscriptions so characteristic of *Rembrandt's J'Accuse* to a tradition of ekphrasis, reinforced by the continuous presence of voice-over commentary.

The film's dramatizations and tableau scenes further contribute to its ekphrastic character—to, that is, the use of one art to describe, comment on, and even to inscribe another. Ekphrasis gives life to the film's reading of Rembrandt's painting by couching it in a detective narrative: the fiction that unifies its scenes is that Rembrandt has been accused of falsely indicting the militia. To this end the film's central strategy is that of investigation. The Law enters the film when Greenaway posing as prosecuting attorney cross-examines the witnesses in Rembrandt's case, in particular Rembrandt's wife Saskia and his students, Ferdinand Bol and Carel Fabritius. These and others who serve as "witnesses" look straight out of the camera at the film's spectators who—it's suggested by virtue of our position before the screen—then serve as jury. As "evidence" in the case, Greenaway uses citations from his fiction film, *Nightwatching*. *Rembrandt's J'Accuse* thus drives home Greenaway's reading of the murder mystery at the center of the painting, taking the pedagogical stance of a documentary. The film makes a plea not only for an elucidation of the conspiracy inscribed into Rembrandt's painting, but more broadly for the greater visual literacy of all beholders and spectators, arguing that the public's inability to read images is the explanation for our "impoverished cinema." Centrally, then, Greenaway's reading of the visual intricacies of Rembrandt's *Night Watch* is meant to model the activity of reading images for his spectator.

The making visible of painting takes place directly in a film: in *Rembrandt's J'Accuse* there is a play between showing the painting's parts—details in close-up—and revealing the whole of *The Night Watch* in medium or long shot. Here Greenaway's strategy differs from that of other art documentaries, which tend to withhold the *whole* of the art work from the eye of the spectator

even while the camera caresses its surface and reveals its details in close-up. Such films prefer the control over the painted image that its piecemeal revelation gives them. Not revealing the whole of the work—not revealing its edges, its frame—brings painting and film closer together, it undermines the idea of painting as a framed art, and suggests that painting too, has the "limitless realism" that André Bazin admires in cinema.[53] In Greenaway's film, however, the lure of the image is heightened by a strategy of veiling and unveiling the work, showing the whole and then showing its parts, a form of control that fuels spectatorial desire.

Greenaway's voice comments on Rembrandt's painting, a formal feature of his film that also serves as an ekphrasis, an "aural inscription" by another art form. His voice-over explicates, interprets, imposes a point of view over the images of the film: language creates a discursive frame around the painting's images as well as the film's own. To give structure to the film, Greenaway resorts to his characteristic strategies of cataloguing and enumeration: the film assigns numbers and titles to the "mysteries" Greenaway discovers in Rembrandt's painting—primarily art historical mysteries that he is only too happy to elucidate. The superimposition of numbers and titles on the film's images are acts of inscription typical of ekphrasis. The idea of a mystery encoded by painting already occurs in *The Draughtsman's Contract* (1982), where the reading of drawings whose content has been engineered leads to the entrapment and ritual murder of the draughtsman who made them.

The logos dominates the image not only in Greenaway's voice-over, but as writing, such as when the titles of each "Mystery" are inscribed in red letters on the image, and it enters the film by way of the text bar that runs from left to right and back again across its images. Written in a florid script, one of Greenaway's characteristic lists covers the text bar: it spells out the names of the famous—artists, scientists, politicians—who have beheld Rembrandt's painting over the centuries. Another relation of sound to image is resorted to in this sequence as a female voice reads out the names: here word and image are an amalgam, since her voice supplements rather than interrogates the image.

At the same time, however, a disjunction between spoken word and image—or spoken word and ambient sound—produces different foci of interest, splitting spectatorial attention. The soft female voice reciting the painting's list of beholders does battle with the sound of police sirens over the images of contemporary Amsterdam, heavily manipulated by windowing, with which the film opens and closes. Soon the female voice recedes into the distance and the male voice—Greenaway's—dominates the film text. By way of these visual and verbal signposts, then, the film exposes the "social structure of representation as an activity and a relationship of power/knowledge/desire—representation as something done to something, with something, by someone, for someone"[54] that W. J. T. Mitchell reads as characteristic of ekphrasis.

This brings us to the film's textual layering, to the superimposition that is the hallmark of Greenaway's style in this art documentary. Against the

opening images of the street outside the Rijksmuseum, Greenaway tells his audience that the museum is "currently the scene of a shooting" when the sound of a real shot provokes the camera to track into Rembrandt's painting, next to a tableau vivant based on it, then to a graphic design of muskets, and finally to the real painting displayed inside the museum. The images of the city act as a frame for Greenaway's interpretation of the painting, a frame that opens and closes the film, anchoring his reading of the painting in a present in which police sirens, never commented upon by the voice-over, create an agitation that is unresolved and whose origin remains unknown. But instead of commenting on the street scene, Greenaway carefully invokes the historical frame of Rembrandt's painting: the visit of Marie de Medici, exiled Regent of France, to Amsterdam. In the film, de Medici's visit to Amsterdam provides an occasion for a montage of details of paintings by Rubens, who had often painted her as a classical heroine. But Rubens wasn't considered suitable to paint the Amsterdam militia, Greenaway as art historian tells us, because Rubens was Catholic. Hence the Protestant Rembrandt was hired instead.

In his reading of *The Night Watch*, Greenaway takes care to establish the connection of Rembrandt's work to the Italian style of history painting, something he also does in *Nightwatching*. In Mystery #8, "The Italian Connection," he informs us that while Rembrandt did not wish to travel to Italy, Italy came to him in the form of prints of work by the Italian masters. Indeed, this sequence is of central importance in the film: here Greenaway argues that Rembrandt satirized and pastiched the Italian style, using details from several of Rembrandt's mythological paintings as "evidence" of his mockery of Italian art. As the film camera travels over these images, Greenaway's voice-over comments on "the Italian land of sudden treachery," calling it a land of "vicious assassination." Here the film uses a staged scene from *Nightwatching* in which it's claimed that assassination "is not the Dutch way." "Or is it?" asks Greenaway. "Was Rembrandt being prophetic?" This loaded question serves as a segue into two quick images from recent Dutch history—one of the assassination of Pim Fortuyn, in 2002, of whose bleeding corpse the film includes a photograph, and one of Theo van Gogh's assassination in 2004. Here art documentary becomes something else entirely, a document of another kind, as the film becomes a vehicle for history and political sentiment. Indeed, these inclusions make sense of the seemingly arbitrary police cars in the film's opening and closing frames and call up the spectatorial anxiety occasioned by their blaring sirens. Perhaps the murder that Greenaway's film is really intent on bringing to our attention is not the imputed assassination of Hasselburgh by the members of the Amsterdam militia that Rembrandt's history painting is seen to represent, but rather the more recent assassinations of Fortuyn and van Gogh. I suggest that Greenaway's call for the spectator to learn to read images doesn't only refer to the images of painting, but also refers to the images of film, in particular to those of this film.

To clarify Greenaway's intention, the film displays the famous image of Zola's open letter printed on the front page of the Parisian newspaper *L'Aurore*, the letter by which Zola risked his career in order to defend Dreyfus. As is well known, Zola's accusation of the French army and the government hinged not only on their obstruction of justice, but on their antisemitism, and he wrote his letter in hopes that he—Zola—might be prosecuted for libel so that new evidence in the case might come to light in his trial. And in fact, the inclusion of the newspaper page in the image track of the film occurs at a telling moment within it, in Mystery #32: "Rembrandt's Self-Portrait." This begins with a scene from Jacob de Roy's accusation in *Nightwatching* concerning the self-consciousness promoted in the painting by the inclusion of the artist looking out. "Why does Rembrandt include an image of himself in *The Night Watch*?" is the question posed by de Roy, and in *J'accuse* Greenaway asks why Rembrandt should be content with this "Hitchcock walk-on role." Referring to the many paintings in which Rembrandt included his own image, Greenaway suggests that in such paintings Rembrandt serves as a witness to the represented scene. By way of these inclusions, Greenaway argues, Rembrandt also sets himself up as prosecutor and provider of evidence while we, the painting's beholders, serve as witnesses, even as jury. It is at this point in the film that Zola enters the discussion as the writer who made "an entirely fearless accusation." The link between Rembrandt and Zola in the voice-over is Hitchcock: in other words, the link is cinematic. Then comes Mystery #33: "Jacob de Roy." Greenaway, whose speaking head in windowed space throughout the film is dressed in a black suit, suddenly—and briefly—appears in the costume of de Roy, in a red ruff and cloak to which his voice-over draws attention. "Is he trying to tell us anything?" Greenaway asks, and again he responds to his own question: "He asks the spectator to unravel the plot . . . his eyes to our eyes." Wearing de Roy's red ruff, Greenaway looks straight out of the film's windowed space at us, its spectators.

I suggest, then, that the passion that fuels what is in many ways a remake of *Nightwatching* in a more modern idiom is not that of unearthing and laying out the subtext of Rembrandt's painting yet another time, rather that it has everything to do with Fortuyn and van Gogh, both of whom were assassinated because of their public expressions of anti-Muslim sentiments. Fortuyn's case is the more politically confusing: as is well known, he was in early life a Marxist, then a Liberal, then founded his own party and was accused of harboring nationalistic right-wing sentiments by advocating that the Netherlands change its immigration policies to bar Muslims from entry into the country. His argument, Fortuyn claimed, was made in order to protect the liberal policies of the Netherlands; his own gay identity, which he flaunted, was decried by Muslim clerics in discriminatory terms. During a televised debate with one cleric, Fortuyn turned to face the camera directly and denounced the cleric as a "Trojan horse of intolerance." Here is the straight look out at the camera and spectator manifested by Rembrandt, de Roy, and Greenaway.

As is well known, the filmmaker, producer, and writer Theo van Gogh was the great-grandson of Vincent van Gogh's beloved brother Theo, the art dealer. The last film that van Gogh released before his death was a fictionalized film about Fortuyn called *The Sixth of May* (*06/05*), but it was probably not this film that precipitated his death. That was almost certainly the ten-minute short called *Submission* on which van Gogh had collaborated with a Somali-born woman, the writer and would-be politician Ayaan Hirsi Ali, a film highly critical of the treatment of women in Islam, a film in which the naked bodies of its four characters are covered in texts from the Qu'ran—a formal device that must have intrigued Greenaway, considering his strategy of inscribing the body in *The Pillow Book* (1996). Van Gogh did not take the threats on his life seriously and therefore chose not to go into hiding. He was assassinated in a particularly gruesome manner: for one thing, a knife with a message threatening Hirsi Ali was left in his body.[55]

In *Rembrandt's J'Accuse*, I am arguing, Greenaway participates in Fortuyn's and van Gogh's indictment of Muslim illiberality, but is unwilling to do so openly, perhaps for fear of his life. He does not take the direct route of Zola's *J'Accuse*; this film does not adopt the mode that Greenaway calls Zola's "fearless accusation": it resorts to the strategy of the encoded message. Reading for the shared themes of assassination and murder and bringing those crimes to light is the task that Greenaway takes on and encourages in his spectator. By modeling image-reading, Greenaway urges the spectator to unravel his film's interest in assassination in the Netherlands, more particularly the assassination of image maker Theo van Gogh, who also made a film about an assassination. In fact, Van Gogh's film reads a political conspiracy around Fortuyn's death similar to the one that actually did surround the Dreyfus case, which like the two recent Dutch assassinations was also a matter of religious discrimination. This mise-en-abyme constitutes the subtext behind Greenaway's pedagogical attitude in the film, the reason why he exhorts the spectator to acquire "visual literacy," to learn to decipher images. When Greenaway is costumed as de Roy he is indicating that we are actually watching *Greenaway's J'Accuse*. Is it violence against persons in general that's at stake for Greenaway? Or is his accusation—like Fortuyn's, like van Gogh's—also an accusation against militant Islam? Fortuyn's assassin was a liberal Dutchman and van Gogh's a militant Muslim, so it's difficult to say which political position Greenaway favors, although, with another intertextual reference, Abel Gance's *J'Accuse*, in mind, we can surmise that it's senseless killing that Greenaway opposes. From a formal point of view, this film's direct address of its spectator is a variant of the strategy promoted by the Dutch artistic volition of (fictionally) including a painting's spectator—an implied spectator—in its dramatic tableau. But in *Rembrandt's J'Accuse*, not only is the real world brought into the space of film, but the film's ekphrastic and pedagogical character directs us back out into our own reality.

Fruit seems to spill out of the painted bowl in Nicolas Poussin's *Midas Giving Thanks to Bacchus*, bleeding into the space of the film. *The Bitter Tears of Petra von Kant* (R. W. Fassbinder, 1972), frame enlargement.

Chapter 3

Frame

Unframing the Image: Theatricality and the Art World of *Bitter Tears*

Why is a painting framed? Not so much to emphasize its composition as to mark off its space as separate from that of the natural world it inhabits. So argues André Bazin—perhaps a reader of Kant—in an essay called "Painting and Cinema." It's the "discontinuity between the painting and the wall"— between painting and reality—that is at issue.[1] Hence the prevalence of gilded frames, writes Bazin, frames whose primary quality is their ability to reflect light, their luminosity. As Bazin sees it, the frame offers us its contents as a space of contemplation "opening solely onto the interior of the painting."[2] For Bazin painting shares with theater its concentration on a contained space: in both instances, a centripetal force directs the attention of the spectator inward. In this, painting differs from the cinematic screen, whose edges simply mask the reality that extends beyond it. What happens, then, if the film camera reveals the interior of a painting to our view—shows us the painting without its frame, rendering its world continuous with the world of the film? For Bazin a painting without borders disorients the spectator since its images are assimilated into the space of the greater, "picturable" world, blurring the space of the constructed world with that of the real one. Sometimes film takes this technique to extremes: Bazin's example is Alain Resnais's *Van Gogh* (1948), a film in which the painter's canvases constitute a landscape over which the camera travels as though it were the real world. The film camera transports the spectator up to a painted window of Van Gogh's house on the Rue d'Arles, then tracks back from a window "right up to the bed with the red eider-down."[3] Somewhat surprisingly, Bazin doesn't criticize Resnais's treatment of the painted image as a filmic one. Indeed, he describes it by means of an organic metaphor: "The film of a painting is an aesthetic symbiosis of screen and painting, as is the lichen of the algae and mushroom."[4] It's a parasitic relation, in other words, but there are models for it in nature.

How interesting, then, that when Fassbinder's *The Bitter Tears of Petra von Kant* (1972) makes use of Poussin's *Midas Giving Thanks to Bacchus*, it is in a cropped, frameless, and vastly enlarged version that covers one whole wall of the set. It is, in fact, wallpaper—it's mass-produced, a copy that invites our

amused and ironic viewing. Poussin's actual painting, of course, is a tableau, "a pure cut-out segment with clearly defined edges, irreversible and incorruptible," as Roland Barthes claims in common of pictorial, theatrical, and literary tableaux.[5] A tableau is a scene that has been laid out—mise-en-scène—to represent the pregnant moment, the telling instant. Barthes refers his reader to Denis Diderot, who likewise equates theatrical with pictorial tableaux. In a post-Brechtian theater or a post-Eisensteinian cinema, Barthes suggests, when the tableau's composition is altered, its meaning will be of another kind. The tableau is susceptible of corruption—of cropping. And why shouldn't it be? As we shall see, in Fassbinder's film Poussin's painting as wallpaper nevertheless bears the weight of several meanings.

Abandoning Poussin's sense of scale, Fassbinder's wallpaper magnifies the size of Poussin's figures with respect to their beholders, while the cropping to which the tableau's been subjected increases its proportion of human flesh. Poussin is in danger of becoming Rubens. Cropping has effected another change, as well, with Dionysos's male member replacing the tension between two gestures that is at the center of Poussin's painting.[6] The dramatic poses of the painting's figures—to which their gestures are integral—find their way into Fassbinder's film. It's a theatrical film, composed as if to conform to Diderot's claim that a well-made drama is a succession of tableaux moments and that paintings in the manner of Greuze are mute theater. Time and again the poses assumed by the film's actors refer to the figures on the wallpaper. What does it mean to say that there's no frame to separate what's intrinsic to the work from what is extrinsic to it when the boundary between artwork and the world of the film is in so many ways transgressed? Diderot, we recall, suggested that visitors to the Salon hide the frames of paintings they viewed by means of a mirror "which takes in the field of the painting and eliminates the border."[7] Blurring the border between reality and representation is as much Diderot's goal as blurring the boundaries between the genres. Similarly, in *Bitter Tears* the lack of frame around the Poussin reproduction promotes its continuity with the theatrical world of the film. And while Poussin himself was an advocate of the literal frame, Arnheim argues that although "the power of the center" organizes Poussin's compositions, in his work "framed space is not quite closed, making the painting appear to continue beyond the frame in all directions."[8]

Painting as Mute Theater

Let's begin with the painting itself. It's housed in Munich's Alte Pinakothek, hence easily available to Fassbinder for the close scrutiny and focused attention advocated by Bazin. Its mythological subject is taken from Ovid, whose *Metamorphoses* was the source of many of Poussin's drawings and paintings—his

favorite source, in fact, from 1624 when he left for Rome till the mid-1630s.
In a letter to his friend and patron Chantelou, Poussin exhorts him to read his
paintings, to "read the story and the picture, so that you can judge if every-
thing is appropriate to the subject."[9] It is to aid in this process of reading,
to aid in the eye's concentration on the images of the painting, that Poussin
recommends his paintings be framed. Preempting Kant, Poussin insists that
painted images and the things of the world not be susceptible to confusion.[10]
For Poussin, reading a painting means reading the poses and expressions of
its human figures: "A composition is to be studied figure by figure, and each
will express its role in the story exactly, as does an actor on the stage . . . [by
means of] an alphabet of gesture."[11] Here he anticipates eighteenth-century
interest in the theatrical pose.

Judging from the number of drawings and sketches Poussin based on this
subject matter, the story from Ovid that most enthralled him is that of Bac-
chus. The story of Bacchus is Poussin's most frequently featured classical
subject: he created more images of this tale than of the Christian Holy Family.
Midas Giving Thanks to Bacchus, the painting featured in Fassbinder's film,
contains a virtual catalogue of Bacchic images. Poussin's tableau includes
putti playing with goats and a mask that ties this painting to the satyr play
and theatricality, but these are located at the right-hand side of the painting
and are partly cut for Fassbinder's film. The iconographic references that we
do see in the cropped tableau include the drunk and unconscious Silenus
with his jug, an ivy-garlanded satyr playing the pipes of Pan, another satyr
pursuing a phallic snake entwined in the branches of a tree, and a "panther
with dappled skin," as Ovid calls this beast, another of Bacchus's familiars.[12]
Midas is one of the three featured figures in this painting, of course, and in
the middle right-hand side of the painting—cropped for the film—an episode
from an earlier moment in Midas's story is depicted, the moment when he
washes away the golden touch in the waters of the river Pactolus. Bacchus
having granted Midas his second wish—to rid himself of the death-bringing
golden touch—is in fact the reason that Midas is giving thanks. In Poussin's
painting, Bacchus/Dionysos (the names are used interchangeably) is youthful,
Attic, statuesque, modeled—no doubt based on one of the myriad classical
statues that Poussin admired and sketched.

In the cropped version of the tableau that we see in the film, the male
member is near the center of the composition, often accentuated by the film's
lighting, as Lynne Kirby has pointed out.[13] But most likely Poussin's tableau
doesn't find Midas in the posture of supplication, as Kirby argues, but rather
of giving thanks, as the visual anecdote of Midas bathing—cut from Fass-
binder's wallpaper—makes clear. According to Ovid, when Midas saw that
his golden touch would lead to starvation, he begged to be released from it,
which happens when he bathes in the river. Further, the head of Dionysos is
not cropped for the film; he is neither castrated, as Kirby claims, nor symboli-

cally blinded. And while Dionysos is a figure centrally connected with fertility whose ambiguous gender positioning must have held appeal for Fassbinder, there's no indication in the painting that what Midas desires from the god is the god himself. The disposition of Dionysos's arms unifies that group of three figures and, having cropped the scene at the river Pactolus, Fassbinder might very well have intended the reproduction to figure the relation of sex (the bacchante) to money (Midas), as Kirby argues. At the moment represented by Poussin's painting, however, Midas no longer represents greed and will henceforth lead a simpler life in the woods with Pan.

As the art historian Oskar Bätschmann has noted, in Poussin's compositions involving Dionysos there is always a triangular disposition of the figures—a disposition that is prominently featured in Fassbinder's films,[14] where its narrative form is the sexual triangle. In addition to the triadic figural disposition in Poussin, there is the divided nature of Dionysos to be considered. This duality is connected to the god's sovereign sway over the double nature of water, disposing over both its life- and death-bringing potential. In *Midas Giving Thanks to Bacchus*, water is only present in its positive form—it cleanses Midas, thus keeping him alive, but in other Poussin paintings and sketches involving Bacchus—such as *The Birth of Bacchus*, featuring the dead Narcissus—the death-bringing potential of water is emphasized.[15] And when mythographers such as Edith Hamilton stress the double nature of Dionysos, it's in connection with wine as benefactor and destroyer, again suggesting the wine-god's connection with life *and* death.[16]

The Suffering God

But Dionysos doesn't require the presence of the dead Narcissus to be connected with death, as anyone familiar with Nietzsche's *Birth of Tragedy* is aware. Certainly Fassbinder was. Nietzsche's text enriches the choice of painting for his film, enabling the wallpaper version not only to speak of the staged sexual triangle so integral to his films, but to resonate in the filmic text as a commentary on theater and theatricality. It also calls to mind a much darker problematic: Nietzsche sees it as a "matter of indisputable record" that the only subject of Greek tragedy in its earliest forms was the suffering of Dionysos.[17] Indeed, claims Nietzsche, Dionysos was not the hero of early tragedy alone, but for Nietzsche all Greek tragic heroes are "merely masks" of Dionysos.[18] Dionysiac suffering—the *sparagmos* of the god, which dispersed his body into the elements—reverses the individuation that Nietzsche reads as the source of his pain: it is for pain as well as for pleasure that Dionysos, god of wine and sexual excess, originally stood. Of course Midas enters the story as well: as Nietzsche tells it, after Midas captured the bearded satyr Silenus, Midas asked him what the "best and most excellent thing for human

beings" might be. Forced by Midas to speak, Silenus blurts out: "Why do you force me to tell you the very thing that it would be most profitable for you *not* to hear? The very best thing is utterly beyond your reach, not to have been born, not to *be*, to be *nothing*. However, the second best thing for you is: to die soon."[19]

Silenus's forced pronouncement explains the Dionysian impulse for dissolution, which passes through the intoxication produced by wine and music and the loss of identity in the orgy to the ultimate formlessness of death. For the contemporary reader, Freud's *Beyond the Pleasure Principle* resonates in Nietzsche's words. If, then, Dionysos is a figure of mixed modes it is also because he unites pleasure and pain, because for him the pain of individuation is counteracted by an intoxicating pleasure that finds its ultimate satisfaction in death. With more than a suggestion of the psychological disposition we now call masochism, Nietzsche reads Silenus's outburst as "the ecstatic vision of a tortured martyr," suggesting that Nietzsche is thinking syncretistically.[20] Not only the desire for dissolution, but also the desire "to die soon": this is what Fassbinder shared with Dionysos, and it suggests a deeper motive for his choice of painting. As Greek myth would have it, however, says Nietzsche, Apollo reassembles Dionysos after his dismemberment, undermining Silenus's dark desire. Hence Apollo's drive produces art in order to seduce humans into continuing to live, creating the Olympian world of beauty and calm, "the beautiful, semblance."[21] Hellenic, Apollonian optimism, it is argued, counteracts the state of despair in which people finds themselves, prompting them to make art in order to stay alive. Nietzsche mentions two kinds of art in particular: those that feature the sublime and tame the terrible, and those featuring the comical, which dissipate disgust. And finally, according to Nietzsche, in the Greek art world the gods are split into two groups, with a few gods occupying a position in between, at times sublime and at times comical. "Above all," writes Nietzsche, "Dionysos himself was given this divided character."[22] In Nietzsche's reading, the ambiguity surrounding Dionysos also makes him a figure for mediatic boundary crossing.

As I'll argue, Dionysos as interpreted by Nietzsche serves as a central figure of identification for Fassbinder, not least because he is the god of intoxication, and not least because he is the god of pleasure-pain and the death drive. Humankind's struggle to live with the knowledge of life's absurdity, qua Nietzsche, produces an art that combines the sublime with the ridiculous into a tragicomical work—a work not unlike Fassbinder's *Bitter Tears of Petra von Kant*, over which Poussin's Dionysos presides. Melodrama and ironic humor amid allusions to Greek tragedy: what mix better describes *Bitter Tears* than tragicomedy? Placing Dionysos on center stage, the cropped wallpaper mural of Poussin's tableau is adequate to its task. In addition to underscoring Dionysos's role as the suffering god, we must ask, what other ends are served by this film's deliberate emphasis on classical theater and its appropriations?

Inside the Theater Box: Camera, Movement, and Pose

Covering an entire wall of the film's set, the Poussin reproduction does double duty as wallpaper (complete with seams) and as stage scenery, a backdrop for the exaggerated theatricality of the film's characters. First a play and only later a film, *Bitter Tears* appropriates the classical conventions of theatrical staging as a backdrop for bathos and melodramatic display: the unity of place is reflected in the womb-like enclosure of Petra's loft. The action takes place in Petra's (Margit Carstensen) bedroom, with occasional excurses into the workroom in which Marlene (Irm Hermann) is the primary actor. The setting seems hermetically sealed: a look through a hall window reveals a second window that channels our look back into the bedroom. The film's division into acts, most often signaled by fades, is emphasized by periodic changes of wig and costume. High-heeled shoes in close-up performing a pas de deux of sorts are reminiscent of the high *cothurnus* worn by actors on the Attic stage. Costumes tend to have a metaphorical function in relation to the action: when, for instance, Petra has been "made a fool of" by Karin (Hanna Schygulla), she is dressed in a feminine version of fool's motley, while on another occasion Petra wears the leather and metal evocative of sadomasochistic sexuality. While not strictly observed, the unity of time is suggested in the symmetry of beginning and end, since the film begins with Petra waking in the morning and concludes six months later as the light is turned off at the end of a day. The oppressive closure of set and plot is reinforced by 1950s records on the turntable, whose songs punctuate and underscore the action, ironic stand-ins for the Attic chorus. Exaggerated makeup substitutes for the mask of Greek tragedy; the German word *Maske* means both. Theatricality resides not only in these quasi-parodic references, however, but also in the studied poses and the slow, ritualized movements of the actors: this film resorts to pantomime and gesture in a manner worthy of the eighteenth-century stage.

The theatrical posing of bodies was also a central concern for Poussin. In order to ensure that his painted human figures were in proper perspective—that they were "true to nature" and formed a harmonious scene—Poussin resorted to what was called a *grande machine*, sometimes called a perspective box, a contained scenographic space or "theater box." It comprised a platform or stage marked out in squares and with a painted backdrop, situated within a box closed on all sides. Three sides of the box had apertures through which lighting effects could be deployed, and it was equipped with a viewing hole that allowed the artist to survey the scene. In other words, Poussin created a device that resembled a peep show of a model theater. On its stage Poussin placed nude wax figures in a tableau arrangement, figures positioned amid architectural structures and landscape flats and on a kind of stage.[23] Poussin then clothed these figures in paper or taffeta, and attached strings to them that allowed them to be manipulated in the manner of marionettes.[24] Clearly, Poussin's theater box served the study of gesture and pose as much as it aided

perspective and the study of light and shadow. While similar devices were used by artists in the sixteenth century—especially in Rome—Blunt writes that they were generally out of fashion by Poussin's time, so that Poussin's *grande machine* and the theatrical model for history painting that derived from it seem very much a conscious choice.[25]

Is it a coincidence that in its penultimate act the central space of Fassbinder's film is exposed as a theatrical space, a kind of theater box without a fourth wall? Granted, the film originated in a play and belongs to the chamber play tradition explored by Weimar cinema. But it also features naked mannequins arranged in poses that comment on the actions of the actors. Indeed, these mannequins are "clothed" with fabric during the course of the film, and frequently repositioned by some unseen puppeteer. Perhaps Fassbinder, struck by Poussin's painting in the Alte Pinakothek, did some reading that led him to Poussin's *grande machine*—his theater box—and asked himself what it might mean to use such a model for film. Of course, the more likely explanation is simply that the film is a chamber film. For whatever reason, the mise-en-scène of *Bitter Tears* is a plausible result of meditations on Poussin's method of working.

In making the film, the only material Fassbinder added to his play is the opening credit sequence and the conclusion of the final scene. But the film centrally features the camera, brilliantly deployed by cameraman Michael Ballhaus to emphasize its movement and acts of framing: its spatiality is primarily filmic, not theatrical.[26] It has often been noted that the camera is virtually a character in *Bitter Tears*: tracking and zooming to mark out the film's spaces, it's the dynamic presence in a mostly static film. The camera's eye thus frames and reframes what is seen. The film's prominent camerawork addresses the cinematic frame as constantly shifting—or, Gerald Mast writes, as "an operation, a process, wandering, roaming, masking, sighting, covering, focusing, shooting."[27] As the film opens, the camera focuses on a black cat and a pale Siamese sitting on steps that lead down to Petra's bedroom. The camera stays low—at knee level, perhaps—to record the movements of the cats as they groom and scratch themselves. The cats' movements and actions will be almost the only ones in the film that are natural, although the cats, too, will be retrospectively co-opted for art, since they suggest the complementary opposites that the same-sex characters will show themselves to be, suggest the "cat fights" that will constitute the film's action—and, in a comically ironic sense, point to the leopards and panthers in Dionysos's entourage. The camera holds on the cats throughout the credit sequence, at the end of which it moves away from the stairs, films the wall at lower than waist level as it moves around the corner, angles across the Poussin wallpaper to reveal the brightly lit bacchante, and then shoots Petra lying on the bed. Dressed in a white nightgown, pale face bare of makeup, Petra reclining on her bed is the mirror image of the white bacchante. And there is a filmic reference here, too: since Petra's face is striated by light that enters through Venetian blinds

and, given the obtrusiveness of camera movement and the voyeuristic look it engenders as it moves into the bedroom, the films of Alfred Hitchcock are fleetingly evoked.

After the initial tracking shot that launches the narrative, the camera seems tentative about its reframings in the first act, sometimes altering its position by only a few degrees. When in this act the camera in close-up fixes on the un-made-up face of Margit Carstenson as Petra, a facial close-up that is inherently filmic, it is one of the few moments the camera is used to record bare flesh—her naked face is another of the few bits of reality unmarked by artifice in the film. Soon the camera will focus on Petra's face as doubly aestheticized—as a reflection in an oval mirror with a gilded frame, already portraitized in the mirror of art—and as a face in the process of being made up, painted. Further, in a signature shot for Fassbinder, the camera tricks the spectator when it seems to be trained on a primping Karin, with Petra entering the frame. For when the camera moves laterally, it reveals the "real" Karin and Petra, acknowledging the previous shot to have been a mirror shot in the manner of Douglas Sirk. Does the mirror shot suggest that Karin's narcissism is the source of her relationship with Petra? Certainly it concerns illusion, since it blurs the boundaries between the "real" image and the reflected one. Particularly in this act, the camera's tracking calls attention to the use of multiple mirror shots that—similarly to Diderot's mirror mentioned above— function to blur illusion with diegetic reality, unsettling the spectator's relation to film space.

At the same time, however, it is suggested that the camera is in some sense embodied. Stalking its prey in this essentially static film, the camera reminds us that the essence of film is movement. And in this film of arrested gestures and poses, the camera marks out the space of the film by tracking repeatedly between Marlene's workspace and Petra's bedroom. Ostentatiously establishing lines of force between these two characters, in one sequence it pans and zooms to Marlene, with Petra going out of focus. When it immediately reverses this movement, with Marlene in rack focus, the camera points to their interdependence and doubling by specifically cinematic means. Thus the camera's eye establishes structural and thematic connections, again recalling the use of the camera in Hitchcock. Amid the arrested gestures and poses of the actors, the camera seems more alive than they are. It lurks in Petra's workspace, peering out from behind the beams that divide it from her bedroom, framing actors and mannequins alike. Indeed, here the camera is unnaturally low, shooting as if from the point of view of someone seated as it tracks across the mannequins from behind, at the level of their lower backs. More than once a waist-high horizontal beam marks the bottom of the film frame. Instead of the expected cut following an over-the-shoulder shot, the camera tracks across a character's naked back to focus on her respondent. In thus calling attention to its unusual movements, the camera dislocates the spectator.

Indeed, it "deframes" the spectator, as Pascal Bonitzer might put it, precisely at the moments of greatest attention to framing.[28] On one occasion the camera is positioned between two beams forming a thick frame that radically restricts its point of view. Repeatedly the camera's emphasis on framing is accentuated and reinforced by the wooden beams that divide the loft. The camera's framings continue to be emphasized by the set's wooden beams in the third act, where one such instance in particular is worthy of attention. Here Karin in the distance leans against the Poussin tableau, with a beam dividing her image from that of Petra, whose reclining body in the foreground is confined to a rectangular space. The horizontal composition that contains Petra's body places her in the position of the bacchante, while Karin's vertical form allies her with Dionysos. More importantly, however, with a horizontal beam dividing the women, the compartmentalization of spaces within the film frame collapses the depth effect of the image and denaturalizes Petra's figure, making it seem two-dimensional, while Karin's, posed against the Poussin wallpaper, appears three-dimensional. By way of the interior framing performed by the beam, two forms of spatiality coexist in the same film frame. (See also chapter 1.) Suggestive of the abstraction we find in modernist cinema, this moment calls attention to *Bitter Tears*'s modernism. Interestingly, the Poussin reproduction is not on view again until the end of this act, and then it functions only in the most conventional way. Reinforced by internal framing, the film frame itself has become the place of art, taking the place of painting.

Then, during the fourth act, the space of the film is radically altered. While it (like most of the action) takes place in Petra's bedroom, all furniture has been removed from this space so that it is more completely dominated by its Poussin wallpaper than ever. In one sense the floor of the bedroom is now a theater stage, comically covered in the white shag rug that renders three-dimensional—materializes—the goat of Poussin's painting, whose hind end is visible in the reproduction. But there is nothing to separate this stage from our space—no Bazinian footlights divide this theatrical space from that of the real world. Cleared of all furniture, the rug forms a foreground for the images of the Poussin, suggesting the space that T. J. Clark has described as "certain complex, imaginary lit space, from which we look back at the picture in front of us, feeling ourselves part and not part of it—this is what painting, for Poussin, most deeply is."[29] But Fassbinder's film goes further still. Throughout the sequence the room's emptiness enables the camera to be at floor level, allowing for remarkable examples of blocking and framing. In one such moment, Petra's friend and daughter are posed in front of the Poussin, with her mother's shoe in extreme close-up at the front right of the frame, near Petra's supine body.[30] The mother's shoe and skirt are coterminous with the right-hand edge of the film frame—suggesting part of the theatrical proscenium arch. The strategy of interior framing we observed earlier in the film is no longer operative.

Indeed, this penultimate act of *Bitter Tears* is shot so that the beams no longer appear and the film is in several ways unframed. By way of the creeping, floor-level camera that produces the spectator's point of view, the white shag stage is not only a foreground for painting. Shot at floor level, the close-up of the rug figuratively suggests that the spectator has entered this intermedial space—a hybrid of the painterly, theatrical, and filmic—like Diderot fictively entering the space of painting, walking through the landscape paintings he describes. Here theatricality in Michael Fried's sense takes the modernist form of breaking the fourth wall, figuratively rendering the screen permeable, extending spectatorial space into the space of representation. Now let us recall to mind Bazin's contention that an unframed painting bleeds into the real world—it is by this means that Fassbinder most emphatically suggests a fusion of picturable world with picture. We the film's spectators take our place among the other bodies, as though ours were the bodies toward which the painterly, sculptural, and cinematic bodies had been gesturing all along. The immersive space thus created is an intermedial space.

It is at this moment in the film that the diegetic songs of the 1950s are replaced by an extradiegetic tenor singing Verdi. The introduction of opera into the film does not simply amplify the exaggerated theatricality of this scene; it is not merely a moment of high camp. The aria from Verdi serves to underscore the coming together of representational systems that, according to Nietzsche, constitute opera, once again referencing *The Birth of Tragedy*, where the fusion of representational systems—the Apollonian with the Dionysian; the world of semblance, of the image, with that of sound—produces the *Gesamtkunstwerk* that is Wagnerian operatic theater. As we have seen, however, fusion is not the representational principle that Fassbinder espouses. His intermedial text—unframed—lets its multiple representational systems show.

Parerga: Unframed Again

The Bitter Tears of Petra von Kant is a veritable discourse on framing, unframing, and reframing, both in contrast to and as a reminder of the mobile and changing film frame we often disregard. Such moments suggest that Fassbinder's film is both *of* Kant—"von Kant"—and different *from* Kant— "anders als Kant." It has been famously written of Kant's *Third Critique* that "the whole analytic of aesthetic judgment forever assumes that one can distinguish rigorously between the intrinsic and the extrinsic, between inside and outside."[31] At the liminal point between inside and outside, participating in both, are Kant's *parerga*, of which he gives three examples: the clothes on statues (recall the mannequins), the columns on buildings (recall the beams of the loft), and the frames of paintings. At the point in *Bitter Tears* when inside and outside flow into one another—at the point of its greatest theatricality—it is not André Bazin with whom the film takes issue.

For Kant, the subjective element in a representation—the element that must be exorcised—is "the pleasure or pain which is bound up with it."[32] Fassbinder's film asserts the contrary. The film transforms Poussin's painting into reproduced wallpaper that is *figurative*—not the wallpaper-as-design, "the delinéations à la grecque" of which Kant approves as "free beauties," since they "represent nothing."[33] The figures in Poussin's painting are *reframed* by cropping and then enlarged in a manner that undermines Kantian disinterestedness by emphasizing the flesh. In *unframing* the reproduction Fassbinder emblematically undermines the detachment that Kant mandates for the spectator of the work of art. Rather than excluding affect and desire from aesthetic response—which for Kant the frame of a painting does when it marks off aesthetic space and separates it from the space of the world—the act of *unframing* makes the mutual permeability of art and reality possible. In admitting desire into aesthetic response, Fassbinder significantly allies himself against Kant with Nietzsche and Artaud, two of his central figures of identification.

A brief reference to another painting by Poussin is in order, an additional frame for my argument, a *parergon* with a connection to the inside of this essay, though gesturing outside it. In 1650, at the behest of Chantelou, Poussin reluctantly painted a self-portrait as a gift for his friend. This self-portrait of 1650, at the Louvre, is a veritable discourse on framing. While a gilded frame contains this painting as it hangs in the museum, the several canvases it depicts behind the self-portrait of the artist are in various ways incomplete, unframed. Directly behind him there is an unpainted—though inscribed—canvas with most of its frame obscured, leaving the painting "open" at the right. Behind it there is a rendering of a woman embraced by male arms. She is most often read after Bellori as the figure of Pittura embraced by the artist—as an allegory of painting. Cropped in Poussin's portrait, this painting dramatically gestures toward a space on the left not visible to us, a space that contains that figure. Behind this canvas there's yet another painting, of which we see only a small portion of the frame. And behind them both is either the recto of a large canvas—as some have read it—or a door, as others have claimed. In either case, Poussin's self-portrait includes the suggestion of a space behind—either a place where one might see the front of the averted canvas, or a door through which one might pass. As to the space in front of the figure, with Poussin looking out of the frame, it is figured as coextensive with spectatorial space. Unframed, theatrical, Poussin asserts his bodily presence. Approaching the status of trompe l'oeil, Poussin's body suggests that it is real, present to his friend Chantelou—and to us.

Posing; Poseurs

When the Poussin reproduction is a source for the multiple poses assumed by the film's characters, the film suggests that it functions as a tableau vivant,

an embodiment of painting by human actors that is the meeting point of painting, theater, and sculpture. Since the pose involves a suspension of movement, it suggests an uncanny sense of their lifelessness—even *objecthood*—that links the actors to the world of the dead. And while the variously bonded women of *Bitter Tears* dominate the scene, they are not its only poseurs: the mannequins arranged variously in the spaces of the loft are also bearers of the pose. They are naked, with breasts but no other sexual characteristics, and while the eyes are marked on these sculptural figures, they are as sightless as those of classical statuary. Just as the film's actresses mimic the poses in Poussin's tableau, so the mannequins are placed in postures that both mime and comment on those of the actors. Linked in an embrace, they mirror the lovers Petra and Karin; as models for Marlene's sketches, their blank eyes appear to be watching her. When Petra stands, unmoving, near the record player during her date with Karin, there is a mannequin in the background, similarly posed. Like the wax models deployed by Poussin for his scenographic "theater box" or diorama, they are covered with fabric draperies by the designing Marlene, and in one sequence they are given false eyelashes and wear lipstick. Like the actors, they are positioned in tableaux whose changing scenarios gesture toward a director as puppeteer. Who positions these human but immobile figures? Who arranges their appendages to comment on the action? When Petra, at a time of extreme desolation, is made up to resemble the expressionless mannequins, it becomes clear what is at stake. Both the human and the manufactured figures play out the relations between subject and object, with moments of abjection suggesting a merger of the two. The issue of identity formation takes center stage.

But the mannequins are not the only diminished, uncanny images of the human figure. In *Bitter Tears*, dolls also have a role to play. The camera often rests on two dolls decoratively balanced on the beams that divide bedroom from workspace. Suggestive of Kleist's essay on marionettes, these props likewise evoke themes of manipulation. The dolls speak poignantly of childhood scenarios; like the mannequins, dolls "exemplify the iconic suspension of . . . temporal laws," writes Gaylyn Studlar,[34] while for Susan Stewart dolls embody "the still life's theme of arrested life."[35] Yet motion is involved: again the hand of an unseen puppeteer makes itself strangely felt, since the dolls are moved, their clothing changed, and a third doll is added to the original two during the course of the film, underscoring their relation to the actors and mannequins by way of the arranging hand that disposes over all.[36] The role of the doll as a vehicle for expression and manipulation—as *Puppe*, or puppet—is most apparent in the fourth act, when Petra is given a doll that noticeably resembles the lover who has definitively left her. While the gift signals that Petra has been toying with Karin, its darker suggestion is that Petra use the doll as a substitute for the woman—as a sex toy, a fetishistic prop in some erotic scenario. The gift of the doll is what precipitates the manic breakdown in which Petra, threatening suicide, is both the drunken bacchante and Dionysos as dying

god. The white shag rug—now become the goatskin of the scapegoat and of sacrifice—underscores the mock martyrdom Petra is enacting.

With respect to the erotic significance of the doll in *Bitter Tears*, another cultural reference has a role to play: Hans Bellmer's nearly life-size female doll arranged in pornographic and sadistic tableau poses. In 1934 Bellmer published photographs of this doll in Germany in a book made for private use (*Die Puppe*); in 1936 the book was translated and published in Paris as *La poupée* by Editions G.L.M. By 1936 Bellmer had met the Surrealist André Breton and the poet Paul Eluard, whose story of a girl who dreams about her double was inspired by and illustrated with Bellmer's photographs.[37] A second, ball-jointed doll constructed by Bellmer in 1935—resembling, in fact, those used by artists such as Poussin—became the subject of photographs published in *Minotaure* (1937) and *Les jeux de la poupée* (1947). Although it is likely that Bellmer was already inspired to make his first doll by the life-size doll Kandinsky carried around with him, provocatively and accurately called "Fetish," a performance of Offenbach's *Tales of Hoffmann* in 1932 also influenced his project. Significantly for *Bitter Tears*, the second, ball-jointed doll was made after Bellmer saw a display of articulated artists' mannequins, ca. 1520–30, in a Berlin museum.

Over the years, Bellmer's work appeared in various international exhibitions of Surrealist art, despite—or because of—the fact that it is highly controversial, more in the nature of repugnant pornography than art.[38] Bellmer's photographs of his second female doll are of arranged tableaux evoking the aftermath of sexual assault and violence enacted upon it. Both Rosalind Krauss and Therese Lichtenstein read Bellmer's dolls as evidence of his bigendered position, while Sue Taylor interprets the doll as Bellmer's alter ego, "a form of feminine identification integral to Bellmer's obsessive sadomasochistic manipulations of the female body in his art.[39] In point of fact, Bellmer's feminine identification is reflected in a self-portrait with his lover, the graphic artist and writer Unica Zürn.[40] Bellmer's and Zürn's relationship ended in 1970, when, newly released from a mental institution, Zürn committed suicide by jumping out of the window of their Paris apartment. What significance does Bellmer hold for Fassbinder? Their relation is traceable through Bellmer's liaison with Zürn, one of three artists to whom Fassbinder dedicated his film *Despair* (1977). In 1969 Hans Bellmer made a series of eleven copper engravings illustrating Heinrich von Kleist's essay on marionettes,[41] which would no doubt have fascinated Fassbinder for in *Bitter Tears*, as we have seen, a puppet master is in control. (See chapter 7.)

Unframed Identity: "Marlene Is Not Marlene"

In *Bitter Tears*, there is one shot in particular whose composition points to the citational character of Fassbinder's work. In this shot the camera reveals Mar-

lene with her outspread palm pressed against a window, watching Petra and her friend Sidonie (Katrin Schaake) through its panes and through another window set at an angle to the first. The camera shoots through the two thicknesses of window glass at angles, glass panes that separate Marlene from the women she watches, and from whom she then averts her gaze. Once again, impressions of depth are collapsed, and while Marlene is at two levels of remove from the scene before her, it is suggested that she is in another psychic space altogether. The shot constitutes a determining cinematic allusion: it refers us to the final images of the pretitle montage of Bergman's *Persona* (1966), to the heart-rending view of the young boy who places his hand on vastly enlarged photographic images of two women alternating on a movie screen, women whose relationship is at the heart of Bergman's film.[42] The boy, *Persona* suggests, takes these images to be of his mother, but more importantly, the identities of these women oscillate and merge—they, too, are unframed. By the placement of her hand, the masochistic Marlene, emotionally fettered to her sadistic counterpart Petra, both exposes her vulnerability and seeks to defend against the encounter that she views in Petra's bedroom. The camera holds on the motionless Marlene literally for minutes while the other two women converse: the image of Marlene seems photographic in its stasis against Petra and Sidonie's movements in the background. Importantly, Fassbinder's reference to Bergman is not only formal but also thematic, addressing as it does the issue of unframed identities. By way of this composite image, *Bitter Tears* suggests the multiple maternal images in the masochistic subjectivity that defines Marlene.[43]

As if to underscore its connection to *Persona*, *Bitter Tears* derives other prominent images from Bergman's film. Several times in *Bitter Tears*, the camera rests on the immobile heads of two women—first Marlene and Petra, later Petra and Karin composed to resemble a two-headed woman recalling Bergman, with Karin's blond hair and Petra's black wig announcing their complementary natures. Such images figure the fragility of identity per se, as well as its mutability in the masochistic scenarios we see enacted. In *Persona*, the doubling of the two women is not confined to their emotional bond, but produces the transfer of identity from one to the other. Petra and Karin perform a similar exchange of roles, from dominant to subservient, and vice versa, while the suspension of movement as the pose is held points to the arrested images of the masochistic scene more generally. In fact, the conjunction of black wig with the blond renders the image doubly cinematic, referencing as it does the earliest and best-known lesbian scene in Weimar cinema: Pabst's Lulu as a bride in white dancing with the Countess Geschwitz in black in G. W. Pabst's *Pandora's Box* (1929). But the film's citational character is not postmodern: rather, it is the mutability of authorial identity that is reflected in these multivalent images. In the context of Fassbinder's work the alternating female faces of *Persona* function as emblems of multiplicity.

Questions of identity resonate with the Marlene character. In *Bitter Tears* it is Marlene who pulls the theatrical curtains on the action when she opens the blinds that awaken Petra, and it is she who turns off the lights to close the film. While Marlene is in a relation of extreme dependency to Petra—she is her sexual slave—she is also Petra's "right hand," her amanuensis. In keeping with the film's allusions to the world of classical Greece, Marlene is the hand-maiden who prepares Petra's tea, sketches her design, and types her letters. A designer, a "director" who opens and closes the production, and a writer as well: Marlene is in control of all modes of representation, very much like Fassbinder himself. But she is not simply his stand-in: typically in this theater of oscillating identities, Marlene is also his opposite, figuring the mutuality of sadist and masochist. In the film's opening credits Irm Hermann, who plays Marlene, appears in the featured position—last—where she is credited as one who has participated in a special way ("unter spezieller Mitarbeit von Irm Hermann"). Since Hermann's real-life relationship with Fassbinder is said to have closely resembled the masochistic role she plays, what is implied is that her "special" performance is not a performance at all. Once again a (double) citation is close at hand. Alluding to Flaubert's "Madame Bovary, c'est moi," Josef von Sternberg famously claims of Marlene Dietrich's roles in his films that "Marlene is not Marlene. Marlene is me." But, as usual in Fassbinder films, a triadic relation is suggested as well: the film's dedication to "one who here became Marlene," suggests a lover in real life who is other than Irm Hermann. Perhaps it is for his own benefit as well as that of his ensemble that Fassbinder follows Brecht's suggestion for epic theater that a play (or film) be staged as much to instruct its actors as its audience.

Marlene the character is most centrally a voyeur, seemingly with sadistic as well as masochistic, active as well as passive aims. Pleasure in looking also arises out of masochistic impulses—witness Karin's response to Petra's question about whether she enjoys art: she says she likes movies about love that make her cry.[44] The moment in *Bitter Tears* that most self-consciously addresses the question of voyeurism connects it centrally to sexuality: it is the tableau of two mannequins on Petra's bed locked in an erotic embrace. Above them hovers a third mannequin, positioned as an onlooker, a tableau that makes explicit the erotic aim of such looking. With reference to the plot of our film, this manne-quin represents Marlene. Further, the mannequin threesome expresses the trian-gulation of desire imaged so often in Fassbinder's work, most often represented as an erotic bond between two male characters who share a woman, perhaps most poignantly and destructively in *Berlin Alexanderplatz* (1980). Tellingly, at the moment when Fassbinder himself appears in *Bitter Tears*, his image occurs in a newspaper photograph, positioned between Petra and Karin in a tri-adic composition. Fassbinder remains unidentified in the diegetic conversation about the photo, which was clearly a production still. With the introduction of the director's body into the text, the film's puppeteer is rendered visible.

In one sense, the photograph that contains Fassbinder is the most extreme form of the arrested image to occur in *Bitter Tears* (aside from the Poussin wallpaper), its stasis brought into relief by the modest mobility of the film's characters, mannequins, and dolls. In Bergman's *Persona*, as we recall, the alternating images of the composite "mother" are touched by the hand of a would-be son. But in Fassbinder's film Marlene both reaches out to and defends against the relationship of Petra and Sidonie, whom she sees in Petra's bedroom. Marlene's pose is arrested for what seems an eternity while the two other women converse on the other side of the glass. Marlene and those whom she represents—herself, the real-life Irm Hermann, a male lover of Fassbinder's, and Fassbinder himself—participate both in the figure of the boy who touches *and* in the two images of the composite woman. By way of this deeply troubled and troubling image that gestures toward Bergman, the master of psychological film, Fassbinder discloses the fluidity of identities in which he is caught up. Also disclosed is a dialectic of sadism and masochism, the origin of the pleasure/pain polarity anchored in another figure *Bitter Tears* represents as a static image: Poussin's Dionysos.

Masochistic Theatricality and Metastatic Unframing

Many of Fassbinder's films conform in important ways to a masochistic aesthetic, complete with martyr figures and a mise-en-scène that creates the art world Gaylyn Studlar has emphasized in her work on Josef von Sternberg.[45] (See chapter 6.) The importance of retarding narrative by way of the pose that sculpturally arrests the body links them to this aesthetic—as does their theatricality, which is performative. When Studlar suggests that the rituals of masochistic sexuality are theatricalized so that sexuality's "naturalness" is exposed as a construct, she anticipates some of Judith Butler's arguments concerning queer sexuality. Masochism's theatricality was first noted by Theodor Reik, for whom the masochistic scene "corresponds to the staging of a drama and is related to the phantasies, as is the performance of the dramatist's conception."[46] In his writings, Reik expands the masochistic scenario to include not only its two principal players, but also a third figure, a "witness figure"—or spectator—which is another way to read the figure of Marlene in Fassbinder's *The Bitter Tears of Petra von Kant*.[47] Further, the importance to the masochist of retarding the narrative by way of posing can be read through Reik's understanding of suspense in masochism. Suspense, Reik notes, is often expressed by the patient literally—as *suspension*—in the theatrical scenarios in which the patient participates and whose author he is.[48] This formal feature of masochism recalls the "puppeteer" of *Bitter Tears*, that invisible someone who clothes and arranges actors, dolls, and mannequins—those marionettes without strings.

In *Bitter Tears* the art world connected with the masochistic aesthetic is constituted by way of painting, theatrical devices, sculpture in the form of mannequins and dolls, and its many tableaux shots, themselves fetishistic insofar as they suspend narrative progress. The use of the body as a vehicle in tableaux is itself problematic: the body's very lack of motion enhances its eroticism, its libidinal pull on its beholder.[49] This is certainly one motivation for the posturing that Karin and Petra perform for one another. What for the spectator of Fassbinder's films may translate into moments of tedium as a film's narrative is nearly arrested serves as an erotic lure for its characters. In tableau vivant, the motionless body is the source of titillation produced by an aesthetic illusion that is never complete, that always remains partial: the oscillation between the body of a subject and that same body as a motionless object bereft of subjectivity is central to its appeal. In *Bitter Tears* it is the appeal to Petra of Karin's body as this particular kind of person/object that Sidonie acts on when she gives Petra the Karin doll as a gift.

Putting suffering and humiliation on display is crucial to the masochist's project. But masochistic displays are not exhibitionistic: for Reik they are better understood as demonstrative. Perhaps the drive to demonstrate the self and its circumstances is the reason Fassbinder literally includes himself—as actor, as image—in so many of his films. Fassbinder's contribution to *Germany in Autumn* springs particularly to mind in the following example from Reik: "When the body is consciously felt as ugly and the phantasy or the display as disgusting, this feeling itself becomes a characteristic of masochistic pleasure and contributes to sexual excitement."[50] In this context, the flaunting of the director's fleshy body in connection with—and displaying—sexual excitement in *Germany in Autumn* (1977) is not only an attempt to demonstrate the abjection of the body—to wallow in self-contempt—but a means of fueling erotic pleasure.

Central to the reading of the masochistic scenario is the citational aspect of the art world that constitutes its mise-en-scène. Resonating with this project, masochistic scenarios as understood by Reik are full of "hidden meanings." In designing the masochistic scenario, Reik's "scenarist" frequently finds support in reading or daily experience and—strangely—in "distilled memories of films," from which he makes careful and very detailed selections.[51] While the proclivity for citation in masochism is left unexplained by Reik, it is surely related to the multiplicity of roles, the shifting of identities in masochism as understood by Studlar, following Deleuze, and it also expresses the formal principle of repetition so central to masochism. Michael Finke intriguingly refers to the citational aspect of masochism as "aesthetic mirroring" or "reduplication,"[52] thus stressing its formal concerns—here, too, with Deleuze. Finke goes a step further, however, when he emphasizes the manner in which reduplication functions as a *metastatic* process, a process that blurs or effaces the boundary between art and the real.[53] Tellingly for our project, Finke spec-

ulates that a metastatic aesthetic is one that *unframes* "by breaking down the boundaries between the real world and that of the subjective fantasy."[54] For Finke the reason for this blurring remains unclear, but I suggest that it promotes a suspension of identity—and serves as an effort to shore it up. In Fassbinder's films, figures of identity stand in place of the self as distorted mirror images or as unconvincing doubles. And, most importantly, the mutability of identity is reflected in the multivalent cinematic image.

Let me assert once more that the citational character of Fassbinder's work is not ascribable to a postmodern sensibility. Instead, we might say that in Fassbinder films citations are *cropped*, like Poussin's painting in *Bitter Tears*—torn from their context, or unframed—then reframed as part of a collection. From this perspective, citations "extend subjectivity through investment in a series of *objects*."[55] For Fassbinder, citations are such "objects." Are these fetishized? Perhaps. Mieke Bal asserts that "the predominant aspect of fetishism that informs collecting is anchored in anxiety over gender."[56] But whatever the explanation, in Fassbinder's films citations both shore authorial identity up and empty it out: citation functions as both an (Apollonian) affirmation of form *and* its (Dionysian) dispersal, or opening out. In *Bitter Tears*, unframed, Poussin's painting as wallpaper lacks the boundary that introduces Bazin's necessary "discontinuity between painting and wall."[57] In this film, the spilling over of Poussin's tableau into the theatrical space of actor interaction—and into spectatorial space, as argued above—mirrors the citational nature of authorial "identity," one that colors narrative and mise-en-scène alike.

Chapter 4

Color

Effacement: Color, Modernism, and the Female Body

Kasimir Malevich's masterpiece *White on White* (1918), for Frank Stella the "touchstone of modernist flatness," still represents the human figure framed by a landscape, "albeit," as Stella argues, "clothed in pigment and severely compressed."[1] And Stella's own striped paintings, read by more than one critic as bolts of flannel waiting to be made into a pinstriped suit, likewise retain the suggestion of a figure, which—in all likelihood—is male.[2] It is not only the female body that is effaced by abstraction or that figures as its substratum. Despite the advent of abstract painting, however, it is primarily woman who remains the "subject and possession" of the painter's art, as Svetlana Alpers has famously put it.[3] This chapter examines films in which the female face or body is effaced in the service of formal and aesthetic ends that derive from their concern with painting and color. Repeatedly this body is pressed into service for the sake of artistic ends, caught up, as I shall argue, and "inserted in a function whose exercise grasps it."[4]

Examples of such moments in film are not difficult to locate. In Michelangelo Antonioni's *Red Desert* (1964; see chapter 1), Monica Vitti's Giuliana is set off from the drab industrial environment by virtue of her strikingly green coat. Yes, the green color suggests that organic nature is staged against its demise in the environment, but something else is also at stake: it is by way of the woman in green that movement is introduced into Antonioni's color schema. When Giuliana enters the factory with its prominent pipes, pipes that function as red, blue, and yellow lines, their static placement is set off by the green coat's progress through the factory's spaces, changing the color relationships in the film frame as Giuliana makes her way from pipe to pipe, color to color. In keeping with the artifice of musicals, Jacques Demy's *Les demoiselles de Rochefort* (1967) similarly choreographs color, and costumes matching or contrasting with the film's setting bedeck male and female characters alike. But it is Catherine Deneuve's Delphine whom the camera frames more than once to suggest that she blends into the wall of a building—or is trapped behind wallpaper. In Hitchcock's *Frenzy* (1972), the poisonous Hetty (Billie Whitelaw), seated on her living room sofa, seems to meld with this heavy piece of furniture. And in *The Red Desert* what initially appears to be a realistic detail—the worker's wife removes her red apron as she greets her

The artist Frenhofer paints over the earlier portrait. *La belle noiseuse* (Jacques Rivette, 1971), frame enlargement.

visitors—soon emerges as a pictorial ploy, since the removal of red from the film frame promotes the blending of her clothing with the apartment's décor. Now her mauve sweater and dark skirt match the wallpaper, whose design of outsized flowers recalls interiors by Édouard Vuillard, where women's costumes are similarly continuous with the patterns of wallpaper, tablecloths, or upholstered chairs. Such moments promote the collapse of three-dimensional into two-dimensional effects, rendering film's spatiality dissonant.[5]

And then there is Greenaway's *The Cook, the Thief, His Wife, and Her Lover* (1989), in which most characters wear costumes color-coded to match the film's spaces, each dominated by a single color.[6] But here, too, it is Helen Mirren as Georgina who is most noticeably redecorated: when Georgina leaves the predominantly red dining room for the white bathroom, her dress changes from red to white in harmony with the décor. Of course Georgina is not literally effaced—her face and body remain distinctive and recognizable—but her dress's color coordinates her with the film's settings. Only the cook, of whom Greenaway says that he is a figure for the director—for himself—remains dressed in white throughout the film.[7] (See chapter 2.) Prior to *The Cook, the Thief* Greenaway had staged the relation between clothing and the female figure in *A Zed and Two Noughts* (1985) by way of Vermeer. Here Alba (Andrea Ferreol) is a model for the surgeon Van Meegeren, a forger of Vermeer's paintings: sitting for her portrait, Alba complains that she is "stitched and sutured" into the famous blue and yellow bodice in which more than one Vermeer woman is dressed. Positioned incongruously atop recognizable garments lifted from Vermeer, Alba's face sets up jarring discontinuities.

Vuillard is not the only modernist painter who comes to mind in these games with the female body. Gustav Klimt's portraits may also serve as a touchstone for the figuration of the woman in relation to décor, costuming, and dress. In Klimt's work the opulent costumes primarily of female figures merge with background and décor, while their carefully drawn faces and hands remain distinct. Klimt's portraits suggest a form of merger with, but also the dissonance between, figure and ground effected by the rupture between face and body and the colorful patterns that surround them. In Klimt's portraits jewel-tone fields of color suggest patterns on fabric rather than clothes that outline the three-dimensional body. In these portraits, only faces and hands remain uncovered in a strategy that calls Balzac's novella *The Hidden Masterpiece* to mind, where the outline of a woman's figure on canvas is gradually covered in swirls of paint until only one carefully modeled foot remains in view.

In delineating the relationships between color, paint, costume, and the female body, this chapter draws on the centuries-old and ideologically inflected—indeed, gendered—debates on color and line that continue to haunt Western thinking about painting. Their articulation in Ingmar Bergman's *Cries and Whispers*, Jacques Rivette's *La belle noiseuse*, and Alfred Hitchcock's *Marnie* is my topic.

The Color Wash

From a thematic perspective, Ingmar Bergman's *Cries and Whispers* (1972) emphasizes the intersubjectivity so often the topic of Bergman's films, the blurring of boundaries among characters as well as the crossing of gender boundaries stressed by some critics.[8] Oscillating with the film's intersubjective gestures is the multisensory, even synaesthetic, stance from which *Cries and Whispers* derives its resonance and intermedial character. In the context of this film's intermediality, I take up the several attitudes toward painting, color, and the body that Bergman's film sets up, referring to the modernist attitude toward color as well as to the gendering that haunts European art theory in debates that pit painting against writing and color against line. These debates are more than a fitting vehicle for the film's problematic; they are as integral to Bergman's film as the familial drama and loss of identity played out within its frames.

Bergman's first film that is fully in color, and one of his particular favorites, *Cries and Whispers* is an experiment with the relation of actor and décor to color, especially in its use of red, moving between strategies such as Hitchcock's repeated alternation of red color, blood, and paint in *Marnie* (1964), and Jean-Luc Godard's modernist attitude, conveyed in his notorious assertion concerning blood in his 1965 *Pierrot le fou* to the effect that it wasn't blood at all, just "red."[9] Like many of Hitchcock's films, *Cries and Whispers* (1972) moves between realist and modernist paradigms, promoting and upholding ambiguity concerning the color red as blood, paint, or merely nonreferential "red."[10]

The saturated red that permeates the décor of the country house where three sisters spent their childhood and the film's action takes place is overtly connected with female blood: in some sense the mother's house is always the body of the mother. (This may be the place to cite once more Bergman's oft-quoted claim that "ever since my childhood I have pictured the inside of the soul as a moist membrane in shades of red." In Bergman's materialist inversion, the soul resembles a mouth or a vagina.)[11] The color red is linked to the blood of wounds as well as to the suffusion of flesh by blood, as in blushing. The blood of would-be suicide Joakim (Henning Moritzen), one of the film's few male characters, is spilled, too, but more telling is the self-inflicted wound by which Karin (Ingrid Thulin) tortures herself and her husband. Dipping her hand into her bleeding vagina, Karin smears blood on her face as though it were rouge—or war paint: by way of this stunning gesture, the film confirms the analogy between blood and paint. Red sofas, red wallpaper, red rugs, red curtains and, for Maria (Liv Ullmann), red clothing: the overwhelming presence of red in the décor of the film contributes to its intense affect for the spectator.[12] In contrast, we never see the blood of the dying and dead Agnes (Harriet Andersson), who grows increasingly pale, drained of blood, one explanation for the episode in which she vampiristically attaches herself to

Maria's throat.[13] The film's palette includes black (connected with Karin) and the ghostly white associated with Agnes in addition to the predominant red. A painterly reference may be close to hand: as Erwin Panofsky reports, Titian maintained that a good painter requires only three colors: white, black, and red.[14] Small wonder that Titian was notoriously thought to have a "bloody" palette.

Performances in the film are rigorously controlled, often simply played out across the face, but the film's overwhelming redness suggests that the actors' bodies cannot contain the affect they feel, an affect that spills out across the mise-en-scène in the manner of melodrama. Sartre's distinction between theater and film—loosely cited by André Bazin—to the effect that "in theater the drama proceeds from the actor, but in the cinema it goes from the décor to the man"—meaning actor[15]—is problematized in *Cries and Whispers* by virtue of the film's hybrid identity. It is a chamber film, a film with a theatrical mise-en-scène, but it has a painterly disposition. In *Cries and Whispers*, the lines of force connecting actor and décor run in both directions.

In this regard one sequence in particular stands out: when Karin and Maria face one another across the vast expanse of a dining table, the editing adheres to the classical shot reverse-shot paradigm, but the strictness of their alternation suggests an either/or—two alternatives: Karin is seated before an intricately carved, black wooden cupboard that frames her erect body while, across the table, Maria is positioned in front of a painted screen. If the marked relief of the cupboard's carvings speaks to the textured three-dimensionality of its surface, the straight-on, frontal shots of Maria render her red hair part of the screen's pictorial surface and suggest the film's connection to the two-dimensionality of painting. But a second ambiguity structures the shots of Maria, making the convergence of pictorial design and body difficult to read, since the presence of the screen behind her also flattens her image by subsuming her body within its two-dimensional, pictorial space. Is it Maria's wisps of red hair that render her appearance diabolical, or the screen's wispy, flame- or tongue-like florals? In this sequence the color red creates a perceptual tension between figure and ground, a tension that Brian Price reads as one effect of color in film.[16] Here tension results from the melding of actor and décor via color, as color works to ambiguate space. In this sequence Maria is not completely effaced, of course, but the oscillation of figure/ground relations moves in that direction.

Moreover, the color red in Bergman's film participates in modernism's concern with the nonreferential image, which in *Cries and Whispers* is another effect of figure and ground ambiguities. Teetering between realism and modernism, a shot of the pastor speaking over Agnes's corpse is important in this regard: on the one hand, his head and shoulders stand out in relief against a crimson background the spectator understands to be the room's wall. But in the absence of architectural and spatial markers in the film frame, this predominance of red is unsettling—it is pure color, spatially unanchored,

as if suspending the pastor's head in a different kind of space. Another such moment occurs when the doctor is reading in an armchair, a rectangle of red behind him. In this scene and others—most notably headshots of two women, Karin and Maria—an undifferentiated red backdrop behind the close-up of the head promotes an impression of abstraction. This effect is particularly evident in the reconciliation sequence between Karin and Maria, a scene in which diegetic sound is replaced by cello music, one of two scenes on the film in which a utopian relation between two women is figured. Color abstraction and Bach in concert create an aesthetic space that is utopian—that is, of no place and no time. (The second such scene—also accompanied by cello music—is the tableau vivant reminiscent of the Pietà in which Anna [Kari Sylwan] as the virgin holds Agnes as Christ in her arms.) And then there are the more glaringly modernist moments when red suffusions or color washes become fully opaque and linger on the screen, covering its surface completely. At such moments color is simply that, functioning to underscore the screen as the material support of the image.

With its several velleities, the color red is markedly unstable. Stressing the film's link with painting in the context of its representational strategies, the repeated red coloration of the frame does not simply suggest red's corporeal origin, its link to blood. Indeed, in *Cries and Whispers* the presence of red on the screen is not necessarily connected with its characters at all: that this coloration is a formal device is suggested from its first occurrence on the screen, when red gradually begins to cover the screen, then becomes opaque. The resulting red frame separates the last image in the montage of static shots with which the film opens from its second montage, a montage of clocks. From one perspective, the red suffusions are an aspect of the film's grammar and perform a structuring function that both connects *and* separates. And in the context of visual arts practices, the repeated red coloration of the film's frames suggests a color wash—a filmic equivalent of painting,[17] a layering of color over the image. These are the images by which intermediality is most notably expressed in the film—the color wash alludes to painting but it is also wholly cinematic, changing over time.

If the color wash most often takes place during close-ups of the female face, the connection of the female face and color is in keeping with an earlier moment in art theory. As I have suggested elsewhere,[18] by way of its two opening montages, *Cries and Whispers* stages a modernist formal battle with temporality, against the narrative flow of film itself by using formal devices that link it to the spatial, static visual arts—to photography, sculpture, and painting. As is well known, the battle of images with stories, of space against time, was theorized by G. E. Lessing in his *Laocoon: An Essay upon the Limits of Poetry and Painting* of 1766, although Lessing was not the first to make these connections. In Lessing's essay, poetry (which for him means writing, narrative)—the forward-moving, temporal art he connects with cerebration

and the masculine principle—is pitted against painting, the spatial art tied to bodies and coded female. As W. J. T. Mitchell has compellingly argued, "The most fundamental ideological basis for Lessing's laws of genre [are] the laws of gender."[19] Importantly for Bergman's film, whose generic hybridity argues against Lessing's dictum, Lessing believes that the arts should be kept distinctly separate, that there should be no illicit boundary crossings from one art form into another. He would have been very much put out by Bergman's intermingling of the arts and its implications.

It has been provocatively suggested that "Ingmar Bergman is the first major contemporary filmmaker who publicly raised the essential question: 'Am I, perhaps, a woman?'"[20] We can speculate that this purported identification with the female as well as Bergman's interest in gender crossing underpins the director's formal and imagistic emphasis on the spatial arts in *Cries and Whispers*. The crossing of gender boundaries finds its generic counterpart and formal principle in the opening montages of *Cries and Whispers*: from its beginning, the film experiments with arresting the image through a discontinuous series of nearly static shots in the first montage and suggests its spatiality, its objecthood as photograph and as "image object" through the accumulation and overlapping of images effected by superimposition. When, as a mode of transition between these two forms of spatialization, red coloring operates both to separate and to bind these montages into a film body, painting—Lessing's female art—enters the mix.

Color's production of spectatorial affect is a commonplace of art theory from its beginnings, and its importance to Gilles Deleuze's thinking on affective images is in keeping with this tradition. Although Deleuze's *The Movement-Image* makes only a passing reference to *Cries and Whispers*,[21] his insight concerning the faciality of all objects shot in close-up may well have had its source in this particular film. After the camera moves over the last of a series of clock faces in the film's second montage and the sequence is punctuated by a red film frame, it moves directly to the face of a woman, also in close-up, cementing the connection of cinema, face, and close-up that Deleuze sees as fundamental to Bergman's work. Importantly, too, the cut from clock to face connects the textured images of the clock to the flesh. Not only does the camera's tactile looking carry over to the rest of the film, but it is also underscored in the narrative by the repeated caress of the face, a signature gesture for *Cries and Whispers*, one practiced by nearly all of its characters. One scene of looking in particular illustrates this point: in a sequence that calls to mind Jacques Lacan's mirror stage, the doctor (Erland Josephson) reads Maria's face—displayed to the spectator in a frontal close-up—claiming to find indifference, indolence, impatience, and ennui in its wrinkles and contours. When she questions him about this physiognomic character reading, the doctor confesses that he does not *see* these emotions in Maria's face, but rather *feels* them when she kisses him. With this recourse to touch, Bergman undermines both

the classical scene of looking (the mirror stage that confers identity does not do so here)[22] and the physiognomic tradition of reading the face.

If Deleuze's disquisition on reading the face has its origins in ideas concerning the passions which run through aesthetics and discourses on painting,[23] with respect to the cinema he concurs with others that the close-up is central to the intensification of affect. Face and close-up are reducible to one another, referent and technique are equivalents, claims Deleuze: "The affection-image is the close-up, and the close-up is the face."[24] Not surprisingly, the close-up tends to despatialize and to "suspend individuation"[25] by blurring the coordinates of the image, and it is the despatializing effect of such framings with which Bergman's film is centrally concerned. Flatness effects are generated both through the agency of color—the flatness of the color field as backdrop—and through the close-up itself. The face in close-up, argues Deleuze, promotes the depersonalization first noted by Béla Balázs. Metamorphosed by the proximity of the camera, suggests Balázs, the face exists in another dimension entirely: "Faced with an isolated face, we do not perceive space. Our sensation of space is abolished."[26] While Balázs is in fact cited in Deleuze's elaboration of the affection image, Deleuze goes further than the earlier theorist to extend the power of the facial close-up to close-ups of other body parts. Wrenched from all spatiotemporal coordinates, for Deleuze the object in close-up belongs to "any-space-whatever," since in close-up it is abstracted from the spatiotemporal coordinates of the world, no longer connected to "the state of things."[27]

Bergman is *the* director of the facial close-up, Deleuze contends, and "the facial close-up is both the face *and its effacement*" (my emphasis), he claims, "Bergman reaches the extreme limit of the affection-image, he burns the icon, he consumes and extinguishes the face."[28] Burning the icon, extinguishing the face, "the effacement of faces in nothingness"[29]—Deleuze describes the violence of his *own* project, if not precisely Bergman's, and he implies that this violence releases a compound affect of desire and astonishment in the film's spectator. More pertinent to us here, however, is the impulse toward effacement that Deleuze's reading of Bergman suggests. Whether Bergman identifies as female or as male, in his films it is the female face that is extinguished, effaced. In *Cries and Whispers* this is accomplished by the red color wash that repeatedly covers it. Creating a kind of color bracket that frames a memory represented in flashback (in the case of both Maria and Karin) or a dream (in the case of Anna), the red wash signals the beginning and end of sequences in which the interiority of these women is explored. Each such sequence begins with a frontal close-up and ends with a close-up of the face subtly turned away, at a slight angle, with lighting effects that recall the Old Masters. What starts as a frontal filmic close-up ends in a portrait shot.

Let us return briefly to questions raised by aesthetic theories, to debates that precede Lessing's seminal essay. The link of the feminine, color, and affect in Bergman's film takes up a central debate dating back to Roger de Piles's

Dialogue on Colors (1673). Here de Piles defends colorist painters such as Rubens and Titian by asserting the importance of color over line in a direct contradiction of traditional art theory—for which line and design implicitly took precedence because they were considered central to analysis, not merely generative of emotion.[30] Writings on the topic of color traditionally relegated it to the domain of affects and emotions: considered the "feminine" aspect of painting, it was linked to artifice and deception—and makeup, an idea that Baudelaire would take up in *The Painter of Modern Life* (1864). However, as de Piles points out, it is only color that allows the artist to render human flesh properly. In the debate on color and line, Poussin, who intended his paintings to be read and who based his human figures on classical statuary, is pitted against Rubens, famous for the sensuousness of his flesh tones, as well as against Titian, artist of the "bloody palette."

In de Piles's defense of the centrality of the senses—the passions, the affects—in the making and beholding of painting, he rejects images that "paint in stone" (Poussin's work is a central example) as paintings that wish to satisfy our intellect rather than please our eyes. Through a series of complex maneuvers, de Piles allies line and drawing to sculpture by virtue of what he terms their connection to the hand, thus disrupting their connection to the eye, a move that allows de Piles to read color as *the* specifically visual aspect of painting. Because color evokes affect, de Piles suggests, color—not line—is the feature of painting that is truly "eloquent," that speaks to us by moving us.[31] Hence the mode of painting de Piles supports is colorist painting.

Yet another aspect of the debate concerning color and line is also pertinent to our reading of Bergman's film. If the defenders of line and design—of drawing and perspective—fear the effects of colorist paintings, this is because they think that such paintings, as Jacqueline Lichtenstein puts it, "block the possible synthesis of representations in which the subject is finally able to comprehend and recognize himself,"[32] since "in the sensuous pleasures of color, line, design, and identities are blurred."[33] As we have noted, fluid identities and a pronounced intersubjectivity are central to *Cries and Whispers*. Further, with its modernist breaking of the fourth wall, character look extends to embrace the film's spectator, drawing us into its affective bath as well. It should be noted, however, that intersubjectivity is primarily promoted not by the film's *narrative*—which actually stresses the disjunctive identities of the sisters—but by its *formal procedures*. The female face, the close-up, the look out of the frame, and color: their conjunction in *Cries and Whispers* promotes the lack of demarcation that blurs identities and boundaries.

The melding of female subjectivities—surely one aspect of effacement—takes several forms, including that of substitution. The most obvious example of this strategy is the use of the same actor for different roles: Liv Ullmann plays both Maria and her mother, and the mother's portrait on Maria's bedroom wall has Ullmann's features. Editing procedures have a role to play as well: when toward the end of the film Karin asks to be forgiven, Anna begins

to approach her, but a cut reveals that Karin is actually addressing Maria. Dream sequences are another area in which identity confusion can reign: at the beginning of a dream that starts as Anna's, both Maria and Karin are portrayed as catatonic figures. During its course, Anna twice disappears from view, and on these occasions Karin and Maria in turn are figured as actor, perhaps as dreamer. Sound is used in a similar way: at the end of the film Anna begins to read from Agnes's diary, but soon the dead woman's voice-over carries on from there. And of course close-ups function to this end as well: often half obscured by shadow, the female faces in close-up seem to complement or even to complete one another. But what reinforces the fluidity of female identities most clearly is the red color over these headshots—whether blood, paint, or mere color is at issue. Drawing on Lichtenstein and others, Brian Price has suggested concerning color's deterritorializing effects that "the blurring of contours promoted by color is one of its greatest threats."[34] Given *Cries and Whispers*'s subject matter, however, for this film the deterritorializing effect of color may be one of its greatest formal *assets*.

Again Deleuze comes into play, namely by way of his claim that the true color image can also constitute a mode of "any-space-whatever," a "space of virtual conjunction, grasped as pure locus of the possible."[35] Like the effect promoted by the face in close-up, color creates a space no longer contained within boundaries, a disconnected, emptied, or abstract space. What is at issue for Deleuze is *not* the correspondence between color and affect—red and passion, for example. Rather, color is the affect itself,[36] and the point of it is the absorption of all characters into the "mysterious" space that corresponds to colors, which have an "almost carnivorous, devouring, destructive, absorbent function."[37] It is precisely *because* it is "de-territorializing" that there is a suggestion of a utopian space here: Deleuze's formulation is staged against the color phobia of earlier art theorists who preferred the line.

As noted earlier, images in *Cries and Whispers* invade spectatorial space in the modernist moments of the direct look out, and by way of a color bleed, moments when the affect suggested by the color red infiltrates our space. Alternatively, we may be brought up short at moments when color promotes the abstraction of the image and reinforces the flatness of the screen. The color wash of red over close-ups of female faces, the wash that effectively *effaces* them, also promotes abstraction: while such shots begin as a translucent application of color, more and more color is gradually applied to the image until the red is finally opaque. The film resorts to this formal procedure with respect to all of its female characters save Agnes. At the level of the diegesis this procedure is arguably linked to Agnes—who is a diarist, watercolorist, maker of images, and stand-in for Bergman: in some sense it is she who covers over, obliterates the faces of her sisters with watercolor that becomes ever more opaque until only color remains. According to this reading, then, Bergman as Agnes is the source of the violence that Deleuze reads in the director's effacement of the face.

When all movement disappears from the film frame and only the color red remains, our sense of space is abolished. If the "any-space-whatever" produced by the power of pure color as affect is a space of "pure conjunction," as Deleuze insists, in such moments affect is desire in its negating form, the violent, erotic desire to abolish all distinctions. One distinction that Deleuze—and Bergman—are interested in abolishing is that of gender. How fitting to use color—coded female—to cover over the lines—coded male—of the female face. The gesture of flooding the film frame with color is—in its temporality—a *filmic* device, but it also points to painting. Is the female face when covered over with opaque red in fact obliterated—effaced—by color? Or does this formal device suggest a merger of face with screen? If the female face is screen, it serves as the substratum of the image.

Color and Line: The Occulted Body

The question "Blood, paint, or red?" does not originate with modernism: it is a trope of illusionism in its various forms, resuscitated in the nineteenth century by a literary interest in the implications of realism. In Edgar Allan Poe's *The Oval Portrait* (1842), blood and paint are fused in an astonishing parable—and critique—of realism in art. Poe's tale is familiar: it describes a painting that, in the manner of a vampire, absorbs the lifeblood of the woman who sits for it. As the portrait becomes more lifelike, the woman grows ever paler. Obsessed with her image on canvas, her artist husband is blind to the real body before him. When the woman dies at the moment of the painting's completion, it is implied that her blood, which gives the painting its quality of lifelikeness, is now used up.

An inversion of the Pygmalion story, *The Oval Portrait* has much in common with Balzac's *The Hidden Masterpiece* (1831), which likewise concerns the realist impulse to bring the painted body to life. In his attempt to create a lifelike portrait, Balzac's artist Frenhofer succeeds in representing only "an enchanting foot, a living foot,"[38] while the rest of his painting is "a mass of confused color, crossed by a multitude of painted lines, making a sort of painted wall."[39] Frenhofer's painting is primarily abstract—it does not contain color within line—but the illusionistic foot that peeps out behind pure color appears so real that, were the "wall" of paint to be removed, it is suggested, a living woman might be revealed. Balzac's story famously makes its way into film via Jacques Rivette's very loose adaptation, *La belle noiseuse* (1991). While the pertinent painting is never shown in its entirety by Rivette, toward the end of the film we see a flash of red at the bottom of the canvas. Once again Godard comes into the picture: like Bergman, Rivette no doubt had in mind his notorious assertion concerning blood in *Pierrot le fou* (1965).[40] Notably, in tableau 12 of *Vivre sa vie* (1962; see the introduction), its final tableau, Godard himself reads in voice-over from Poe's *Oval Portrait*. The

parallel between Poe's artist—read Godard here—and his vampiristic relation to the body of his real-life wife—read Anna Karina—is clearly effected: *Vivre sa vie* concerns a pimp and his lover, the sex worker Nana (played by Anna Karina), who is shot by gangsters, her body mercilessly left on the street. Sexuality, present only by implication in Balzac's story and Poe's tale, comes to the fore in Godard. Relations among artist, model, and lover are equally entangled in Rivette's film.

While Eros is percolating just under the surface of *La belle noiseuse,* it is largely sublimated, cloaked by Frenhofer's (also the name of the artist in the film, played by Michel Piccoli) burning desire for "truth in painting." "The truth in painting": by way of this phrase Rivette cites a concern of seventeenth-century French academic critics such as André Félebien, for whom the relation of pictorial representation to truth resides in the depiction of "the natural" governed by an idea or design. There is an obvious relation to the line here. But Rivette's artist takes this position in another direction: for him the "truth in painting" is "cruel," as he puts it, and the film unsurprisingly connects this "truth" with the artist's desire metaphorically to "crush," open up, or expose the body of his female model so that he may convey its essence to the canvas. In this way, Rivette pays tribute to Balzac's interest in the connection of paint to corporeality, and to Poe. The degree zero of illusionism would be to paint with nature itself, to paint with blood.[41]

Rivette's aging Frenhofer is no longer capable of painting and contents himself with pen-and-ink and crayon sketches. Connected to his virility, Frenhofer's artistic power has stagnated: it has been ten years since he has worked on his unfinished masterpiece, *La belle noiseuse,* for which his wife Liz (Jane Birkin) originally served as model. Since Liz no longer invigorates his art, the portrait is abandoned until the dealer Porbus sets Frenhofer up with a new model, Marianne (Emmanuelle Béart), the young lover of another artist, Nicolas (David Burzstein; he stands in for Nicolas Poussin in the Balzac novella). As Frenhofer puts it to Nicolas, "If I go the whole way, there's blood on the canvas." The modeling sessions begin with instructions that Marianne assume contorted postures, pass through a stage in which Frenhofer literally adjusts her body, and end in her body's rough handling. A desire for penetration is barely disguised when Frenhofer tells Marianne that he wants to "know and see the inside of your body." Indeed, he wants "everything," he confesses, "the blood, the fire, the ice that's inside your body." Later, as the intensity of the painting sessions escalates, Frenhofer threatens her with effacement, indeed, with extinction: "I'm going to crush you—you're going to break up [*dispersé*]." Metaphors of origin—the "sounds of origin . . . of the forest and sea together"—*sounds* that ironically serve as Frenhofer's definition of painting, a visual art—are connected to a violent drive that would reduce the female model's body to the molecular level.

For Nicolas as painter—true to his model Poussin (recall his significance for de Piles)—it's "the line, the stroke" that is at issue, but Frenhofer's struggle

is once again between line/contour and color. He gradually paints over the original "belle noiseuse,"[42] first layering white and then blue paint over the representation of Liz's body in a style that recalls the palimpsest of pigments the painting in Balzac's story finally becomes. In this process, Liz's body all but disappears, leaving only a dim rendering of her face behind a transparent layer of blue paint, her body trapped behind applications of color. Over the color that covers the outlines of Liz, Frenhofer paints the lines that mark the strong contours of Marianne's torso. On canvas, this torso, faceless, is at right angles to, juxtaposed with, Liz's face under blue paint. But this is not the end of it: Frenhofer paints several long, angry red slashes over the contours of the female body, as though to fully negate its representational aspect. After she surreptitiously views the painting while Frenhofer is asleep in his studio, Liz confronts him: "You had to wipe me out . . . What's the word for it, you replaced me, yes . . . You put some buttocks in place of my face." While this is not strictly true, these disparate body parts—Liz's barely visible face and the outlines of Marianne's body—do not coexist happily on the picture plane. They do not connect: face and body are at right angles, askew, evocative of Cubist portraiture, attesting to the film's interest in modernist strategies. Although Liz cautions Marianne not to let Frenhofer paint her face, to protect her face from his vampiristic art, later on in the film sketches of Marianne's face adorn the studio walls.

In Poe, the portrait is in some sense the "devil's work," and Liz calls Frenhofer's new work "shameless." Like Poe's artist, Rivette's Frenhofer aspires to bring life into art, but the struggle is fruitless and he merely succeeds in killing it off. Recognizing this, Liz paints a black cross next to Frenhofer's signature on the stretcher bar, marking Frenhofer's composite portrait with the sign of death. Rivette and his screenwriter, none other than Pascal Bonitzer, whose critical work on film and painting is well known, give Balzac's story another twist: after both Liz and Marianne have seen *La belle noiseuse* with disastrous consequences, Frenhofer decides to wall the painting up. (Recall that in the Balzac story, the female body is trapped—effaced—behind a wall of paint.) One could argue that a feminist perspective of sorts enters the film at this point, insofar as the exploitative portrait is forever hidden from view.

Interestingly, in Frenhofer's decision to brick up *La belle noiseuse*, his "masterpiece," there is yet another allusion to Poe: the artist's strategy resonates with Poe's *The Tell-Tale Heart* (1843), in which the heart of a murder victim continues to beat after it has been sealed up under floorboards by the murderer. Although it is only the murderer, a madman, who hears the heart beat, Poe's tale nevertheless implies that in some sense the life force cannot be stilled. Like Poe's tale, Rivette's film may also be suggesting that Frenhofer's portrait had in fact truly brought life into art and that this is why the unholy merger needs to be forever hidden from view. A certain kind of creative endeavor is sacrilegious, akin to murder, Rivette's film suggests. Hence the film establishes an ethics of representation to the effect that the *film,*

unlike the painting, must not "bare all." Arguably it is for this reason that the completed portrait is hidden from our view, save for the flash of red we see as it is moved over to the wall. In Frenhofer's masterpiece the double negation of the female body—first Liz's, painted over in white and blue, and then Marianne's, defaced by large red slashes of paint—documents the modernist denigration of figural painting. But it also contains the suggestion—lurking in Bergman—that the body of the woman is nevertheless the substratum of art in modernism, effaced though she may be. As in the Balzac novella, there is an implication that a real body exists under the layers of paint. In *La belle noiseuse*, as in *Cries and Whispers*, the significance of color red moves among blood, paint, and simply red.[43]

Contour and line are juxtaposed with color in Frenhofer's portrait. The actress Emmanuelle Béart, who serves as the artist's model in the film, seems to have been chosen for her pronounced, three-dimensional buttocks, constantly pursued by the camera.[44] Indeed, the lines with which Frenhofer depicts them stress their sculptural three-dimensionality. Later, in the hastily painted portrait with which Frenhofer replaces the bricked-up masterpiece[45] (the "fake" *noiseuse*, the perfunctory, uncontroversial work he deems appropriate for public consumption) the three-dimensionality suggested by the simple lines that demarcate the body is particularly pronounced. Painted in a few bold strokes, these lines are superimposed on a painted field of blue. Here line is superimposed on color, and line defines the female body. This painting need not be walled up. But if color—according to de Piles the specifically visual aspect of painting—does not in this work either supplement or efface the female body, it is also unable to render it "eloquent" or affective. In both of Frenhofer's works, Marianne's body, depicted by way of line, is—from de Piles's point of view—connected to drawing and sculpture. Only in the walled-up *noiseuse* is color connected to the blood of its subject. Hence, the second, the perfunctory, public painting suggests a transition away from a realist paradigm that works with the material of the body, as Poe's portraitist does. Later on, when one of the beholders of the "fake" *noiseuse* tells Frenhofer that she does not like the painting because she only likes Titian, the painter of the "bloody palette," Frenhofer responds, "It's Titian that I have *done*." Clearly his remark refers not to the painting on display at the *vernissage*, but to the original work, with its obliterating bold, red strokes of color that metaphorically suggest the model's blood. For the contemporary Frenhofer, the "truth in painting" lies in the violence of the realist struggle to bring the body into the work—as well as in the modernist impulse to negate it. The "blood" that the female figure contains is both marked and covered over by slashes of red paint, by lines of color.

While in Rivette's film no realistic foot remains on the canvas, Liz does accidentally leave a footprint on one of Frenhofer's sketches. It is probably no accident that a footprint is an indexical image—an imprint of the real, like André Bazin's death mask, prized for the way it is a trace of the body. For

Bazin its trace of the real is the privileged characteristic of the photograph, hence of central importance to the predigital cinematic image. Herein lies a bit of one-upsmanship: by virtue of its indexical image, film, it is claimed, *can* in fact bring the body into the work, if only indirectly. Another Bazinian idea is at play in Rivette's film, as well: in "The Ontology of the Photographic Image," Bazin famously argues that film has liberated painting from representing the world, from realism. Thus the film image takes pride of place in the intermedial mix that is Rivette's film.

Like Bergman, Rivette also brings the other arts into play. When Magali (Marie Belluc), the housekeeper's young daughter, who flits about the house like a spirit of the place, dances to Stravinsky, she imports music and dance into a film that primarily engages painting. But she is not the only character who participates in another art: Magali as household factotum also helps Liz with her efforts at taxidermy, Norman Bates's notorious "hobby." Liz—more literally, more materially than Frenhofer—actually does bring the body, the real—into art. The "sculptures" of the birds she stuffs are identical with the object of representation, since the body *is* the work. No occulted bodies here. A foil for Frenhofer in this regard, Liz also kills off life in order paradoxically to preserve it, but she does this without the transformative work of the imagination necessary to produce "real" art. Not only does woman serve as a model from whom the lifeblood is metaphorically drawn, but her work, her art, is also the pastime of Norman, the famous psychotic of cinema. Rivette is making a misogynist move or two.

The early conception of the movie camera as "chasseur d'images," a hunter of images, also comes to mind, a phrase that links the hunting of images to their preservation in film. Examining one of Liz's displays, the art dealer Porbus (Gilles Arbona) says it reminds him of the work of Jean Baptiste Oudry (1686–1755), whose game and hunting scenes derive from Dutch realism.[46] The film's take on Liz's "art" is that it is identical to the body it "represents"— and hence is not representational at all. In its stance toward painting, toward both Frenhofer's and Liz's work, Rivette's film assumes a mediatory position between the realist struggle to bring the body into representation, literally in Liz's "sculptures," but also in the manner of Poe's portraitist, who metaphorically paints with his wife's blood, suggested in Frenhofer's drive to achieve "the truth"—versus the antifigurative painting that the hidden masterpiece had become. Fortunately for the medium of film, it is suggested, its photographic image necessarily contains a trace of the body. While interlarded with nods to the other arts, and despite the reference to Stravinsky's *Agon* in the credits, *La belle noiseuse* never fully represents the relation of the arts to one another as agonistic. Nor does it effect their happy conflation in film.

As the credits also note, the hand of the actor Bernard Dufour substitutes for that of Michel Piccoli as Frenhofer in the sequences in which a hand is actually painting. The obvious explanation for this substitution is that the camera focuses on the hand for long stretches of time as it sketches and

paints, hence the hand of a "real" artist is required. No doubt Rivette knew the art documentaries that show Picasso's hand at work, films such as Paul Haesaert's *Visit to Picasso* of 1950 or Henri-Georges Clouzot's *The Picasso Mystery* of 1956,[47] so it seems likely that the painting hand as indirect reference to Picasso serves to underline the relation of painting to eroticism and to the abstracted body of the woman.[48] This may be why the shots that record the hand at work in *La belle noiseuse*—and the sense of duration those shots convey—have such an important role to play in Rivette's film,[49] since its long takes and lack of camera movement are designed to let reality enter its frames. As we watch the process of painting take place in the film, we sense in these sequences a documentary feel that sets them apart from the narrative. Here film is recording the act of painting as it produces real works.[50]

While the film's human drama is fatuous and clichéd ("You're sad because you're no longer young"), the passages in the film in which Frenhofer's canvases are shown full screen mark how profoundly *La belle noiseuse* engages with the art of painting. Indeed, film's innate indexicality, while imbuing Marianne's painted buttocks with an extra measure of the real, cannot stand up to the effort to bring the body into art in which its artist hero is engaged. And color on the canvas, the boldly inscribing and negating X's in red, have more force than Rivette's plot and dialogue can muster. The character Marianne, who is not only the artist's model but also a writer, speaks the film's voice-over, but language does not have the last word—at least not metaphorically. While the word with which the film concludes—Marianne's emphatic "no"—is intended as a counterweight to her exploitation by Frenhofer and Nicolas, it cannot stand up to the red slashes of pure color across the buttocks, abstracted from the body, that simultaneously negate the female figure and break down three-dimensional space.

Color in *Marnie*: Seeing Red and the "Assimilation to Space"

In Hitchcock as in Bergman, color is a floating signifier with shifts in function that anchor it in realism at one moment and in modernist abstraction at others.[51] In *Marnie* (1964), the color red has a psychologically charged and duplicitous role to play. Marnie's (Tippi Hedren) mental illness is registered in the domain of sight, with the film linking her trauma to the blood of an inaugural crime scene. Here too red is the color of intense affect, and warning chords provide a recurrent aural accompaniment to Marnie's "seeing red." Red gladiolas in her mother's house trigger her first "attack." Marnie's response is the same during the dream sequence there, and red ink spilled on her white blouse has a similar effect.[52] At the races, a jockey's silks with red polka dots on a white background triggers it again. A second dream in the Rutland house connects the color with the traumatic event expressed in her fear of red: "No, Mama, don't cry . . . Don't hurt my Mama!" And during an

association game with Sean Connery's Mark as amateur psychoanalyst, the cue "red" provokes Marnie to shout "White! white!" Finally, a riding habit will set off the chain of events that leads to Marnie's mercy killing of her horse. Red is the color of affect, and it is also the color of blood, for which the red in this film so obviously substitutes. The code would appear to be a simple one, the associations the film provides readily decipherable.

It should be noted, however, Marnie "sees red" only metaphorically: while something red is the object of her look, it is her image that is suffused with that color in virtually each instance, with red flashing light extending to fill the film frame.[53] If the suffusion of the film frame suggests a permeability between the image and its material support, does this bleeding in the frame signal a "reality" they have in common—the color red as blood—or does it signal artifice—the color red simply as color? In some sense, the red film frame disturbs the spectator's vision, transferring the character's symptom to us. Like a wash over realist images, however, it also cloaks the film image in pure color.

The thunderstorm experienced in Mark's office is the exception to the rule that Marnie's image and the film frame turn red during her "attacks." In this sequence red light flashes in the window, not on Marnie, although the light immobilizes her, pressing her against the door as she begs, in a child's voice, "Stop the colors!" In a film whose system of metaphors is so carefully contrived, why is Marnie's image not suffused with red during her experience of the storm, as in all other instances? At one level, this variation undermines the notion of a closed color system. But perhaps the explanation is that Mark's effort to "stop the colors" leads to an embrace, and when the camera moves in to a tight close-up of their mouths—hers wearing surprisingly red lipstick—her painted lips seem to substitute for the omitted suffusion. As we recall, the origin of Marnie's trauma lies in the murder she committed as a five-year-old, when she killed a sailor both in defense of her mother and—it is suggested—in disgust at his kiss. Mark's kiss both taps into and covers over the repressed memory, while the fleshiness of the couple's mouths in extreme close-up seems to stand in for a more private encounter—for the female body's interior spaces. As Marnie and Mark leave her mother's house at the film's conclusion, its red brick walls are prominent in the frame. (See also chapter 1.) They are covered with raindrops from yet another thunderstorm, which look for all the world like drops of blood. As in *Cries and Whispers*, at the level of metaphor, the mother's house is rendered body—it is yet another representation of a female interior, bleeding.

Lest we think that *all* images suggestive of the body are red in this film, however, we have only to recall the yellow purse in its opening frames: while its shape is suggestive of intimate parts of the female anatomy, its color is jarring, unrealistic, out of sync with the subdued palette of the sequence. Here the bright yellow of the purse counteracts its anatomical shape, drawing attention to its color *as* color. A similar situation occurs in one of the film's final scenes: in this sequence there is an alternation between Marnie's dream-

like memories of the killing and the diegetic present. Her memories are set off
from the film's diegetic present by means of color: they have the sepia tones
of old photographs—until crimson blood covers the sailor's suit, and, filling
the frame, suffuses the screen itself. At this moment what was blood becomes
mere color, the screen a painted surface. As in Bergman's film, the spectator
experiences an oscillation of meanings as realism is replaced with abstraction.

But Hitchcock's use of color can be very sly. In *Marnie*, the eponymous her-
oine is a character for whom the question of identity is fraught: she is a thief
who moves from job to job, theft to theft, assuming pseudonyms and donning
disguises—tasteful garments that are repetitions of one another, hence not
real disguises at all. The heroine's personas are actually identical, repetitions
of one another: seriality, a modernist strategy, is at play. Altering her hair
color is Marnie's most effective way to change identities, and a breathtaking
sequence early in the film is most notable in this regard. It involves a series
of cuts: from a woman with black hair, to a sink with water tinted black by
hair dye, to a woman—Marnie—emerging from the water, tossing back her
golden hair. This is Hitchcock's version of *The Birth of Venus*. Color inflates
these shots with meaning, and the black dye dissolving in the sink takes on
the look of paint. Hitchcock, tongue in cheek, draws on the connection of
paint to makeup addressed by Baudelaire and given common expression in
the trope of the "painted woman."

Interestingly, this sequence does not draw on the clichéd contrast between
the "dark" woman and the "light" one—no metaphorical difference is implied,
there is no change in identity from one persona to another: a thief is a thief is
a thief. The impact of the shampooing sequence resides in the startling change
of color—as well as in the close-up of the face the hair color frames. Radiance
streams from Tippi Hedren's face as it is finally revealed, wreathed in auratic
golden hair, unrestrained by the severe chignons worn by her character's other
personas. The implication is that this is her "true," natural face. But in fact
her face remains identical in all close-ups of Marnie—Hedren's face is the
constant the film never distorts. Not for Marnie a fake scar, a beauty spot, or
crass, heavily applied makeup used to disguise. She purchases and discards
one set of clothes after another, clothes that are different yet interchange-
able, a disguise that is not one. The camouflaging coloration of Marnie's
clothes—their understated, pale colors, along with the blacks and whites that
spell elegance in the Hitchcock heroine—admit her to Mark Rutland's so-
phisticated, upper-class world. But they also spell out Marnie's unalterable
sameness, evoked as well in the first initials of her pseudonyms—Marnie,
Marion, Mary—which both suggest and cover over her real name, Margaret.
These acts of substitution extend back in time to Marnie's conception, when
her mother traded her virginity for a basketball sweater, forever consigning
Marnie to substitution and seriality.

Mark, Marnie's husband and would-be lover, is an amateur zoologist who
reads Freud. "A wild jaguarandi" is what Mark calls Marnie, and there is

another phenomenon in nature he links to Marnie as well. Found in Kenya, in appearance it is a beautiful, coral-colored "flower." But if one reaches out to touch it, the flower is discovered to consist in hundreds of small insects.[54] Reading this natural phenomenon as camouflage by means of which bugs escape the eyes of hungry birds, Mark also alludes to the gap between appearance and reality in Marnie herself—a thief camouflaged as a "decent" woman. (Perhaps he refers also to her neurotic avoidance of the male touch.) At this point in the film Lacan's discussion of mimicry within the context of the gaze sheds light on Mark's anecdote. Here Lacan refers to the work of Roger Caillois, who argues that insects do *not* take the shape or coloration of other insects or plants in order to defend themselves from their predators, who are in any case not deceived. In making his argument, Caillois refers to the behavior of a crustacean called a caprella, which, when it settles among "quasi plant-animals" known as brizoaires, resembles their intestinal loop, which looks like a stain. For Lacan (and for Hitchcock via Slavoj Žižek) the stain is, of course, an operative term, and the caprella, by imitating the stain, "becomes a picture," is "inscribed in the picture."[55] This is the origin of mimicry, Lacan claims with Caillois: the activity of the caprella is *not* Darwinian, does not exemplify adaptive behavior; rather, as Kaja Silverman writes, it is a matter of "visual articulation."[56] The caprella's mimicry of the brizoaires' intestinal loop is not motivated by adaptation, Caillois argues, but is simply a "*depersonalization by assimilation to space*" (my emphasis).[57] Contrary to Caillois, for whom mimicry in lower creatures is akin to art in human beings, Lacan asserts that beyond this simpler form of mimicry, there are mimetic activities in which only human beings can participate: "travesty, camouflage and intimidation."[58] In offering the image of the Kenyan insect "flower" to Marnie as an image for herself, Mark refers to the way Marnie—with her disguises that do not actually function as such—positions herself within representation. For the subject, claims Lacan, the aim of imitation is ultimately "to be inserted in a function whose exercise grasps it."[59]

To be caught up in representation, to be grasped by it: in the case of *Marnie*, we have read this preoccupation as expressive of Marnie's subjectivity and as locatable in the trauma that remains repressed until the film's narrative comes to an end. As to Hitchcock as director, Joe McElhaney points out that *Marnie* expresses the pressure Hitchcock had begun to feel from the formal innovations in Antonioni's work,[60] especially perhaps in terms of color. But how to read the assimilation to space as a formal choice made by Hitchcock? Or, for that matter, by Antonioni—if not through borrowings from painting? That Gustav Klimt and Édouard Vuillard provide models for the figure/ground effects against which the partial effacement of the woman has been read is not up for debate. And modernism's privileging of the medium of paint and of color over the human figure is not open to question. When, for the purposes of experiment with color and space, the woman is trapped behind paint, as in Balzac's novella; covered over in design, as in portraits by Klimt; or nearly

obliterated by color, as in Bergman, Rivette, or Hitchcock, she is inserted into a "function whose exercise grasps [her]."[61]

We close with an example that illustrates this phenomenon vividly: Vicky, the Moira Shearer character in Powell and Pressburger's *The Red Shoes* (1948), is tormented by red ballet slippers that will not allow her to stop dancing, seemingly at the command of the impresario/sorcerer Lermontov (Anton Wallbrook). Caught up in a function—in an art form, the ballet—Vicky can be released from dance only by her act of suicide. When, in her final moments, Vicky begs to have the red shoes removed, her request is complied with—but her release is purchased with the pool of blood in which she lies.

Coda: Agnès Varda's Intermedial Portraits

How does the female filmmaker recover the woman's face and body co-opted for his use by the male director, for whom that face is a canvas, the very support of his art, perhaps to be covered over by color and painterly technique as in the films discussed above? More specifically, how might the art of painting function in a feminist film project? A look at two of Agnès Varda's most intermedial films suggests a number of shapes it can take. Nearly all of Varda's films feature the art of painting to some degree. Varda, who studied art history, is intent on incorporating painting into her work, and *Jane B par Agnès V* (1988)[62] and *The Gleaners and I* (2000) draw on painting and the history of art even more freely than Varda's other films do. *Jane B* takes up the question of what it means for a woman to display her body in a painting or as a performer, and what this role-playing may hide, a question the filmmaker poses as early as 1961 in *Cléo from 5 to 7*. In *The Gleaners and I* social concern substitutes for the relentless focus on theatricality and images of women, even as the film generates a moving self-portrait of Varda.

As we recall, Jane Birkin plays Liz in Rivette's *La belle noiseuse*, the woman whose portrait is covered over by her artist husband. When asked about her role in *Jane B*, the actress, singer, and starlet ventures, "I think I'm in a painting by Agnès," even while Agnès claims, "I am filming your self-portrait." This crossing of two subjectivities and of two art forms—Jane and Agnès, painting and film (not to mention photography, writing, and sculpture)—is in evidence throughout the film. The film is characterized by a labyrinthine structure, as when stories break off only to resume later; by layered spatialities, as when what seems to be the diegetic world is suddenly exposed as a film set in another location; and by an overwhelming theatricality through which it can be difficult to make one's way. One of the threads that holds together this film "of bits and pieces," as Varda puts it, "out of which a picture emerges" is Jane's intermittent narrative of her thoughts and feelings, one of the film's more documentary aspects. But then there is artifice: Jane is featured

in multiple roles, some from myth and others that parody a variety of film genres. A thriller about an art dealer and her artist-lover takes place among art books in which money has been hidden. When the books are opened, the artist (Philippe Léotard) muses appreciatively about the beautiful "rouge" of blood in a Francis Bacon and the luminous blue of David Hockney's swimming pools. A short black-and-white slapstick sequence set in a bakery stars the cross-dressed Laura Betti as "Lardy" and Jane as "Laurel," an artist who paints white canvases à la Malevich—with whipped cream—and shows his work in a bakery. A picnic sequence of Birkin with Jean-Pierre Léaud features a New Wave relationship that vaguely speaks to Manet's *Déjeuner sur l'herbe* (1863), and there are a parodic few seconds of a jungle stage performance against Henri Rousseau's 1910 painting *The Dream*. A desert tableau vivant based on a Salvador Dali painting morphs into a scene from an explorer film, and a western setting features Jane B. as Calamity Jane writing in a journal intended for the daughter she abandoned at birth. Finally, Birkin plays an unheroic Joan of Arc at the stake with a satirical twist on Dreyer's film—the stone-faced men who surround Joan are replaced by quick shots of actual stone sculptures. In the latter vignettes genre is not the only organizing principle: there is also a play on the name Jane, a linguistic principle of organization: "Me Tarzan; you Jane"; the cowgirl Calamity Jane; and Jane/ Joan of Arc, France's epic heroine. More importantly, each vignette speaks to one of the arts—painting, most often, but also sculpture, writing, and photography—suggesting that these arts inform not only Varda's work, but filmmaking per se. Finally, each vignette works to undermine the myths of women each genre exploits.

Among these genre-inflected roles of women there is a representation of Jane as neoclassical muse who lives in the vicinity of her poet's tomb—crying not in sorrow, however, but in anger that he has died and abandoned her, thus rendering her unemployed. So often in Varda's work there is a sense of humor—an unimaged smile—that relativizes the more serious moments of her films, signaling the freedom she takes with images that she gently mocks. At one point Jane protests about having been put into the costume of a flamenco dancer and leaves the stage in a huff. Iconic images of woman are tested against Birkin's face: displaying the death mask of the "inconnue de la Seine," Varda wonders, in the spirit of André Bazin, whether the death mask may be a subject's true portrait, then displays Jane's face positioned against the same black background. What comes across here is the specificity of Birkin's living face, not its classical contours. As always in Varda's work, the reference is multiple: there is an homage to André Bazin's contention that the fingerprint and the death mask are emblematic of the indexical photographic image central to Varda's work,[63] but this homage is rendered more complex by an implied reference to the centrality of the woman's face to cinema. Finally, Varda's voice-over tells us that the death mask was taken and

marketed because the face of the nameless drowned woman was perceived to be beautiful—and ponders about whether the smile on that face was manipulated, artificially produced.

With reference to the threads that hold the film together, Jane is more than once presented as the mythological Ariadne who gave Theseus the ball of string that allowed him to slay the minotaur—only to be abandoned by him later. But here Jane as Ariadne is represented not as a weeping, abandoned lover, but as winding the ball of string through a labyrinth of mirrors herself—searching for an authentic self?—within the multiple images that surround her. When Ariadne appears with her roll of string, it is suggested that we too must find our way through the labyrinth of the film's narrative line with the help of at least one red thread. Yet what we are to do with the labyrinthine pattern of relations that govern complex narratives?[64] In *Jane B par Agnès V* the labyrinth of female roles is as complex as the mirror relations the film repeatedly sets up—mirrors that reflect Jane, yet can be made also to reflect Agnès and even the filmic apparatus at moments when the camera is moved. And then there are the funhouse mirrors that enlarge, multiply, or distort Jane's image, setting up surprising relations with other images—and thereby providing other figures, another Ariadne's thread, through which to read the film. *Jane B*'s fragments provide insights into the multiplicity of stereotypical roles in which women are placed, but at the same time the film offers the spectator images that are Varda's personal complement to more public images of Birkin as star. The photos in which Jane posed for girlie magazines—in one she is shown naked from the rear, handcuffed to a radiator—are relativized by her family photos, those of herself and her children. While the persona that emerges from the film's fragments remains in Birkin's case somewhat unfixed and fluctuating, Varda nudges Jane toward greater self-understanding by way of interviews and conversation.

But the mirror images in the film do more than suggest personas for Jane: they do double duty as a means of figuring intermedial relations. One image reflects Jane accurately in close-up against a background that is upside down: it stresses the apparatus, more particularly the soundman, who is imaged upside down in the same mirror, suggesting that sound and image can be out of sync, can belong to disparate systems. The dissonance between sound and image is already in place in the opening of the film when Varda's voice-over about a "calm image"—a tableau vivant—is disrupted as Jane comes forward to tell the story of a drunken night spent vomiting on her thirtieth birthday. The stasis of pictures—still tableaux—can contain the turmoil within the figures who act in them—and film can release them back into expressiveness. The decorum of tableau vivant—the requirement that it be motionless—is breached by film, and Jane's monologue adds another dimension to the image, one that stresses the actor's material body.

The most prominent tableau vivant, which frames *Jane B*, is a composite image of Titian's *Venus d'Urbino* (1538) and Goya's clothed and naked *Majas*

(circa 1800–1803; Varda's Majas are positioned to the left of the frame or screen, unlike Goya's, but like the *Venus*). As Jane speaks her monologue, the tableau vivant "comes alive," instantiating the link between the still and silent art of painting and the time-based, verbal arts of theater and narrative film. Varda recurs to this tableau on three occasions, according it special significance by using it to open and close the film. As the opening tableau continues, Jane is featured both as the clothed and the naked Maja. Unwilling to exploit Jane's naked body, Varda's camera traces its contours in extreme close-up, shooting naked flesh abstractly, without any body parts becoming recognizable—until, that is, the camera arrives at Jane's breasts, then moves to her face. As Alison Smith notes, "The woman puts herself on show—but as a stereotypical figure who finally reveals nothing of herself."[65] Gazing out of the frame like the Maja and Titian's Venus, here Jane asserts her right to display her naked body—in a feminist gesture. Later in the film Varda will comment that Jane never looks directly into the camera, and she will try more than once to ensure that Jane declares possession of her image by means of an assertive frontal look.

The directness of the figure's gaze brings another important painterly source for Varda's tableau vivant to mind, oddly unmentioned by critics: Éduard Manet's *Olympia* (1863), whose naked female figure is known for her confrontational look out of the painting. *Olympia* scandalized the French public for its brazen representation of an unrepentant (fictional) prostitute. The prostitute's name notwithstanding—Manet calls her Olympia—one point of the painting is that there is nothing Olympian, or classical, about the female figure. There are no rounded body contours, and the painting features a generally diminished illusionism. In the abstractness with which Varda at first represents Jane's undefined naked body, we see another link to this Manet, which is noted for the flatness with which it presents the human figure. This painting's assertion of the flatness of the canvas as support famously led Clement Greenberg to find the origins of modernism here. For art historian Michael Fried, the female figure's look is theatrical, since it acknowledges the painting's beholder, breaking with the denial of this look in French art of the eighteenth century as well as in realist painting of the nineteenth: the figure's gaze out of the painting "definitively forestalls all possibility of compositional closure."[66] Fried's remark, made about *Déjeuner sur l'herbe* (1863), where the naked woman also looks boldly out of the canvas, could as easily have been about *Olympia*. Interestingly, the model for both paintings, and a good many other Manets as well, is Victorine Meurent, herself an artist who exhibited her work in the Salons. Varda was undoubtedly aware of the identity of the model as a painter in her own right. Perhaps the identity of the model as herself a maker of images underpins—enables—the bold look. Jane Birkin, actor, singer, and sometime writer, is invited to emulate that look.

Another aspect of the tableau vivant's political significance emerges in the second sequence in which it occurs. Here Varda allows the servant women

in the background of the *Venus d'Urbino*—Jane performs one of these—to complain about the indolence, egotism, and privilege enjoyed by their mistress. Then, when Jane as servant dons her mistress's dress, the camera shoots through multiple doorframes to create a stunning pictorial composition. As Jane begins to read from a book of poetry, the period picture is animated, and Jane as servant might very well be the mistress she imitates. Here the issue of social class comes to the fore: leisure and the pursuit of the arts are the privilege of the rich. The poor must work, says the other servant, a Varda look-alike, echoing the right-wing leitmotif the Laurel and Lardy slapstick routine had earlier mocked. That mockery, expressive of the film's socialist politics, also contains a measure of autocritique: Varda—and Jane—are not poor and thus have the privilege of making art.

But what is the film's attitude toward Jane Birkin? Jane's shifting roles and the film's multiple perspectives complicate this question. More than once what may well be scripted dialogue puts favorite motifs of Varda's into Jane's mouth, such as when Jane admires the scars, blemishes, and other imperfections of human bodies more than their regularities. The film's spectators are also privy to the domineering role that men have played in Birkin's career, which the episode of being coached in singing by Serge Gainsbourg makes painfully apparent. In the sequence in which Jane reminisces about Marilyn Monroe and then sings Monroe's signature song, "My Heart Belongs to Daddy"—with its appeal to the lover as Daddy—provokes another moment of discomfort. In the film's final tableau vivant, it is Jane's fortieth birthday—a pendant to the events of the thirtieth birthday narrated in the film's opening—and the film's characters and technicians alike join her on the set to present her with flowers and offer congratulations. Jane observes that she is very spoiled—that perhaps her previously expressed desire to be filmed anonymously, as though she were just any woman, has been disingenuous. Nudged by Agnès, and during the process of making the film, Jane unsurprisingly realizes that her desires for both anonymity and stardom are incompatible. The process of making the film, playing its various roles, has served as Jane's education, calling to mind Brecht's contention that for the actor in epic theater the playing of roles should be a pedagogical and enlightening experience. (See chapter 7.) As in *Cléo from 5 to 7*, the central character, an actor, comes to a better understanding of herself. And what of Agnès? Interacting with her subject, Varda puts her own subjectivity on view.

Like *Jane B*, *The Gleaners and I* takes up the interrelation of word and image from the start, when Varda opens a Larousse and reads aloud its definitions of the term "gleaning." The dictionary illustrates these with paintings of gleaners, including the most famous, François Millet's *The Gleaners* (1857). Usually performed by women, the work of gleaning—of picking up the detritus left after the harvest—is what guides Varda's method in this film. It is predominantly an essay film and a collage of the diverse materials Varda has

gathered, a process illustrated in the work of the well-known French collage artist Louis Pons, whom she interviews. The filmmaker's method of gleaning and collaging is in keeping with the term Varda herself coined: "cinécriture," a writing with images that, as Domietta Torlasco puts it, is "at once specific and heterogeneous, gathers or occurs around the figure of the author, whose individual voice is as much constituted as expressed" by this process of composition.[67] Varda's film features footage of gleaning in different regions of France: wheat, potatoes, grapes, oysters, and refuse are gleaned in country and city, suggesting the ubiquity of the normally unseen and muted poor. Interestingly, the film's portrait of poverty coexists with the self-portrait of the filmmaker.

Indeed, the film's medial references have the double function of an objective, if targeted, exploration while also serving to elaborate Varda's subjectivity and experience. Varda began working as a photographer in the 1940s and '50s, and her films—most obviously *Daguerréotypes* (1976)—are rife with references to photography. Varda's love of painting also has echoes in the film: not only does *The Gleaners and I* make reference to the chrono-photography of Etienne-Jules Marey, ancestor of the moving image; it also visits *The Last Judgment* by Rogier van der Weyden (also known as the Beaune Altarpiece) and touches on a self-portrait by Maurice Utrillo, whose painted hand is cut with the filmmaker's own. Painting is seen in analogy with filmmaking, as when handheld shots seem to imitate a brushstroke. Literature also finds a place here: Jean Laplanche, interviewed primarily as vintner rather than post-Lacanian analyst, recites lines from Joachim Du Bellay, and Varda herself deliberately misquotes lines from Corneille's *Le Cid*[68] in a feminist gesture that makes them her own. The filmic collage sets high against low art—the bricolage of a junk collector is accorded the same attention as the van der Weyden. Reverence for the art of painting is counteracted by Varda's free hand with tradition, as in the misquotation of Corneille: postcards of Rembrandt portraits—one a self-portrait—exemplify and contain the tension between of high and low. In keeping with these juxtapositions, the film's emotional register connects Varda's political aim of documentarian *showing* with her melancholy but also humorous contemplation of her own aging and of temporality itself, as suggested by the clock without hands that Varda rescues from the junk pile.

Taking her cue from Millet's painting, Varda adopts a deliberately political stance that illustrates the plight of the rural and urban poor while interrogating her own face and body. The politics of Millet and his fellow painter of peasants, Gustave Courbet, mandate an art that speaks to the everyday life of the people, and Varda follows him in this. Gleaning was in Millet's time—and is today—a task performed by the poorest of the poor, who in France have the legal right to do so. An artist from a peasant background, Millet depicts three peasant women gleaning stalks of hay, remnants of the harvest, in a work that scandalized the French middle and upper classes. The women's bent

and worn bodies, their brown faces barely in evidence, are at odds with—in a dissonant relation to—groupings of three women that suggest mythological figures such as the three Graces.[69] This remnant of an idealizing classicism undermined by the imaging of swarthy peasants enhanced the political impact of *The Gleaners*. The painting's thematization of rural work provoked outrage as well, and the large size of the figures, a size usually accorded to religious or mythological figures, was perceived as controversial, an in-your-face reminder of the role played by peasants after the revolution of 1848.[70]

Millet's first peasant subject, *The Sower*, was perceived in its 1850 version to have been emergent—"the figure literally bulging from the canvas in virtual relief."[71] A later version of the painting was touted by Théophile Gautier as so lifelike that it seemed to have been "painted with the very earth that the sower is sowing."[72] Millet's pronounced layering of paint—his thick impasto—spoke both to the materiality of his work and to his interest in the material world per se. The emergent figure, the conceit of painting with the substance of the things depicted, and a fidelity to the material world: these are tropes that characterize realism. Varda imitates these realist gestures in her film. A sequence in Varda's film speaks poignantly to the notion that the realist painting is continuous with objects in nature: at the end of the film, she holds up yet another painting of gleaners, *Gleaners Fleeing the Storm* by Edmond Hédouin (1857), a painting she has unearthed from the storage rooms of a museum in Villefranche. This scene is filmed outdoors with two women supporting the painting, which is blown by gusts of wind (not quite a storm) as if it *were* the landscape it represents. And in an earlier sequence, Varda poses in a tableau vivant intended to materialize the female gleaner in Jules Breton's *La glaneuse*, a painting she visits in the Arras Museum of Fine Art. This tableau vivant is not simply an amusing way of enforcing Varda's identification with the female gleaner of Breton's painting. Standing next to Breton's canvas, Varda in a held pose speaks complexly of the relation of painting to the real world by performing a (figured) merger with the painted subject by means of the tableau vivant. (A reference to photography is present in this tableau as well: behind Varda is a colorful cloth, a scrim like those used in early photographic portraits.) This too is compatible with the project of realism. In the tableau of *La glaneuse* we find the embodiedness, the "making real" privileged by realism, along with the antithetical theatricality of the frontal direct look out. Here Agnès takes the approach to her image that she has urged on Jane. The frontal look is both a feature of the documentary genre and a way of acknowledging the artifice of the filmic medium. In other words, the tableau performs a "both/and" that allows it to evoke realism and yet to stand outside and against it in a gesture typical of modernism. Another ironic tension is expressed when the heroic stance and figure of Breton's gleaner is emulated by the filmmaker, who acknowledges her own diminutive physical stature and lack of ideal body while proudly assuming the heroic attitude of

the painted figure. Varda is confident in her role as filmmaker/gleaner, as a collector of images.

Following immediately on the tableau vivant is another sequence that undermines Varda's realist aesthetic. After a long tracking shot featuring the requisite mirrors for investigating the self, the digital camera comes to rest on Varda's face, creating pixelated, blurred, and arty images along the way that Varda refers to as "stroboscopic." The digital camera is used to create painterly images without clear contours precisely at the moment when Varda's own subjectivity—and aging body—are interrogated. The ability to expose—even to mock—the self and the body while nevertheless affirming them is one aspect of Varda's feminist stance. While she seems melancholy about the passage of time, Varda does not hesitate to film her gray roots or the age spots on her hand: "cemetery flowers," as she remembers her mother calling them. In this film the hands we see are often working hands, bringing Chantal Akerman's *Jeanne Dielman* (1975) to mind. While this is not the place to explore the repeated imaging of hands in *The Gleaners and I*, one instance in particular needs mentioning. It occurs when Varda uses her digital camera to "film one hand with the other," as her voice-over tells us. This may be the central trope of Varda's filmmaking in this film, one that playfully—and ironically—denies the gap between subject and object that haunts Western metaphysics,[73] a gap she had already tried to blur in *Jane B*. The image of one hand filming the other explains why the political project of exposing poverty can be embedded in the self-portrait—and vice versa. Homay King has rightly written that "Varda crafts a digital cinema that is materialist, feminist, phenomenological, and political."[74]

But is not the figured collapse of the subject (the filmmaker) with the object filmed (her own hand) problematic as a feminist stance? What is emancipating is not immersion into the object filmed, but rather an analytical attitude before that object. Only if we keep in mind the mediating—and, more important, *alienating* function—of the camera as instrument does Varda's feminist project remain intact. Her digital camera does not cut "deep into [the tissue] of reality," as Benjamin famously argues concerning the cinematographer's camera.[75] Unlike the camera that produces the photographic, indexical image, the digital camera's technology dematerializes the objects seen through the viewfinder into numerical digits—even as Varda's film affirms the material world through its ubiquitous objects and the hands that touch them. In other words, a dissonant textuality is produced by the digital camera's dematerializing medium over and against Varda's many gestures toward the material, resulting in a textuality in a state of tension. Echoed formally by the many fragments and disparate narratives of which *The Gleaners and I* is composed in juxtaposition with its subjective, associative editing, the tension between fragment and whole remains suspended. Could this be a way in which a Brechtian open-ended form is accommodated to a feminist aesthetics?[76] Might

not the insistence on realist immersion in conjunction with modernist effects of distanciation be a feminist stance against the aloof intellectuality of male modernism?

Other echoes of a Frankfurt School aesthetic are at play in *The Gleaners and I*, most notably in Siegfried Kracauer's insistence on film's project of redeeming (by showing) the things of the world,[77] and in the important overlap of gleaning with collecting. The collection forms the basis for Varda's film collage—it is a collection of people, places, things, and media. When Varda misquotes Corneille and makes the lines her own, we recall the Benjaminian strategy of fragmenting texts through citation and—as Hannah Arendt asserts—Benjamin the writer who prized his quotations from the texts of others more than his own writings.[78] We may find another source for the film's collection specifically of images of hands in Benjamin's "Unpacking My Library," where he observes that "property and possessions belong to the tactical [tactile] sphere. Collectors are people with a tactical [tactile] instinct."[79] To touch an object makes it one's own: it is a mode of acquisition,[80] a way of augmenting the collection—and, more importantly, the self the collection defines and amplifies. (See chapter 6.) While tactile images can only be simulated, the many hands of *The Gleaners and I* repeatedly bring touch to mind. When Varda makes a "lens" with her thumb and finger, suggesting the capture of images, the link between image and collection is confirmed.

Interestingly, a collection itself creates a narrative that, as Susan Stewart puts it, "seeks to reconcile the disparity of interiority and exteriority, self and object,"[81] a project that resonates with the sequence from *The Gleaners and I* that features one hand filming the other. Stewart's meditation on the collection prompts us to ask whether that sequence should be read as an ironic but also as an explanatory narrative: by way of the collection the self is put on display. Viewed in the context of the film as a collection of specially selected images the seemingly arbitrary inclusion of Varda's souvenirs from her trip to Japan is not arbitrary at all, not merely another filmic gesture toward thingness and materiality. Rather, it is linked to the discourse on time that the prominent theme of the filmmaker's aging evokes. Varda's souvenirs—and the other objects in her filmic collection—call out for a supplemental narrative "which articulates the play of desire," a personal narrative such as we find in the voice-over integral to Varda's film.

But it is not primarily the self with which Varda's filmic collection concerns itself. The many kinds of gleaning imaged in the film—of which filming itself is only one—produce a narrative structured by the regions of France, as well as a view into the country's class structure and its arts. Perhaps we should put it this way: *The Gleaners and I* connects its politicized portrait of many Others with that of the filmmaker's aging body, by means of which Varda emphasizes the human fragility she shares in common with her subjects, once again blurring the lines between them. Also a portrait of an Other as well as of the self, *Jane B par Agnès V* pits iconic images of women against one another,

with gender predictably revealed as a construction. The sheer superfluity of this earlier film's iconic images serves to call them all into question, to leave us—as in *The Gleaners and I*—with the image of an aging material body: at the end of the film Jane Birkin celebrates her fortieth birthday on the set. In *The Gleaners and I*, her later film, Varda's emphasis on female roles is subsumed by a focus on social roles. In both films Varda portraitizes bodies that bear the marks of labor and time—like Millet and Breton—while calling attention—like Manet—to the medium that enables her to do so.

Death's hand arranges the gold coins. *Destiny* (Fritz Lang, 1921), frame enlargement.

Chapter 5

Props

Object and Thing in Lang's German Films

"The Apartment of a Collector" is the title of the photo essay in *Die Dame* (1923/24) that features the fashionable apartment shared by Fritz Lang and Thea von Harbou on Berlin's Hohenzollerndamm.[1] A Chinese rug with dragon motif covers one wall of the living room, while vases and scrolls of the same provenance join a cabinet with a collection of East Asian statuary on another. One of the photos shows Lang posing proudly beside the display. Erotic drawings by Egon Schiele and paintings by Gustav Klimt (said to have influenced Lang's own paintings) decorate the walls, as does Lang's extensive collection of masks from Ceylon, Africa, and Japan. In the dining room, carved wooden furnishings coexist with Russian icons and ornate candelabra. Although these interiors house an eclectic assemblage of objects, their décor forms a harmonious, if ornamental, whole. Objects are not merely accumulated, they are imaginatively displayed. Art and life are coextensive. Von Harbou's robe suggests that the apartment's décor is a total environment in which costume also plays a role: as art director Erich Kettelhut reports, von Harbou's dress on set always reflected the style of the film in production.[2] Lang's collections similarly connected the domestic environment to the sets of the films: *Spies* (1928) contains a notable space in which Lang's Russian icons are featured, while his collection of masks adorns Baum's study in *The Testament of Dr. Mabuse* (1933).

Is it Lang's collector's drive—a drive that extends the self into the object world, enacting control over objects—that is operative here?[3] By the time of the essay in *Die Dame* (1923/24), Lang had already achieved a reputation for the two-part *Spiders* (1919/20), *Destiny* (1921), and *Dr. Mabuse the Gambler* (1922); *Siegfried* (1924) and *Kriemhild's Revenge* (1924) were soon to appear. Aestheticized décors rife with objects are featured in all of these films. But the urge to collect is only one pressure that acts on objects in Lang's German films. Even if it had explanatory power, suggesting materialist as well as aesthetic concerns, Lang's collector's impulse is both inflected and contextualized by a variety of discourses that surround objects in the first three decades of the twentieth century. Objects function in Lang's work in ways that are consistent across the films, suggesting an aesthetic if not psychological predisposition toward them, but they are also subject to historical trends in image making.

Consequently, this chapter examines objects in Lang's films from 1919 through 1933, contextualizing them within aesthetic and cultural orientations toward the object during this time, as well as within object/thing distinctions more recent and more speculative. While it locates Lang's representation of objects with respect to décor and mise-en-scène, this discussion extends beyond formal concerns. A surplus of significance is accorded to objects and things in Lang's work—more is always at stake. While they are never far removed from gesture, performance, or the relation of vision to tactility, objects tend to signify only obliquely in their relation to the actor, complicating André Bazin's contention that in film the mainspring of the action "goes from the décor to man."[4] Predictably, the tendency of objects to take on emblematic meanings is more prevalent in earlier films such as *Destiny* (1922) and the two Nibelungen films, films inflected by Expressionism. Later, by the mid- to late 1920s, objects in Lang's films tend to speak to the indexicality of the photographic image enshrined by Bazin, even as their gestures toward cinematic realism are contained by an overriding modernism. And since significant objects in Lang's films often include letters and maps, pictorial signs and writing also come into play, transforming inscribed things into harbingers of death, into Things that stand in death's place.

Temporality and death are centrally at issue. Objects, writes W. J. T. Mitchell, "are the way things appear to a subject." Things, on the other hand, "play the role of a raw material, an amorphous, shapeless, brute materiality, awaiting organization by a system of objects."[5] With roots in Derrida's work on the poetry of Francis Ponge, Bill Brown's "thing theory" likewise affirms the distinction between object and thing with respect to form and formlessness: "Temporalized as the before and after of the object, thingness amounts to a latency (the not yet formed or the not yet formable), and to an excess (what remains physically or metaphysically irreducible to objects)."[6] Lang's films struggle to express this latter conception of the Thing as unrepresentable excess, an attitude toward the object later taken up by Alfred Hitchcock. For Slavoj Žižek, the object-stain and the Thing are intimately connected in Hitchcock's cinema: "metaphysically irreducible," in Brown's parlance, they point to the paradoxical attempt of the image to figure the unrepresentable Real. As Žižek suggests with Lacan, it is the object-stain, a representation that fills out a hole in the Symbolic, which gives form to the unrepresentable.[7] In Hitchcock's films the stain may be an uncanny object, the object gone awry, incongruously rendered or denatured by its context. The glow of a cigarette in a dark room (*Rear Window*), a corpse in dramatically foreshortened perspective, feet sticking up (*The Trouble with Harry*), or the awkward and looming ship in the set of *Marnie*: these uncanny Things cover over the fissure in representation that speaks to the presence of the Real. Similar moments occur—albeit earlier—in Lang's German films. And trumping Hitchcock in prospect are those images in Lang in which the movement between form

and formlessness, between taking shape and dematerializing is foregrounded, moments when figure/ground relations are virtually indistinguishable.

The following discussion takes up Lang's imaging of object and thing in some detail. First it focuses on the notable and curious conjunction of object and hand that runs through Lang's oeuvre. There follow discussions of the object in its relation to indexicality, of objects in regard to pattern and abstraction, of the art object and, finally, of the inscribed object/thing. We will begin, however, with the attitudes toward objects and things that circulated in the visual arts during the first few decades of the twentieth century, attitudes within and against which Lang's filmed objects must be located.

The Avant-garde; Expressionism; the New Objectivity

A preoccupation with the capacity of cinema to transform the objects of the material world permeates the discourse of the European avant-garde from 1918 through the late 1920s. For Jean Cocteau, writing in 1919, "a sort of moonlight sculpts a telephone, a revolver, a hand of cards, an automobile. We believe that we are seeing them for the first time."[8] Objects in film are enhanced by *photogénie* in Jean Epstein's "Magnification" of 1921, in which it is the close-up and movement that serve as the "intensifying agents" that endow objects and faces with photogenic—poetic—qualities.[9] In "On Décor" (1918), Louis Aragon notes that "on screen objects that were a few moments ago sticks of furniture or books of cloakroom tickets are transformed to the point where they take on menacing or enigmatic meanings."[10] The auratic quality with which the camera endows the object as described by Cocteau, the poetic quality of an ineffable *photogénie*, and the enigmatic qualities of objects are supplemented by menacing meanings that emerge when objects seem uncannily to have lives of their own. In a comedic vein, the latter attitude is the motor of Chaplin's comedies, mentioned by all of the writers cited above. A similar perspective on objects still governs Hans Richter's 1928 avant-garde film *Ghosts before Breakfast*, where hats, plates, and other objects comically elude human control. This attitude is integral to German Expressionist films, in which the presence of uncanny objects is a film historical cliché.

Writing in 1924 about "the face of things," Béla Balázs notes that "every child knows that things have a face, and he walks with a beating heart through the half-darkened room where tables, cupboards and sofas pull strange faces at him and try to say something to him with their curious expressions."[11] In these early writings, Balázs defines Expressionism as the tendency to bring the latent physiognomy of things into view. Later, in *Theory of Film* (first published in Moscow in 1945), Balázs posits a "physiognomic resonance" that establishes continuity among material objects, the human face, and the landscape that film lays bare. In this later text, "physiognomic resonance" is

a photographic quality, one not operative in Expressionism. For the Balázs of *Theory of Film*, the Expressionist *Cabinet of Dr. Caligari* (1920) is uncinematic, a "film-painting." Citing Van Gogh's late paintings as examples, he claims that objects in *Caligari* have "an even more intense physiognomy, so that the violent expressive power of the objects makes the human characters pale into insignificance."[12] "In the earlier *Expressionism and Film* (1926), Rudolf Kurtz also comments on objects in Van Gogh's paintings, in which Kurtz reads "the dynamic power of things scream[ing] to be given form."[13] Kurtz's formulations were taken up by Lotte Eisner in *The Haunted Screen*, published in France in 1952, and they are not far removed from the fixation on the "non-organic life of things" that Gilles Deleuze sees in Expressionist film more than thirty years later.[14] In the German school, Deleuze suggests, it is the intensity of the inorganic life of objects that calls out for expression; in it "the difference between the mechanical and the human has dissolved, but this time to the advantage of the potent non-organic life of things."[15] Here Deleuze echoes Balázs, Kurtz, and Eisner—and Raymond Bellour. In 1966, following Eisner, Bellour had suggested that in Lang's films, "the object . . . seems to acquire through the intensity of its images something of the same symbolic life as the bewitched objects in Hoffmann or Arnim; the subject, an errant body, is often no more than an object among others."[16] In Bellour's reading, the gap between subject and object is uncannily bridged in favor of the object.

But to what extent is an Expressionist orientation toward the object actually operative in Lang? Although some of their décors are indebted to the Expressionism, his films are never wholly given over to this aesthetic disposition. In *Dr. Mabuse the Gambler*, it is primarily the ornamental spaces of the gambling clubs and certain chic interiors that reflect this style. But the gambling clubs' geometric designs are out of sync with the human bodies that inhabit them; the placement of the actor amid patterned walls, ceilings, and floors is even more incongruous than in *Caligari*, where, as film historians agree, costumes and gestures to some extent incorporate the actors' bodies into the artifice of the set. (See chapter 1.) In the court sequences in *Kriemhild's Revenge*, however, their patterned costumes overwhelm the actors, who seem merely to function as part of the overall décor—a point that Eisner made in 1952[17]—and the movement of the human body is slowed to a nearly inorganic motionlessness.

When objects in Lang's films do display the intensities of the Expressionist object, they tend to be revealed in subjective shots that express visionary states or madness. In this manner, they live on in his films through the hallucinated glass telephone and desk of *The Testament of Dr. Mabuse* (1933). Even in *Destiny*, hallucination transforms a loving cup into an hourglass on which a skeleton is superimposed, rendering the inanimate object a thing doubly marked by temporality and death. Since *Destiny*'s significant objects—primarily figurines or sculptures—have a human form, here too objecthood suggests the ossification of life rather than the animation of the object.[18] When

Metropolis (1927) does in fact animate the inert statuary of the Seven Deadly Sins, it is Freder's hallucination that brings the allegorical figures to life. Here is also where we find that conjunction of the mechanical and human cited as another signpost of Expressionism by Deleuze, since the crazed inventor Rotwang, having lost one hand while creating the Machine Woman, wears a mechanical hand in its place. But nowhere in *Metropolis* do organic and inorganic dissolve in favor of "the potent non-organic life of things."[19] Reinforcing the conjunction of mechanical hand with living body, the black glove Rotwang wears would seem, rather, to mark the hand as Žižek's uncanny "thing that sticks out," an object-stain.

Like many of Lang's other films, *Metropolis* is a stylistic hybrid. Along with its residue of Expressionism, it is shaped by the machine aesthetic of Constructivism that came to Germany from the Soviet Union in 1921, an aesthetic that favored the mass-produced object of industrial process. But although the film was released during the period of the New Objectivity, this aesthetic is not in evidence, even though *Metropolis* was released in 1927, the same year as *the* filmic exemplar of this movement, Walter Ruttmann's *Berlin, Symphony of a Great City* (1927). What these films share in common, in fact, are sequences in which objects—and people—are used for their formal properties, abstractly and ornamentally, as Siegfried Kracauer bitterly noted.[20] For Kracauer the prevalence of mute objects in Weimar film symbolized the ascendance of a Fascist ideology, no matter whether a film participated in the Expressionist or the more "matter-of-fact" attitude toward objects touted by the New Objectivity.

As an artistic movement, the New Objectivity began with a gallery exhibition curated in 1925 by Gustav Hartlaub. In his monograph on the New Objectivity published shortly thereafter, titled *Post-Expressionism*, Franz Roh praised the object orientation of the New Objectivity using the term *Gegenständlichkeit*,[21] a term best translated, perhaps, as "objecthood." Like Expressionism, the New Objectivity does not refer to a coherent visual style: some critics claim that it is not objects themselves that are at issue in the paintings, photomontages, and films connected with the New Objectivity, but rather a new attitude toward the world, an objective attitude designed to supplant the subjectivity of the Expressionism. Others suggest that beginning in 1925 a new realism enters film, now replete with the objects of everyday life, objects that define the space of human action. In these attempts at periodization, the role of objects is subject to various forms of instability, especially that of ideological orientation. For the Constructivist, use value and mass production have the salutary effect of undermining the uniqueness of the art object, and to a certain extent this attitude was shared by most practitioners of the New Objectivity. But it was not the only attitude toward the object held during this period. Concurrently, new photographic techniques promoted abstraction in still photography: in 1928 the *Film und Foto* exhibition in Stuttgart in particular featured photographs of objects displayed for their abstract qualities.

That same year, Albert Renger-Patzsch published a book of photographs titled *The World Is Beautiful*, a collection despised by Walter Benjamin. Indeed, in an address to the Institute for the Study of Fascism held in Paris in 1934, Benjamin bitterly condemned the "New Matter-of-factness," complaining that bourgeois modes of production and publication were assimilating and thus neutralizing revolutionary themes. When photography becomes "more modern," he claimed in "The Author as Producer," it does not depict a "tenement block or a refuse heap without transfiguring it."[22] Referring to Renger-Patsch's photographs specifically, Benjamin vilified their transformation of abject poverty into an aestheticized object of consumption. Still photography, he argues, requires the help of a caption—of language—to make a political point. Not photography, but cinematography has an emancipatory capacity for Benjamin: in conjunction with editing procedures, it promotes the critical dissection of the world it records, making material objects and their traces newly visible, opening up the sedimented ideologies they reveal. Ideologies are legible in surface effects and by means of the optical unconscious—Benjamin's much-cited term—which cinematography reveals.

Interestingly, Renger-Patzsch originally planned to call his collection of photographs *Die Dinge* (*Things*), a title his publisher asked him to change. Could the publisher have decided that the proposed title spoke too clearly to the special status of *das Ding* in German poetry and philosophy? *Das Ding*—as opposed to *der Gegenstand*, which accords more closely with our term "object"—suggests a rather different concept of an object from that promoted by the New Objectivity. In the German philosophical and cultural tradition, the *Ding* is another matter entirely, as Rainer Maria Rilke's *New Poems* (*Neue Gedichte*), with their *Dinggedichte* (poems about objects), makes clear. Written in Paris early in the century, the *New Poems* were published in 1907, while Rilke was engaged with the second part of a monograph on the sculptor Rodin and an essay on Cézanne, the objecthood of whose paintings he—and many others—praised. From Rodin Rilke claimed to have learned to see objects as a sculptor might: *sehenlernen* (learning to see) was his leitmotif during the writing of these poems; their poetics, Rilke claimed, was based on the sculptural technique of modeling (*le modelé*). Thus the metaphor of the shaping hand is central to Rilke's poetics and writings, where the making of poetry is repeatedly referred to as *Handwerk*, work of the (sculpting) hand. Although the topic cannot be pursued here, Rilke's *New Poems* refined the German lyric tradition of the *Dinggedicht*, poems indebted to Kant's idea of the *Ding-an-sich*, poems that portray art objects as autonomous, inviolable, and utterly detached from their observer. Clearly, this poetic orientation toward the *Ding* has little to do with the representation of reality. Rather, as I argue in another essay, poems such as these strive for the verbal capture of material objects—often to the extent of figuring themselves as objects.[23]

We have moved, then, from the interest the avant-garde takes in filmed objects from 1918 and beyond to the fraught subjectivity of the Expressionist

imaged object in film (1919–25), through the photographed and filmed object of the New Objectivity (1925–33), whether reflective of contingency and the everyday or aestheticized, and finally to the art object outside use value, a concept with a firm hold on German culture from Kant through Heidegger. In addition to these loosely periodized cultural orientations toward objects, we also noted the collector's orientation toward objects, and Žižek's Lacanian reading of the Thing as marker of the unrepresentable, of death, of the moment when "the object looks back." All of these orientations toward the object world in art can be located in Lang's German films; indeed, it is their spectrum of orientations toward the object and thing that sets Lang's films apart from other films of the Weimar period. Since these attitudes do not exist in isolation in Lang's films, but coexist and overlap, a strictly chronological study would miss the mark.

Object and Hand

In *The Diamond Ship* (1920), part 2 of *The Spiders*, the adventurer Kay Hoog is consulted by the Englishman Terry about the whereabouts of the "Buddha-faced diamond," whose location is charted on a missing map. The need for information is pressing: Terry's daughter has been kidnapped by an international gang, the Spiders, and they will exchange her only for the diamond. Fortunately, a clue to the diamond's whereabouts is at hand: Terry's ancestor's logbook mentions the jewel. As Terry relates the story to Hoog, a flashback illustrates the ancestor's sojourn in a Falkland Islands cave: imaging the story, the film shows a man holding out a diamond-filled hand. Consulting the logbook's text for clues, Terry and Hoog debate a puzzling passage: "I hold my hand over what is mine." Since the ancestor's portrait is conveniently in place over Terry's mantle, Hoog's glance at the portrait prompts him to read these words literally. Then, in running his hand over the painting's surface, Hoog feels the texture of actual paper: what seemed to be an image of a document in the ancestor's hand is a document in actuality. Removing it from the painted surface with a knife, Hoog discovers that it is the missing map. The following shot—of Hoog's unmoving hand holding the map—is a signature shot for Lang; shots of hands holding objects will continue to be in evidence in his films through the American years. When, in the next shot, a spying servant pens a message about Hoog's find, the camera focuses on the servant's writing hand. Until this sequence with logbook and portrait, there had been only two fleeting shots of hands in this two-part, 137-minute film, but these are fugitive images, glossed over, not particularly in the service of narrative or image. The portrait scene is where the Langian fixation on the hand begins.

What is happening in this scene? The hand becomes the focus of attention in the dialogue, cuing Hoog to the whereabouts of the missing document both as word in the logbook ("I hold my hand over what is mine") and as an image

in the portrait. By conjoining text and image to produce meaning, logbook and portrait resemble the medium of film. When the verbal cue in the logbook leads Hoog to use his hand for exploring the portrait, a modernist interest in the tactile image is in evidence and objecthood is figured. More importantly, when an image is revealed to be an object, a decided rupture in the film's illusionism takes place, one that renders the object uncanny. Does this sequence speak only to the "making real" of cinematic representation? Or does it speak to a tactile appropriation of the visual?

Clearly, the map in *The Diamond Ship* is not an object that contributes to an impression of reality. It figures in the plot, of course, but it is not simply a prop: the objecthood of the map is confirmed in *The Diamond Ship* by the act of display. If the map's transformation from an image in a painting to a "real" map had not already marked this object's importance, then the close-up of the hand that holds it out for viewing would confirm it. Like other maps in Lang films, it is inscribed with a mix of letters, images, and indecipherable pictorial signs. Such objects figure frequently in Lang's German films and, as I will argue later, resemble the object-stains and sinthoms that Žižek discerns in Hitchcock.[24] As we noted, the displayed map is followed closely by the image of a writing hand producing yet another document. As an image for the production of textuality, this shot figures the modernist preoccupations of Lang's Weimar period films. Thus a spectrum of images, objects, and Things emerges even in this early film.

The hand comes similarly into play in *Destiny*, made the following year. Again two shots feature a hand—which happens to be the hand of Death himself. Using finger and thumb, Death arranges coins in rows, creating a pattern that would render the image nearly abstract if the arranging hand were not present in the frame. Is Death an artist? This shot confirms the interest in line and abstraction in Lang's films, perhaps a tribute to the avant-garde. But the shot also speaks to the collector's fixation on arrangement and display (coin collecting is one of the most common forms of collecting) and—more pointedly—to the tactile inclinations of the collector. And by manipulating the coins, the hand of the maker fashions an abstract yet decorative material image whose display briefly suspends cinematic narrative in favor of the image. There follows a shot of another hand as it reaches into the frame, a hand that puts signature and seal to a document: the document to which the hand appends a signature is the deed that cedes a plot of land to Death. One shot of a hand stresses the design of the image while another images writing—these, too, are signature shots. By these means, the tactile and the visual are intimately linked.

In later films, hands take on multiple functions. In *Spies*, a film that gestures toward the New Objectivity in significant ways, a noticeable temporal ellipsis elides the scene of the protagonists' lovemaking by way of a montage that begins and ends with the lovers' clasped hands. Here the passage of time is both pointed to and denied by the image: once again images of objects stand

in place of action. Yet in *Spies* the camera also pays attention to hands as they perform an elaborate series of actions: Sonja's hands fix tea, move cup and saucer over to a samovar, lift a cream pitcher, and hold out a cup to the hero, Number 326. These actions of everyday life would seem to accord with the concerns of the New Objectivity, but the silver tea things and samovar form part of a carefully arranged still life display of *objets* very likely taken from Lang's personal stock. (Not surprisingly, Lang's excessive ministrations to such objects and their imaging, even in his American films, was a source of frustration for his actors, for whom the many hours devoted to their shooting seemed obsessive.) In the tea sequence, then, a concern with aesthetic display undermines the quotidian actions performed by these hands, whose transactions with objects evoke the arranging hands of the collector.

In the Langian shots that feature the hand in relation to the object, the stress is on the tactility of the film medium—on the way touch is evoked by the presence of the hand or the way hand and eye together "make real" the phenomenal world by simulating three-dimensionality. But in *Spies* objects also circulate by way of hands much as information circulates via a surplus of technologies—or the media. Their end point is death. The much-commented-on opening sequence of *Spies* features a rapid montage of hands at work. In the opening shot hands reach into the frame, manipulating an as-yet-unidentifiable object soon to be revealed as the lock of a safe. (Similar shots of hands occur in *M* and *The Testament of Dr. Mabuse*.) Gloved hands fill an envelope with the stolen documents that other hands transport to their destination—to the waiting hands of Haghi, the master criminal. When, at the end of this rapid opening montage, Haghi looks malevolently out of the frame in close-up, the fourth wall and the film's illusion are broken, causing a moment of textual rupture that recalls the discovery of *The Diamond Ship*'s imaged document become object. Holding the documents and looking directly out of the frame, Haghi is marked as Death.[25] The following shot is puzzling: a small slit of light interrupts a black frame, resembling somewhat the letter *I*. But is this a slit of light in the darkness—or is it a white mark superimposed on a black surface? Effects of surface and ground are blurred, rendering the image indecipherable, signaling the "nameless figure of the Real that cannot be perceived or represented," according to Mitchell, which, "when it destabilizes or flickers in the dialectics of the multi-stable image . . . becomes a hybrid thing."[26] Not surprisingly, this shot recalls a similar moment in *Destiny*, the moment when a slit of light in the middle of a black frame expands to become the Gothic doorway into the domain of Death.

Toward the end of *Spies* the hero, Number 326, will be discovered in the rubble of a train wreck when Sonja catches sight of a hand sticking uncannily straight up and out of the rubble. (For Žižek this hand would belong to the phallic regime of the signifier.) Sonja recognizes the hand as belonging to 326 because it is holding the medallion with Virgin and Child she gave him as protection from Haghi. The medallion is a magical object, one that has ritual

significance; archaic rather than modern, it belongs to another regime of the object altogether. During the course of the film, the medallion is repeatedly lost and found, once emblematically landing on the hero's heart. It is a prop, then, for the film's romantic subplot, albeit one that co-opts the object of Expressionism with its "life of its own," recuperating it for romance and Christianity. Then, some seconds later, the hero's hand again pops up out of the rubble. This time it is holding a gun, a harbinger of death, a Thing. When the amulet that wards off death is replaced with the weapon that brings it about, the hand seems to be performing its intended function. Earlier in *Spies*, the camera focused on a hand in close-up placing a gun on a table in order to encourage a traitor to shoot himself. We see the hand and gun in close-up— the suicide we do not see. Many years later, the opening shot of *The Big Heat* (1953) is of a gun on a table. Then a hand invades the frame. In the next shot a man picks it up and shoots himself. In both films—*Spies* and *The Big Heat*— the hand/object relation and the close-up that reveals it disrupt narrative in favor of the image even as they link the object to narrative, as in a gun used to commit suicide.

As suggested above, hands figure in the most enigmatic of Lang's signature images: a stilled image of a hand in close-up holding an object, an insert shot that doesn't further the narrative, but simply displays hand and object to the view. Is it the hand or the object that is of greater significance? Perhaps Lang's signature shot is a poignant one, one that seeks to visually bridge the gap between subject and object that has long plagued Western philosophy. Or does the motionless hand itself become object, like the object it proffers? In one sense at least, the hand suggests that the making of film is *Handwerk*—as when Rilke refers to his *New Poems* as *Handwerk*, verbally sculpting or giving shape to the objects of the world.[27] Interestingly, Lang himself studied sculpture as well as painting. Clearly, the Langian focus on the hand is fetishistic and overdetermined: as Tom Gunning points out, images of hands in Lang films are usually of his own.[28] As we have seen, the hand often figures in connection with death: in *Metropolis*, the black glove on Rotwang's prosthetic hand marks the hand of the Maker as the hand of death.

Indexicality and the Object

As Joe McElhaney has noted, "Lang's work is dominated by the fingerprint, the footprint, the trace, the index."[29] The indexical image is all-pervasive in *Spies*, and noticeably present in *M* (1931) and *The Testament of Dr. Mabuse*, but it is not surprising that films made during the New Objectivity, especially films of the detective genre, should be haunted by photography. It's here that the objective, rational orientation of the New Objectivity may be most "in evidence" in Lang's German films, where good guys as well as bad look fast

and furiously for clues. In *Spies*, a policeman's hands hold a small camera used for espionage up to our view, and the master criminal Haghi drops into a wastebasket shreds of a photograph that has served to incriminate Lady Leslane. Since Haghi has the negative, he tells the woman he is blackmailing, more copies of the photograph can be made. Photographs have truth value—they serve as evidence and are reproducible—but the film's attitude toward this practice is often comedic or ironic. The film clearly views the photograph albums kept by the head of the Secret Service satirically: although they closely resemble family albums, one album, marked by a black cross in the manner of German death announcements, contains only photos of spies who have died. Photographs not only serve as evidence but also speak eloquently of arrested time and arrested life.

Along with photographs of their dead, the Secret Service keeps snapshots and fingerprints of foreign spies on hand. Headshot and fingerprint are printed together on the same card, as if to reinforce the photograph's indexicality by way of the fingerprint that shares its ontology. Both record the past presence of the body in the image. In *M*, the fingerprint of the child murderer and rapist is projected on a screen, hugely amplified: its scale registers its significance—perhaps its monstrosity—and also, perhaps, a pride in magnification as the product of technological innovation. But the greatly enlarged image also renders the fingerprint abstract, hence relativizing its "objectivity" by way of an aesthetic charge. Handwriting analysis is practiced, but when "science" in its various forms is enlisted in the service of "truth," it is treated ironically.

A chalk print of a hand marks the murderer's shoulder in *M*. This hand-print is the mark of Cain, as has often been suggested—but it is most resonant simply as an imprint made by a hand. In *Spies*, bodies and objects variously leave their mark. In a comedic mode, 326's body is registered when, in his Chaplinesque tramp disguise, he leaves indexical hand and fanny prints on a white chair. Evidence of his presence, they are quickly covered with a blanket to hide them from the police. A spy working for the Japanese secret service makes a wax impression—another indexical image—of the lock of Sonja's front door, hoping to produce a key that will admit him to the house. Intending to send a telegram, Number 326 writes on a blotter that retains traces of other scribblings; unbeknownst to him, carbon paper under it records his message on another sheet of paper. Indexicality and the photographic imaginary are at issue here, even if what is being traced—literally—is writing.

The photographic imaginary is equally in evidence in the film's décor. After the opulently decorated interior of Sonja's house—its walls once hung with an array of Russian icons and crucifixes—is stripped bare by Haghi's men, its walls are shockingly empty, denuded. Marking the place where the objects once hung are dust or soot marks that reproduce their outlines; 326's flash-light plays over them in the dark interior. Light passes over the traces of things: this is what happens in cinema. Gone are the signifiers of "Russianness," the

richly textured icons, the silver samovar and tea things over which the camera had lingered earlier. Now the walls are bare and modern, in keeping with the architecture of the house. Only the outlines of objects speak of their past presence as elaborately furnished interiors make way for the indexical trace. Perhaps the replacement of the ornament by the trace that denotes its absence in these spaces is a response to contemporary critiques of the ostentatiously ornamental *Siegfried* and *Kriemhild's Revenge*.

Like *Spies*, *The Testament of Dr. Mabuse* contains a notable sequence that features the trace of an object no longer present, a moment that—at first glance—seems also to speak to the film's photographic imaginary. This is the outline of a urinal, its former presence imprinted on the wall of the room that contains the "man behind the curtain," the Mabuse facsimile comprising a cutout figure and a loudspeaker with recorded messages. Does the outline of the urinal function as bathroom humor to entertain the spectator? Or does it recall Marcel Duchamp's *Fountain* (1917), by means of which Lang wittily allies himself with the artistic avant-garde? In this sequence Kent, trapped in the room with his beloved Lili and listening to the ticking of a time bomb, catches sight of the water pipe that once serviced the urinal and breaks it off in hopes of promoting a flood. Sure enough, after the water reaches a certain level, the floor opens up and a huge fountain sprays up in the middle of the room. Perhaps alluding to Duchamp's "fountain" once again, the geyser of water also brings to mind the male member associated with the urinal, this time perhaps—since Kent and Lili think their hours are numbered—in an erotic key.

There is humor and irony, then, in this sequence, and it is also at play when Mabuse, the "man behind the curtain," is revealed to be no more than a wooden cutout in human form. By this means the film's investment in indexicality as a bearer of truth is called into question, insofar as this sequence features several shots in which the cutout figure and the loudspeaker are shown to be floating amid debris in the gradually rising water, shots that reveal the great Mabuse to be a hoax. It has not been the body of Mabuse at all that has cast a shadow on the curtain, but its facsimile. Both cutout figure and loudspeaker are tied to the cinematic medium, also at issue when Kent shoots into the curtain, literally depriving the medium of the curtain that alludes to performance and covers over illusion. This laying bare of the device also includes a formal marker: it occurs when the film breaches the fourth wall immediately after Kent's shot into the curtain. There follows a reaction shot on the part of Kent and Lili, whose frontal stares break the fourth wall and register shock at what they see. Only after this reaction shot do we see the object of their looks. However fleetingly, for a moment it is we the spectators who seem to provoke their consternation. We are in the place of Mabuse as object-stain. Thus *The Testament of Dr. Mabuse* undermines the veracity of the photographic image, dismantles the cinema machine of which the spectator is a part, and asserts its modernism.

But the film's modernist self-consciousness does not preclude the fact that *Testament*, like *M*, is engaged in displaying the world of objects. In the film's opening shot, the camera meanders along a cellar room crammed with a superfluity of junk. *Testament* features tables covered with loot in the process of being sifted by criminals, and the camera repeatedly focuses on arrangements of objects on desks, a still life, a favorite image in this film. Clocks and telephones are prominently displayed on desks, pointing to the animating mechanism of Lang films, the mechanism Tom Gunning calls the "destiny machine."[30] Lohmann's desk holds a messy accumulation of objects that includes pipes and coffee cups. Kent's is sparsely arranged, featuring fetishistic objects that recall his lover Lili—her photograph and a small bouquet of violets that she has touched to her face and that Kent himself has kissed. Dr. Baum's desk displays primitive statuettes and Mabuse's writings, and an Expressionist scene features the mad Hofmeister's imaginary desk, on which all objects, including a telephone, are made of glass to indicate that they are hallucinated by this mad detective. In this film—granted—desks and tables have something to say about their owners, yet the film's attention to objects exceeds its interest both in realism and metaphor. *Testament*'s editing procedures underscore the film's attention to objects, to props: time and again sound bridges "connect"—by means of juxtaposition only—radically disjunctive imaged objects with objects mentioned in the film's dialogue—such as a bomb with a soft-boiled breakfast egg, or a shot of a chemical fire with Lohmann speaking the words "magic fire music" from the libretto of *The Valkyrie*, or a conversation about Mabuse as master criminal with a cut to the floating cutout or to his corpse in the morgue. Since sound and image are on a collision course in their interest in registering objects, the film's editing procedures contribute to its self-parodic project and once again expose it as a modernist construction. Particularly in *Testament*, indexicality is undermined by formal procedures that relativize it. Given that the film was completed in 1933 and Hitler had already come to power, it is not surprising that the evidentiary value of representation is called into question.

Be that as it may, the photographic process does have a pivotal role to play in *Testament*, after all. Photographic procedures are essential to deciphering the scratch marks that the mad detective Hofmeister has etched into a windowpane. These scratches are revealed to be Mabuse's name—which both does and does not solve the mystery. As Lucy Fisher has astutely pointed out:

> The process of deciphering the name of Mabuse seems like nothing so much as a procedure for printing an image from film. The glass pane is a negative that must be "developed" with certain chemicals to strike a "print" . . . The word scratched into the pane bears a striking relation to what we must do to read a word etched into the emulsion of a film frame as it comes off the reel: we must flip it laterally and turn it upside down.[31]

Fisher also notes that in the background of this scene there is a camera on a tripod that serves to cement the connection. But perhaps it is *not* just the truth value of photography, its customary role in the detective genre, that's actually at stake here: perhaps it's the latter part of Fisher's reading, "a word etched into the emulsion," that should be emphasized in explaining this sequence. Lang is known for having personally scratched words and images onto the film stock of a number of his films—this technique was used for the bursts of light in the Tower of Babel sequence in *Metropolis*, for example, and as late as *House on the River* (1950), which features an image of a small fish inscribed onto the negative.[32] Thus the trace of the object, the trace of the real that privileges the indexical image—an image that takes up something of the object or person into itself—coexists with the deliberate inscription of the film stock by an image-making instrument. It coexists, in other words, with the *simulated* trace of the real—call it the inscription or signature of the auteur. The episode of the scratches in the windowpane, I argue, is connected with acts of inscription such as these; it does not merely reference the idea of the indexical image as truth bearing. Like the unmasking of "Mabuse" and the cinema machine, it is a modernist gesture. But it is made with the hand— made by hand, it is also *Handwerk*—per Rilke's definition, not Heidegger's.

Pattern and Abstraction; Art Objects

In *M*, earlier than *Testament*, the camera likewise tracks slowly across assemblages of props displayed on tables—across the thieves' booty, silver spoons and wallets, and the tools of their trade. A hand arranges props—adds objects—as the camera slowly moves across the display. On a later occasion, the camera tracks over scavenged sandwiches that serve as currency for the beggars, while another shot is of artistically arranged cigarette stubs and partially smoked cigars and cigarillos, a frame once again entered by a hand. Needless to say, thievery, begging, and scavenging address political and sociological issues concerning the distribution of goods in German society during this period, an all-too-grim concern after the crash of 1929. Do these shots then also relate to the shop windows that, more than once in this film, display enticing commodities that create a space of desire—knives that lure a murderer or the toys and candy that lure his victims? That would seem to be at least one point of the sandwich display. But the other shots, those that contain the arranging hand, may point to something else. In *Destiny* Death's hand lines up coins to form a geometric pattern; in *Testament* bills arranged in neatly spaced stacks are on display. In shots such as these, the abstract, geometrical arrangement of these props is part of the point. But what is at issue in such shots and how do they relate to the décor of Lang's films?

As Rosalind Galt has pointed out, the ornament moves from Islamic art to Western abstraction.[33] Instances of both occur in Lang's German films.

Destiny is one of Lang's films that engages ornament and pattern most thoroughly: its first episode, set in Baghdad, features Islamist, geometric designs in its curtains, hangings, and fancy grillwork. (The look of this episode is in keeping with the interest in exotic décors held by Lang and von Harbou, fashionable in Germany, but already out of style in Paris.) Geometric designs and patterned surfaces in this film are unstable, however—they are susceptible to disruption: those characters in collusion with Death, particularly the Sultan, violently break through them. The patterned surface is penetrable, vulnerable to destruction by the Real. In *Destiny*'s second, Venetian tale, characters are trapped by an architecture shot to accentuate its symmetry, anticipating the design and décor of the *Nibelungen* films. In this episode the structures themselves are not disrupted, even if Death does gain entry into them, but characters are trapped and killed in the spaces that the symmetrical architecture generates. Patterns and symmetrical arrangements, then—recall Death's placement of coins in a grid across the film frame—are not only susceptible to destruction, but may be in collusion with it.

By the time *M* was shot, the décor of Lang's films was more realistic, although his films never completely abandoned the stripes and textured surfaces he favored. Stripes find their way into *The Testament of Dr. Mabuse* in the form of a gangster's suit and as prison bars, and ornamental patterns are still present in the excessive décor of a killer's apartment as late as *The Big Heat* (1953), now presumably signaling low-life bad taste. Here the gangster Vince's apartment is replete with patterned wallpaper, grillwork from room dividers, and a striped sofa that recall the patterned surfaces of *Destiny*. This apartment, too, is a space in which violence is enacted. In *M*, much as in *Destiny*, architectural spaces are permeated by death—here it is especially those spaces without a human presence that signal death most eloquently. In the shot depicting Elsie's place setting at the table, complete with plate and spoon, objects call out for use by a subject that is not there. The absence of the human is underscored by geometric patterns in a shot from above of an architectural space—a shot of the empty staircase where Elsie is nowhere to be found. Granted, the staircase is a common motif in Expressionist film— recall Murnau's *Nosferatu* (1922) and *The Last Laugh* (*Der letzte Mann*, 1924)—but it is the angle from which we see the empty staircase, shot from above, that renders it geometric and abstract: its banisters establish receding spaces through a series of lines. Another instance of abstraction in *M* has already been mentioned: it occurs when the extreme enlargement of a fingerprint turns it into mere design, and the epistemological relation to the image is undercut by an aesthetic relation.

The most extended abstract passage in a Lang film is Kriemhild's "Dream of the Hawks" in *Siegfried*, an insert designed by Walter Ruttmann. An example of the abstract or "absolute" films of the German avant-garde, including those of Hans Richter, Viktor Eggeling, and Ruttmann himself, it features a battle between black and white shapes—two black hawks and a white dove—that

resemble nothing so much as two-dimensional patterns, or, as Rudolf Kurtz put it, a "fluttering of light and darkness.[34] For Kurtz the dream sequence is a purely decorative surface in nuances of black and white, a surface in rhythmical motion. A striking bow to pure pattern or abstraction, the sequence also thrives on the confusion of figure and ground such as one might see in M. C. Escher, and thus the dream as a whole gives an impression of undecidability, of Thingness in Mitchell's sense.

Kurtz's observation concerning the abstract style of the dream sequence, which he links to Expressionism, is in keeping with what Lotte Eisner—no doubt drawing on Wilhelm Worringer—sees as the Expressionists' aim of attaining "pure abstraction."[35] In *Abstraction and Empathy* (1908) Worringer had himself relied heavily on the work of art historian Alois Riegl concerning the artistic volition of particular cultures. According to Riegl, the Egyptians were the first practitioners of the abstract tendency in art, since their art preferred outline to three-dimensionality as a means of representing the materiality of the object. For Worringer, writing in 1908, Egyptian art expressed "maximum crystalline regularity in composition,"[36] while in Expressionist art, Worringer argues, there is a need to "de-organicize," a "desire at any price to force the natural model into geometrically rigid, crystalline lines."[37] (It is clear that Deleuze read Worringer.) Underlying this tendency in art, however, Worringer insists, there is a psychological need: it is "the only possibility of repose in the confusion and obscurity of the world picture, and creates out of itself, with instinctive necessity, geometric abstraction."[38] The order-creating function of geometric abstraction may very well be the rationale for Lang's investment in it, but his films suggest repeatedly that it is ineffective. As Frieda Grafe puts it, "Architectural structures in Lang must be dynamited, because they are merely images of that which cannot be depicted . . . There is a second world beyond the forms, dangerously formless, and . . . there are always unassimilated remainders that do not fit into systems, that assert their otherness."[39] It will be apparent that Grafe's formulation anticipates Mitchell's definition of the Thing in several respects and that it suggests a link between formlessness and the Real that emerges at the moment of form's rupture. But, again, if patterns and structures in Lang are intended as barriers against formlessness and death, they fail in that mission.

Art objects have a role to play in Lang's films, of course, and the stunning décor of Baum's study in *The Testament of Dr. Mabuse* speaks to the topic of form and formlessness that we have addressed in pattern and abstraction. Here décor evokes Expressionism by way of the objects that line its walls, primitive masks from Africa and the South Seas, part of Lang's private collection. For the Expressionists, the art of primitive peoples was powerfully evocative of emotions: in 1911 Worringer writes of its "higher level of tension in the will to artistic expression."[40] Although Expressionism may have been "just a fashion" for Lang, as he is reputed to have said, he used the icons of

primitive art as late as 1933. In distorted form, the primitive masks evoke the human face to which they are metonymically and literally close—masks serve to cover the face. The skulls also on display were once the armature of faces, natural things until they entered a collection—or a film. The montage that presents these objects to the spectator's view, composed as it is of short takes, suggest that the masks and skulls are more than mere props, that they themselves have the power to see, that they are objects that look back—or Things—and indeed, after the spirit of Mabuse has entered Baum's body in this sequence, his face takes on the shape of a mask. Once again the human is presented in object form and, in the case of the skulls at least, in the shape of death. Once more the double relation to form and formlessness is operative— ritual masks signify death even as they seek to ward it off, and the skulls speak for themselves. Recalling that Mabuse is known as "the man behind the mask," this sequence—like the one in which Mabuse is tellingly absent, replaced by a cutout figure and microphone—indicates that Mabuse is ulti- mately insusceptible to representation. He is the formless, Bill Brown's "not yet formed or the not yet formable," as well as an excess, that which "remains physically or metaphysically irreducible to objects."[41] Here the formless is the Thing.

Finally, another kind of art object requires mentioning. In Lang's films as in Hitchcock's, the décor often includes statuettes in human form—in the amusing cops and robbers sequence toward the end of *Testament*, the frame includes a kitschy bust of a laughing boy, in seeming self-conscious commen- tary on the scene. *Spies* contains another item of kitsch, a small reclining nude that speaks to the body of Sonja, offered up in the service of spying. But a vase in *Spies* is of another order entirely, perhaps not very far removed from Heidegger's jug, the quintessential Thing.[42] But what it contains is not wine. At first the vase seems covered in a design or pattern, but this is soon revealed to be spy equipment, visible through the vase's translucent material. In the German tradition, without this equipment, the large and well-formed vase would signify as a work of art. Initially, the film's spectator reads the few lines on the vase's surface that represent the equipment inside it as a design, as decorative, indicative of the vase as art object: the vase is shot in close-up, no hand interferes with it, and it exists in an auratic space. But the narrative of *Spies* instrumentalizes the vase, deprives it of its identity as aesthetic object, making it what Heidegger terms equipment by turning it into the container of "equipment." Or does it? In a sense this is true: insofar as it contains stored information, the vase functions in the plot in the manner of a prop. We're aware, of course, that Lang was known to favor vases as part of his décor— should we therefore accord the vase less or more significance in this film? Whatever the answer may be, in order to access the information in the vase, the film's spies must smash the vessel; they must perform an act of iconoclasm for the sake of information. It is tempting to see in this gesture the deliberate

destruction of the *Ding*, the inviolate work of art of an older aesthetics, and an affirmation of the modern communication networks of which film forms a part. In this sequence, yet another structure is destroyed and the formless is released in the guise of death-bringing information.

Intermediality: Writing, Image, Thing

In Lang's German films, intermediality can be negotiated by way of the object. The seeming impasse created by the juxtaposition of word and object, an impasse Rilke's object-oriented poetry seeks to overcome, is an issue that surfaces repeatedly in these films. We recall, for instance, the way that dialectical editing and sound bridges actually emphasize the distance between word and image in *The Testament of Dr. Mabuse*. A recurrent preoccupation, the act of writing is often staged in Lang's films. By this means the hand comes into play again. One of the more abstract, symmetrically arranged shots in *Spies* is of two hands holding pens and signing documents, arranged in a pattern and shot from above. These hands are signing a treaty, and several people will die for its sake. In this shot we do not witness the signing per se; it is not the act of writing that is on view. The usual pictorialism of Langian documents has migrated to the abstract composition of the scene. But repeatedly in Lang's German films, letters and maps covered with pictograms (*Metropolis*), with a combination of pictorial signs and writing (*The Testament of Dr. Mabuse*), or simply with writing (*Spies*) ultimately stand revealed as Things, blots in collusion with death. The map in *Metropolis*, covered with mysterious markings, leads workers to catacombs littered with skulls.

In Lang films single words may also approach the status of things or take up things into their inscription, linking his work to the poetry of Rilke and looking forward to that of Paul Celan, for whom "words are stones." In *The Testament of Dr. Mabuse*, the word *Mord*, "murder," is several times the object of the camera's scrutiny. The word attains the status of an object; its materialism is emphasized. Singling it out for our view in close-up, more than once the camera tracks out of this word and into the surrounding space as if to suggest that the word itself has powers of pollution. Time and again we see it on posters, black, seemingly in bold—it is printed in an old German font that turns the word in the direction of the image. In *M*, the letter the murderer sends to the newspapers is written on a window ledge; its script is distorted by the ledge's rough surface, which imprints itself in the writing process. In *Spies* a document that condemns two men to death is printed in Cyrillic, an alphabet that, to the Western eye, is equally on the side of the image. In this film, too, Haghi communicates with his nurse in Sign (a language that uses visual signs), and a blotter inscribed with the imprint of word fragments has the look of abstract art. In all of these instances, writing has an imagistic aspect that defamiliarizes it and takes the objects on which it is inscribed into the realm of Things.

Most notably, of course, it is the mad Mabuse whose writing begins as pure design, as a series of indecipherable hieroglyphs. Later, as Baum the psychiatrist reports to his students, words become visible in Mabuse's scribblings, and gradually sentences emerge, although these writings retain a pictorial aspect. Covering the pages of his testament with curlicues, Mabuse's imagistic script resembles Expressionist lettering on film titles and frames. When Mabuse's imagistic writing is made available in close-up in the form of the slides Professor Baum uses to illustrate his lecture, the photographic slides are intended to convert them into scientific evidence of mental instability. But after Mabuse's death his writings gain control over Baum: as ur-texts "dictated" to the mad Mabuse, they will now dictate the behavior of Baum. Much later in the film, Inspector Lohmann gains access to the notebooks in which Mabuse's sentences are strung together to form coherent narratives, texts that construct blueprints for crimes of destruction.[43] Even as they form pretexts for crime—and perhaps for films—these writings remain image-oriented not only because of their script, but because they are illustrated by hand with drawings and cartoon-like lines that suggest explosions of light—as in the Tower of Babel sequence in *Metropolis*, for which Lang himself etched lines into the film stock. Here, too, some words are writ large (as in the case of *Mord*) and seem to exist primarily for their graphic qualities. Written over their illustrations, Mabuse's writings operate in palimpsest-like layers, creating an object effect that defamiliarizes writing. If we examine in close-up the page that advocates the destruction of the chemical works, for instance, we see that beneath the writing and expressive lines there is another image: a drawing of a *hand*. It is the hand of the maker, who—like Rotwang—is also the artist of destruction, marked with the black glove of death. This image is particularly striking in Mabuse's chemical works text, where the hand is shown against a white background, a sheet of paper. It's a commonplace of Lang criticism that he himself lit the match for the many fires his films depict.

While a represented object can never fully be the Thing, the inscribed objects in early Lang films are defamiliarized by their imagistic aspect and through the pointed act of marking. And these inscribed textual objects are almost invariably in concert with death. Perhaps *the* central example of the death-oriented text occurs in *Destiny*, where Death's wall is inscribed by irregular squiggles that suggest a sign system, but one that can under no circumstances be read. Important to an understanding of the textuality of the wall is the fact that it fills so much of the film frame: there is no horizon line above it, and it extends beyond the sides of the frame. Thus perspective goes flat, emphasizing the connection of wall to writing surface. Standing in front of his wall, Death stands on the ground represented as a stripe across the frame: that is, in a space that tends toward abstraction, accentuating the pictorial qualities of the squiggles on the wall, which is, of course, the screen.

Although illegible, the wall's squiggles as design are loosely connected with the domain of writing insofar as they relate to other signs—to the alpha and

omega arranged around the sign of the Cross that Death inscribes in the ground in front of his wall. Thus the squiggles tantalize us with the promise of significance even as they deny it. Not so the alpha and omega: in Christian terms they signify "In my beginning is my end," but in our context they bring to mind Freud's *Beyond the Pleasure Principle* (1920), which posits the simultaneous movement toward origins and death. More pertinent to our project, perhaps, is Lacan's revision of Freud's death drive as a strategy of representation. For Lacan, "the death instinct is only the mark of the symbolic order, in so far . . . as it is dumb, that is to say, in so far as it hasn't been realized."[44] From this perspective the skewing of writing toward the pictorial is an effort to ensnare the spectator with the decorative aspect of marking or sign-making, to distract us from the object as Thing that both points to and covers over the gap in representation.[45] If in Lang films the making-object of handwriting stands in for the process by which the film text renders the screenplay image, it always exceeds this project. Self-reflexive, uncanny, the props we have been discussing speak to the unrepresentable that cannot be directly imaged, but only gestured toward. Whether the object is out of place—a stain—in a realistic décor, whether arranged in ornamental patterns, whether rendered only as a trace that marks its absence, whether it is the art object per se, whether a hieroglyph or an illustrated text rendered Thing, the prop in Lang exceeds locatable meaning, pointing as it does toward death. In a related gesture, Mabuse and Haghi, the two most notable instances of character as formlessness and Thing, both mark and cover over textual fissures by way of their modernist look out of the frame—and in that process affirm that the object does indeed look back. These are strategies that Hitchcock appropriated.

Chapter 6

Décor

Collection and Display in Fassbinder's *Lola*

The repeated occurrence of an étagère—an open display case—in films by Fassbinder speaks to a concern with the showcasing of objects, framing their significance in the décor: étagères figure in *Despair* (1978), in *Chinese Roulette* (1976), in *The Stationmaster's Wife* (1977), and, in the form of beams, in *The Bitter Tears of Petra von Kant* (1972). (See chapter 3.) While objects displayed on these shelves seem carefully arranged, during the course of a film they are moved or replaced, suggesting that the changing arrangement of objects enacts a plot in its own right. That the presence of the display cases and their collections is never commented on in the dialogue heightens their mystery; they are simply there, mutely present in their opaque thingness. Granted, there is a film historical reference here to Douglas Sirk, who notably claimed that he made films not about people but about things, an idea that intrigued Fassbinder.[1] But in fact objects in Sirk, as for instance in *All That Heaven Allows* (1955), do relate to the subjectivity of the film's characters even as they function in the film's condemnation of materialism. Hence, they must be smashed, repaired, and re-placed. In Sirk's films props are objects that prop up subjects.

A fashion of the 1950s interior, the étagère or display case holds the collections through which its owners seek to define and extend their subjectivity. Introduced into the décor of films made twenty years later, the étagères seem curiously anachronistic. That étagères have a framing function for the displayed objects is clear enough, and that they serve as room dividers—mark out space—is also apparent: the film's characters move around them, further accentuating the mute objecthood of the things the étagères support.[2] Their shelves are open, not closed off in back as customary in a bookcase or cabinet; visually, they suggest a scaffolding of sorts, a *Gestell*, the space of a collection. I suggest that in Fassbinder they serve as placeholders for the scaffolding of identity, a framework for the display of citation objects. What is their function? If the displayed objects they support have a function in Fassbinder's films, it is not in relation to the films' characters.

With the étagère as a backdrop, this chapter brings together a concern with décor and mise-en-scène in relation to strategies of intermedial citation in Fassbinder. Its focus is on *Lola* (1981), a film initially intended as a remake

Lola on her bed with mirror, projected color, and butterflies. *Lola* (R. W. Fassbinder, 1981), frame enlargement.

of von Sternberg's *The Blue Angel* (1930). What happened instead and where the traces of von Sternberg's aesthetic may be found—and what other films have left their traces in *Lola*—are among our topics. That the relationships so constituted pose intermedial questions is another.

Von Sternberg's Art Model

There is a "working relationship" between cinema and theater, André Bazin writes in his essay "Theater and Cinema" (1951):[3] the links between film and theater are "much older and closer" than is generally acknowledged, certainly not confined to what is known as "filmed theater."[4] Choosing not to elaborate on their interdependence, Bazin expands on their distinctness. Citing Jean-Paul Sartre, Bazin notes that in theater the drama "proceeds from" the actor, while in the cinema "it goes from the décor to the man" and is therefore "bound up in the very essence of the *mise-en-scène*."[5] For Bazin, of course, cinematic mise-en-scène should be intimately tied to realism, with the cinematographic image merely "masking" the reality that lies beyond the frame—indeed, even generating it by way of the "centrifugal force" that emanates from it. Cinemas that undermine this relation to reality, asserts Bazin, are doomed to failure. First and foremost among these is German Expressionism, and *The Cabinet of Dr. Caligari* (1920) in particular violates Bazin's dictum. *Caligari*'s décor is wholly artificial, its sense of space pictorial and theatrical and, since Wiene's film obscures the reality of space by way of lighting and décor, it undermines what Bazin sees as film's psychological modality. (See chapter 1.)

This is not to say that cinema cannot profit from attempts to impose the laws of one art upon another—those of theater upon film, for example.[6] On the contrary, the arts may benefit "a great deal" from such interaction,[7] so it is also possible that for Bazin *The Cabinet of Dr. Caligari* is simply too extreme in its adoption of theatrical and painterly modes. From Bazin's perspective, the successful filmed drama must reconvert film's world of space by refocusing it toward the stage—toward that closed area on which the "human soul" is illuminated by the "two-fold concave mirror" of theatrical décor and audience.[8] (See chapter 7.) It is between these polarities that matters of space in theater and film play out. Unlike the relation to space exemplified by film, where space, far from being bounded by the image, emanates outward from it, the spatiality of theater is defined in relation to the stage. The set's reverse side—its verso—is the limit point of its artifice: it lays bare theater's material support.[9]

It has become nearly a truism concerning Fassbinder that he worked in film as though it were theater and in theater as though it were film—indeed, he spoke of many of his films as "theater films."[10] Although the point is rarely made, Fassbinder's deliberately intermedial cinema is less surprising when viewed against the tradition of interarts experimentation, against the

fetishized artifice that flourished in German cinema of the 1920s. As late as 1930, some German films still reflected interarts values, with von Sternberg's *The Blue Angel* a notable and popular example, though not for all of its critics. Siegfried Kracauer's scathing 1930 review disparagingly locates von Sternberg's film on the side of ornament and décor. Rather than focusing on its protagonist, Kracauer asserts, *The Blue Angel* evades reality "like the painting on the theater curtain which gives the illusion of the play."[11] For Kracauer, ornament and décor are "stagy," not the province of film, which is the real— the sociopolitical—world.

In fact, Kracauer's reading of *The Blue Angel* is completely justified. As Gaylyn Studlar has pointed out, von Sternberg's iconic world deliberately seeks to keep "authenticity"—the "real" world—out of its frames.[12] Reality is nowhere to be found: "There is nothing authentic about my pictures. Nothing at all," von Sternberg vigorously—and somewhat slyly—asserts.[13] *The Blue Angel*'s opening sequence signals the film's self-placement within a filmic tradition as a montage of images citing Expressionist films constructs the aesthetic world in which this film situates itself. There are brief visual allusions to the mise-en-scènes of Paul Wegener's *The Golem* (1915), Walter Ruttmann's *Berlin: Symphony of a Great City* (1927), Fritz Lang's *M* (1931), and the study scene (*Studierzimmer*) of Murnau's *Faust* (1926), and Marlene Dietrich's Lola Lola is conceived against the backdrop of Pabst's Lulu (*Pandora's Box*, 1929), although this list does not exhaust the references that *The Blue Angel* makes to other films in the Weimar canon. And while we may be tempted to attribute some of these citations to Otto Hunte (set designer for Fritz Lang's *The Nibelungen* [1924] and *Dr. Mabuse the Gambler* [1922], among other Weimar period films), who helped design *The Blue Angel*'s set, von Sternberg vehemently asserted that he himself exercised complete control over every aspect of his films.

Von Sternberg's model for filmmaking is an art model: for this director a film is an animated painting whose shifting values must be controlled, an actor merely "a tube of color which must be used to cover my canvas."[14] In the tradition of *Caligari*, and likewise by means of a theatrical set, von Sternberg undermines the camera's potential for modernist vivisection admired by Sergei Eisenstein and Walter Benjamin, while eliminating from his frames the reality that Bazin so intensely privileges. Indeed, von Sternberg notoriously suggested that his films are ideally viewed upside down, so that their spectator, freed of the constraints of plot, might see their images abstractly. Expressing disappointment in *The Blue Angel*, Rudolf Arnheim seems nevertheless to have gotten it right when he noted that "between form and content there is no difference."[15] Recognizing the same tendency in von Sternberg's work, Kenji Mizoguchi, for whom painting is also the model for film, claims to admire von Sternberg for "sacrificing narrative for the sake of ornamentation."[16] Under what circumstances, we ask, is it possible for style itself to become significant content?

It has seemed to critics that von Sternberg's interest in formal innova-
tion and abstraction—already in evidence in *The Blue Angel*, if not yet fully
developed there—signals a modernist engagement with the medium of film.
In *Ideology and the Image*, Bill Nichols reads von Sternberg's emphasis on
the film medium as evidence of such engagement, suggesting that his over-
the-top style is in the employ of a modernist critique of illusion.[17] As Gaylin
Studlar argues convincingly and in great detail, von Sternberg's films express a
masochistic aesthetic, with its marked emphasis on the iconicity of the image
over its indexicality—on the value of the aesthetic, that is, over a concern
with photographic registration.[18] Especially the narratives of von Sternberg's
films with Marlene Dietrich play a significant role in contextualizing their
particular brand of aestheticism: the fluid gender identifications that typify
their characters and the sadomasochistic trajectories of their plots are telling.
In *The Blue Angel*, the fetish objects related to Lola Lola—the postcard image
decorated with feathers that alternately obscure and reveal, and the phallic
image of the famous leg—have been referenced repeatedly in the context of
sadomasochism.[19]

More central to our discussion is the fetishization of the film's space by
means of its décor. The film's theatrical use of lighting, the netting suspended
from ceilings, the mobile of a dangling putto, sketches on the walls—all func-
tion to aestheticize the film's frames. In *Fun in a Chinese Laundry*, his autobi-
ography, von Sternberg agrees with Bazin about the relation of actor to décor,
claiming that in his film *Salvation Hunters* (1924) "the emotions infused into
[Georgia Hale's] image were caused by the movement of a dredge, reflections
in the water, chalk scribbles on the wall, chewing gum, real estate signs, a
seagull and a cracked mirror."[20] Von Sternberg's formulation recalls Fassbind-
er's interest in a similar strategy in Sirk: "Sirk has said you can't make films
about something, you can only make films with something, with people, with
light, with flowers, with mirrors, with blood."[21] Light was also at issue: von
Sternberg was particularly obsessed with animating what he called the dead
space between the camera and its subject.[22] He often covered the camera's
lens with gauze, which derealizes the image, and in *The Blue Angel* Marlene
Dietrich's face is relentlessly embellished by veils or shadows. In this way the
camera's subject is both revealed and obscured, her face an inscribed surface
on which lighting, curtains, netting, and veiling impose textures. Von Stern-
berg's "iconography of the veil," Mary Ann Doane writes, postulates woman
herself as surface, as the material substratum of film, yes—but also, as Doane
points out, as *mere* surface, as surface "appearance"—and as dissimulation.[23]

In fact, the dialectic of inside and outside is prominent in the language
of Kracauer's review of *The Blue Angel*, which is likewise situated within
the philosophical debate that interrogates the relation of surface to depth,
reality to illusion. To what use, Kracauer asks, does von Sternberg put "the
legs, the effects, the technique, the gigantic theater?"[24] As Kracauer reads
it, the aim of *The Blue Angel* is to cover over reality, to screen it from our

view. Reality is "veiled"—Kracauer's term—in this film, its space hermetically sealed, its atmosphere so stifling that its characters lack the very air to breathe. Kracauer's critique extends to set architecture, which he feels is designed not only to imbue the plot with the significance it intrinsically lacks, but actually to obscure its "true" subject: "One places decorative walls in front of subjects that are only pretexts and claims that they are real subjects."[25] That a person's "interior" world rushes to fill the space left vacant by the denial of an exterior world is not surprising to Kracauer: it is this "interior" world that develops into the "ostentatious façade" that decoratively covers over, veils—the "real" social world. Kracauer' s metaphor for this inversion is the image of the inverted glove: "The inside becomes the outside so that the outside is made invisible."[26] In his opinion, *The Blue Angel* leaves itself open to "psychic invasion," and "spiritual events" take on a decorative function. When Kracauer singles out an Expressionistic harbor street that is clearly a set, one wonders whether Hitchcock had *The Blue Angel* in mind when he made *Marnie* (1964). With artifice its defining characteristic, the world of von Sternberg's film is reduced to mere décor, but the interior world, expressed by this décor, is the privileged one.

Painting, Light, Color

Even at their most political, Fassbinder's films resort to theatricality and artifice. This is certainly true of *Lola* (1981), the third film of the BRD trilogy (although the second to be made). A remake of sorts of *The Blue Angel*, this theatrical film has repeatedly been performed onstage.[27] In what sense *Lola* draws upon von Sternberg's film will be one of our questions, since its adaptation of *The Blue Angel* is very loose indeed. (Peter Märthesheimer followed Fassbinder's request that he adapt *The Blue Angel* in writing a screenplay, but Fassbinder found his screenplay banal and subsequently wrote his own.)[28] With Sirkean melodrama in mind, we examine the function of *Lola*'s self-consciously intermedial—theatrical, painterly, and filmic—mise-en-scène and décor. Does the emphasis on theatricality and décor position *Lola* within modernist self-reference or postmodern pastiche—or is there another explanation for its persistence? Keeping in mind the flagrant use of citation in *The Blue Angel*, how does citation function in Fassbinder's film?

It is at the level of mise-en-scène and décor that *Lola* is particularly given to citation. In the opening credit sequence, a black-and-white photograph of Konrad Adenauer seated next to a radio and tape recorder becomes an inscribed surface as each contributor's name is written out in a script whose many colors decorate the image: the indexical image of the photograph is covered over—veiled, embellished—by writing in garish shades of pink, lavender, red, and green. Even in its opening frames, then, the film has merged von Sternberg with Sirk, from whose 1950s films *Lola* derives its palette, if

not its color style. The German flag is referenced in the credit sequence by way of vertical ribbons of color, and while they still signify, the flag is reduced to a decorative border of color that bisects the photograph. Sound is brought into the picture by way of the objects the photograph records—the radio, the tape recorder—as well as by an extradiegetic pop song of the 1950s, "A White Ship Sails to Hong Kong." Sung by pop icon Freddy Quinn, its lyrics articulate the complex attitude of avoidance and return that expresses the film's ambivalence toward the homeland, toward *Heimat*: the lure of the exotic draws one away from home, claim the lyrics, but once away, one is soon pulled back. Thus the credit sequence gives the effect of an interarts palimpsest— photograph, film image, the image of writing, music—that aligns Fassbinder with von Sternberg and Sirk/Sierck, émigrés both, and with a German art film tradition.[29]

The conflation of art with "home" (*Heimat*) is carried over into *Lola*'s opening narrative sequence. In keeping with the style of the credits, the film's first diegetic image is an extreme close-up of a woman's hair suffused with red light, "painted," that is, by the theatrical projected lighting effects that dominate the look of this film. After the camera pulls away from her tresses, we see Lola at her dressing table in a composition that links her to narcissism, to introspection—and to art. The image is complex and compelling: screen right features Lola before a Sirkean—or, in fact, Sternbergian—mirror, heavily bathed in red light, while screen left resembles nothing so much as an abstract painting. Rectangles of lavender and turquoise coexist with a vertical stripe of red-orange that is only gradually identified as a mirror frame. As in the dressing room setting of *The Blue Angel*, shapes are difficult to discern—we recall that this tendency toward abstraction is what von Sternberg demands from his films. At this point in *Lola*, the soundtrack features a recitation of Rainer Maria Rilke's "Fall" ("Herbst"), a poem whose opening lines famously claim that whoever does not yet have a home will never have one. They are spoken by Esslin, the film's follower of Bakunin and self-styled humanist, who explains to Lola that since poetry originates in the soul, it is necessarily melancholic. The left-wing melancholy of which Fassbinder has been repeatedly accused is evoked and connected with a German high art tradition.

Esslin's recitation takes place in a setting worth lingering over: Lola's home, her boudoir/bedroom in the brothel where she works. This space visually recalls von Sternberg's mise-en-scènes. Daylight rarely penetrates the room: its windows are obscured by several curtains, and its lighting is wholly theatrical. The obligatory mirror is over the bed, and the walls surrounding it are hung with quilting, a borrowing from Sirk's *Written on the Wind* (1956), perhaps also a fashion of the 1950s. The quilting serves to obscure the architecture of the room, as is von Sternberg's wont, while the room's colors are Sirkian and melodramatic. Intensifying the theatricality of the film, projected light is applied over décor and characters in painterly fashion, creating layers of color over objects and persons. As Fassbinder wrote of Sirk: "Besides him only Josef

von Sternberg uses light so well."[30] But theatrical lighting does not simply saturate the spaces of this film with affect; it also has an ornamental and a self-referentially filmic function. Designs created by openwork lamps are projected as decorative shadows on the wall, recalling von Sternberg's attempt to animate dead space by means of a *cucaracha*, which he described as "a transparent plastic contraption with a broken surface"[31] through which light was projected. It was used to good effect in his project of total aestheticization. But, in keeping with Fassbinder's tendency toward multivalent reference, the designs on Lola's boudoir walls—produced by painting in light—also evoke the decorative effects of the painted *Caligari* set, especially of its boudoir scene. When these colored lights pulsate chaotically in *Lola*, they constitute the visual equivalent of the shrieking, soap operatic chords in which so many of the film's sequences culminate. The pulsating quality of both light and sound in this film transpose von Sternberg's use of alternating light and dark tones at the center of the film frame—von Sternberg's "pulsating rhythm" of black and white, as Barry Salt calls it in his essay "Sternberg's Heart Beats in Black and White"—into another register.[32]

In keeping with the melodramatic genre to which it belongs, *Lola*'s most aestheticized effects are reserved for its eroticized spaces—the performance space of the brothel, the men's room, and various bedrooms. Color and lighting are similarly over the top in the bedroom spaces of Sirk's *All That Heaven Allows* (1955) and *Written on the Wind*, suggesting the unchecked passions that hold sway there. In *Written on the Wind* these spaces resort to purple, blue, pink, and red both for their furnishings and for the projected light that embellishes them, while bedroom scenes in *All That Heaven Allows* alternate projected light and more naturalistic lighting to accord with the emotional climate of each scene. In our first view of the mother's bedroom in *All That Heaven Allows*, lavender light paints the faces of mother and daughter with stripes of color, while the blue light of evening enters from a window screen right. The mother's sexuality is at issue, Freud's name is loosely bandied about by the daughter, and tempers run high. Later on, when the bedroom is again the setting of a mother-daughter confrontation, red joins the lavender projected light, striating the women's faces with color, but now color allows persons to merge with the spaces they inhabit. Lighting effects such as these serve to evoke spectator affect, of course, but they also denaturalize setting and character—not only by way of their unusual color choreography, but also because projected light destabilizes objects, turning a red quilted headboard in one scene into a pink one in another. Clearly related to the spotlights of theatrical lighting, projected lighting enables objects to change color, and spaces and persons to merge in an unsettling way. Again the *Caligari* set with its dissolving boundaries comes to mind: its Expressionism—now rendered in color—lurks in the background of Fassbinder's film.

But it is not only Lola's boudoir that is ornamented by projected light. Von Bohm, the building inspector (Fassbinder's substitute for *The Blue Angel*'s

professor), has a bedroom that is similarly decorated: here, too, blues and reds are prominent, and the lavender projected lighting no doubt alludes to Sirk.[33] Like the Sirkean bedroom, this space is expressive of von Bohm's interiority insofar as the classical violin repertoire he plays here defines his bedroom as the space of art and culture, if in clichéd terms. But its ornamentation with the pink and lavender light of other bedroom spaces also designates it as libidinal, and it is no wonder that the classical piece von Bohm plays here morphs into Lola's signature song. Even if the erotic is one origin of culture, it is implied, it also destabilizes form and genre. But *this* is precisely where the both/and so typical of Fassbinder comes into play: if von Bohm's bedroom does have something to say about his inner life, suggesting the analogy between décor and character that predominates in films by Sirk, this is only *one* of the strategies operative in Fassbinder. Kracauer's metaphor of the inverted glove—by which he critiques von Sternberg's emphasis on a décor that speaks to the interiority of the film's characters and obscures the external, social world—only partially explains what is going on in *Lola*.

As in the example of Lola's boudoir, sequences set in von Bohm's bedroom ostentatiously feature shots in which projected lighting is used abstractly, used, that is, simply to create blocks of color. Interestingly, such moments tend to occur in tandem with Fassbinder's famous vertical compositions, arguably his most aestheticized shots, shots in which characters are encased and constrained by framing devices within the film frame. Such moments take place even in Fassbinder's more naturalistic and politicized films such as *Ali: Fear Eats the Soul* (1974). In the latter, shots of the bar frequented by foreign workers—visually the most Sirkean setting of this film—include moments when the film frame is abstracted by means of color fields that surround characters, once when the bar maid is first positioned in what is a modernist, if ironic, evocation of Manet's *Bar at the Folies Bergères*, then in a space destabilized by color effects. In shots such as these aesthetic attitudes are articulated that coexist with rather than amplify the sociopolitical meanings we tend to read in Fassbinder. At such times Fassbinder's film may be citing not only Sirk, but also tendencies toward abstraction in the work of Hitchcock, Antonioni, or Godard, effects that are often cued by color. Whatever their source, shots such as these keep Fassbinder's modernism in plain view.

In keeping with an observation made by Lola's mother that the new building commissioner von Bohm is traditional at home, but "modern" at work, von Bohm's office is freed of clutter and nature (the potted plants are tossed out), transformed into a modern space with the aid of enlarged architectural photographs[34] and the acquisition of a mobile. Is the latter a tribute to von Sternberg, whose interiors are rife with objects dangling from ceilings? or a tribute to Alexander Calder? or to both? As in *The Bitter Tears of Petra von Kant*, where mannequins change location from scene to scene, changes to *Lola*'s décor generally take place without being noted in the dialogue. And while projected light is put to good use in von Bohm's office space, its colors

tend to be green and yellow—colors associated in *All That Heaven Allows* with the outdoorsy Rock Hudson character to whom von Bohm bears absolutely no similarity.

It is at this juncture that Brian Price's fine essay on Fassbinder's deliberate refusal—or call it failure—to use color metaphorically, in the manner of Sirk, must be mentioned. In a complex argument that draws on theories of melodrama, on color theory (Kant's assertion that color is epiphenomenal), and on philosophical discussions of being, Price argues on behalf of the "contingent character of the social" that Sirkian melodrama reveals and in which, for Price, melodrama's political potential lies. Sirk's melodramas provoke a contextual reading of color rather than an essentialist distinction between inside and outside: if color is viewed as contingent, Price argues, then the relation of inside to outside is susceptible to change, which amounts to a belief in the possibility of social change. Price advocates a phenomenological reading of the relation of being to the social, one based on the insight that "*we discover who we are as we become what we are in our encounter with what is at hand,* no matter whether what is at hand are people, animals, inanimate objects, or images."[35] From Price's point of view, Fassbinder denies the contingency of the social that is expressed in the relation of color to interiority in Sirk. What informs Price's reading of immutability in Fassbinder is the director's view of love as the cruelest form of oppression, as "a pernicious illusion that keeps us wanting what is bad for us."[36] There is much in the latter contention with which Fassbinder himself would have agreed.

In fact, color in Fassbinder *is* excess; it *is* used in jarring juxtapositions—that is, dissonantly—that refuse the color coordination on which analogy relies. The use of various shades of green in a sequence in *Ali: Fear Eats the Soul*, for instance, is read by Price to suggest that Emmi "cannot be defined by the objects and spaces that constitute her being on a contingent—and thus reversible—basis."[37] The credit sequence of *Lola* is seen to imply that the clashing colors of these frames undermine any attempt at political analysis. This may be going too far. The cacophony of color that we find in the bedroom scene of *All That Heaven Allows* is viewed as the exception to the rule in Sirk, while for Fassbinder, writes Price, the abstract spectrum of mixed color is the norm. Here we are in complete agreement: this use of color is certainly characteristic of Fassbinder, and I agree as well that color in *Lola* has a decorative function. But it may not be "inessential to meaning,"[38] even if its meaning is not political and is unrelated to the diegesis; rather, its meaning may simply be of another kind. I refer again to my earlier point that in Fassbinder often an aesthetic problem is being worked out that does not amplify, but rather coexists with, concerns about the social. Again the multivalence—indeed, the dissonance—of Fassbinder's frames is crucial: on several occasions, for example, the written names of *Lola*'s credits occupy the entire frame, a strategy also found in *The Marriage of Maria Braun* (1979). When the film image is

inscribed, writing is rendered pictorial, suspended between image and meaning. In the German literary tradition, when words are evenly spaced across the film frame in this manner they probably reference concrete poems by Eugen Gomringer, even while their colors evoke those of 1950s movies and '60s clothing. My point again is that the mise-en-scène of a Fassbinder film is always multivalent, its vectors pointing in directions both high and low, both "exterior" and "interior," social and aesthetic. What we should ask is whether these antithetical meanings cancel one another out, whether they supplement one another, or whether—as I believe—they put into play a dissonant space of multiple and heightened meanings. As I suggested earlier, the film's credit sequence serves both as semiotic grid and intermedial palimpsest.

Color in film, when it is applied over the profilmic by way of projected light, is not only theatrical: it also bears a relation to painting. Throughout *Lola*, projected light is applied over décor and characters as though it were paint, creating layers of color over objects and persons. This strategy creates a space that hovers between the theatrical and the painterly, as when the opening sequence features Lola bathed in red light before a mirror while the other half of the frame resembles a color field painting. As we have noted, there is a pronounced tendency toward abstraction in this film, toward the derealization of spaces through lighting and other effects of décor, as when rectangles of lavender and turquoise are complemented by a vertical stripe of red-orange that on closer inspection is revealed to be a doorpost. The sequence that takes place in the men's room of the brothel offers a compelling example of this strategy: here graffiti signifies, and it also embellishes the walls. Projected color draws attention to itself, derealizing the architectural elements that structure its spaces (is that stripe part of a door frame or a mirror?), derealizing as well as the objects that inhabit these spaces. The presence of mirrors with their destabilizing effects of surface and depth in sequences that feature this use of color likewise ambiguates these spaces. Further—and interestingly—the inclusion of brightly colored abstract shapes in the frame is not restricted to the use of projected light on surfaces. At one point in *Lola*, when the camera shoots von Bohm and Schuckert through a doorway (Fassbinder's most typical interior framing device) that leads to a beer garden, the shot also contains a large red circle screen right. This circle, as it turns out, is painted directly on the wall—it is a decorative effect, and not an object at all. In such instances Fassbinder may be alluding to decorative images painted on walls in *Caligari* and in *The Blue Angel*, even though Fassbinder's film substitutes abstract shapes for representational forms.

Filmic, painterly, and literary citations saturate *Lola* in a spectrum I take to range from the conscious into the preconscious and unconscious. What is the relation of interior to exterior that is suggested by this aspect of Fassbinder's filmmaking? Is it really posited on essentialist distinctions? Or does citation function as a narcissistic support? I argue that signifiers in Fassbinder extend

subjectivity through investment in a series of citational strategies, evoking figures of identity that stand in place of an authorial subject. In one sense, we might say, these citations constitute a collection, a collection of citations as described in Walter Benjamin's *Unpacking My Library*, a collection that at one and the same time asserts form and its emptying-out by means of the cutting that the act of citation implies. In Fassbinder's films citations are cropped, torn from their context, or unframed—then reframed as part of a collection. If Fassbinder's films accumulate authority by drawing fetishized fragments from other texts into his own, a countermovement typically undermines or suspends such moments, as when projected light creates a space that dereal-izes an image that consequently oscillates among the theatrical, painterly, and filmic. In *Lola*'s décor the resonance of multiple citations confirms that for Fassbinder, too, "*we discover who we are as we become what we are in our encounter with what is at hand,* no matter whether what is at hand are people, animals, inanimate objects, or images."[39] Objects and images from other texts: in fact, this procedure for the accumulation of authority may best describe the process by which Fassbinder's films are constituted.

Collections and Citation Objects

Props also notably connect von Bohm with the art world: displayed among 1950s furniture and lamps, von Bohm houses his collection of costly Ming porcelain in his living room. But if these objects seem to suggest that von Bohm shares the pop song's yearning for Hong Kong (the Freddy Quinn song played over the credits), it is ironically expressed by way of this collection, through which he takes possession of an exotic locale by typically bourgeois means. While *Lola*'s dialogue refers to collections only in connection with von Bohm's Ming porcelain, the collection may be this film's governing metaphor. As the décor of her boudoir suggests, Lola herself collects snow globes, but-terflies, and—as is so often the case in Fassbinder—dolls. We are tempted to read the myriad objects that clutter the décor with reference to the interiority of the film's characters, but—and here my line of argument bears a relation to that of Price, who denies that color speaks to interiority in Fassbinder—their significance lies primarily in their allusions to other texts. In *Lola*, props such as snow globes, butterflies, dolls, and birds are citation objects, a collection of those things that constitutes the art world of Fassbinder's film. (Von Stern-berg again looms large: a famous collector, he was the owner of a prominent collection of modern paintings and sculptures, some of which are now housed in the Museum of Modern Art.)[40] While *Lola* displays its collection of objects overtly, their significance is less open to the view, their field of allusions exten-sive. If the film's interior spaces are a museum of sorts, the objects on display there do not have a relation to the film's characters.

Snow Globes

During his recitation of Rilke in Lola's bedroom, Esslin holds a snow globe in each hand—indeed, he is surrounded by a large assemblage of snow globes, and they obviously signify. As an icon of childhood memories for Orson Welles's Kane, the snow globe is one of the more overdetermined props in the history of film, and Fassbinder does not use it accidentally, even if it is not Lola's interiority to which the snow globes point. Tied to Kane's childhood home, the snow globe miniaturizes and objectifies the wintry Colorado scene in which he was irrevocably separated from his mother. When the camera first detects a snow globe like Kane's among the childhood photographs of his future wife, Susan Alexander, it is suggested that the snow globe reifies and commodifies childhood memories—that it is an example of mass-produced kitsch available to anyone. But present in the same frame with her snow globe is a photograph of Susan with her parents that effects a connection to his childhood idyll for Kane. Present in this frame, too, is the mirror reflection of Susan that helps to aestheticize her in his imagination, to render her an artifact in the manner of snow globe and photograph. Because of the relay that this assemblage of objects establishes among Susan, home, and art, Kane marries her and forces her to pursue a career as an opera singer. When, in this sequence, Susan mentions her mother, the final link in a powerful chain is created for Kane, who is on his way to view his dead mother's belongings, now held in storage along with his own. Kane, too, is a collector: his fetishized snow globe is mirrored in the classical statuary Kane compulsively collects in his travels to Europe. Among the objects in Kane's collection there is also a photograph, a formal portrait of his mother and her son.

It is a commonplace that the snow globe with its house and snowy scene is the reification of the idyll that precedes the traumatic event of the boy's separation from his mother. Hermetically sealed, the frozen scene is a three-dimensional representation of an eternal present: it is simultaneously a denial of temporality and a moving—hence temporal, filmic—image, its "stage" both obscured and enhanced by the falling "snow." A self-contained, encapsulated world, the snow globe itself emblematizes interiority: its winter landscape is the setting of Kane's sled Rosebud, object of his desire, linked forever with the moment when the loving but cold mother—impassive as a statue—exiles him from this space. Following Žižek, the kitsch object that is the snow globe "vouches for the fantasmatic, incestuous link" that Kane cannot relinquish until the moment of his death.[41] In several ways, then, the snow globe calls to mind Sacher-Masoch's *Venus in Furs*, whose frozen setting suggests the coldness of the masochistic scene—the coldness, too, of the oral mother of the steppes, the temptress Deleuze calls "Venus of ice."[42] For Deleuze, the frozen scene in Sacher-Masoch's novel represents the "freezing point . . . at which idealism is realized"; its "coldness is both protective milieu and medium, cocoon

and vehicle" that "protect supersensual sentimentality as inner life."[43] The statues in Kane's collection populate his world with analogues of the unmoved mother, still images that recall the erotic tableaux that suspend time in Sacher-Masoch's novel—and bring Fassbinder's *Bitter Tears of Petra von Kant* to mind. (See chapter 3.)

Welles's film serves as a foil for Fassbinder's filmmaking in a number of ways, primarily with respect to *Citizen Kane*'s central task of understanding and representing the enigma of identity. In Welles's film the task assigned to Thompson, the newsreel filmmaker reporting on Kane for "News on the March," cannot be adequately met, no matter how many interviews Thompson conducts. At the end of the film, Thompson cynically concludes that even knowing what "rosebud" signifies—it is Kane's last word—could not explain Kane's life. No word could do that, he says; "it's just a missing piece in a jigsaw puzzle." But the word alone is not that piece—it is the sled that signifies, a fetishized object in a film rife with things. Thompson remains forever blind because he cannot access what the spectator sees as the camera travels across the vast storage space, then swoops down to reveal the sled in close-up. But Rosebud is consigned to a fiery furnace to be burned along with "the rest of the junk," and no coherent identity for Kane emerges from Thompson's quest because the object that might have pointed to its grounding is forever lost.

Citizen Kane's narrative dependence on objects is reflected in its décor. Does the symmetry of *Citizen Kane*'s beginning and ending simply mock the idea of coherence, as Borges thought, or does it proffer meaning of some kind? Both sequences feature aestheticized objects that replace one another in a series of fades and superimpositions. The iron mesh and wrought-iron grillwork of fences and the leaded glass in the gothic window are decorative surfaces that both embellish and veil. Like theater curtains pulled open and then drawn again, the film's final frames nearly repeat its opening images in reverse. At last the gates are closed, but, all appearances to the contrary, "no trespassing" is only ironically the film's final message. Substantiating Bazin's claim that the force in film "goes from the décor to the man," *Citizen Kane* interrogates the nature of that connection, asking in the manner of Expressionist cinema whether the objects proffered to the spectator are realistic detail, merely ornamental, or indeed symbolic objects.

Butterflies

And then there are the butterflies that populate Lola's boudoir. Fassbinder's film adaptation of Nabokov's novella *Despair* had been out for three years by the time *Lola* appeared, and it seems likely that Fassbinder had read Nabokov's memoir, *Speak, Memory*, in preparation for filming *Despair*. Here Nabokov, the inveterate collector of butterflies, describes his passion for and fascination with the "magic" of butterflies, with "their game of intricate enchantment and deceit."[44] For Nabokov butterflies are nature as art and his experience of them

an "ecstasy" connected with timelessness: "I confess I do not believe in time. I like to fold my magic carpet, after use, in such as way as to superimpose one part of the pattern upon another."[45] Hence the butterfly functions as imago, as the image per se. Aby Warburg, an intermittently mad founding father of art history, was known to have spoken to butterflies for hours on end, modeling "the definitive way of questioning the image as such," suggests Philippe-Alain Michaud, "the living image, the *image-fluttering* that a naturalist's pin would only kill."[46] For Nabokov the butterfly as image is timelessness, motionlessness, a pattern—for Warburg it emblematizes the image in motion that he paradoxically reads in painting.

In *Lola* butterflies have a function beyond their decorative value as items of display; they are visible in the film either as objects literally pinned to the walls, framed and displayed under glass, or attached to the quilted hangings around Lola's bed. Like the dolls also present there, the position of the butterflies is altered during the course of the film. Like the boudoir's projected and decorative lighting, they visually "animate the dead spaces" of the film frame, and their color changes, as well. Butterflies are beautiful—this is one reason they are collected—but in order to be collected, they must be killed. In one somewhat grim sequence of the film, the butterflies on the quilted walls are a deep black, intensifying the iconography that (provisionally) connects them with death: tradition has it that the butterfly is a representation of the soul—of Psyche—and of metamorphosis, associated in the Christian context with rebirth into everlasting life. But in *Lola*—undermining any metaphorical significance they usually suggest—the arrangements of butterfly bodies seems to emphasize simply that—a still(ed) life. Fassbinder's materialist imagination wins out over spiritual connotations: the iconography of the soul is undermined by the butterflies' aestheticized corpses. Here, then, I suggest, in a nod to Price, is an indication of Fassbinder's pessimism about the possibility of change. As elements of the room's décor, the butterflies function not only as decorations, but as props on display, items in a collection. Unlike other artworks, they are not representations: importantly, butterflies *are* the thing they represent (*acheiropoetae*). Here is a gesture that tropes representation by doing literally what art only manages metaphorically—bringing the thing itself into the work. By this means, too, Fassbinder effectively undermines metaphor.

Dolls and Birds

By virtue of their lifelessness, the butterflies are related to that other set of objects conspicuously on display in Lola's boudoir: the collection of dolls that occupies sofas, chairs, and bed. Dolls are everywhere in Fassbinder, and all of von Sternberg's films with Marlene Dietrich feature them as well, beginning with *The Blue Angel*.[47] Yet the dolls that litter the chairs and sofas in *Lola* are not emblematic of Lola's emotional development or even of Esslin's,

although it is often he who holds them. While Kaja Silverman has connected dolls to characters in *Berlin Alexanderplatz*, where she reads Franz's character as "metaphorically re-inscribed through an inanimate object," a rag doll,[48] Fassbinder's strong identification with Franz Biberkopf ambiguates this connection. While dolls are images of persons and may serve as props for a variety of scenarios, they always remain mere objects.[49] Esslin holding a doll in Lola's boudoir recalls Professor Unrat of *The Blue Angel*, who wakes up in Lola Lola's bed holding her baby doll. Moreover, while reciting Rilke's poetry Esslin holding the doll also serves as another citation of Rilke, in whose writing dolls are recurring images. As Rainer Naegele points out, Rilke's essay on Pritzel's wax doll suggests that the power of dolls originates in failed "love ties" between mother and child, in false familial relations.[50] Puppets or dolls harken back to childhood, maintains Rilke, but since they are incapable of emotion, they serve to undermine fantasies of familial love.[51] If these collected objects amplify an identity, it is no doubt authorial.

Like dolls, birds are also signature images in von Sternberg's films, and they are speaking objects in *Lola* as well. When *The Blue Angel* begins with the removal of a dead canary from its cage by the Professor's landlady, it is a telling commentary on his sexuality: as a cultural icon, the image of the bird reaches back to the erotic poetry of Catullus, where it substitutes for the male member. In keeping with tradition, then, the dead canary in *The Blue Angel* is one of a chain of signifiers that connects birds to sexuality (and impotence, in the case of the dead bird) in von Sternberg's film, where the Professor's final performance is as a cuckolded cock. But in Fassbinder's film, while Lola's apartment contains a caged bird, the camera barely pays attention to it. That this reference to von Sternberg's décor nevertheless signifies as a citation, however, is established toward the end of *Lola* when a bourgeois garden is shown to include another—and quite large—caged bird. Out of place in this backyard, a peacock displays its glorious tail, its so-called pride, showing off to both the film's oblivious characters and its knowing spectators the gay icon of "the full peacock"—erect, not flaccid, even if caged. Citing and revising von Sternberg, Fassbinder exposes himself to his audience.

To recapitulate briefly: *Lola*'s décor contains a collection of props I call citation objects—the snow globe, the butterfly, the doll, the bird—each of which has a role to play in the shoring up, the establishing, of a dispersed authorial identity. "Speaking" objects, they tap into a web of intermedial associations, commenting eloquently on the erotic life and on death. As a strategy for self-articulation, then, these citation objects are crucial to the performative nature of Fassbinder as auteur, suggesting that an interior life, as it were, is exhibited in the film's mise-en-scène. The objects that proliferate in von Sternberg's films have something to say about the characters who live among them as well as about the director himself, whereas in Fassbinder's *Lola* objects simultaneously point outward toward other texts and inward toward an authorial identity that is merely gestured toward. Insofar as this

identity is dispersed across a field of references, it is always in danger of being reduced to a chain of signifiers. "Identity" is finally the assemblage of citations that suggests interiority but always stands in place of it.

Icons: Marlene and Ludwig

It has become a commonplace that Judith Butler's work on the performativity of gender as a reiterative and citational practice suggests its difference both from the performance that is an acting out of the psychoanalytic scene, and from the theatricality associated, let us say, with drag. Jack Babuscio reads in von Sternberg's films what he calls "the perception of an underlying emotional autobiography—a disguise of self and obsession by means of the artificial," an orientation on which Babuscio bases his definition of camp. In the context of this mindset, appearances have a "deep significance," and it is the "sumptuous surface that serves not as an empty and meaningless background, but as the very subject of the films."[52] For Babuscio, artifice and illusion are expressive of von Sternberg's "interior world," and "spiritual events" are never "mere" decoration, as Kracauer complains of *The Blue Angel*. In the context of queer theory and camp, artifice is given ideological pride of place. As Susan Sontag notably puts it, camp is "the farthest extension, in sensibility, of the metaphor of life as theater . . . of being-as-playing-a-role."[53] "Truth" resides in surface appearance. Needless to say, Fassbinder also features in Babuscio's essay.

In yet another act of citation—here of Flaubert's "Madame Bovary, c'est moi"—von Sternberg famously claims that "Marlene is not Marlene in my films. Marlene is me and she knows that better than anyone."[54] Is von Sternberg expressing a hoped-for merger with Dietrich as the phallic mother, or is this allusion to Flaubert yet another curtain that veils his subject, another signifier in a seemingly endless chain? Following in the footsteps of von Sternberg and Flaubert, Fassbinder dedicated *The Bitter Tears of Petra von Kant* "to him who here became Marlene." (See chapter 3.) As a name for a character, "Marlene" is overdetermined, not readily susceptible to unhitching from Dietrich—it is also attached, as we have seen, to von Sternberg. But Marlene is also the mute servant in *Bitter Tears*, the masochist in an obviously sadomasochistic relationship, while the person "who here became Marlene" in that film refers to Fassbinder's mistreated gay lover in real life. By likening his lover to the character Marlene in *Bitter Tears* (whose role is the reverse of the one played by Dietrich in her films with von Sternberg), Fassbinder places himself in the role of Dietrich.[55]

In his autobiography,[56] von Sternberg represents Dietrich as an actor prostrating herself before him in "crawling abasement to a mentor," but also as phallically emitting what he describes as "geysers of praise" shooting in his direction "hot and steaming, on the hour every hour."[57] Self-abasement and (male) sexual potency coalesce in the paradigm of sadomasochism. This

moment of authorial self-fashioning revels in ambiguity: does this scenario refer to Marlene as actor in her relation to von Sternberg as director, or is Marlene a self-representation of the director himself in von Sternberg's anecdote? As in the masochistic scenario, characters are mutable and take on a variety of roles. Identifications are multiple. For the art world that is integral to the masochistic aesthetic—von Sternberg's art world—queer theory provides another valuation for veiling, for artifice, for the decorative façade.

Yet another queer icon lurks on the periphery of *Lola*. Just as Marlene is not Marlene, the Lindenhof—a housing development that is to be built after von Bohm is co-opted—is not only, perhaps, the Lindenhof. To a German audience the project's name would inevitably bring to mind the Linderhof, Ludwig II's primary residence. In early Fassbinder films especially, Ludwig functions as a camp icon, as part of a queer iconography: in *Gods of the Plague* (1970), for example, the transvestite who sells a poster of Ludwig in an antique store calls him "a beautiful man." An intensely theatrical figure, the historical Ludwig rowed his golden shell-shaped boat in Linderhof's Venus Grotto, a replica of the famous Blue Grotto of Capri. (Could this be another reason that "Capri Fishermen" was chosen as one of Lola's signature songs?) Like the Blue Grotto, once the bath of the Roman emperors, Ludwig's Linderhof is now a tourist destination, much as, in *Gods of the Plague* (1970), Ludwig is a poster image, multiply reproduced and commercialized. Not surprisingly, Kaja Silverman reads the poster of King Ludwig in this film as a narcissistic support.[58]

But if Fassbinder's films ironize this icon, they nevertheless cite it, suggesting a multiple explanation for Ludwig's presence in Fassbinder's films. In a story by Wanda Sacher-Masoch, *The Adventure with Ludwig II*, Ludwig of Bavaria plays a prominent role in the fantasy life of her husband Leopold. Wanda's purportedly autobiographical account begins with a letter from someone named Anatole, who claims that Leopold von Sacher-Masoch's "The Love of Plato" has enflamed him. In his turn, Leopold is deeply moved by Anatole's declaration, suggesting that he has found the object of *his* "sacred desire" in Anatole. Adding erotic interest to the affair is its indefinite and curiously shifting nature of the gender and identity of the correspondent. In Wanda's tale the tantalizing mystery of identity is resolved only obliquely, by way of inference, in a chance conversation under the sign of art. Throughout the story, identities are mutable, they are performed by both Anatole and Leopold, and meetings are set up in the inns or hotels typical of fictional encounters—and in the dark. Anatole's identity remains hidden because the demand made is supposedly for spiritual love, hence all inquiries concerning his body are met with references to art. At one point it is suggested that he resembles the young Lord Byron.

A recurrent theme in Sacher-Masoch's fiction—and of Fassbinder's films— the sexual triangle is at the center of Wanda's story, as well. Close encounters take place in costume and mask (Leopold) or are effected by the substitution

of another body—Wanda's—for his. A rendezvous is arranged at the theater, not only so that the couple will be the object of Anatole's unidentified and unlocalizable gaze, but also because the theater is the appropriate locale for this theatrical story. In the scenarios described by Wanda, the fulfillment of desire is constantly deferred in the manner of the masochistic encounter. By way of its deferral, "art" itself is promoted.

Leopold's emotion, claims Wanda, is inseparable from his fiction-writing impulse: passion is kindled in and through the medium of language. One text generates another, producing a proliferation of written texts, and the letters lead seamlessly from the "real" world to fiction and back again. Wanda approves of the exchange of erotic letters, she writes, because "it could add spice to literature."[59] Life, in other words, is shaped to the demands of art. It seems utterly appropriate, then, that Wanda would suggest that the mysterious Anatole is actually Ludwig II, someone particularly noted for a subjectivity that is unstable, theatrical, and blurs the boundary between life and art. The model of textual proliferation described in Wanda's text is also that of Sacher-Masoch's *Venus in Furs*, whose citational art world need not be read as imitative and secondary but can, rather, be seen as creating an aesthetic space in which the icons, props, and citations that point beyond its boundaries are collected and displayed.

Using Judith Butler's insights to resuscitate the study of the film auteur, Janet Staiger suggests that authorship may be regarded as a "technique of the self," as performative. As she puts it, "The citation of authoring by an individual having the authority to make an authoring statement[,] . . . the repetitive citation of a performative statement of 'authoring choice[,]' produces the author."[60] While somewhat awkwardly phrased, Staiger's claim that authorship is performative is a suggestive one, since it reads citation neither as a symptom nor as the mark of a secondary imagination. Although I have never doubted that Fassbinder is an auteur—it is probably impossible for such a brilliant egotist working within a more or less independent cinema not to be—Staiger's argument that authorship is performative provides insight into the technique of citation in Fassbinder. It suggests that acts of citation are not only acts of appropriation, that they do not only infuse films with camp and/ or queer resonances, and that the act of citation need not "merely" express a masochistic aesthetic. Citations are also acts of authority. Ornamentation and a decorative surface, a mise-en-scène and décor that incorporate citations in the form of lighting techniques, colors, objects, and icons: these do not so much put an inside on display—or put an inside on the outside, as Kracauer would have it—as create an assemblage, a collection of citations. Fassbinder famously claimed that his films are a house. Its décor is telling.

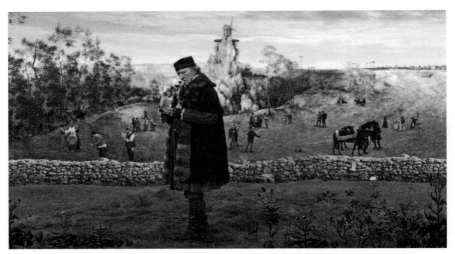

Pieter Bruegel in front of (moving) figures from his painting *The Way to Calvary*. *The Mill and the Cross* (Lech Majewski, 2011), frame enlargement.

Chapter 7

Actor

Dissonance: Bodies between Registers

Contemporary thinking on the position of the actor in the debate between theater and cinema is hardly univocal, often revolving around the idea of "presence" in the theater and its absence in cinema. Erika Fischer-Lichte's aesthetics of performance neatly summarizes changing ideas of presence in theater history, uncovering a duality in the conception of the performer's body in eighteenth-century theater and before. The semiotic body by which an actor portrays a character's emotions and actions, she reports, is distinguished from the phenomenal body, by which actors affect the spectator with their erotic presence.[1] In the nineteenth century these two notions of the actor's body in theater informed the distinction between competing performance strategies, one that served the dramatic character and one that preserved the aura of the performer.[2] The discussion around the star in classical narrative cinema springs to mind in this context. Stanley Cavell famously contends that the film star is there to be gazed at[3] and the camera's power to meditate on the physicality of the actor—her photogenesis—is central to his thinking. For Cavell, character becomes secondary to the performer's bodily presence, generating one of the most profound distinctions between film and theater.[4] In *Acting in the Cinema*, James Naremore suggests that the "impenetrable barrier" of the screen uncannily promotes a sense of the simultaneous presence and absence of the actor.[5] Similarly, for André Bazin, the presence of the actor is central to the theatrical medium, but not lacking in film; it simply gives us "his" (*sic*) presence "in the same way as a mirror," since "everything takes place in the time-space perimeter, which is the definition of presence."[6] For Bazin there is something between absence and presence that is anchored in the realism of film's space and in its photographic nature. Jean-Luc Nancy's more recent remarks on film and theater are not unrelated to Bazin's. By way of the actor, the theater gives the text "flesh and blood, breath and posture," writes Nancy, while the cinema makes bodies signify.[7] Arguing, however, that a cinematic image—indeed, *the* image per se—does not represent an absence but is a "manner of presence," Nancy believes that the actor's body in theater has the same status as the image of the actor in cinema, since they are both modes of occupying the "empty place of the absent."[8] Clearly, there is no consensus

among these points of view, but the recurrent terms of the discussion include the actor's body, the space of performance, and the status of the image.

What happens when the cinema takes on theater? We return to Bazin to frame our thinking about the intermedial possibilities of film in its relation to the actor, drawing on "Theater and Cinema—Part Two" (1951) as a point of departure. Bazin's essay delineates the boundaries between the two media from a number of different vantage points. With respect to the audience, the theater transforms physical reality into an abstraction, thereby distancing and calming the spectator, while the cinema excites its audience and turns it into a mass. But both media have means at their disposal to ensure the reverse—to lessen identification and stimulate thinking, in the case of cinema, and, in the case of theater, to diminish what Bazin terms the psychological tension between actor and spectator. "Two psychological modalities" are at play in theatrical and cinematic performances,[9] modalities of performance that have much to do with their competing spaces. Theater's condition relies on the demarcation between the stage—bounded metaphorically by footlights—and the real world, while cinematic space is continuous with that of the world, with the screen on which it is projected simply a "mask" on reality. Citing Sartre, Bazin famously writes, "In the theater the drama proceeds from the actor, in the cinema it goes from the décor to the man."[10] All force fields in the aesthetic microcosm that is the theater stage are centripetal, converging on the actor at its center. In the case of cinema, on the other hand, dramatic force "dissolves . . . into the ether."[11] Its action is centrifugal, moving into offscreen space. For Bazin, this "reversal of dramatic flow" is connected with "the very essence of mise-en-scène" in cinema.[12] While both theater and cinema are arts with their own laws, film's conjunction with theater (here in the form of filmed theater, the actual topic of Bazin's essay) allows cinema to rethink its own laws, if only for the sake of discovering the "unbridgeable gulf" that divides them.[13] Media archeologist that he is, Bazin concedes that "at some stage in their evolution there has been a definite commerce between the technique of the various arts."[14] The films under discussion in this chapter deliberately emphasize that gulf, drawing on and preserving the dissonance between media rather than suggesting their synthesis.

Seventy years after Bazin's essay, faced with films that flaunt their hybridity, we think somewhat differently about medium specificity, about the conditions that separate—and join—the arts. This chapter investigates the status of the actor when theater, film, or painting are juxtaposed or layered over one another in a single cinematic text. The films with which we are concerned would not have won the approval of Bazin, for, like *The Cabinet of Dr. Caligari* (1920), they "substitute a fabricated nature and an artificial world for the world of experience."[15] Precisely for this reason, perhaps, these films address theater, painting, and cinema in ways that expand their own boundaries. We focus on their relation to the actor with respect to décor, on their differing spatialities, and on the ontological disparities these engender.[16] How does

film use the body of the actor to satirize the actor's presence/absence and spectatorial identification? What is the register of the actor's body when film adopts the artifice of theatrical décor? What becomes of the actor when two attitudes toward space and acting collide, when a film's décor transforms physical reality into an abstraction or a fantastical space?

Several of the films under discussion make use of tableau vivant to stage intermedial relations. I suggest that the dissonance between figure and space in these films can be seen as a foil to tableau vivant. Whereas in tableau vivant the posed, static body is the nodal point that simultaneously focuses film, theater, sculpture, and painting, in our examples the actors are not always rendered uncannily still and statue-like against a naturalistic set. Rather, at issue is the disparity between space, décor, and the actor's body. In these instances theater, film, and sometimes painting collaborate to denaturalize the human figure, whose performance is only one aspect of the dissonance between figure and space.

We begin with Lars von Trier's *Dogville* (2003), where Brechtian epic theater vies with film melodrama. The problematic presence of the seemingly human and yet nonhuman bodies of puppets and the film's literal and parodic reading of spectator identification are the focus of discussion concerning Spike Jonze's *Being John Malkovich* (1999). In this film, the actor's body is made to signify as and among things. Subsequently we examine the situation of the actor in Eric Rohmer's *Perceval* (1978) and Lech Majewski's digitized *The Mill and the Cross* (2011), where the bodies of human actors are uncomfortably positioned between registers, serving as a site of intermedial friction. In *Perceval* and *The Mill and the Cross*, bodies inhabit spaces that are deliberately artificial, uninhabitable, at odds with the living, moving actor's body.

Dogville: Defamiliarization Meets Film Melodrama

In his "A Short Organum for the Theatre" (1948), Brecht further defines the aesthetic practices derived from theatrical performances grounded in the definition of epic theater he had laid out in *The Modern Theater Is the Epic Theater* of 1930. Not unlike Bazin, Brecht invites "all the sister arts of the drama [in], not in order to create 'an integrated work of art' in which they all offer themselves up and are lost, but so that together with drama they may further the common task in their different ways; and their relation to one another consists in this: that they lead to mutual alienation."[17] The common task is political awakening, and alienation (*Verfremdung*) refers to the distancing of the spectator from identification and immersion in dramatic plots by means of effects now conventionally translated as defamiliarization effects. The separation of its elements is of utmost importance in the play, since it is fragmentation that produces detachment. Brecht welcomes the other arts into his theater because their presence engenders positive effects of interruption

and dissonance.[18] Written against the "bourgeois narcotics business"[19] (or entertainment industry), and in favor of the accurate representation (read: the political representation) of social life in the theater, Brecht's essay explains why it is right to engender "a scientific attitude" in the spectator. It also delineates the formal mechanisms by which these ends may be achieved through performance, since the Brechtian play is intended to promote the same attitude in its actors as in its spectators. In fact, Brecht claims that epic theater is intended as much for the enlightenment of the actors as for that of the audience.

For Brecht, the state of *trance* in which the spectator traditionally gazed at the play, "an expression that comes from the Middle Ages, the days of witches and priests,"[20] must be rejected in favor of a detached attitude. Aristotelian catharsis and its purging of emotion is jettisoned in favor of the transformation of consciousness. Epic theater is didactic and pedagogical, and defamiliarization in all aspects of the play brings its ideas to light. The central formal principle of epic theater—the separation of elements, their dissonance—is of utmost importance because it is fragmentation that produces critical detachment. And the social situation of the play is to be analyzed as a process that exposes political conditions, the better to enlighten both spectator and actor and to promote political engagement outside the theater. For the actor, this implies that she must "show," or narrate, a character rather than meld with her. In order to do this, the actor should draw on the social gests of the action's historical period, meaning that the gestures that express social relationships should determine the actor's body language, tone, and expression.

It takes only a cursory look at von Trier's *Dogville* to isolate its Brechtian elements—although, as we shall see, that is not the only thing that is going on in this film. On the Brechtian side, there is a narrator (John Hurt) whose voice-over tells the story of Grace and the town of Dogville. He remains unimaged and undefined. The narrator's voice is not objective—if that is ever a possibility—but often inflected by emotion and innuendo. Ostensibly in the service of the ethical, the narrator takes on the judgmental role of a transcendental consciousness. In its subjectivity his voice-over resembles the subjective movements of the camera, of which there will be more to say. The film's intertitles with chapter numbers and text in the manner of Brechtian stagings foreshadow its storyline in order to defamiliarize the action and punctuate the film in the service of fragmentation. These written texts speak jointly to the placards and projections of epic theater and to novelistic form. The set is itself Brechtian: instead of walls dividing the houses of the village, there is only the outline of where they would be. Chalk lines delineate streets and houses, and Elm Street has no elms. Even the (suggested) objects—the gooseberry bushes that are a bone of contention—are simply lines drawn in chalk and written words; so, too, the dog that we nevertheless intermittently hear barking. The word "dog" marks his place; words substitute for things. One of the film's commonplaces is "Dictu ac factu"—no sooner said than done.

Does *Dogville*'s set design operate theatrically or cinematically with respect to the actor? In its minimalism, the set of the film would appear to be a Brechtian stage—with the intertitles of the film taking the place of the filmic projections with which we are familiar in epic theater. But its expanse (240 by 75 feet)[21] makes it clear that what we see is a movie soundstage, complete with black walls to indicate night and white walls to indicate day. (The black walls that suggest nighttime are arguably ambiguous, implying as they do a black box theater.) While its expanse is too vast for the theater, the set nevertheless suggests a hermetically sealed world to which there is only access via a barely represented Canyon Road. Spaces that lie outside this world, that are unimaged, are signaled through sound: we hear birds singing somewhere, the distant pounding of hammers said to be constructing a penitentiary, and the gunshots that herald the arrival of the gangsters. What lies outside Dogville—offstage or in its offscreen space—is indicated by sonic means, means common to both theater and cinema. Further, the townspeople that populate this space tend to be acted without much expression. To a great extent acting in *Dogville* follows Brecht's dictum of distancing the audience, since the actors pantomime the opening of doors, the sweeping of paths, and other actions posited on the presence of things that are absent from the set.

Strictly cinematic, of course, is the film's editing, its fades to black, and its camerawork. Frequent overhead shots reveal the set as a schematic layout, a kind of board game with its characters the pawns. At one point—after Grace (Nicole Kidman) has been raped—the camera spirals upward as if reeling with shock. Here the omniscient camera with its overhead, bird's-eye or god's-eye shot is subjective, much as the narrator's voice intermittently expresses emotion. In keeping with the *Dogme* principles that von Trier in other respects rejects in *Dogville*, the camera is often handheld and has a nervous mobility, suggesting subjectivity by that means as well. Its framing is erratic: one tends not to find the centered compositions of Hollywood narrative cinema here. And its wide-angle lens is out of place, especially in sequences featuring conversations in medium shot or close-up. At other times, the camera focuses on the space between characters rather than resorting to a conventional two-shot. In the rape sequence the reactive camera is more expressive than the film's actors, whose characters cannot—in the fiction of the film—see the rape but are nevertheless contained in wide-angle shots along with Grace and her attacker. In other words, the camera work and the set without walls jointly imply that the characters could see should they choose to do so.

As to the action of the film, its center is chapter 5 (there are nine in all), the Fourth of July picnic: this episode marks a turning point—ironically an Aristotelian *peripeteia* of sorts—in the plot. The narrative's rising action culminates in the seeming harmony of chapter 5, which moves quickly to a turning point and to the falling action more typical of the Aristotelian drama against which Brecht conceived epic theater. What makes it Brechtian at one and the same time is the way the events of the falling action (leading to

disaster) repeat but invert the action of the first four chapters. In tension with this systematicity is the film's melodramatic component. In one scene especially a handheld and mobile series of shots focuses in close-up on Grace's face, as if to underline the medium specific and centrally cinematic ability to render the human face. This happens during the sequence in which Grace's figurines—ersatz children, the "offspring of the meeting between the townspeople and herself," as the narrator puts it—are smashed by the irate mother for whose live children Grace has been caring. Kidman's sobbing response and her expressive face captured by the camera in close-up breaks with her hitherto more reserved acting style. It breaks as well with the performance of the other actors, which tends to be impassive.

Violence against children is a topic of melodrama, even if the figurines here are ersatz. The pacing of their smashing and the sounds that accompany it, along with the close-up of Grace's face that in this instance forges identification with her character, engender profound affect in the film's spectators. The emotional cruelty that marks this sequence, in evidence both in the dialogue and through the camera's framing, is central to these melodramatic effects. On the other hand, our awareness that the figurines Grace has purchased with money she has earned through hard labor are Hummel figurines speaks to the Brechtian aspect of the action, because Hummel figurines, almost always of children, are collectors' items that operate in the realm of kitsch. As kitsch figures they evoke secondhand emotion: not only are they fetishistic reifications of the human, but for Brecht they would belong to the realm of bourgeois narcotic that help us to cope with inequity and thus anaesthetize us against the wrongs that should promote political action. The two attitudes toward these figurines—the fetishistic love felt by Grace and the condescension toward consumer culture held by Brecht and no doubt von Trier—mark out the film's conflicted emotional territory.

Time and again the specificity of one medium—epic theater—is played off against that of at least one cinematic genre, most notably melodrama. Indeed, aesthetic dissonance is present in von Trier's strategy to play off Kidman the Brechtian actor against Kidman the melodramatic actor. Like the film's other actors, Kidman pantomimes her actions in Brechtian fashion, but it is virtually Kidman alone who is asked to act intimate scenes of suffering, such as in the figurine sequence, and—even more painfully—in the sequence in which her character is raped, the affective impact of the latter intensified by the unmoved characters that surround her. The profound suffering visible in Kidman's face and body language in these sequences suggests that *Dogville*'s dominant cinematic genre is the melodrama. Richard Sinnerbrink, who defends *Dogville* against Jacques Rancière's claim that it suggests political narratives and solutions be avoided in favor of ethical ones ("the ethical turn"),[22] calls the film a "philosophical melodrama" and, in the film's defense, points (though not in any detail) to its Brechtian aspect to suggest that it espouses a politics after all.[23] As for von Trier himself, he has claimed that the impetus for *Dogville* was

the "Pirate Jenny" song from Brecht and Weil's *Threepenny Opera*, "a song of revenge" that is in fact highly political.[24] Toward the end of the film, when Kidman's exploited character speaks a line from this song—"no one's going to sleep here tonight"—almost under her breath—Kidman's performance covers over the act of citation, leaving it barely recognizable as such. This approach is profoundly anti-Brechtian, since the Brechtian actor is enjoined to emphasize the act of quotation as another means of fragmenting the text and thus opening it to political thinking. Arguably, then, the Brechtian and the melodramatic aspects of the film are on a collision course that leaves both ineffective, an intermedial logjam between epic theater and film melodrama.[25]

Linda Williams insists that film critics and historians have failed fully to recognize melodrama's importance as *the* typical form of American narrative, a form that struggles to resolve social and political conflicts (although not always progressively), since "all of the afflictions and injustices of the modern, post-Enlightenment world are dramatized in melodrama."[26] For Williams, the "basic vernacular" of American film melodrama lies in narratives that generate sympathy for a suffering hero and lead to a climax in which sympathy for that hero is produced both in the film's other characters and in its spectators.[27] Melodramatic pathos tends to produce a suffering, if not a masochistic, spectator. Certainly Grace, the Kidman character, endures ever-greater suffering during the course of the film's narrative. But then von Trier's film takes a surprising generic turn: in her final act of murderous revenge Grace abandons the role of sufferer to inflict death on her torturers in what amounts to a cataclysmic reversal. Here melodrama, with its ability to weigh moral choices, is left behind in favor of the gangster film's apocalyptic violence.

No new dispensation is signaled by this apocalypse. Rather, it represents a return to a more primitive system—one that the spectator has been tricked into applauding—while reintroducing the question of catharsis. But what takes place here is certainly not Aristotelian catharsis: we are not purged of the heroine's violence. Does she lose our sympathy? Or do we applaud her act? Kidman dominates the film's final sequences. Her conversation with her gangster father in his limousine returns to the two-shots of classical—Hollywood—narrative cinema, with close-ups for both of them the norm rather than the exception. For von Trier, abandoning Brecht and adopting the language of Hollywood cinema and the gangster genre's "solutions" to maltreatment is in itself to make a political point about the United States—a fraught topic with respect to this film. Presented as regressive, violent, nothing like the consensus politics that are also held up to question in *Dogville*, this sequence culminates in the materialization of the dog that thus far only been signified by its bark and its written name. Here it is the ethos of dog-eat-dog that is being critiqued.

For those invested in a Cavellian dedication to photogenesis, rooted in the understanding that actors recorded on film always reveal themselves through their physicality, the dissonance between two performance styles may not offer

a fully convincing example of a body between registers.[28] Interestingly, actor recognition—another way of approaching the concept of star status—can be given a Brechtian spin as well, since for Brecht the actor's identity *as actor* has the potential to disrupt the narrative. For those who subscribe to Cavell's line of thinking, nothing can undermine the predominance of the actor's body in the cinema. But there is a sequence in which *Dogville* pays homage to the melodramatic mode—whose origin is in the theater—which may succeed in doing so. One formal characteristic shared in common by French theater of the eighteenth- and nineteenth-century American popular theater—where melodrama flourished—is the tableau, a scene in which the actors hold their poses in order to express and underline the dramatic and ideological significance of the scene.[29] Following Peter Brooks, we note that the melodramatic text is often the "text of muteness," a text that downplays language in favor of bodily expression, in which "even the scenes constructed of words tend toward a terminal wordlessness in the fixed gestures of the tableau."[30] In such theatrical scenes, the characters' poses were sometimes based on paintings.

In *Dogville* there are moments when the action is slowed down for our contemplation, but none of them recalls the tableau as readily as the sequence in which Grace attempts to escape the town in a truck. It is shot from above—seemingly cinematic—to create a painterly composition that shows Grace lying in the truck bed amid crates of apples that compartmentalize this space. Here Kidman seems to be shot through a transparent cloth whose texture is interestingly visible in the image—or is this a grid, digitally produced? Although a moving, not a static image, Grace resembles a painted portrait on a canvas with a visible grain, since the shot is digitally rotated in space so that Grace appears to be upright, not lying down at all. Or is Grace, arranged for display with the crates of apples, an object among objects in a Joseph Cornell box? Ironically, it is at the moment when the image is most obviously digital that it gestures toward the other arts—toward painting, the sculptural Cornell box, and the theatrical tableau at one and the same time. This sequence calls up an intermedial conflation of registers, a Bazinian use of the other arts to expand the boundaries of film as well as a Brechtian attempt to defamiliarize by similar means. Not surprisingly, the sequence finds Kidman as Grace in a marked position of dissonance. Are we to perceive her image as two- or three-dimensional? Is she actor or image? To the extent possible, this intermedial image divests the actor of her photogenesis by transforming physical reality into an abstraction, here achieved by transforming the filmic image into a hybrid one that blurs mediatic boundaries.

Presence/Identification: *Being John Malkovich*

With the "performative turn" of the 1960s, actors deliberately intensified the split between the semiotic and the phenomenal body, Fischer-Lichte writes.[31]

(We have seen a similar tension play out—filmically—in von Trier's *Dogville*, with its Brechtian, semiotic performances set against Kidman's expressive and melodramatic close-ups.) Rather boldly, Fischer-Lichte also notes that with respect to live performance—theater and performance art—aesthetic theory since the 1960s suggests that the performer's presence can heal the mind/body split of Western metaphysics—a somewhat tall order. For Fischer-Lichte, in live performance the actor's presence can collapse this dichotomy "by making the concerned performer appear as embodied mind, thus enabling the spectators to experience the performer as well as themselves as embodied minds."[32] Moments of presence are experienced by spectators as moments of happiness, she claims, as an "experience of the ordinary as extraordinary."[33] Film performance is *not* live performance, of course: it can only gesture toward it. Since the actor's phenomenal body is absent in film, from Fischer-Lichte's perspective the film spectator can only experience the immaterialized bodies of the film actor aesthetically. Yet Bazin and others have claimed that something like presence can be suggested by cinema and that the spectator's identification with a character played by the film actor—a psychological process—can serve as a substitute for live presence.[34] I lay out this territory not because I will argue for a genuine sense of the actor's presence in film, or because I concur with Fischer-Lichte's reading of the curative experience of presence in live performance, but because the narrative of Spike Jonze's *Being John Malkovich* (1999) plays on notions of performance and identification that seem indebted to such strains of thought.

The (simulated) "presentness" of performance is signaled linguistically by the film's title, by the present participle "being," Samuel Weber points out.[35] Its somewhat preposterous narrative involves the story of a film star and theater actor, John Malkovich (played by the eponymous actor), whose body has a portal that may be entered by fans—indeed, by anyone who wants to be a star for the duration of Andy Warhol's fifteen minutes. Malkovich's portal is discovered by Craig Schwartz (John Cusack), a puppeteer, and together with Maxine (Catherine Keener), the woman he loves, he sells trips into Malkovich's "head" for two hundred dollars a time. Performance is centrally cued here: being literally occupied by a series of different characters is analogous to the way in which any actor is "inhabited" by the different roles he or she plays—just as the characters' *literal* inhabiting of Malkovich's body stands in for a radicalization of the film spectator's identification with film actor through character.[36] The film's satirical bent is signaled when each person inside Malkovich's head is rudely dumped out near the New Jersey Turnpike.

There is a running joke in the film that while people on the street recognize Malkovich, no one can recall any of the films in which he starred. Nevertheless, the presence of the portal comments on Malkovich's star quality. When people slide through the portal, they see the mundane actions Malkovich is performing at the moment—ordering towels and a bathmat, eating toast and drinking coffee—through his eyes, by sharing his point-of-view shot. When

Malkovich towels himself dry after a shower, Lotte (Cameron Diaz) has erotic sensations, claiming that she has discovered her true gender identity while occupying his body. Those who pass through the portal are well satisfied with their experiences "in" Malkovich. Indeed, the film suggests John Malkovich's embodiment and presence by figuring the other characters as being inside his body: inside the actor, they can see and feel through him. They are happy when two pairs of eyes—those of Malkovich and their own—see as one: here "ordinary moments are perceived as extraordinary." In sequences such as these, *Being John Malkovich* is working out a way to image and satirize both the concept of the theatrical actor's "presence" and spectatorial identification with the film star. Needless to say, in *Being John Malkovich* the actor's body—with its portal—grotesquely merges with the film's set and décor.

Later on in the film, Craig the puppeteer will learn how to remain inside Malkovich, manipulating his body from the inside much as he manipulates his puppets with strings. In this way Craig imposes his will on Malkovich's body, creating a hybrid body/mind that again literalizes the mind/body split—just as the film is suggesting that this duality has been overcome by embodiment and presence. A related issue—the collapse of difference—is imaged when Malkovich decides to enter his own portal, only to discover a fantasy space that consists only of "Malkovich": every character in the restaurant space of his dream is Malkovich himself, costumed differently. This sequence allows the film both to gesture toward the performativity of gender and to image the collapse of gender distinctions in the transgender performance that takes place in the dream space. Not surprisingly, the difference that enables language has collapsed along with other forms of difference: every word on the menu is "Malkovich." When Malkovich "enters" himself through his own portal, he emerges into a prelinguistic state in which there is no difference between self and other. The mind/body split does not exist here.

Puppetry is the other modality of performance central to Jonze's film: not hand puppets, but marionettes with strings. The puppet performance with which the film opens—in close-up on a blue velvet theater curtain later revealed to belong to a puppet theater—is titled "Craig's Dance of Despair and Disillusionment," a dance somewhat surprisingly based on Heinrich von Kleist's essay "On the Marionette Theater" (1811). The film's screenplay is by Charlie Kaufman, screenwriter of *Eternal Sunshine of the Spotless Mind* (2004) and *Adaptation* (2002), who had certainly read Kleist before he wrote it. In Kleist's essay, comprising several narratives, it is somewhat perversely argued that marionettes move with a grace impossible for the human dancer, who is limited by his physical powers. A "machinist" controls Kleist's marionette, powerfully undermining the notion of free will. Kleist's essay also includes the story of a young man who, when glancing into a mirror, becomes self-conscious and loses his natural grace. These points all have resonance for Craig's puppet dance: on seeing himself in a mirror and catching sight of the strings that control him, Craig's marionette dancer runs over to smash

the mirror in despair. The marionette, which resembles Craig and is in fact played by John Cusack, discovers that he is being manipulated by a puppeteer. Further, his perceived unity of mind and body, hitherto unquestioned, is undermined by the mirror image with which he identifies—Lacan's mirror stage lurks in the background of this sequence. Thanks to Kleist, in *Being John Malkovich* the puppet theater becomes a place where metaphysical issues are staged.

Constituting the intermedial aspect of the film, puppet performances serve as a foil to Malkovich's performance as a stage actor—we see Malkovich onstage in the costume of Richard III, and, on another occasion, reading *Uncle Vanya* in preparation for a rehearsal. Unlike the human being, of course, the puppet is a hybrid creature—an object to which the puppeteer gives voice.[37] The puppet's in-between status as human and object is what produces the feeling of uncanniness it so often elicits. As Ken Gross suggests, the puppet's body "brings out hidden lines of connection between inhuman and human, animate and inanimate, things both inside and outside the self."[38] When Malkovich the actor is fully inhabited by Craig and becomes a life-size, living Malkovich "puppet," these boundaries are in fact transgressed. Having taken over the body of Malkovich from within, Craig transforms him from actor to puppeteer: the scene in which John Malkovich acts being inhabited by Craig as puppeteer is a tour de force. (His film role garnered the real-life Malkovich a New York Film Critics Best Supporting Actor award—"the first and probably only time that an actor will be awarded for playing himself.")[39] A later scene in which Malkovich/Craig as puppeteer manipulates a life-size marionette resembling Craig is particularly unsettling. When Cusack as a marionette encased in wooden limbs is shown dancing with human ballerinas, the disparity between ontological registers is fantastical. Inside Malkovich, Cusack is ostensibly manipulating a life-size puppet of himself—and this body is decidedly between registers. Operating as a foil to this body within a body is Maxine's pregnancy. In both instances the film emphasizes the Russian doll effect of the mise-en-abyme to create effects of dissonance.

Another creature within the spectrum between human actor and inanimate puppet is the chimpanzee Elijah, who functions as a substitute child for Lotte. In Western culture monkeys or apes are represented as mimic men—and hence a degraded form of the actor—living creatures capable of imitation, but not of understanding. But in Jonze's film, Elijah—undergoing psychotherapy despite his inability to speak—has a breakthrough when Lotte's cries for help bring the trauma that produced his ulcer back to consciousness. Presented as more feeling than the puppets, certainly, but also more empathic than the human actor, Elijah is not merely a creature. His actions extend beyond mimicry: among the film's characters, Elijah alone performs an act of compassion, skewing in another key the relationship between the human and inhuman. For *Being John Malkovich* film is a space where questions of identity are both staged and undone. Craig's puppets are a projection of

the puppeteer's desires, and Malkovich the actor is a vessel inhabited by his roles, but the identities constructed by the film are not only determined by its theatricality or its interest in the performative nature of gender. They are also cued by Craig's lachrymose reworking of Descartes's *cogito ergo sum* into "I think. I feel. I suffer." In keeping with its questions concerning identity and role-play, *Being John Malkovich* is a film rife with characters for whom speech is problematized—a bird can talk, a woman with aphasia consistently muddles speech—suggesting, perhaps, that film's reliance on words is less pronounced than theater's.

In conclusion, a word about space and décor in Spike Jonze's film. The imaging of presence and its undermining and the collapse of actor and spectator that satirizes psychological identification are in keeping with the film's tendency to literalize metaphor, as in "seeing through someone else's eyes" or "being in someone else's skin." Spatially, the film's narrative is grounded in the conceit of a miniaturized world: the 7½th floor (between the 7th and the 8th) of the office building that contains the portal into Malkovich's body. In the film's diegesis, this extra story was built to accommodate a dwarf—"a lady of miniature proportions"—with whom a nineteenth-century merchant falls in love. Like Malkovich inhabited by Craig and Maxine inhabited by her fetus, the 7½th floor also materializes and questions the metaphor of an interior—and of interiority per se.[40] In this fantastical film, lines of force travel from the décor to the man—which is what Bazin claims for cinema, but the manner of its doing so isn't what he had in mind. This literal interior space from which its preposterous and amusing narrative issues is another concretization of the empty "interiors" of puppet, actor, and film character alike. These creatures are vessels in need of filling, but no "soul" or "mind" are available to do the job. Hence the film's predilection for mise-en-abyme structures. Instead of filling empty spaces, it simply places another empty vessel within them. Perhaps what is ultimately at issue intersects with Fischer-Lichte's interest in the ability of live performance to suggest that the performer is an embodied mind, hence to promoting the awareness of her own embodied mind in the spectator. *Being John Malkovich* is a film in which performance—whether by film actor or puppet—cannot be "live" in any sense, a film which is nevertheless always yearning for liveness—and life. This theme is played out in its sci-fi subplot, which involves metempsychosis and time travel, brilliantly analyzed by Garrett Stewart.[41]

Actor and Décor: Rohmer and Majewski

Eric Rohmer has spoken in detail about performance and décor in his *Perceval le gallois* (1978), a film judged by critics to have been a failed experiment.[42] Based on Chrétien de Troye's eponymous courtly romance in rhymed couplets, the film follows *The Marquise of O* (1976) in Rohmer's oeuvre, a film he

adapted from the eponymous novella by Heinrich von Kleist and shot in German with German actors. Claiming to have shot the film as though Kleist himself were making it, Rohmer studied German along with visual art and drama contemporaneous with the late eighteenth-century period in which the novella is set.[43] One aim was to produce the appropriate Empire look of the interiors, another was to study the gestures and poses—the body language—expressive of human interaction in this period. In *The Marquise of O* décor is a carrier of ideology and gesture is a key to the emotional tenor of the times. For *Perceval le gallois* Rohmer was engaged in similar researches, and the sources to which he turned this time were medieval paintings, miniatures, and illuminated manuscripts. The mixed perspectives of medieval art, the issues of scale (as we see them), the lapis, azure, purples, and reds of stained glass windows, the poses of the depicted figures—all found their way into the style of the film. It was never Rohmer's intention to create a historically accurate rendering of the Middle Ages, if such a thing were possible; rather, he meant "to visualize the events Chrétien narrated as medieval paintings or miniatures might have done."[44] No doubt Rohmer's model was also Carl Theodor Dreyer's *The Passion of Joan of Arc* (1928), a film whose avant-garde set, costumes, and props its set designer Hermann Warm (of *Cabinet of Caligari* fame) based on medieval art—a film Dreyer understood as a historical document.[45]

Gesture was again key, and for a year Rohmer's actors rehearsed different ways of holding their bodies until the postures became second nature. In particular, Rohmer claimed to have found an "overall system of gesticulation" that would justify the stylization of medieval gesture, locating this in the technique of pivoting "the forearm around the elbow, keeping the elbow close to the body and never opening the upper arm."[46] The idea was not to follow too slavishly the codes of gesture—Perceval the naif (Fabrice Luchini) was allowed greater freedom of movement than the courtiers and musicians—but for the women in particular these stylizations were thought to provide "a certain behavioral grace, close to that of the dance and now quite obsolete."[47] One often sees them posing with their lower bodies pushed forward to emphasize the rounded, fecund belly favored by medieval art.

In the cinema, we recall Bazin having written, lines of force run from the décor to the actor. While *Perceval le gallois* attempts to reproduce the bodily gestures of medieval art and to this extent creates a period specific diction that works in tandem with the film's décor, its overall artifice produces a dissonance between the human body and its setting; we find this sort of dissonance in *The Cabinet of Dr. Caligari* (1920), no matter how often Rohmer denies this similarity between the films. (See chapter 1.) The living, three-dimensional actor moving through sets that create spaces so far from naturalistic as in these two films is necessarily experienced as out of whack, not of a piece. In *Perceval*'s exteriors, actors—and their horses—pass in front of what is obviously a painted backdrop, a flat painted more or less in stripes to suggest land and sky. The set is minimal at best, with cardboard castles and

rocks functioning as mountains recycled for different scenes, and a "forest" composed of highly stylized facsimiles of oak trees painted metallic silver. In one amusing scene, Perceval and his horse are seen to enter a castle through a diminutive door through which they can barely pass, with the horse nosing its way in. Rohmer has been expansive about the film's set in relation to the actor: it was conceived as semicircular, again with medieval painting in mind, "so that when a character walks straight ahead, his walk must in fact describe a curve."[48] This technique was designed to suggest the curvature of the human figure in illuminated manuscripts, where the edges of the frame often constrain the shape of the figure. The film's staging, then, is very much that—the set design is theatrical rather than filmic and serves to showcase the body of the actor (and horses) in a style reminiscent of medieval art.

Asked by one interviewer how the film's actors were able to relate to such an artificial set, Rohmer conceded that their relation to the décor differed from the relationship actors would have to the "real world" favored by cinema. In particular, he noted that the actors do not relate to the décor by means of touch, to which they would customarily resort in both film and theater. Pointing to the way the actors tend barely to perch on benches, Rohmer insists that he was attempting by his direction to create "a kind of magnetism between actors and décor, a perpetual play of attraction and repulsion,"[49] but the attraction is not actually in evidence. Rather, the body's reluctance to engage with the set is what comes across. When the same curving routes around the soundstage are taken repeatedly by the film's actors, the tension between living body and set is heightened. It is notable as well when the characters pass through castle interiors with arches and colonnades. What, then, is the nature of this film's space? Rohmer claims that it is properly filmic, that Bazin's requirement that film display a "realism of space"[50] is fulfilled in *Perceval*. But do we actually believe in a space beyond the limits of the screen? The circular movement of the action is just one reason this cannot be the case.

Rohmer likewise insists that there are no false perspectives in *Perceval*, that its impression of flatness, designed to emulate the space of medieval art, derives from its décor alone. Daniel Fairfax interestingly reads the décor of *Perceval* as indicating Rohmer's refusal to participate in Quattrocento perspective and therefore as an ideological statement expressive of solidarity with French apparatus theorists of the early 1970s.[51] Granted, by declaring that the attempt to flatten perspectives by means of the camera results in failure and adding that "photography is photography,"[52] Rohmer concedes that the camera tends to reproduce Quattrocento space. So Rohmer's formal choices might very well engage with the debate around the theoretical and ideological quarrel with perspective then raging in France. (See chapter 1.) But several factors contextualize Fairfax's claim. One is the director's insistence that the "flattened perspectives" produced by the film's décor conform to period style (in the medieval visual arts), making aesthetic accuracy the criterion on which all matters of style rest. There is also Rohmer's contention that there are no

perspectives in Romanesque art, that Romanesque art has no sense of space,[53] but of course that is not true of its architecture, on which he models the film's castles.

Most pertinent to our discussion is that Rohmer resorts to one-point perspective in one courtyard scene (Blanchefleur's) and also suggests it in specific interiors—those coded as belonging to the "right-thinking," the interiors of castles inhabited by Blanchefleur and by the Fisher King. This is especially apparent in the sequence in which Perceval and the Fisher King, seated at table in front of three symmetrically positioned windows with Romanesque arches, watch the bleeding lance pass in front of them, carried by a youth. When the bleeding lance, symbol of Christ's suffering, reaches the midpoint of the composition, there is suddenly a cut to a close-up. This close-up of the literally and ideologically centered lance also marks the place of the camera that produces the perspectival view. In none of the other castles—including that of King Arthur—are the interiors shot so as to produce symmetrical arrangements and the perspectives they suggest. On the contrary, these interiors are shot to make such compositions impossible and, as a result, their spaces appear unstructured and chaotic, expressive of the disorder that reigns in these courts. Not only, then, does Rohmer resort to perspective, but his intentional, if rare, use of it is decidedly Christian and ideological.

In order to narrate the story of *Perceval*, the unusual choice was made to ask the actors to speak the lines of the poem belonging to the narrator along with their own lines in the first person, often pantomiming the actions they describe as they do so. Hence the actors simultaneously speak as subject and object of the narrative. And while members of the chorus of singers and musicians noticeably stare at the major players of the action, turning them into objects of their looks to emphasize their distance from them, an actor who is part of the chorus in one scene often acts as a minor character in another. Such techniques promote the fluidity between subject and object, character and spectator, that we connect with certain kinds of theater performances, where the intention is to create a communal experience in which the "bodily co-presence of actors and spectators"[54] is privileged. Fischer-Lichte's notion of performance as a "spatial, embodied event"[55] is the basis of her aesthetics of the performative, and it is operative as well in Jacques Rancière's theories concerning performance and spectatorship in the theater. For Rancière, "theatre is the place where an action is taken to its conclusion by bodies in motion in front of living bodies that are to be mobilized"—preferably politically.[56] Like Fischer-Lichte, Rancière believes that theater's essence is communal, that theater should be participatory, not a spectacle to be observed. The blurring of boundaries between the spectator of a play and its players is emancipatory for both, Rancière contends.

Such blurring is precisely what takes place in the Passion play that occupies the last ten minutes save one of *Perceval*. Here Perceval, the hapless knight of Chrétien's courtly romance, takes on the role of Christ, which he enacts.

Perceval the sinner becomes the martyred Son of God: to reenact Christ's Passion is also to participate in Christ. Blanchefleur assumes the role of Mary Magdalene, Perceval's mother plays the Virgin Mary, and the male members of the chorus, singing in the traditional Latin, appear to assist in a Mass as they narrate the story. A Passion play is religious theater as ritual—or ritual as religious theater. Communal bonds are stressed and transformation is at issue. Performing in the chapel of Perceval's uncle the hermit, the actors in this play are the characters we have encountered along the way, including the various knights and the chorus of musicians and singers. Medieval religious theater often took a processional form,[57] and in the small space of the chapel, the erstwhile knights now playing soldiers move in circles even more relentlessly than they did in the space of the forest. In some sense, linear narrative is replaced by the circular notion of eternal return.

But the most notable formal characteristic of Rohmer's Passion play is that the circular movement of the characters toward "Golgotha" is periodically halted as the actors assume a static pose in tableau vivant compositions based on the arrangement of figures in medieval painting. In such moments their pointing fingers, heavenward or at Christ—*Ecce homo*—emphasize both the borrowings of their poses from painting and the actors' striking motionlessness. One historian of theater, George Kernodle, bemoans the fact that the tableaux vivants of medieval processional theater and street shows have been neglected by art historians—no doubt, he explains, because they are "halfway between painting and drama."[58] The actors' bodies, oscillating between the held poses of the tableaux vivants and the dramatic procession as it wends its way to the Crucifixion—between a startling stasis and a circular motion—periodically take on emblematic meaning in a tableau, only to break once more into the motion required for narrative progress. Hence, the awkward placement of their bodies in the too-small and too-artificial décor is supplemented by their alternating position between emblem and player, thus introducing temporality into the mix. Here the body of the actor is the site of intermedial relations that create effects of dissonance both with respect to the film's décor and in accordance with the generic conventions of the Passion play. Then, at the play's conclusion, Fabrice Luchini resumes his role as Perceval the hapless knight and rides off across the frame. The film's spectator, who cannot of course *participate* in the blurring of boundaries between spectator and player that defines the religious and aesthetic experience of the Passion play, is nevertheless sensitized to the generic boundary crossings that both determine Rohmer's film and expand its medium.

In our century, digital animation enables effects of dissonance such as intrigued Rohmer in *Perceval* by different means. In *The Lady and the Duke* (2001), Rohmer once again experimented with the disparity between living body and set when he adapted a journal of a Scottish woman written during the Terror in Paris to the screen. Here, too, a major concern was period authenticity, but this time the desire to create a realistic décor—paradoxically

effected by artificial means—was what promoted Rohmer's use of period renderings of Paris for the perspectivally accurate paintings of buildings and streets that serve as a backdrop for character action. By 2001, live action could be combined with painting digitally, creating a new mixed spatiality. But so many of the film's scenes are interiors, shot in the bedroom and boudoir of Grace Elliott (Lucy Russell), that the friction between live action and painted backdrop is somewhat mitigated, more thought-provoking than jarring. With respect to the outdoor scenes, however, the disparity between figure and backdrop is marked: we are very much aware of the ontological disconnect between the actor's body and the painted set. Nevertheless, Rohmer once again cloaks the dissonance produced by his experimental technique in the mantle of (aesthetic) period accuracy.

One sequence in particular self-consciously displays its indebtedness to the painterly conventions and entertainments of the times in their relation to the cinema. It involves a painted panorama of a distant Paris from a parapet on a hill where Grace's maid observes the scene through a spyglass, a primitive handheld telescope. Not only is the spectator on the hill a convention of period landscape renderings, but this scene—of real actors as spectators against a painted backdrop—also displays a period awareness of the panorama, a protocinematic form, as merging just such different registers. An entertainment that spectators paid to access, panoramas had platforms from which spectators could see painted views—often of distant cities and their environs. The frisson these images generated in contemporary spectators had everything to do with the conjunction of their own bodily presence with the painted view they saw. Yes, the curved view created an immersive space that was intended to look naturalistic, but this impression was relativized by the spectator's awareness of its artifice. No doubt it was just this oscillation between illusion and artifice that was a primary source of spectatorial pleasure. Further, the presence of the spyglass in this scene—not used in panoramas—plays to the period interest in visual toys and picturesque travel even as it gestures toward the cinema, where the ability to "see at a distance" is readily available through editing. In the diegesis of the film, the (unimaged) view seen through the telescope is the beheading of the king and his family, problematizing spectacle by focusing the violence of revolutionary France in a film that takes a conservative stance

Ten years later, Lech Majewski makes use of advanced CG technology to effect the conjunction of living actors with a digitized backdrop that images a painting by Pieter Bruegel the Elder, variously known as *The Way to Calvary* and *Christ Carrying the Cross* (1565). There seems little doubt that Majewski was aware of Rohmer's films, for his *The Mill and the Cross* (2011) likewise features a complex intermedial layering of spaces that problematizes the relation of actor to setting. We should keep in mind that the CG technology of 2011 was so evolved that the dissonance we perceive between ontologically diverse images in this film is a matter of directorial choice, not necessity—that

Majewski *chose* to let their ontological differences show in order to create a collage of diverse bodies and spatialities. The film's precredit sequence is especially intriguing in this regard, with its suggestion that what follows is a performance, when several women in the foreground of the film frame are elaborately costumed by assistants. But performance is not the only modality that is at play here. The space of the frame is layered—in bands—and the next band up from the foreground features a row of human figures holding their pose in the manner of tableau vivant. Beyond that layer—in the farther distance, as it were—there is a band of moving live-action figures against the digitized, painterly backdrop. Theater, tableau vivant, filmic action—all three modes of performance will figure repeatedly in Majewski's film. An opposition between the obviously artificial, painterly set taken from Bruegel's painting and real locations is established by the juxtaposition of this precredit opening with a series of shots of men in the Polish woods (the film was shot in Poland) choosing trees that will serve as crucifixes for Christ and the two thieves. The realism of these scenes produces strong affect, but it is immediately followed by shots that feature small live-action figures carrying torches across the landscape of the painting at night, with the light emphasizing their motion against a painterly backdrop. Actors in the realistic scene are juxtaposed with those that move across a painting.

The human figure occurs in another modality as well. Pieter Bruegel himself (played by Rutger Hauer) and his patron the banker Nicolas Jonghelink (Michael York) serve as commentators on the process of composing the painting, which we paradoxically already see as the backdrop of the film. Their dialogue—in fact, the whole of the film's screenplay—is based on *The Mill and the Cross*, a detailed commentary on Bruegel's painting by art critic Michael Francis Gibson which prompted Majewski to make the film and from which it takes its title.[59] Not only are Bruegel and Jonghelink among the very few characters that have a speaking role—there will be more to say about this later—but they often occur in a space separate from the main action of the film, in flattened, portrait-like shots that have the appearance of cutouts superimposed on the frame's hybrid—moving and static—background. In several sequences they are seen to walk laterally across the foreground of the film frame, their motion conspicuously not engaged with the action that spills in vignettes across the frame, as it does in Bruegel's painting. If anything, their motion suggests the back-and-forth traveling shots in which the camera is often engaged, as if to set Bruegel the artist and Majewski the filmmaker in relation. As Lev Manovich has suggested, with the advent of digital technology, the filmmaker paradoxically becomes a painter: "no longer a kino-eye, but a kino brush."[60]

Disparity or dissonance, then, is the effect of the several registers in which the human figure appears within cinematic space. The layering of different media and their juxtaposition within the frame has an analogue in the layering of temporalities featured in Majewski's film. This, too, impacts the actors. As

the Bruegel character tells us—and as we know from the painting itself—
one source of its temporal layering derives from the artist's intention to use
the biblical story of Christ's Passion as a commentary on the acts of terror
Spanish mercenaries were inflicting on the Flemish in the 1550s and 1560s,
when those who supported the Reformation were brutally executed as here-
tics. The political situation in Flanders is centrally featured, as the red tunics
of the Spanish mercenaries depicted on the painting form a "dotted red line
dividing the painting horizontally along the middle,"[61] tunics very clearly
recognizable to Bruegel's contemporaries. Like the figures in the painting,
all of the characters in the film wear contemporary attire—with the excep-
tion of the group of figures the precredit sequence shows in the act of being
costumed. This suggestion that the film includes a theatrical performance, a
Passion play, is also a transposition of sorts. In Bruegel's painting, this group
of distinctly biblical figures—the Virgin Mary, Mary Magdalene, and St. John
among them—occupies a foreground that is raised above the scene of Christ's
Passion, facing not the road to Calvary, but the painting's beholder. These
bodies are at odds with the space of the painting, not a part of its drama. They
are neither painted in the style of its peasants nor costumed as biblical figures.
As Joseph Koerner points out, their "elongated forms, delicate features, muted
colors, sharp silhouettes, and cascading drapery belong to the visual language
of painters who predated Bruegel by more than a century"—to Jan van Eyck,
Rogier van der Weyden, and Hugo van der Goes.[62] Another space and time
in both picture and film, then, is that of fifteenth-century Flemish painting.[63]

The film's mix of temporalities and spatialities does not stop there, how-
ever. Imitating Bruegel in his intention to comment on the politics of his time,
Majewski adds a twentieth-century Polish dimension to *The Mill and the
Cross*. The political unrest that prompted the rise of Lech Walesa and the
imposition of martial law in 1981 caused Majewski to flee Poland for England
and subsequently the United States. How is this temporal layer indicated by
the film? No doubt the "red tunics" do double duty as references to commu-
nism, but it is dialogue that actually does the work. Since there is virtually
no dialogue at all in the film until twenty-eight minutes in and the film has
very few speaking parts, spectator attention is called to the staging of sound.
(Majewski returned to Poland for the shoot, where it may have been difficult
to hire actors with flawless English for the minor parts.) The three central
characters in the film, played by Hauer, York, and Charlotte Rampling, who
is cast both as the Virgin and as a Flemish mother, all speak in English. But the
mercenaries in red tunics can be heard on several occasions to speak Polish,
most clearly as they gamble and argue at the foot of the Cross. Here the men
in red tunics, perpetrators of extreme cruelty, are marked as Polish and the
martyred Christ may stand in for a Polish martyr, just as in Bruegel's painting
he is both Christ and a martyred Flemish "heretic."

This is the doubling of allegory, of course. Charlotte Rampling's double
role—as the Virgin in elaborate draperies and as the mother of a Flemish peas-

ant pursued by the mercenaries—also participates in the allegory, but the film deliberately ambiguates her character when it effects another cross-temporal connection to biblical time through the figure of the Virgin. Bruegel painted two Virgins in 1565: Mary with Christ as a babe in arms in *The Adoration of the Magi*, modeled on Bruegel's young wife, and the older Virgin acted by Rampling as *mater dolorosa* in *The Way to Calgary*. Confusion is generated in the film concerning the relation of Bruegel's time, marked by his young wife (the historical figure was twenty when she married the nearly forty-year-old Bruegel), to the biblical time of the Crucifixion. This is especially evident when one of Rampling's interior monologues—she never speaks to an interlocutor—is delivered over images of Christ's torture, suggesting that the man she refers to as her son is Christ. But then her monologue is followed by the sequence about a young Flemish man who comes to embrace Rampling as his mother before he flees the mercenaries. The film promotes confusion in other ways, as well, since differences of register continue to be crucial with respect to the human figure. Unlike the painted figures trapped in the frontally facing tableau of Bruegel's picture, Rampling as Virgin and the uncredited actor who plays Mary Magdalene participate in the procession that makes its way to Calgary to fulfill the biblical story. But there painting is again in play when the Virgin and Mary Magdalene weep at the site of the Cross, recalling countless images of the Deposition that evoke an art historical as well as biblical space and time. The complex temporal layering of the film ensures that time, too, is out of joint. By these means spaces are collaged and time is spatialized.

Unlike *Perceval*, *The Mill and the Cross* is not overly interested in the performative aspect of the Passion play. Yet the film is aware of the theatrical conventions of the period. The procession that it images—and, indeed, any form of processional street theater during Bruegel's time—was accompanied by tableaux vivants to be "read" by its spectators. Unlike Rohmer, Majewski makes no explicit claim to aesthetic accuracy, but the presence of tableau vivant in his film seems based on an understanding of Renaissance theatrical performances. No doubt the interest derives from Gibson, whose text traces a close connection between Bruegel and participants in the Landjuweel, the national competition of the Flemish Chambers of Rhetoric in Antwerp in 1561. Twenty-three triumphal chariots and nearly two hundred carts decorated by the Lucasgilde, the artists' guild of which Bruegel was a member, participated in this festival. As George Kernodle points out, in many Flemish cities the alliance between the Chambers of Rhetoric and the guild of painters produced an interest in relating painting, poetry, and drama. But it is the simpler street theaters that primarily featured tableaux vivants, "born of the desire to make visual art more active—to make it breathe and speak with living actors."[64] "Show-pieces" with (living) pictures were designed for festival purposes, such as the triumphal entry of a monarch into a city. Media archaeology suggests that Majewski's film, complete with static and moving pictures, may very well hark back to the "show-piece."

In *The Mill and the Cross* intermedial relations are most centrally staged in one astonishing tableau vivant. In conversation with Bruegel, Jonghelink asks the painter how he can arrest the procession to Calvary: how, Jonghelink wonders, can Bruegel transfer the many swarming figures around him into static images in his sketchbook? In response, Bruegel looks up at the mill, with the camera following his look to settle in medium close-up on the miller standing on a parapet. Then the miller claps his hands, the mill stops turning, and the miniature figures scattered across the painterly landscape halt their motion as in a game of "statues." The miller of both painting and film—recalling God the Father pictured in many renderings of the Passion—is in league with time. The mill wheel *is* the wheel of time, its inexorable grinding marking Christ's—and our—inevitable course toward death. Connected from the first with the cacophonous noise of creaking wheel and wooden clogs that punctuate the film's aural surface, after the Crucifixion mill and miller seem agents of the crashing thunderstorm that signals the wrath of God: recall the timeworn phrase "the mill wheel of the Lord grinds slow, but exceeding fine." But when the miller, responding to a signal from Bruegel, causes time and the assembled company to stand still and silent, what is at stake for Majewski's film? For one thing, the contrast between the narrative devolution of a play or film and painting's arrested moment—their differing temporalities—is underlined. Earlier in the film the layering of different registers of the image—live action, the static pose, drawn and digitized images—showcased the technology that allows such disparate images to be unified and subsumed—as well as Majewski's choice *not* to subsume them, but rather to let them show. In the mill sequence, the emphatic stilling of the moving image with its transformation of noisy narrative to silent picture underscores the ability of the artist to shape the world, not merely to depict it. And Majewski does this by means of the tableau vivant—with historical accuracy, that is, as in the case of Rohmer.

Repeatedly in the film, views through a window or an archway consist of digitized images from Bruegel's static painting. This is not surprising, since that is what the film's set primarily is. The rectangular shape of Bruegel's paintings is stressed by the interior shots of Jonghelink's house, where the patron and collector displays two paintings on his wall. (The two that we see are *The Tower of Babel* and *Hunters in the Snow*, suggesting that their choice is an homage to Andrei Tarkovsky's *Solaris* [1972].) That the shape of Bruegel's paintings resembles that of a window has been repeatedly noted by art historians. In his film, Majewski uses the paintings to remind us that Leon Battista Alberti's concept of a painting is a "window on the world," but there is more. Toward the end of *The Mill and the Cross* there is a shot of Bruegel *en face*, seated near another window, eyes closed, tracing an imagined sketch with his finger. As we look on, dancers and musicians move into the space framed by the window behind him, introducing movement and sound into the frame—which hereby becomes a screen. Painting and film are conjoined

and perhaps television is in the mix as well, since it is the television screen that the window's shape most closely resembles. With the film's oscillation between character movement and stasis, between the two-dimensional (recall the "portraits" as cutouts) and the three-dimensional human figures of the narrative, Majewski styles himself as painter and filmmaker at once. Perhaps Majewski, who is arguably better known for his installations than his films, is using *The Mill and the Cross* to experiment with the elements of this more disparate form.[65] Both the film's spatialization of time and its collaging of different registers of the image could suggest this.

In his essay on filmed theater, Bazin suggests that the director must reconvert "a window onto the world of a space oriented toward an interior dimension only" (theater) into something like the "realism of space" that characterizes film.[66] Does this happen in Majewski's ostentatiously intermedial film, rife with artifice? Getting up from his seat near the window, Bruegel turns to look through it. What Bruegel and the spectator jointly see is peasants dancing against a digitized background: motion, sound, and color dominate the scene. Then the screen goes black briefly, marking a distinct temporal and spatial hiatus, after which the camera travels out of the framed painting, *The Way to Calvary* now in place in Vienna's Kunsthistorisches Museum. The camera continues to travel out and back to reveal what to us seems the moribund space of this museum with black moldings and gray walls: it is empty of people, silent, bereft of the life and movement of the human figures in Bruegel's painting. That may be the point of this coda that does, in fact, reinstate a realistic film space, but leaves it open to critique. While a bustling Vienna may lie outside its walls, the museum's corridors constrain space and reveal it as lifeless. Bazin claims that "the drama on screen can exist without actors,"[67] and here it does—but only the camera moves. There is "no trembling of a branch in the wind"[68] or anything else to evoke the natural world. In contradistinction, the digitized, collaged space with its ontologically disparate figures is marked as the space of life.

Our passage through the films above delineates some ways in which the film actor is used to stage a tension between the confluence of several arts—or media—in cinema. *Dogville* juxtaposes Brechtian epic theater with film melodrama through the contrast between its theatrical décor and erratic camera, and by way of performance styles. And then there are the films that place their focus on the actor's body. Turning this body into a staging ground by way of a portal that promotes a satire on identification and presence, *Being John Malkovich* contrasts the human actor with the puppet. A theatrical set and décor is juxtaposed with the bodies of human actors in *Perceval le gallois*, where a Passion play performance also sets up a tension between the emblem in tableau vivant and the processional play. The exteriors of Rohmer's *The Lady and the Duke* are painted sets against which human actors incongruously move, while in Majewski's *The Mill and the Cross* live action is super-

imposed on a digital backdrop of Bruegel's *The Way to Calvary*. The latter film complexly images different registers of the human figure within the multiple spatialities and temporalities enabled by digital technology, taking care to keep them separate from one another. These films either cannot achieve a synthesis—I think of *Perceval*—or do not entertain it as an option, choosing instead to let dissonance show.

NOTES

Introduction

1. Jean-Luc Nancy, *The Evidence of Film: Abbas Kiarostami*, trans. Christine Irizarry and Verena Andermatt Conley (Brussels: Yves Gevaert Éditeur, 2001), 28, 18.

2. Jonathan Rosenbaum, "*Shirin* as Mirror," last posted June 8, 2017, http://www.jonathanrosenbaum.net/2017/06/shirin-as-mirror/.

3. Noa Steimatsky, *The Face on Film* (New York: Oxford University Press, 2017), 1.

4. André Bazin, "Theater and Cinema," part 2, in *What Is Cinema? Volume 1*, ed. and trans. Hugh Gray (Berkeley: University of California Press, 1967), 109.

5. Maureen Turim, "Three-Way Mirroring in *Vivre sa Vie*," in *A Companion to Jean-Luc Godard*, ed. Tom Conley and T. Jefferson Kline (West Sussex, U.K.: Wiley-Blackwell, 2014), 89–107, 91.

6. Steimatsky, *Face on Film*, 64.

7. As Kaja Silverman points out, "It is thus Godard, not Nana, who insists upon the relation between her and Jeanne." Kaja Silverman and Harun Farocki, *Speaking about Godard* (New York: New York University Press, 1998), 11.

8. Gilles Deleuze, *Cinema 1: The Movement-Image*, trans. Hugh Tomlinson and Barbara Habberjam (Minneapolis: University of Minnesota Press, 1986), 103.

9. Steimatsky, *Face on Film*, 64.

10. Susan Sontag, "Godard's *Vivre sa vie*," in *Against Interpretation and Other Essays* (New York: Dell, 1962), 198–211, 206.

11. Silverman and Farocki, *Speaking about Godard*, 24.

12. Jean-Luc Godard, *Godard on Godard: Critical Writings by Jean-Luc Godard* (New York: Da Capo Press, 1986), 187.

13. Turim, "Three-Way Mirroring," 94.

14. Interview, December 1962, which originally appeared in *Cahiers du Cinéma* and was then excerpted in *Godard on Godard*. Reprinted in Criterion DVD supplement, p. 31.Turim mentions that the twelve tableaux are in imitation of Brecht's *Mother Courage* ("Three-Way Mirroring," 95).

15. Sontag, "Godard's *Vivre sa Vie*," 201.

16. Godard, *Godard on Godard*, 26.

17. Francesco Casetti, *The Lumière Galaxy: 7 Key Words for the Cinema to Come* (New York: Columbia University Press, 2015), 182.

18. Casetti, *Lumière Galaxy*, 181.

19. Ibid., 255.

20. Another link in the chain: Turim points out that in Renoir's film *Nana*, his wife played the title role ("Three-Way Mirroring," 97). And we should not forget Zola's novel *Nana*.

21. Rosenbaum, "*Shirin* as Mirror," 2. Kiarostami served on the jury of Cannes Film Festival three times, and was himself a winner of the Palme d'Or for *Taste of Cherry* (1997).

22. Rosenbaum, "*Shirin* as Mirror," 2.

23. Nancy, *Evidence of Film*, 18.

24. Ian Balfour, "Nancy on Film: Regarding Kiarostami, Re-Thinking Representation (with a Coda on Claire Denis)," *Journal of Visual Culture* 9, no. 1 (2010): 29–43; http://vcu.sagepub.com.

25. Nancy, *Evidence of Film*, 18.

26. Tyborg, commentary.

27. Jeff Wall, "A Note on *Movie Audience*," quoted in Michael Newman, *Jeff Wall: Works and Collected Writings* (Barcelona: Ediciones Poligrafa, 2007), 25.

28. Stephen Teo, "Iranian Cinema and Inward Space," in *The Asian Cinematic Experience: Styles, Spaces, Theory* (New York: Routledge, 2013), 160.

29. Ibid.

30. Dudley Andrew, "Announcing the End of the Film Era," *Cultural Critique* 9 (Winter 2017): 263–84, 265.

31. Jay David Bolter and Richard Grusin, *Remediation: Understanding New Media* (Cambridge, Mass.: MIT Press, 2000).

32. Brigitte Peucker, *Incorporating Images: Film and the Rival Arts* (Princeton, N.J.: Princeton University Press, 1995); and *The Material Image: Art and the Real in Film* (Stanford, Calif.: Stanford University Press, 2007).

33. Yvonne Spielmann, "History and Theory of Intermedia," in *Intermedia: Enacting the Liminal*, ed. Hans Breder and Klaus-Peter Busses (Dortmund: Dortmunder Schriften zur Kunst, 2005), 131–36.

34. Jacques Rancière, "The Pensive Image," in *The Emancipated Spectator*, trans. Gregory Elliott (London: Verso, 2009), 107–32, 131. See also André Bazin, "Theater and Cinema," part 2, 116.

35. Cited by Dudley Andrew in his thought-provoking review of Francesco Casetti's *The Lumiere Galaxy*, "Announcing the End," 278.

36. Alain Badiou, "Cinema as Philosophical Experimentation," in *Cinema*, ed. Antoine de Baecque, trans. Susan Spitzer (Cambridge: Polity Press, 2013), 202–32, 216.

37. Ágnes Pethő, *Cinema and Intermediality: The Passion for the In-Between* (Newcastle-upon-Tyne: Cambridge Scholars Publishing, 2011), 1.

38. Rosalind Krauss, *"A Voyage on the North Sea": Art in the Age of the Post-medium Condition* (New York: Thames and Hudson, 1999).

39. Ibid., 5–6.

40. Rosalind Galt and Karl Schoonover, eds., *Global Art Cinema* (New York: Oxford University Press, 2010).

41. Victor Fan, *Cinema Approaching Reality: Locating Chinese Film Theory* (Minneapolis: University of Minnesota Press, 2015); Stephen Teo, "Iranian Cinema."

42. Jean Ma, "A Reinvention of Tradition: Hou Hsiao-hsien's *The Puppetmaster*," in *Hou Hsiao-hsien*, ed. Richard Suchenski (Vienna: Synema, 2014), 87–105.

43. Hao Dazheng, "Chinese Visual Representation: Painting and Cinema," in *Cinematic Landscapes: Observations on the Visual Arts and Cinema of China*

and Japan, ed. Linda C. Ehrlich and David Desser (Austin: University of Texas Press, 1994), 45–62.

Chapter 1

1. André Bazin, "The Ontology of the Photographic Image," in *What Is Cinema? Volume 1,* ed. and trans. Hugh Gray (Berkeley: University of California Press, 1967), 12; first published as "L'ontologie de l'image photographique" in *Les problèmes de la peinture,* ed. Gaston Diehl (Lyon: Confluences, 1945).

2. Ibid., 12.

3. Ibid., 16.

4. We must keep in mind, as Philip Rosen has recently pointed out, that "spatial likeness and deviance are finally not the crux of Bazinian realism," arguing as well that we must "'disentangle' . . . likeness from the evidentiary in photographic and cinema images." "Subject, Ontology, and Historicity in Bazin," in *Change Mummified: Cinema, Historicity, Theory* (Minneapolis: University of Minnesota Press, 2001), 19.

5. Hubert Damisch, *The Origin of Perspective,* trans. John Goodman (Cambridge, Mass.: MIT Press, 1995), 26. Originally published as *L'origine de la perspective* (Paris: Flammarion, 1987).

6. See Daniel Fairfax's short summary of these debates in "The Tale of Perceval le Gallois and the Young Althusserians," *Senses of Cinema* 54 (April 2010), http://sensesofcinema.com/2010/feature-articles/the-tale-of-perceval-le-gallois-and-the-young-althusserians/. As Fairfax points out, it is Jean-Louis Comolli who suggests a way to circumvent the ideological pressures of perspective: by means of the flat image, by means of montage, and by varying the camera lenses to achieve "varying degrees of proximity to the Quattrocento model." Cited by Fairfax from Comolli's *Cinéma contre spectacle* (Lagrasse: Éditions Verdier, 2009), 156.

7. Nöel Burch, *Theory of Film Practice,* trans. Helen R. Lane (Princeton, N.J.: Princeton University Press, 1981), 162. Burch refers to Pierre Francastel, "Peinture et société," in *Oeuvres* (Paris: Denoël/Gonthier, 1977); and to Jean-Louis Baudry's "Ideological Effects of the Basic Cinematic Apparatus," *Film Quarterly* 28, no. 2 (Winter 1974–75): 33–47. Other apparatus theorists who shared Baudry's point of view include Jean-Louis Comolli and Christian Metz.

8. Stephen Heath, "Narrative Space," in *Questions of Cinema* (Bloomington: Indiana University Press, 1981), 53.

9. There is a dialogue of sorts between the two critics, however. In "Narrative Space" Heath refers to Burch's *Theory of Film Practice* and its arguments about the tableau space of early film; Burch's "Building a Haptic Space" can be seen as a response to Heath. Nöel Burch, "Building a Haptic Space," in *Life to Those Shadows,* ed. and trans. Ben Brewster (London: BFI Publishing, 1990), 162–85.

10. Heath, "Narrative Space," 31

11. Ibid.

12. Ibid., 52.

13. Cited by Heath in ibid., 71n, from Krauss's "A View of Modernism," *Artforum* (September 1972), 50. The importance of *istoria* to perspectival painting is central to Damisch's *Origin of Perspective.*

14. Heath cites Rudolf Arnheim, *Film as Art* (London: Faber, 1969), 27.

15. Rosen, "Subject, Ontology, and Historicity," 19.

16. Dietrich Scheunemann, "One More on Wiene's *The Cabinet of Dr. Caligari*," in *Expressionist Film: New Perspectives*, ed. Dietrich Scheunemann (Rochester, N.Y.: Camden House, 2003), 138.

17. Kristin Thompson describes a photograph of Reimann in his studio, surrounded by a number of his paintings in the Expressionist style, including a "large sketch that bears a distinct resemblance to Munch's *The Scream*." Kristin Thompson, "Dr. Caligari at the Folies-Bergère," in *The Cabinet of Dr. Caligari: Texts, Context, Histories*, ed. Mike Budd (New Brunswick, N.J: Rutgers University Press, 1990), 121–69, 130. This 1920 sketch—depicted on p. 131 of Thompson's essay—is closely related to the poster advertising Cesare at the door of Caligari's tent.

18. Scheunemann, "One More," 139.

19. Thompson, "Caligari."

20. Alois Riegl's notion of the evolution of styles—the *Kunstwollen*—had an important formative influence on Panofsky.

21. Christopher Wood, "Introduction to Erwin Panofsky," in *Perspective as Symbolic Form*, trans. Christopher Wood (New York: Zone Books, 1997), 22.

22. We recall Arnheim and point out Burch's emphasis on two-dimensionality or surface in the arts of Japan. Nöel Burch, *To the Distant Observer: Form and Meaning in the Japanese Cinema*, rev. and ed. Annette Michelson (Berkeley: University of California Press, 1979), 117–22.

23. Samuel Y. Edgerton, *The Mirror, the Window, and the Telescope* (Ithaca, N.Y.: Cornell University Press, 2009), 18; Damisch qualifies this view in *Origin of Perspective*, 394.

24. Burch, "Building a Haptic Space," 183.

25. Ibid., 170.

26. James Elkins, *The Poetics of Perspective* (Ithaca, N.Y.: Cornell University Press, 1994), 145.

27. Burch, "Building a Haptic Space," 184.

28. The art historian Alois Riegl based his notion of the "haptical" on the Egyptian tendency to emphasize surface texture rather than depth. He opposed this to the "optical" tendency of Roman art, which he saw as depth creating.

29. Elkins, *Poetics of Perspective*, 168.

30. Gilles Deleuze, *Cinema 1: The Movement-Image,* trans. Hugh Tomlinson and Barbara Habberjam (Minneapolis: University of Minnesota Press, 1986), 51. Here Deleuze quotes from Wilhelm Worringer's *Form in Gothic* (1912), trans. Herbert Read (rpt., New York: Schocken, 1964).

31. Deleuze, *Cinema 1*, 52.

32. Heath, "Narrative Space," 53.

33. Interestingly, in an earlier scene in Lina's parental home, both she and Johnnie address McLaidlaw's portrait at length, as though it were the person himself.

34. Heath, "Narrative Space," 23.

35. For discussions on Hitchcock and German Expressionist cinema, none of which take my point of view but which rather tend to focus on thematic issues and reception history, see Bettina Rosenbladt, "Doubles and Doubts in Hitchcock: The German Connection," in *Hitchcock Past and Future*, ed. Richard Allen and Sam Ishii-González (New Brunswick, N.J.: Rutgers University Press, 2004), 37–63;

Sidney Gottlieb, "Early Hitchcock: The German Influence," in *Framing Hitchcock*, ed. Sidney Gottlieb and Christopher Brookhouse (Detroit, Mich.: Wayne State University Press, 2002), 35–58; and Joseph Garncarz, "German Hitchcock," in *Framing Hitchcock*, 59–81.

36. Damisch, *Origin of Perspective*, 424.

37. Steven Jacobs, *The Wrong House: The Architecture of Alfred Hitchcock* (Rotterdam: 010 Publishers, 2007), 58.

38. Frieda Grafe, *Filmfarben*, Ausgewählte Schriften, vol. 1 (Berlin: Brinkmann & Bose, 2002), 92.

39. Rudolf Arnheim, "Two Spatial Systems," in *The Power of the Center: A Study of Composition in the Visual Arts* (Berkeley: University of California Press, 1988), 1–12, 4.

40. Interestingly, *Blackmail* contains a scene in which a painting of a jester is torn—clawed at—to disfigure and disrupt its spatial unity and to open it up to filmic space.

41. Fredric Jameson, "Spatial Systems in *North by Northwest*," in *Everything You Always Wanted to Know about Lacan But Were Afraid to Ask Hitchcock*, ed. Slavoj Žižek (London: Verso, 1992), 50.

42. Jameson, "Spatial Systems," 60.

43. Brigitte Peucker, *The Material Image: Art and the Real in Film* (Stanford, Calif.: Stanford University Press, 2007), 100.

44. If Midge now resembles Madeleine on her museum bench, then Scottie is in the position of the portrait that is the object of her look. The triangulated relation of the first scene of looking in the museum is repeated—but with a difference.

45. Ayako Saito, "Hitchcock's Trilogy: A Logic of Mise-en-Scène," in *Endless Night: Cinema and Psychoanalysis, Parallel Histories*, ed. Janet Bergstrom (Berkeley: University of California Press, 1999), 200–248, 208.

46. Edgerton, *Mirror*, 48.

47. Slavoj Žižek reads the looming ship differently, and multiply, as "a stain that blurs the field of vision," a "fantasy element which patches up the hole in reality," and "the massive presence of some Real which fills out and blocks the perspective openness constitutive of reality." Žižek, *Enjoy Your Symptom! Jacques Lacan in Hollywood and Out*, 2nd ed. (Routledge: New York, 2001), 119.

48. Elkins, *Poetics of Perspective*, 167

49. Žižek, "The Hitchcockian Blot," in *Looking Awry: An Introduction to Jacques Lacan through Popular Culture* (Cambridge, Mass.: MIT Press, 1992), 88–106; and Elkins, *Poetics of Perspective*, 167.

50. Joe McElhaney, *The Death of Classical Cinema: Hitchcock, Lang, Minnelli* (Albany: State University of New York Press, 2006), 127.

51. Clement Greenberg, "Abstract, Representational, and So Forth," in *Art and Culture: Critical Essays* (Boston: Beacon Press, 1961), 136.

52. Ibid.

53. Jean-Luc Godard, "Night, Eclipse, Dawn . . . An Interview with Michelangelo Antonioni by Jean-Luc Godard," *Cahiers du Cinéma in English*, no. 1 (January 1966): 19–29, 28.

54. John David Rhodes, "Antonioni and the Development of Style," in *Antonioni: Centenary Essays*, ed. Laura Rascarpoli and John David Rhodes (London: BFI Publishing, 2011), 276–300. This compelling essay links the moments of

abstraction in Antonioni's style to the landscape of development, thus bringing out the profound ways in which Antonioni's style has sociopolitical significance.

55. Pier Paolo Pasolini, "The Cinema of Poetry," in *Heretical Empiricism*, trans. Ben Lawton and Louise K. Barnett (Washington, D.C.: New Academia Publishing, 2005), 179. See also Rhodes, "Pasolini's Exquisite Flowers: The 'Cinema of Poetry' as a Theory of Art Cinema," in *Global Art Cinema: New Theories and Histories*, ed. Rosalind Galt and Karl Schoonover (New York: Oxford University Press, 2010), 142–63.

56. Richard Gilman, "About Nothing—with Precision," *Theater Arts* 46, no. 7 (July 1962): 11. Gilman reports that when Antonioni visited the studio of Mark Rothko, he declared, "Your paintings are like my films—about nothing, with precision." Peter Brunette mentions the "Rothko-like intensity and blocks and field of color" in the scene in Giuliana's shop. Brunette, *The Films of Michelangelo Antonioni* (Cambridge: Cambridge University Press, 1998), 92. Angela Dalle Vacche, perhaps influenced by Seymour Chatman, notes the influence of de Chirico in "Michelangelo Antonioni's *Red Desert*: Painting as Ventriloquism and Color as Movement," in *Cinema and Painting: How Art Is Used in Film* (Austin: University of Texas Press, 1996), 53ff. Sam Rohdie mentions the influence of Giorgio Morandi on Antonioni's film in *Antonioni* (London: BFI Publishing, 1990), 65.

57. Deleuze, *Cinema 1,* 119.

58. Federico Fellini featured Morandi's work in *La Dolce Vita*, also released in 1960.

59. Heath, "Narrative Space," 44.

60. Jean-Luc Godard, "Night, Eclipse, Dawn: An Interview with Michelangelo Antonioni," *Câhiers du Cinéma in English*, no. 1 (January 1966): 294. Recuperating Antonioni's aestheticism, John David Rhodes reads the play with near and far that results from changes in focus as signaling the "distortions of near and far that occur under global capitalism." Rhodes, "Antonioni and the Development of Style," 292.

61. Pasolini, "Cinema of Poetry," 178.

62. Chatman, "Antonioni's *Red Desert*," 123.

63. Rudolf Arnheim, *Art and Visual Perception: A Psychology of the Creative Eye* (expanded and rev. ed.) (Berkeley: University of California Press, 1974), 299.

64. Here I draw on Rosalind Krauss's insights concerning Clement Greenberg on abstraction to the effect that Greenberg's contention that the essence of painting is flatness was emended to add that "the import of painting" lies in the vector that connects painting to viewer by means of "the projective resonance of the optical field." Krauss, *A Voyage on the North Sea: Art in the Post-medium Condition* (New York: Thames and Hudson, 1999), 15.

65. Heath, "Narrative Space," 28.

66. This is the case even though the cross produced by the window frames holds a religious significance for the painter that promises freedom to the soul.

67. Brunette, *Films of Michelangelo Antonioni*, 102.

68. Eric Rohmer, *L'organisation de l'espace dans le "Faust" de Murnau* (Paris: Union Générale d'Editions, 1977), 15–18.

69. Pasolini, "Cinema of Poetry," 179.

70. Rhodes, "Antonioni and the Development of Style," 293. Interesting in this regard is an essay on Bram Stoker's *Dracula* that argues that the vampire

who invades London should be read as an invasion by the colonial Other, an instance of reverse colonization. This insight supplements Rhodes's argument. See Stephen D. Arata, "The Occidental Tourist: *Dracula* and the Anxiety of Reverse Colonization" (extract), in *The Horror Reader*, ed. Ken Gelder (New York: Routledge, 2000), 162–71.

71. Angelo Restivo, *The Cinema of Economic Miracles* (Durham, N.C.: Duke University Press, 2002), 134.

72. Ibid., 134. More thought provoking even than this observation is the contention that it is color itself that functions as the stain in *Red Desert*.

73. See Rhodes's excellent essay, "Antonioni and the Development of Style."

74. Edgerton, *Mirror*, 39.

75. John Berger, *Ways of Seeing* (Harmondsworth, U.K.: Penguin, 1979), 109.

76. Fredric Jameson, "High-Tech Collectives in Late Godard," in *The Geopolitical Aesthetic: Cinema and Space in the World System* (Bloomington: Indiana University Press, 1992), 158–85, 164.

77. See especially Peucker, *Material Image*.

78. See Steven Jacobs, "Tableaux Vivants I: Painting, Film, Death and Passion Plays in Pasolini and Godard," in *Framing Pictures: Film and the Visual Arts*, Edinburgh Studies in Film (Edinburgh: Edinburgh University Press, 2011), 88–120.

79. Murray Pomerance, "*Passion*'s Ghost," in *A Companion to Jean-Luc Godard*, ed. Tom Conley and T. Jefferson Kline (West Sussex, U.K.: Wiley-Blackwell, 2014), 366–82, 374.

80. Laura Mulvey, "The Hole and the Zero: Godard's Visions of Femininity," in *Fetishism and Curiosity* (Bloomington: Indiana University Press, 1996), 77–94, 83.

81. For Jacobs ("Tableaux Vivants I"), who points out *Passion*'s relation to Christ's passion, finding the "right light" also has a religious dimension. I find this totally convincing.

82. Jameson, "High-Tech Collectives," 163.

83. Ibid., 160.

84. Alain Badiou, "Jean-Luc Godard, *Passion*," in *Cinema,* ed. Antoine de Baecque, trans. Susan Spitzer (Cambridge: Polity Press, 2013), 166–75, 171.

85. Jacobs, "Tableaux Vivants I," 116.

86. Peucker, *Material Image*, 1–15.

87. Badiou, "Cinema as Philosophical Experimentation," in *Cinema*, 216.

88. Raymond Bellour, *Between-the-Images*, trans. Allyn Hardyck (Paris: Ringier et les Presses du Réel, 2011), 18.

Chapter 2

1. Joel Siegel, "Greenaway by the Numbers," in *Peter Greenaway: Interviews*, ed. Vernon Gras and Marguerite Gras (Jackson: University Press of Mississippi, 2000), 66–90, 76.

2. Ibid., 77.

3. Brian McFarlane, "Peter Greenaway" (interview), *Cinema Papers* 78 (March 1990): 44.

4. Quoted from a lecture held at UC Berkeley, November 2010.

5. Lev Manovich, *The Language of New Media* (Cambridge, Mass.: MIT Press, 2001), 237.

6. Jay David Bolter and Richard Grusin, *Remediation: Understanding New Media* (Cambridge, Mass.: MIT Press, 1999), 272.

7. First published in *Screen* 17, no. 3 (Autumn 1976); cited here from Stephen Heath, *Questions of Cinema* (Bloomington: Indiana University Press, 1981), 18–75.

8. Erwin Panofsky, "Style and Medium in the Motion Pictures," in *The Visual Turn: Classical Film Theory and Art History*, ed. Angela Dalle Vacche (New Brunswick, N.J.: Rutgers University Press, 2003), 71. Written in 1931, but published later.

9. André Bazin, "Theater and Cinema," part 2, in *What Is Cinema? Volume 1*, ed. and trans. Hugh Gray (Berkeley: University of California Press, 1967), 104–5.

10. Nöel Burch, "Building a Haptic Space," in *Life to Those Shadows*, trans. and ed. Ben Brewster (London: BFI Publishing, 1990), 167.

11. Heinrich Wölfflin, *Principles of Art History: The Problem of the Development of Style in Later Art,* trans. M. D. Hottinger (New York: Dover, 1950), 30. Translation of *Kunstgeschichtliche Grundbegriffe*, pub. 1915.

12. Ibid., 74.

13. Burch, "Building a Haptic Space," 167–73.

14. Greenaway admits to a fascination with "tricks of culture, tricks of cinema, tricks of painting" and an interest in the "mixture of the real and received worlds" of Dutch art. Don Ranvaud, *"Belly of an Architect*: Peter Greenaway Interviewed," in *Peter Greenaway Interviews*, ed. Vernon Gras and Marguerite Gras (Jackson: University Press of Mississippi, 2000), 49.

15. Alois Riegl, "Excerpts from *The Dutch Group Portrait*," trans. Benjamin Binstock, *October* 74 (Autumn 1995): 28.

16. A short excursus here: it seems very likely that Michael Fried, in his several books on the topic of absorption and theatricality keyed to French painting from the eighteenth century through Manet and extended to his work on wall photography, found his inspiration in Riegl as well as in Diderot's *Salons*. With respect to Fried's binarisms, however, Dutch painting would be *theatrical* insofar as it relies on formal procedures to promote continuity between spectatorial space and the space of representation. When Riegl refers to Rembrandt as theatrical in the context of *The Night Watch*, however, he is referring to his reliance on a dramatic composition.

17. Alois Riegl, *Das holländische Gruppenbild* (Vienna: Österreichische Staatsdruckerei, 1931), 243.

18. Ibid., 244–45.

19. This is not the only point in the film in which the camera moves in this way—it moves all around the table at 00:59:14, roughly in the middle of the film.

20. This strategy no doubt refers to Rembrandt's known theatricality, as theorized by Svetlana Alpers and others. Svetlana Alpers, "The Theatrical Model," in *Rembrandt's Enterprise: The Studio and the Market* (Chicago: University of Chicago Press, 1988), 34–57. Bridget Elliott and Anthony Purdy have distinguished between his "theatrical" films and his "museum" films, with the latter referring to films that "explore alternative logics—such as accumulation, saturation, seriality, and taxonomy." See Bridget Elliott and Anthony Purdy, *Peter*

Greenaway: Architecture and Allegory (Chichester, U.K.: Academy Editions, 1997), 90. To my mind, all of the films participate in these strategies to a greater or lesser extent.

21. Berkeley lecture.

22. Alois Riegl, "Excerpts from *The Dutch Group Portrait*," trans. Benjamin Binstock, *October* 74 (Autumn 1995): 25, 20.

23. This aspect of Riegl's analysis—the painting's indebtedness to Rubens—is also alluded to in de Roy's monologue. Interestingly, the allegation of homosexuality against two of the characters may well have its source in Benjamin Binstock's "Postscript: Alois Riegl in the Presence of *The Night Watch*," *October* 74 (Autumn 1995): 41.

24. Riegl, "Excerpts," 25.

25. Ibid., 20.

26. Ibid.

27. In the course of this sequence, Greenaway's screenplay reports, no fewer than three canonical paintings have been evoked in a matter of minutes: Rembrandt's *Blinding of Samson*, Rubens's *Fall of the Rebel Angels*, and Caravaggio's *Conversion of St. Paul*, citations that locate the film within art historical discourse. Peter Greenaway, *Nightwatching* (Paris: Dis Voir, 2006), 5–6.

28. Greenaway's recourse to these dreams creates a narrative frame for the film that positions it within a psychological framework reminiscent of Riegl's stress on the psychological element of Rembrandt's group portraits.

29. In *Ende der Kunstgeschichte*, Hans Belting points out that "unframing" the framed space of cinema is an explicit aim of Greenaway's, citing an interview with Greenaway in *Film Bulletin* from 1994. Belting, *Ende der Kunstgeschichte: Eine Revision nach zehn Jahren* (Munich: C. H. Beck, 1995), 30. Belting also mentions that Greenaway briefly broaches the topic of framing in his film book on *Prospero's Books*. Greenaway wants to free the spectator from the frame, which he does in his installations but, says Belting, he does this only by achieving the "ungewollte Ziel" of including the spectators in his frames (198). I argue that this is in fact Greenaway's goal.

30. Norman Bryson, *Looking at the Overlooked: Four Essays on Still Life Painting* (Cambridge, Mass.: Harvard University Press, 1990), 71.

31. Ibid., 80.

32. Ibid., 81.

33. Alpers, "Theatrical Model," 39.

34. Ibid.

35. Ibid., 32.

36. Ibid., 34.

37. Ibid., 39.

38. Ibid., 45.

39. Ibid., 46.

40. Riegl, "Excerpts," 27.

41. Bazin, "Painting and Cinema," in *What Is Cinema? Volume 1*, 166.

42. Brigitte Peucker, *Incorporating Images: Film and the Rival Arts* (Princeton, N.J.: Princeton University Press, 1995), 110.

43. Ibid., 107–9.

44. Elliott and Purdy, *Peter Greenaway*, 90.

45. Peucker, *Incorporating Images*, 107–8.

46. John Dixon Hunt, "Theaters, Gardens, and Garden Theaters," in *Garden and the Picturesque: Studies in the History of Landscape Architecture* (Cambridge, Mass.: MIT Press, 1997), 50.

47. Hunt further notes that "in these garden theaters, tableaux vivants were also at home." Ibid., 56.

48. Ibid., 55.

49. Norman Bryson, "The Gaze and the Glance," in *Vision and Painting: The Logic of the Gaze* (New Haven, Conn.: Yale University Press, 1983), 112.

50. See Brigitte Peucker, *The Material Image: Art and the Real in Film* (Palo Alto, Calif.: Stanford University Press, 2007), 1–15.

51. Greenaway, *Nightwatching*, 3.

52. The title also points to Abel Gance's film *J'accuse* of 1919.

53. In "Painting and Cinema" Bazin argues that "if we show a section of a painting on a screen, the space of the painting loses its orientation and its limits and is presented to the imagination as without boundaries" (166).

54. W. J. T. Mitchell, "Ekphrasis and the Other," in *Picture Theory: Essays on Verbal and Visual Representation* (Chicago: University of Chicago Press, 1994), 180.

55. Fortunately, she *did* go into hiding and eventually fled to the U.S.

Chapter 3

1. André Bazin, "Painting and Cinema," in *What Is Cinema? Volume 1*, ed. and trans. Hugh Gray (Berkeley: University of California Press, 1967), 165.

2. Ibid., 166.

3. Ibid.

4. Ibid., 68.

5. Roland Barthes, "Diderot, Brecht, Eisenstein," in *Image, Music, Text*, trans. Stephen Heath (New York: Hill and Wang, 1977), 70.

6. Suggestively, the male signifier replaces and updates the rhetorically based pose to indicate the linguistic foundation of Poussin's images.

7. Denis Diderot, *Salons*, vol. 1 (1763), ed. Jean Seznec (Oxford: Clarendon Press, 1957), 125.

8. Rudolf Arnheim, "Limits and Frames," in *The Power of the Center: A Study of Composition on the Visual Arts* (new version) (Berkeley: University of California Press, 1988), 59.

9. Poussin, *Correspondance* (21), quoted by Anthony Blunt, *Nicolas Poussin* (New York: Bollingen Foundation, 1967), 223.

10. Quoted from Louis Marin, *To Destroy Painting*, trans. Mette Hjort (Chicago: University of Chicago Press, 1995), 33.

11. Ibid.

12. Ovid, *Metamorphoses* (Middlesex, U.K.: Penguin Books, 1955), 91.

13. Lynne Kirby, "Fassbinder's Debt to Poussin," *Camera Obscura* 13/14 (1985): 9.

14. Oskar Bätschmann, *Nicolas Poussin: Dialectic of Painting* (London: Reaktion Books, 1990), 62.

15. Ibid., 87–88.

16. Edith Hamilton, *Mythology* (New York: New American Library, 1942), 57. Hamilton also refers to Bacchus as "the suffering god" (62), the subject of the following section.

17. Friedrich Nietzsche, *The Birth of Tragedy*, trans. and intro. Douglas Smith (Oxford: Oxford University Press, 2000), 5, 51.

18. Ibid.

19. Ibid., 23.

20. Ibid., 21. The figure of the Christian martyr is of central significance to the masochistic scenario.

21. Ibid., 127.

22. Ibid., 131.

23. Anthony Blunt, *Nicolas Poussin* (New York: Bollingen Foundation, 1967), 242.

24. Bätschmann, *Nicolas Poussin*, 29.

25. Blunt, *Nicolas Poussin*, 244.

26. I'm tempted to say that in some sense the camera alludes to the eye of Poussin, peering into his theater box—but of course this remark is tongue-in-cheek.

27. Gerald Mast, "On Framing," *Critical Inquiry* 11 (September 1984): 85.

28. Pascal Bonitzer, *Décadrages: Peinture et cinéma* (Paris: Câhiers du Cinéma / Éditions de l'Étoile, 1985), 18.

29. T. J. Clark, *The Sight of Death: An Experiment in Art Writing* (New Haven, Conn.: Yale University Press, 2006), 135.

30. Surely this composition is overdetermined, vaguely but multiply suggestive of a threatening mother who debases her child—and whose high-heeled shoe is both a fetish and the instrument of a sadistic sexuality.

31. Jacques Derrida, *The Truth in Painting*, trans. Geoff Bennington and Ian McLeod (Chicago: University of Chicago Press, 1987), 61.

32. Immanuel Kant, *The Critique of Judgment*, trans. J. H. Bernard (New York: Hafner, 1972), 26.

33. Ibid., 66.

34. Gaylyn Studlar, *In the Realm of Pleasure: Von Sternberg, Dietrich, and the Masochistic Aesthetic* (New York: Columbia University Press, 1988), 153.

35. Susan Stewart, *On Longing: Narratives of the Miniature, the Gigantic, the Souvenir, the Collection* (Durham, N.C.: Duke University Press, 1993), 57.

36. T. J. Clark refers to figures in Poussin paintings both as mannequins and as participating in a puppet show (*Sight of Death*, 204).

37. Therese Lichtenstein, *Behind Closed Doors: The Art of Hans Bellmer* (Berkeley: University of California Press, 2001), 52.

38. Bellmer's artistic legacy survives in photographs of ball-jointed dolls taken by Cindy Sherman in 1993.

39. Sue Taylor, *Hans Bellmer: The Anatomy of Anxiety* (Cambridge, Mass.: MIT Press, 2000), 6.

40. Titled "Double Cephalopod," it features the artist's head inside Zürn's uterus, representing, in other words, a man contained in the body of a woman who functions as both alter ego and mother.

41. The folio of *Heinrich von Kleist: Les Marionettes*, onze cuivres gravé en deux couleurs par Hans Bellmer (eleven instruments etched in two colors by Hans Bellmer), is available at the Beinecke Library, Yale University.

42. Interestingly, the boy first places his flattened hand facing the spectator of the film—figuratively, therefore, on the very screen on which Bergman's film is projected.

43. Gilles Deleuze, "Coldness and Cruelty," in *Masochism* (New York: Zone Books, 1991), 55.

44. Karin, in other words, enjoys melodrama. The melodrama, so centrally about expressiveness, often included a mute figure—a compelling explanation for Marlene's muteness. Peter Brooks, *The Melodramatic Imagination: Balzac, Henry James, Melodrama, and the Mode of Excess* (New Haven, Conn.: Yale University Press, 1976).

45. See Brooks, especially ch. 5, "Stories of Suffering and Fixation." See also Elena del Rio, "Cruel Performance: *The Bitter Tears of Petra von Kant*," in *Deleuze and the Cinemas of Performance: Powers of Affection* (Edinburgh: Edinburgh University Press, 2008), 89–112.

46. Theodor Reik, *Masochism in Modern Man*, trans. Margaret H. Beigel and Gertrud M. Kurth (New York: Farrar, Straus and Co., 1941), 49.

47. Ibid., 43.

48. Ibid., 52.

49. Jean-François Lyotard, "Acinéma," in *Narrative, Apparatus, Ideology*, ed. Philip Rosen (New York: Columbia University Press, 1986), 356.

50. Reik, *Masochism in Modern Man,* 72.

51. Ibid., 52.

52. Michael C. Finke, "Sacher-Masoch, Turgenev, and Other Russians," in *One Hundred Years of Masochism: Literary Texts, Social Contexts*, ed. Michael C. Finke and Carl Niekerk (Amsterdam: Editions Rodopi, 2000), 126.

53. Ibid., 133. While I've written about such boundary crossings in film elsewhere and primarily as an aspect of aesthetic play, the blurring of boundaries between art and the real centrally characterizes the masochistic text.

54. Ibid.

55. Mieke Bal, "Telling Objects: A Narrative Perspective on Collecting," in *A Mieke Bal Reader* (Chicago: University of Chicago Press, 2006), 283.

56. Ibid.

57. Bazin, "Painting and Cinema," 165.

Chapter 4

1. Frank Stella, *Working Space* (Cambridge, Mass.: Harvard University Press, 1986), 71.

2. Anna C. Chave, "Minimalism and the Rhetoric of Power," 121–22, https://msu.edu/course/ha/452/chaverhetoric.pdf.

3. Svetlana Alpers, "Interpretation without Representation or, The Viewing of *Las Meninas*," *Representations* 1 (1983): 37.

4. Jacques Lacan, "Of the Gaze as *Objet petit à*," in *Four Fundamental Concepts of Psychoanalysis*, ed. Jacques-Alain Miller, trans. Alan Sheridan (New York: Norton, 1981), 100.

5. Angela Dalle Vacche pursues a similar line of thinking, pointing out that Monica Vitti's "disappearance into the décor reaches a climax when we see her hands and nape merge with the oriental pattern of a sofa in the worker's

living room," evokes Henri Matisse's use of fabrics. Dalle Vacche, "Michelangelo Antonioni's *Red Desert*: Painting as Ventriloquism and Color as Movement," in *Cinema and Painting: How Art Is Used in Film* (Austin: University of Texas Press, 1996), 63.

6. It is important to note that it is not only Georgina's dress that changes color when she moves from space to space in Greenaway's film. Spica's sashes change color, for example, as does the clothing of minor characters as they enter the toilet. The only clothing that does not change color is that of the lover and of the kitchen staff—although in the final scene the cook's white uniform becomes red in indication of the affectively charged feast that is about to take place. Eugenie Brinkema, in her bravura reading of this film, focuses on Georgina and does not account for the color changes the other characters' costumes undergo, which somewhat undermines her interpretation. Eugenie Brinkema, *The Forms of the Affects* (Durham, N.C.: Duke University Press, 2014), 172ff.

7. Andreas Kilb, "I Am the Cook: A Conversation with Peter Greenaway," in *Peter Greenaway Interviews*, ed. Vernon Gras and Marguerite Gras (Jackson: University Press of Mississippi, 2000), 60–65, 62.

8. Paul Coates, *Cinema and Colour: The Saturated Image* (London: Palgrave Macmillan, 2010), 79.

9. Jean-Luc Godard, "Let's Talk about *Pierrot*," in *Godard on Godard*, ed. and trans. Tom Milne (New York: Da Capo Press, 1972), 272.

10. Taking a physiological approach to the color red, Bruce Kawin's reading of the overdetermination of this color in Bergman's film anchors it in the real of the body, suggesting that the red we see in the film frame is meant to mark these images as retinal. While I have read the crimson suffusions that permeate Jeff's reverse shots in *Rear Window* from a similar perspective, I find no compelling evidence in this explanation for the pervasiveness of red in the visual field of *Cries and Whispers*. Taking up the implications of Kawin's reading, Paul Coates somewhat surprisingly posits the presence of a spectator who is unimaged but internal to the film, a suggestion that recalls art theoretical readings of unimaged internal spectators in painting. As for the *imaged* spectators in *Cries and Whispers*, there's nothing to suggest that they see red at all. Nor do the film's characters usually close their eyes during the red frames of the film, as Coates suggests (*Cinema and Colour*). Indeed, it is precisely during these passages that they look out of the frame and at the film's external spectator, suggesting that the film's "color bleed" signals a melding of two registers and spaces—of the space of the film with the space of its spectator, in the manner of Hitchcock.

11. Coates, *Cinema and Colour*, 14.

12. It also brings to mind *The Red Room* (1879), title of the novel that first established Strindberg's international reputation.

13. The artist as vampire is a motif Bergman found in Strindberg.

14. Erwin Panofsky, *Problems in Titian, Mostly Iconographic* (New York: New York University Press, 1969), 17.

15. André Bazin, "Theater and Cinema," part 2, in *What Is Cinema? Volume 1*, ed. and trans. Hugh Gray (Berkeley: University of California Press, 1967), 102.

16. Brian Price, "Color, the Formless, and Cinematic Eros," in *Color, the Film Reader*, ed. Angela Dalle Vacche and Brian Price (New York: Routledge, 2006), 78.

17. We should note that there is never an actual brushstroke shot in the film.

18. Brigitte Peucker, "Seeing Red: Bergman's *Cries and Whispers*," in *Seeing Whole: Towards an Ethics and Ecology of Sight*, ed. Mark Ledbetter and Asbjorn Gronstad (Newcastle upon Tyne: Cambridge Scholars Publishing, 2016), 275–88.

19. W. J. T. Mitchell, "Space and Time: Lessing's *Laocoön* and the Politics of Genre," in *Iconology: Image, Text, Ideology* (Chicago: University of Chicago Press, 1986), 109.

20. Dusan Makavejev and M. Duda, "Bergman's Non-Verbal Sequences: Source of a Dream Film Experiment," in *Film and Dreams: An Approach to Bergman*, ed. Vlada Petric (South Salem, N.Y.: Redgrave, 1981), 192.

21. Deleuze, *Cinema 1: The Movement-Image*, trans. Hugh Tomlinson and Barbara Habberjam (Minneapolis: University of Minnesota Press, 1986), 105.

22. One point of this sequence is to suggest that the doctor and Maria, whose images coexist in the mirror, share the same subjectivity.

23. Deleuze, *Cinema 1*, 88.

24. Ibid., 87.

25. Ibid., 100.

26. Béla Balázs, "The Close-Up," in *Béla Balázs: Early Film Theory: Visible Man and the Spirit of Film*, ed. Erica Carter, trans. Rodney Livingstone (New York: Berghahn, 2010), 39.

27. Deleuze, *Cinema 1*, 97.

28. Ibid., 100.

29. Ibid., 101.

30. See especially chapters 1 and 6 of Jacqueline Lichtenstein, *The Eloquence of Color: Rhetoric and Painting in the French Classical Age*, trans. Emily MacVarish (Berkeley: University of California Press, 1993).

31. Ibid., 161.

32. Ibid., 191.

33. Ibid., 165.

34. Price, "Color, the Formless, and Cinematic Eros," 79.

35. Deleuze, *Cinema 1*, 109.

36. Ibid., 118.

37. Ibid., 119.

38. Balzac, *The Hidden Masterpiece* (1831), in *The Works of Balzac*, vol. 28, trans. Katharine Prescott Wormeley (Boston: Little, Brown, 1900), 361.

39. Ibid., 360.

40. As Deleuze points out, Godard's formula—"'it's not blood, it's red'—is *the* formula of colourism." Deleuze, *Cinema 1*, 118.

41. Ibid.

42. A seventeenth-century term for a troublesome courtesan, another woman—like Anna Karina's in *Vivre sa vie*—whose body is a commodity.

43. It should be pointed out, however, that these three colors on one canvas suggest the French flag and nation, an implication underscored by the name Marianne for the artist's model. Perhaps it is the debate between color and line—originally a French debate—that is being alluded to.

44. I owe this observation to Regina Karl's unpublished paper on this film.

45. For another reading of the hidden painting as a "voluptuous bloody portrait," and her reading of the substitute portrait as phallus, see Sue Felleman, *Art in the Cinematic Imagination* (Austin: University of Texas Press, 2006), 97ff.

46. *A Hare and a Leg of Lamb* (1742) is a good example of his work.

47. Steven Jacobs, *Art and Cinema: Belgian Art Documentaries* (pamphlet that accompanies Cinematek DVD of same title), 81.

48. See also the rich and interesting chapter on Rivette in Richard Suchenski's *Projections of Memory: Romanticism, Modernism, and the Aesthetics of Film* (Oxford: Oxford University Press, 2016). Suchenski notes that Picasso created a series of illustrations for the 1931 reprinting of Balzac's novella (134). Suchenski reads Balzac's Frenhofer as a Romantic artist, a genius, but both Balzac and Poe, to whom he also refers, occupy a space in literary history that is between Romanticism and realism. My reading of the "realist" artists in this chapter—in Balzac, Poe, and Rivette—does not preclude Romantic notions of the imagination. The desire to bring life into art is obviously a Romantic desire, but the literalism with which it is written and spoken about in these texts makes them "realist" in their desire literally to conflate art and life.

49. The focus on the hand brings with it the uncanniness of the separable part, of the body in pieces, of castration. As we recall, Fritz Lang's Rotwang, the mad Romantic artist of *Metropolis*, lost his hand in his ungodly attempt to create a living woman. This theme resonates with the work of Balzac and Poe, even if, in some sense, it is its mirror opposite.

50. Additionally, the documentary quality of these sequences undercuts our sense of the hand's uncanniness, thus serving as another check on the film's interrogation of Balzac and Poe.

51. See Brigitte Peucker, "Blood, Paint, or Red?," in *The Cambridge Companion to Alfred Hitchcock*, ed. Jonathan Freedman (New York: Cambridge University Press, 2015), 194–206.

52. This image returns in Hitchcock's final film, *Family Plot*, which recapitulates many motifs from earlier films. Here the bloodstain on a white blouse occurs on the sleeve of the "medium," Blanche.

53. Joe McElhaney, "Touching the Surface: Marnie, Melodrama, Modernism," in *Alfred Hitchcock: Centenary Essays*, ed. Richard Allen and S. Ishii Gonzalez (London: BFI Publishing, 1999), 89. For McElhaney, "vision itself here often becomes a surface in its own right, as in the red flashes which fill the screen whenever Marnie sees the color red."

54. For the relation between touching and looking, see McElhaney, "Touching the Surface," 92.

55. Lacan, "Of the Gaze as *Objet petit à*," 99.

56. Kaja Silverman, *Male Subjectivity at the Margins* (New York: Routledge, 1992), 149.

57. I have benefited from Silverman's reading of Lacan and Caillois in *Male Subjectivity at the Margins*, 148.

58. Lacan, "Of the Gaze as *Objet petit à*," 99.

59. Ibid., 100.

60. McElhaney, "Touching the Surface," 88.

61. Lacan, "Of the Gaze as *Objet petit à*," 100.

62. The film's title should be translated *by*—not *for*—Agnès V, but is not.

63. Bazin, "The Ontology of the Photographic Image," in *What Is Cinema? Volume 1*, ed. and trans. Hugh Gray (Berkeley: University of California Press, 1967), 15.

64. J. Hillis Miller, "Ariadne's Thread: Repetition and the Narrative Line," *Critical Inquiry* 3, no. 1 (Autumn 1976): 57–77, 65.

65. Alison Smith, *Agnès Varda* (Manchester: Manchester University Press, 1998), 42.

66. Michael Fried, *Manet's Modernism, or, The Face of Painting in the 1860s* (Chicago: University of Chicago Press, 1996), 297.

67. Domietta Torlasco, "Digital Impressions: Writing Memory after Agnès Varda," *Discourse* 33, no. 3 (Fall 2011): 390–408, 396.

68. Agnès Calatayud notes that Varda misquotes Corneille. Agnès Calatayud, "*Les glaneurs et la glaneuse*: Agnès Varda's Self-Portrait," *Dalhousie French Studies* 61 (Winter 2002): 113–23, 116.

69. Griselda Pollock maintains that Millet, despite his peasant background, was one of the best educated artists of the nineteenth century and could read the Bible and Virgil in Latin. Griselda Pollock, *Millet* (London: Oresko Books, 1977), 7.

70. Stephen F. Eisenman et al., "The Rhetoric of Realism: Courbet and the Origins of the Avant-Garde," *Nineteenth Century Art: A Critical History* (London: Thames and Hudson, 2007), 259–60.

71. Pollock, *Millet*, 15.

72. Théophile Gautier cited ibid., 19.

73. In making this observation I have profited from the conversation of Regina Karl, who is writing a dissertation on the hand in literature and film at Yale University.

74. Homay King, "Matter, Time, and the Digital: Varda's *The Gleaners and I*," *Quarterly Review of Film and Video* 24, no. 5 (2007): 421–29, 422.

75. Walter Benjamin, *The Work of Art in the Age of Its Technological Reproducibility, and Other Writings on Media*, ed. Michael W. Jennings, Brigid Dougherty, and Thomas Y. Levin (Cambridge, Mass.: Harvard University Press, 2008), 35.

76. Rebecca DeRoo suggests that Varda's *One Sings, the Other Doesn't* uses Brechtian strategies, citing Godard's influence on Varda. As DeRoo herself acknowledges, she could go further in her reading of the film's Brechtian elements. Rebecca J. DeRoo, *Agnès Varda: Between Film, Photography, and Art* (Berkeley: University of California Press, 2018), 71.

77. Siegfried Kracauer, *Theory of Film: The Redemption of Physical Reality*, intro. Miriam Bratu Hansen (Princeton, N.J.: Princeton University Press, 1997).

78. Hannah Arendt, "Introduction: Walter Benjamin, 1892–1940," in *Illuminations*, trans. Harry Zohn (New York: Schocken Books, 1969), 8.

79. Walter Benjamin, "Unpacking My Library," in *Illuminations*, 63.

80. Ibid., 61.

81. Susan Stewart, "Objects of Desire," in *On Longing: Narratives of the Miniature, the Gigantic, the Souvenir, the Collection* (Durham, N.C.: Duke University Press, 1993), 132–66.

Chapter 5

1. This photo essay is partially reprinted in the catalogue for the Lang retrospective at the Filmmuseum Berlin-Deutsche Kinematek: Rolf Aurich, Wolfgang

Jacobsen, and Cornelius Schnauber, eds., *Fritz Lang: His Life and Work. Photographs and Documents* (Berlin: Jovis, 2001), 65–67.

2. Ibid., 105–6.

3. Susan M. Pearce, *Museums, Objects, and Collections: A Cultural Study* (Leicester: Leicester University Press, 1992), 47.

4. André Bazin, "Theater and Cinema," part 2, in *What Is Cinema? Volume 1*, ed. and trans. Hugh Gray (Berkeley: University of California Press, 1967), 102.

5. W. J. T. Mitchell, "Empire and Objecthood," in *What Do Pictures Want? The Lives and Loves of Images* (Chicago: University of Chicago Press, 2005), 156.

6. Bill Brown, "Thing Theory," in *Things*, ed. Bill Brown (Chicago: University of Chicago Press, 2004), 5.

7. Slavoj Žižek, "The Hitchcockian Blot," in *Looking Awry: An Introduction to Jacques Lacan through Popular Culture* (Cambridge, Mass.: MIT Press, 1992), 88–106, here at 90–91.

8. Richard Abel, "Jean Cocteau," in *French Theory and Criticism, 1907–1939, A History/Anthology*, vol. 1: *1907–1929*, ed. Richard Abel (Princeton, N.J.: Princeton University Press, 1988), 236.

9. Jean Epstein, "Magnification," in Abel, *French Theory and Criticism*, 235–41, here at 239.

10. Louis Aragon, "On Decor," in Abel, *French Theory and Criticism*, 165–67, here at 166.

11. Béla Balázs, "The Face of Things," in *Visible Man*, in *Early Film Theory*, ed. Erica Carter, trans. Rodney Livingstone (New York: Berghahn Books, 2010), 46–51.

12. Béla Balázs, "Changing Set-up," in *Theory of the Film: Character and Growth of a New Art*, trans. Edith Bone (New York: Dover Books, 1970), 96.

13. Rudolf Kurtz, *Expressionismus und Film*, rpt. of 1926 ed., ed. Christian Kiening and Ulrich Johannes Beil (Zürich: Chronos Verlag, 2007), 21. My translation.

14. Gilles Deleuze, *Cinema 1: The Movement-Image*, trans. Hugh Tomlinson and Barbara Habberjam (Minneapolis: University of Minnesota Press, 1986), 52.

15. Ibid.

16. Raymond Bellour, "On Fritz Lang," in *Fritz Lang: The Image and the Look*, ed. Stephen Jenkins, trans. Tom Milne (London: BFI Publishing, 1981), 26–37, 34.

17. Lotte H. Eisner, *The Haunted Screen: Expressionism in the German Cinema and the Influence of Max Reinhardt* (Berkeley: University of California Press, 1977), 163, 165.

18. *Destiny* contains several insert shots to such objects in human form—a chandelier features the sculpted figure of a woman, as does a fountain, and during the scene of the great fire the film cuts more than once to a gargoyle representing a water carrier.

19. Deleuze, *Cinema 1*, 52.

20. Siegfried Kracauer, *From Caligari to Hitler: A Psychological Study of the German Film*, rev. and expanded ed., ed. and intro. Leonardo Quaresima (Princeton, N.J.: Princeton University Press, 2004), 84.

21. Shearer West, *The Visual Arts in Germany: Utopia and Despair* (New Brunswick, N.J.: Rutgers University Press, 2001), 161.

22. Walter Benjamin, "The Author as Producer," in *Reflections: Essays, Aphorisms, Autobiographical Writings*, ed. and intro. Peter Demetz (New York: Harcourt, Brace, Jovanovich, 1978), 230.

23. See Brigitte Peucker, "The Poem as Place: Three Modes of Scenic Rendering in the Lyric," *PMLA* 96 (October 1981): 904–13. Although Martin Heidegger was an avid reader of Rilke, Rilke's use of the term *Handwerk* in connection with writing poetry is not to be confused with Heidegger's notion of *Handwerk* as handicraft viz. Heidegger's discrimination between thing and object, art and handicraft.

24. Slavoj Žižek, "Why Is Reality *Always* Multiple?," in *Enjoy Your Symptom: Jacques Lacan in Hollywood and Out* (New York: Routledge, 2001), 199.

25. We find another such example in the sequence in which Haghi and his nurse beside his wheelchair stare at Sonja in Danelli's restaurant, where their frontal looks out of frame "stick out," as out of place in the visual field as Bruno's in Hitchcock's *Strangers on a Train* (1951).

26. Mitchell, "Empire and Objecthood," 156.

27. My reading of *Handwerk*, using Rilke's definition, differs from that of Tom Gunning, who bases his on the Heideggerian use of *Handwerk* as handicraft.

28. Tom Gunning, *The Films of Fritz Lang: Allegories of Vision and Modernity* (London: BFI Publishing, 2000), 2.

29. Joe McElhaney, *The Death of Classic Cinema: Hitchcock, Lang, Minnelli* (Albany: State University of New York Press, 2006), 138.

30. Gunning, *Films of Fritz Lang*, 10–11.

31. Lucy Fisher, "Dr. Mabuse and Mr. Lang," *Wide Angle* 3 (1979): 79.

32. Frieda Grafe, "Für Fritz Lang: Einen Platz, kein Denkmal," in *Fritz Lang*, ed. Peter W. Jansen and Wolfram Schütte (Munich: Hanser Verlag, 1976), 48.

33. Rosalind Galt, *Pretty: Film and the Decorative Image* (New York: Columbia University Press, 2011), 167.

34. Rudolf Kurtz, *Expressionismus und Film*, rpt. of 1926 ed., ed. Christian Kiening and Ulrich Johannes Beil (Zürich: Chronos Verlag, 2007), 83. My translation.

35. Eisner, *Haunted Screen*, 151.

36. Wilhelm Worringer, *Abstraction and Empathy: A Contribution to the Psychology of Style*, trans. Michael Bullock (New York: International Universities Press, 1953), 42.

37. Ibid., 43.

38. Ibid., 44.

39. Grafe, "Für Fritz Lang," 73. Translation mine.

40. Wilhelm Worringer, "The Historical Development of Modern Art," from *The Struggle for Art: The Answer to the "Protest of German Artists"* (1911), in *German Expressionism: Documents from the End of the Wilhelmine Empire to the Rise of National Socialism*, ed. Rose-Carol Washton Long (Berkeley: University of California Press, 1993), 11.

41. Brown, "Thing Theory," 5.

42. Martin Heidegger, "The Thing," in *Poetry, Language, Thought*, trans. Albert Hofstadter (New York: Harper and Row, 1971), 166ff.

43. Michel Chion sees the connection of Mabuse's writing to the text of the film as follows: "So what happens is a transmutation—not from the written word

to the oral, not from a return to the origin (poetry born from the oral, housed in writing, then returning to the oral), but from one written form to another through the destruction of the first—from Mabuse's chaotic diary to the cinemato*graph*." Michel Chion, *Words on Screen*, ed. and trans. Claudia Gorbman (New York: Columbia University Press, 2017), 117.

44. Jacques Lacan, *The Ego in Freud's Theory and the Technique of Psychoanalysis, 1954–1955*, vol. 2, *The Seminar of Jacques Lacan*, ed. Jacques-Alain Miller, trans. Sylvana Tomaselli (New York: W. W. Norton, 1991), 326.

45. In a related gesture, it is these textual fissures that Lang's films both mark and cover over in the form of the modernist direct look out of the frame exemplified by Mabuse and Haghi, the two most notable instances of character as Thing.

Chapter 6

1. Rainer Werner Fassbinder, "*Imitation of Life:* On the Films of Douglas Sirk," in *The Anarchy of the Imagination: Interviews, Essays, Notes*, ed. Michael Töteberg and Leo A. Lensing, trans. Krishna Winston (Baltimore: Johns Hopkins University Press, 1992), 77–89.

2. See Eugenie Brinkema, "Nudity and the Question: *Chinese Roulette*," in *A Companion to Rainer Werner Fassbinder*, ed. Brigitte Peucker (West Sussex, U.K.: Wiley-Blackwell, 2012), 144.

3. André Bazin, "Theater and Cinema," part 1, in *What Is Cinema? Volume 1*, ed. and trans. Hugh Gray (Berkeley: University of California Press, 1967), 77.

4. Ibid., 81.

5. Ibid., 102.

6. Ibid., 87.

7. Bazin: "To justify this point of view completely, one should really discuss it within the framework of the aesthetic history of influence in art in general. This would almost certainly reveal, we feel, that at some stage in their evolution there has been a definite commerce between the technique of the various arts" ("Theater and Cinema," part 2, 116).

8. Ibid., 106.

9. Ibid., 105.

10. Joanna Firaza, *Die Aesthetik des Dramenwerks von Rainer Werner Fassbinder: Die Struktur der Doppeltheit* (Frankfurt am Main: Peter Lang, 2002), 10. See also David Barnett, *Rainer Werner Fassbinder and the German Theatre* (Cambridge: Cambridge University Press, 2005).

11. Siegfried Kracauer, "The Blue Angel (1930)," in *The Weimar Republic Sourcebook*, ed. Anton Kaes, Martin Jay, and Edward Dimendberg (Berkeley: University of California Press, 1994), 630–31.

12. Gaylyn Studlar, *In the Realm of Pleasure: Von Sternberg, Dietrich, and the Masochistic Aesthetic* (New York: Columbia University Press, 1998), 97.

13. Josef von Sternberg, *Fun in a Chinese Laundry* (San Francisco: Mercury House, 1965), 147.

14. Ibid.

15. Rudolf Arnheim, "Josef von Sternberg," in *Sternberg*, ed. Peter Baxter (London: BFI Publishing, 1980), 40.

16. David Bordwell, *Figures Traced in Light: On Cinematic Staging* (Berkeley: University of California Press, 2005), 104.

17. Bill Nichols, *Ideology and the Image: Social Representation in the Cinema and Other Media* (Bloomington: University of Indiana Press, 1981), 125–26.

18. Studlar, *In the Realm of Pleasure*, 97.

19. Paul Coates, "The Cold Heaven of the Blue Angel: Dietrich, Masochism and Identification," *Discours social / Social Discourse* 2, nos. 1–2 (Spring–Summer 1989): 59–67.

20. Von Sternberg, *Fun in a Chinese Laundry*, 155.

21. Fassbinder, "*Imitation of Life*," 77–89.

22. Von Sternberg, *Fun in a Chinese Laundry*, 155.

23. Mary Ann Doane lays out the complex and compelling argument in "Veiling over Desire: Close-ups of the Woman," in *Femmes Fatale: Feminism, Film Theory, Psychoanalysis* (New York: Routledge, 1991), 52.

24. Kracauer, "The Blue Angel (1930)," 630.

25. Ibid., 631.

26. Ibid.

27. Rainer Werner Fassbinder, dir., *Lola*, BRD Trilogy, Criterion Collection, Peter Märtesheimer interview, DVD supplements.

28. Ibid.

29. Von Sternberg's early years were spent in Vienna, to which he returned with his family after a few years. He had been working in the US film industry for years when he went to Germany to make *The Blue Angel*. Douglas Sirk, born Detlef Sierck, had had a career in the German theater and in films before fleeing from the Nazis.

30. Fassbinder, Peter Märtesheimer interview (*Lola* DVD), 89.

31. Von Sternberg, *Fun in a Chinese Laundry*, 248.

32. Barry Salt, "Sternberg's Heart Beats in Black and White," in *Sternberg*, ed. Peter Baxter (London: BFI Publishing, 1980).

33. It is not the case that the lavender projected lighting represents a melding of Lola's primary red with von Bohm's blue, as Tim Bergfelder has maintained, since that color is visible in the bedroom before Lola sees it. Bergfelder, "Popular Genres and Cultural Legitimacy: Fassbinder's *Lola* and the Legacy of 1950s West German Cinema," *Screen* 45, no. 1 (Spring 2004): 32.

34. They are of Frankfurt. The film's narrative recalls the notorious political situation of Fassbinder's play, *Garbage, the City, and Death*, and of *In a Year with Thirteen Moons*, the film dedicated to Alexander Kluge.

35. Brian Price, "Color, Melodrama, and the Problem of Interiority," in *A Companion to Rainer Werner Fassbinder*, ed. Brigitte Peucker (West Sussex, U.K.: Wiley-Blackwell, 2012), 171; emphasis in the original.

36. Ibid., 174.

37. Ibid., 175.

38. Ibid., 177.

39. Ibid., 171.

40. Von Sternberg, *Fun in a Chinese Laundry*, 283.

41. Slavoj Žižek, "Back to the Suture," in *The Fright of Real Tears* (London: BFI Publishing, 2001), 51.

42. Gilles Deleuze, "Coldness and Cruelty," in *Masochism* (New York: Zone Books, 1991), 53.

43. Ibid., 52.

44. Vladimir Nabokov, *Speak, Memory: An Autobiography Revisited* (New York: Vintage Books, 1989), 125.

45. Ibid., 139.

46. Philippe-Alain Michaud, *Aby Warburg and the Image in Motion*, trans. Sophie Hawkes (New York: Zone Books, 2004), 14.

47. Marlene Dietrich is said to have traveled with her collection of dolls. See Judith Mayne, "Marlene, Dolls, and Fetishism," *Signs: A Journal of Women in Culture and Society* 30, no. 1 (2004): 1260.

48. Kaja Silverman, "Fassbinder and Lacan: A Reconsideration of Gaze, Look, and Image," in *Male Subjectivity at the Margins* (New York: Routledge, 1992), 137.

49. In chapter 2 I discuss the implications of Fassbinder's use of dolls in the erotic sphere.

50. Rainer Naegele, *Trauerspiel und Puppenspiel*, ed. Sigrid Weigel (Cologne: Böhlau Verlag, 1992), 19.

51. *The Bitter Tears of Petra von Kant*'s variously posed mannequins and dolls spring to mind: as in this earlier film, the placement of the dolls changes during the course of *Lola*, but they are never mentioned in the dialogue.

52. Jack Babuscio, "Camp and the Gay Sensibility," in *Queer Cinema: The Film Reader*, ed. Harry Benshoff and Sean Griffin (New York: Routledge, 2004), 51.

53. Susan Sontag, "Notes on Camp," in *A Susan Sontag Reader*, intro. Elizabeth Hardwicke (New York: Vintage Books, 1983), 109.

54. Cited in Babuscio, "Camp and the Gay Sensibility," 131.

55. References to Dietrich—a gay icon and figure of identification—also occur elsewhere in Fassbinder's films: in *Gods of the Plague* (1969), for instance, and in *Mother Küsters Journey to Happiness* (1975).

56. Von Sternberg, *Fun in a Chinese Laundry*, 254.

57. Ibid., 254.

58. Silverman, "Fassbinder and Lacan," 135.

59. Wanda Sacher-Masoch, "The Adventure with Ludwig II," in *Masochism* (New York: Zone Books, 1989), 283.

60. Janet Staiger, "Authorship Approaches," in *Authorship and Film*, ed. David A. Gerstner and Janet Staiger (New York: Routledge, 2003), 51. Staiger's interest in her project derives from the insight that auteurism can have positive implications for films produced by minority groups, with their focus on identities.

Chapter 7

1. Erika Fischer-Lichte, *The Transformative Power of Performance: A New Aesthetics*, trans. Saskya Iris Jain (New York: Routledge, 2008), 94–99.

2. Ibid., 95.

3. Stanley Cavell, "Audience, Actor, Star," in *The World Viewed: Reflections on the Ontology of Film*, enlarged ed. (Cambridge, Mass.: Harvard University Press, 1979), 25–29, 29.

4. Stanley Cavell, *Pursuits of Happiness: The Hollywood Comedy of Remarriage* (Cambridge, Mass.: Harvard University Press, 1979), 28.

5. James Naremore, *Acting in the Cinema* (Berkeley: University of California Press, 1988), 30.

6. André Bazin, "Theater and Cinema," part 2, in *What Is Cinema? Volume 1*, ed. and trans. Hugh Gray (Berkeley: University of California Press, 1967), 97, 98.

7. Jean-Luc Nancy, "Distinct Oscillation," in *The Ground of the Image*, trans. Jeff Fort (New York: Fordham University Press, 2005), 65.

8. Ibid., 68.

9. Bazin, "Theater and Cinema," part 2, 102.

10. Ibid.

11. Ibid., 107.

12. Ibid., 102.

13. Ibid., 120.

14. Ibid., 116.

15. Ibid., 109.

16. It should be noted that the interrelation of theater and cinema is also addressed in other chapters of this book—in chapter 3, on R. W. Fassbinder's *The Bitter Tears of Petra von Kant*, and in chapter 2, on Peter Greenaway.

17. Bertolt Brecht, "A Short Organum for the Theatre," in *Brecht on Theatre: The Development of an Aesthetic*, ed. and trans. John Willett (New York: Hill and Wang, 1964), 204.

18. Walter Benjamin, "What Is Epic Theater?," in *Illuminations*, ed. and intro. Hannah Arendt, trans. Harry Zohn (New York: Schocken Books, 1969), 147–54, 151.

19. Brecht, "Short Organum for the Theatre," 179.

20. Ibid., 187.

21. Linda Badley, *Lars von Trier* (Champaign: University of Illinois Press, 2011), 115.

22. Jacques Rancière, "The Ethical Turn of Aesthetics and Politics," *Critical Horizons* 7, no. 1 (2006): 1–20.

23. Richard Sinnerbrink, "Grace and Violence: Questioning Politics and Desire in Lars von Trier's *Dogville*," *Journal of Media, Arts, and Culture* 3, www.scan.net.au/scan/journl/display.php?journal_id=94.

24. Marit Kapla, "Lars von Trier in Dogville," in *Lars von Trier Interviews*, ed. Jan Lumholdt (Jackson: University Press of Mississippi, 2003), 203–12, 206ff.

25. With a similar stress on disparities of register or what I call aesthetic dissonance, Nikolaj Lübecker argues that the film's Brechtian dimension is undermined by a surrealist disposition (he refers to Artaud's *Theatre of Cruelty*) designed to manipulate the spectator affectively—and negatively, in order to produce "the beast in all of us." No surprise there, but Lübecker argues that the film's Brechtian and surrealist dimensions are "incompatible frameworks," and likewise notes that the film derives its tension from the conflictual relation between the two." For Lübecker, the film's center of concern is its audience, not its characters, and its mission is to promote spectatorial pain. While *Dogville* turns film experience into intensified visceral experience, the film's aggression, Lübecker argues, saves it from "facile moralizing" while allowing the spectator to come to terms with his "inner bastard." Nikolaj Lübecker, "Lars von Trier's *Dogville*: A Feel-Bad Film," in *The New Extremism in Cinema: From France to Europe*, ed. Tanya Horek and Tina Kendall (Edinburgh: Edinburgh University Press, 2011), 157–68, 163, 167. Thanks to May Fulton for this reference.

26. Linda Williams, "Melodrama Revised," in *Refiguring American Film Genres: Theory and History,* ed. Nick Browne (Berkeley: University of California Press, 1998), 42–88, 47, 50, 53.

27. Ibid., 58.

28. See Stanley Cavell, "Audience, Actor, Star," in *The World Viewed: Reflections on the Ontology of Film,* enlarged ed. (Cambridge, Mass.: Harvard University Press, 1979), 25–29.

29. See Ben Brewster and Leah Jacobs, *Theatre to Cinema: Stage Pictorialism and the Early Feature Film* (Oxford: Oxford University Press, 1997).

30. Peter Brooks, *The Melodramatic Imagination: Balzac, Henry James, Melodrama, and the Mode of Excess* (New Haven, Conn.: Yale University Press, 1976), 61.

31. Fischer-Lichte, *Transformative Power of Performance,* 97.

32. Ibid., 98–99.

33. Ibid., 99.

34. In "Visual Pleasure in Narrative Cinema," Laura Mulvey famously analyzed the process of identification in film. Laura Mulvey, "Visual Pleasure and Narrative Cinema," in *Feminist Film Theory: A Reader,* ed. Sue Thornham (New York: New York University Press, 1999), 58–69.

35. Samuel Weber, "'Being and eXistenZ': Some Preliminary Considerations on Theatricality in Film," in *Theatricality as Medium* (New York: Fordham University Press, 2004), 313–25, 315.

36. Interested in newer media, Garrett Stewart reads the film as replacing cinematic identification with "electronic invasiveness" and sensory motor action. See Garrett Stewart, *Framed Time: Toward a Postfilmic Cinema* (Chicago: University of Chicago Press, 2007), 157.

37. Ken Gross, *Puppet: An Essay on Uncanny Life* (Chicago: University of Chicago Press, 2011), 67.

38. Ibid., 42.

39. Glen O. Gabbard, "Fifteen Minutes of Fame Revisited: Being John Malkovich," *International Journal of Psycho-Analysis* 82, no. 1 (2001): 177–79.

40. See Susan Stewart, *On Longing: Narratives of the Miniature, the Gigantic, the Souvenir, the Collection* (Durham, N.C.: Duke University Press, 1993), 61ff.

41. "Vessel": this word also cues the time-travel, sci-fi dimension of *Being John Malkovich,* which is not directly pertinent to our topic. See Garrett Stewart, *Framed Time,* 156–62.

42. Gilbert Adair, "Rohmer's *Perceval,*" *Sight and Sound* 47, no. 4 (Fall 1978): 230–34; and Nadja Tesich-Savage, "Rehearsing the Middle Ages," *Film Comment* 14, no. 5 (September/October 1978): 50–56.

43. Brigitte Peucker, *Incorporating Images: Film and the Rival Arts* (Princeton, N.J.: Princeton University Press, 1995).

44. Adair, "Rohmer's *Perceval,*" 231.

45. Carl Theodor Dreyer, *The Passion of Joan of Arc* Criterion DVD, commentary by Caspar Tyborg.

46. Ibid.

47. Adair, "Rohmer's *Perceval,*" 232.

48. Ibid.

49. Adair, "Rohmer's *Perceval*," 234.

50. Ibid.

51. Daniel Fairfax, "The Tale of Perceval le Gallois and the Young Althusserians," *Senses of Cinema* 54 (April 2010), http://sensesofcinema.com/2010/feautre-articles/the-tale-of-perceval-le-gallois-and-the-young-althusserians.

52. Adair, "Rohmer's *Perceval*," 234.

53. Tesich-Savage, "Rehearsing the Middle Ages," 52.

54. Erika Fischer-Lichte, *The Transformative Power of Performance: A New Aesthetics*, trans. Saskya Iris Jain (New York: Routledge, 2008), 68.

55. Marvin Carlson, "Perspectives on Performance: Germany and America," in Fischer-Lichte, *The Transformative Power of Performance*, 6.

56. Jacques Rancière, "The Emancipated Spectator," in *The Emancipated Spectator*, trans. Gregory Elliott (London: Verso, 2009), 3.

57. George R. Kernodle, *From Art to Theatre: Form and Convention in the Renaissance* (Chicago: University of Chicago Press, 1944), 15.

58. Ibid., 52.

59. Michael Francis Gibson, *The Mill and the Cross: A Commentary on Pieter Bruegel's "Way to Calvary,"* rev. ed. (Paris: University of Levana Press, 2012).

60. Lev Manovich, *The Language of New Media* (Cambridge, Mass.: MIT Press, 2001), 308.

61. Gibson, *The Mill and the Cross*, 35.

62. Joseph Leo Koerner, *Bosch and Bruegel: From Enemy Painting to Everyday Life* (Princeton, N.J.: Princeton University Press, 2016), 290.

63. Spatially, too, there is a reference to an earlier Flemish painting, now on display at the Louvre, attributed first to van Eyck and currently to the Brunswick Monogramatist. Also of Christ's Passion, this painting is likely the source for the unusual, somewhat grotesque rock formation on which the mill is perched. In the earlier painting, a dark tower sits atop it. Gibson, *The Mill and the Cross*, 41.

64. Kernodle, *From Art to Theatre*, 52.

65. See Swagato Chakravorty, "Real Bodies in (Un)real Spaces: Space, Movement, and the Installation Sensibility in Lech Majewski's *The Mill and the Cross*," *Acta Universitae Sapientiae, Film and Media Studies* 11 (2015): 7–27.

66. Bazin, "Theater and Cinema," part 2, 111–12.

67. Ibid.

68. Bazin, "Theater and Cinema," part 2, 111.

INDEX

Page numbers in **boldface** refer to illustrations.